DEGAS by himself

de troup derrière la Montagne blue sur une campagne.
absolument semblable à celle des courses et des chattes
anglaise coloriées –

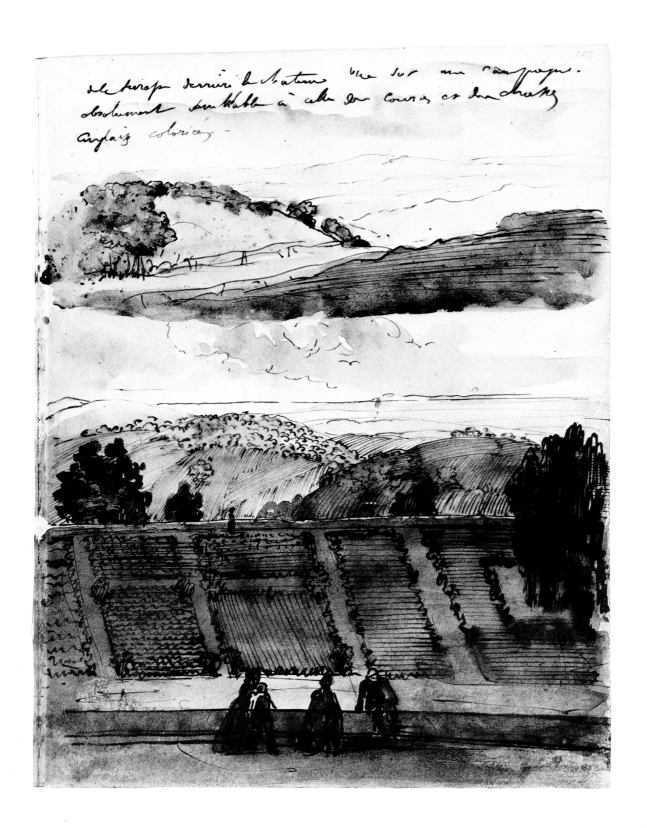

Edited by
Richard Kendall

DEGAS by himself

drawings
prints
paintings
writings

Macdonald Orbis
London

A *Macdonald Orbis* BOOK
© Macdonald & Co (Publishers) Ltd 1987
First published in Great Britain in 1987 reprinted 1988
by Macdonald & Co (Publishers) Ltd
London & Sydney

A member of BPCC plc

British Library Cataloguing in Publication Data
 Degas by himself.
 1. Degas, Edgar
 I. Kendall, Richard
 709'.2'4 N6853.D33
 ISBN 0-356-14932-5

Filmset in Monotype Van Dijck by
Balding + Mansell International Limited
Printed and bound in Italy by Graphicom SRL, Vicenza
Editors: Christopher Fagg, Patricia Burgess
Designer: Andrew Gossett
Picture Researcher: Christina Weir

Macdonald & Co (Publishers) Ltd
Greater London House
Hampstead Road
London NW1 7QX

Special permission to quote extracts from translated
sources has been granted as follows:
My Friend Degas, Daniel Halévy
© 1964
Reprinted by permission of Wesleyan University Press
The Notebooks of Edgar Degas, edited by Theodore Reff
(1976)
© Oxford University Press 1976
Reprinted by permission of the Oxford University
Press

For my parents

Acknowledgements

The guiding spirit behind this book has indubitably
been that of Bruce Bernard, whose exemplary *Vincent
by himself* set me a standard to aim at and whose
encouragement, perspicacity and sheer passion for
painting have been a continued inspiration to me. I
have also depended heavily on the support and
expertise of Martin Heller, Christopher Fagg and
many others at Macdonald Orbis; and on the
exceptionally sympathetic and professional contri-
bution of the book's designer, Andrew Gossett,
and his colleagues at Omnific.
 A book of this kind inevitably leans on the work of
several generations of scholars, writers and editors,
and I would like to acknowledge my debt to them.
I, likewise, have had to lean on a number of my friends
and family, who have sustained me through the years
of my entanglement with Degas and contributed to
this book in a multitude of ways. I must thank
particularly Graham Beal, Peter and Angela Brookes,
Richard Thomson and Arianne Lawson; my wife,
Christine, for her forbearance, and my daughter,
Ruth, who knows more about Degas than most ten
year-olds.

 Richard Kendall

Contents

Introduction

Degas by himself is a collection of the words and the art of Edgar Degas (1834–1917). The intention of the book is to present a full, rounded and, in places, unfamiliar view of the artist and his achievements, with particular emphasis on his views and intentions as revealed in his use of the written and spoken word.

The overwhelming majority of words in this book were written by Degas himself, in the form of letters, notebooks and sketchbook jottings. The final section of the text brings together a number of Degas' remarks, aphorisms and conversations as written down by his contemporaries. Some of this material was published in the years following the artist's death, though much of it has been translated or retranslated especially for this present volume, which is the first to assemble a comprehensive range of the artist's words from every period of his life.

The artist's own writings are divided into three roughly chronological sections, covering the early, middle and final phases of his career. Accompanying these sections are substantial selections of works from the corresponding period, including drawings, pastels, paintings and various kinds of print-making. These pictures include many of the major milestones of Degas' career, as well as a number of less-known but hardly less distinguished works, including some never previously reproduced in colour. Most notable here are a large group of plates from the relatively unknown pages of Degas' notebooks.

It is my hope that Degas will emerge from these pages confirmed as a more plausible, articulate and challenging artist than the mere 'painter of ballet dancers' that he was so afraid of becoming.

Richard Kendall

NOTE
Dates in italics represent likely but unconfirmed attributions.

Degas: a feeling for words

'My art, what do you want to say about it? Do you think you can explain the merits of a picture to those who do not see them? . . . I can find the best and clearest words to explain my meaning, and I have spoken to the most intelligent people about art, and they have not understood; but among people who understand, words are not necessary, you say humph, he, ha and everything has been said.'

Degas' attitude to words, as expressed on this occasion to the Irish journalist and writer George Moore, was both forceful and contradictory. Another contemporary described how Degas 'loved to talk about art, but could not abide others talking about it' and we know that he developed a violent and neurotic distaste for art critics and writers about art of all kinds. In spite of his aversion, a number of Degas' own pithy observations on art were already in circulation during his lifetime and are still quoted with respect by artists today.

His reputation as a wit was formidable, and he could hold his own among the most brilliant conversationalists of the day. There is an account of a sparkling exchange between Degas and Oscar Wilde and it was said that, in Degas' company, James McNeill Whistler's conversation was reduced to 'brilliant flashes of silence'. So celebrated was Degas' way with words that more than a dozen of his contemporaries were inspired to write down his observations and his aphorisms while he was alive, and to publish them in a series of books and articles after his death.

More surprising, in the light of his outbursts against 'men of letters', is the substantial body of Degas' own writings. Although he never wrote systematically or with an eye to posterity, he was a committed letter-writer, an occasional poet and an intermittent diarist. Many tens of thousands of his own words survive in these various forms and together they suggest a writer of considerable humour, versatility and expressive power. Once again, Degas' public attitude belies the reality. We know that he mixed with a number of the most celebrated writers of his age and counted some of them among his close friends. At different points in his career Degas met or befriended Emile Zola, Edmond Duranty, Stefan Mallarmé, Paul Valéry and Ludovic Halévy and his son Daniel. He read contemporary literature, for example some of Zola's *Rougon-Macquart* novels, discussed his own attempts at poetry with the leading poets of the day, and was closely involved with a number of the theatrical, operatic and literary creations of his distinguished circle of friends.

Degas' delight in words is nowhere more clearly evident than in his letters, some 300 of which still survive today. Some of these are hastily scribbled notes to customers or collectors, but a significant number are substantial, considered compositions written during his travels or in order to share his thoughts with a distant friend or relative.

Degas' manner can vary from the confessional to the theatrical, from the business-like to the anecdotal. With certain of his closest friends, such as Henri Rouart or Ludovic Halévy, Degas could be disarmingly intimate and he delighted in the kind of obscure language and private jokes reserved for such relationships. In certain circumstances, such as his visit to America between 1872 and 1873, Degas could write at considerable length, conjuring up new sights and experiences with his skilful use of words and an eye for the telling image. Later in his life, Degas' letters tended to be shorter and more direct, but he was always capable of the sudden indiscreet expression of feeling or a delight in some bizarre verbal construction.

The other important body of written matter that has come down to us from Degas' career is his notebooks. Thirty-seven of these exist, in a variety of shapes, sizes and formats, most of them containing mainly visual rather than written material. Degas appears to have used his notebooks on a regular basis in the early years of his career, but their usage becomes increasingly sporadic and finally peters out in the 1880s. They contain a wide variety of drawings, ranging from finely detailed studies of Old Master paintings to the most rapid, improvised scribbles done in a moving carriage or at the theatre. Interleaved among these drawings, sometimes in single sentences and sometimes in lengthy sequences of several pages, Degas put down an equally varied collection of written notes. There are descriptions of journeys undertaken and pictures seen; there are notes for his own paintings and ideas for projects in the future; quotations from literature, private reflections and intimate thoughts; and the inevitable addresses of models and fellow-artists, titles of pictures for exhibitions and even accounts and laundry lists.

In conjunction with his letters, Degas' notebooks provide an important written counterpoint to the events and achievements of his life, often illuminating his studio activity and casting light on his own bewildering personality. Degas' affected dislike for professional writers must not be allowed to detract from his own feeling for words, though he did remain true to one aspect of his aversion throughout his own writings. Though he may write about art in a descriptive or practical sense, he rarely, if ever, theorizes about it. Theories, speculations and abstract systems had no place either in his art or his career. As he exclaimed on one occasion: 'Let us hope that we shall soon have finished with art, with aesthetics. They make me sick. Yesterday I dined at the Rouarts'. There were his sons and some young people – all talking art. I blew up. What interests me is work, business, the army!'

The apprentice years

Degas' childhood years prepared him well for his later enjoyment of language and literature and helped foster his natural gifts as a writer. He was born in Paris in 1834 and put through a strict classical education at the Lycée Louis le Grand. Here he learnt to read Latin and Greek, and memorized formidable sections of the French classics. Degas had strong family ties with Italy and it appears that he also picked up Italian on visits to his relatives in Naples and Florence. His father, Pierre-Auguste-Hyacinthe de Gas, was a banker with a strong inclination towards the arts, who seems to have passed on to his children, among other things, his particular love of music. He also encouraged them to write long letters when they were away from home to which he replied with suitable approbation and occasional censure. Many of these family letters have since disappeared, but those remaining illustrate the close personal ties and the keen sense of loyalty among the scattered Degas clan.

Degas lost both his parents when he was relatively young, his mother in 1847 and his father in 1874, but in his early years he was able to enjoy the privileges and freedoms of belonging to a wealthy, cultivated Parisian family. His father's prosperity meant that the young artist could travel, and between 1854 and 1859 he made a series of extended visits to the south of France and to Italy. His aim, which he shared with many young and aspiring artists at this time, was a kind of self-imposed apprenticeship based on the study of historic monuments and works of art. He drew sculptures and sarcophagi, cathedrals and landscapes, and made hundreds of copies of the paintings he admired. As he travelled, his notebooks filled with such drawings, often accompanied by written notes and extended accounts of his journeys. Here his descriptive powers are at their most vivid, as he evokes for us a journey at night in a horse-drawn carriage, or his own scarcely contained delight as he rushes into a museum or church for the first time. Degas often chose to use the present tense in his notes, accentuating the immediacy of the experience:

'*Monday 5.30 – I have my luggage brought to the coach – I am about to leave – in the end I stay. I am so undecided – I must make up my mind . . . First I rush to the Church of the Camaldules – fresco by Raphael – there is something of Fra Bartolomeo – I think only of Assisi which attracts me like a magnet – nevertheless I want to leave . . .*'

The short, staccato quality of these sentences adds urgency and vividness to their meaning and descriptive power. In places the notes are arranged across the page in the manner of a prose-poem, evoking sights and sensations as much as

describing them:

'*Yellow plain, cut corn,*
mountains grey with night
falling at their feet.
Hazy mountains
truly azure blue
7.30
All is grey,
except the foreground.'

As we might expect from a young artist in training, particular attention is given to colours, to light and shade and to effects of distance and texture. A certain pond is likened to 'the green of an unripe lemon', a drapery to a 'purée of peas'; the grey of a seascape is compared to that of a pigeon's breast, a reddish-brown landscape feature looks 'like a little branch of dead pine laid in the sunshine'.

Responsive though Degas was to the qualities of nature, the majority of his notebook pages are devoted to his greatest enthusiasm – the art of the past. From the portraits of Van Dyck to the frescoes at Assisi or the paintings of the Renaissance masters, Degas copied or described them wherever he travelled. Such copying had many purposes, but one of them was certainly to build up a repertoire of compositions and subjects for his own artistic career, a kind of reference library for the future. In the late 1850s Degas had already started to plan some of his own early paintings and in many cases the field work had been done in Italy. Pictures such as *The Young Spartans* and *The Daughter of Jephtha* are large, ambitious canvases based on classical literature and the Bible respectively, each one containing a large number of draped or nude figures in an elaborately conceived composition. Characteristically, he produced many hundreds of drawings for these figures, gradually refining his ideas and developing a mastery of draughtsmanship that was to distinguish his later career.

Degas' early pictures also show the influence of his own contemporaries. During his travels in Italy, he mixed with a number of other young French artists, such as Joseph-Gabriele Tourny, Elie Delaunay and Gustave Moreau, who would often debate the relative merits of Ingres, with his emphasis on drawing as the basis for art, and of Delacroix, with his famous love of colour. The letters from Degas to Moreau, besides illustrating Degas' great capacity for friendship (in this case with a man eight years his senior), also hint at this continuing artistic debate. Degas writes, '. . . it is time for you to come to draw in Florence . . . you have sufficiently indulged your penchant for colour . . .' and it is possible to see this conflict between the two rival approaches in Degas' own early work. These early history pictures were clearly intended to launch Degas' artistic career along a traditional and well-defined route, and it is possible that the more finished ones were submitted to the annual Paris Salon. It was not, however, until 1865 that Degas first submitted successfully, with his picture of *The Misfortunes of the City of Orleans*, and by this time his career was poised to take off in a quite different direction.

In the same letter of 1858 Degas told Moreau, 'I am busy with a portrait of my aunt and my two little cousins', a project that was to culminate in the large Bellelli family portrait. Degas' inclination towards portraiture and other subjects drawn from his immediate surroundings (rather than from literature or history), increased significantly in the early 1860s and was reinforced by a number of new influences and acquaintances. About this time, he first met Manet and began to mix with a less traditionally minded group of artists and writers. Inspired by painters like Courbet and the new school of realist writers, young artists were turning their attention to the subject matter of their own times, to the cities and streets of an industrial society and to the personalities and dramas of their own experience. Degas' privileged childhood and his conservative artistic training might have made such a transition difficult, but gradually 'modern life' subjects took over his art. Along with portraits of his family and friends, he began his lifelong obsession with the racetrack – with horses, jockeys and the varied social confrontations of the racing world. As the decade progressed, his first ballet pictures and paintings of the orchestra appeared, and, unexpectedly, some pastel studies of the landscape.

Unfortunately, very few letters survive from this period to help us follow the corresponding changes in Degas' thinking, but one or two notebook entries hint at his new preoccupations. He notes how artificial most skin-colouring is in painting; he urges himself to study facial expression and the effects of lamplight; and he decides to 'make portraits of people in typical, familiar poses, being sure above all to give their faces the same kind of expression as their bodies. Thus, if laughter typifies an individual, make her laugh.' In an effort to reconcile his years in Italy with his new role as a painter of modern life he exclaimed, 'O Giotto, let me see Paris, and you, Paris, let me see Giotto!'

The Impressionist era

The early years of the next decade were dramatic ones for Degas in a number of ways. In 1870 he enlisted in the National Guard and helped to defend Paris when it was under siege by the Prussian army; in 1872 he travelled to America with his brother René and while there painted a number of pictures of his relatives; and in 1874 he became one of the principal organizers of the first Impressionist exhibition. As the decade advanced, Degas emerged as a successful and respected figure in Parisian artistic circles and he began to sell work through established dealers and to influential collectors. Many of these developments are vividly recorded in his letters and notebooks, and it is possible to chart his progress from the self-effacing and tentative initiate of the 1860s to the confident, ambitious and fully-fledged artist of the 1870s.

Degas never recorded his reasons for travelling to New Orleans in 1872. It has been suggested that he needed to recuperate after the rigours of the Siege of Paris, but it is just as likely that family affection and his lifelong love of travelling prompted the visit. Whatever the pretext, the journey inspired the most sustained and colourful groups of letters to survive from Degas' pen. With characteristic frankness, Degas described the dullness of the Atlantic crossing in the company of reserved Englishmen, the cosmopolitan bustle of New York and the delights of sleeping compartments in long-distance trains. From New Orleans, he painted a verbal picture of bright sunshine, the colourful local populace, the cotton-centred life of his family and the antics of his young cousins. Surprisingly, there are very few notebook drawings to correspond with these events, indicating perhaps that some notebooks have been lost, but a number of paintings and drawings brought back by the artist create a vivid impression of this time spent abroad.

The most familiar of Degas' American pictures, *The Cotton Office, New Orleans*, is discussed at some length in a letter of 1873 to the painter James Tissot. In this letter and a number of others from the 1870s we are reminded that Degas was now a professional artist, needing to earn his living and having to attract the attention of dealers like Agnew, Deschamps and Durand-Ruel. Degas never married and maintained only a modest apartment in Paris, but he came to rely less and less on his family money, and after the death of his father in 1874 he took it upon himself to make good the family debts. The exhibiting and selling of pictures became a necessity, and Degas threw himself into the newly proposed exhibition of 'Independent artists', later called the Impressionists, with typical vigour. He pestered artists like Tissot and Manet to join the new group and in this and subsequent Impressionist shows he involved himself in many aspects of the organization – selection, and publicity .

Despite the generally hostile public reaction to the Impressionists, Degas' work was well received and he began to attract the attention of a number of private collectors, among them the famous baritone, Jean-Baptiste Faure. As his letters show, Degas became involved in a complicated series of transactions with Faure, including the return of certain pictures for re-working and an eventual lawsuit when the exasperated singer could wait no longer and demanded to have his pictures returned.

Degas' writings from the 1870s provide a number of insights into his working practice. His letters show him arranging access to ballet rehearsals and sketchbook notes record his attendance at performances, such as that of *Robert le Diable*. At the end of the decade, when he was involved with artists such as Camille Pissarro and Mary Cassatt in a project to publish their etchings in a journal, he noted down a remarkable sequence of thoughts for future pictures. 'A severely truncated dancer, do some arms or legs, or some backs . . . corsets that have just been removed . . . which retain the form of the body . . . the hollowing of the cheeks of the bassoonists . . . different blacks, black veils of deep mourning floating on the face – black gloves, mourning carriages . . . still lives of different breads, large, oval, long, round, etc.' Degas' highly original visual intelligence is demonstrated here once again, allied with his lively pen to remind us of his transformation into an artist of contemporary life, delighting in the unexpected image, the startling composition and the freshly observed detail.

The 1870s was the period when Degas' distinctive repertoire of images was established and some of his most well-known pictures produced. He seems to have explored Parisian society from its highest levels to its lowest, its public as well as its private faces, experimenting with an equally wide variety of techniques and pictorial devices to capture the novelty of city experience. His portraits became more audacious and circumstantial, whether showing the writer in his study or the woman on the street. His pictures of laundresses and cabaret singers capture characteristic gestures and distinctive body movements as well as their respective habitats. Ballet dancers practise at the bar, pirouette in the glare of the footlights or collapse exhausted after a day's exercise. The subject of movement, whether of a racehorse, a dancer or a blurred face in a crowd, came to preoccupy the artist and perhaps to summarize those essential qualities of modern city life – speed, energy and ambiguity.

Another theme which runs through the letters of this period and into his later years is that of friendship. Degas could be fierce when crossed, as one or two of his notes show, but as a friend he was loyal, tenacious and capable of disconcerting displays of affection. 'How moving friendship

is, in its mystery and diversity!' he once wrote to Evariste de Valernes, and he continued to write to his intimate circle until the end of his life. His close friends were diverse indeed: Henri Rouart, engineer and amateur artist; Paul-Albert Bartholomé and Georges Jeanniot, sculptor and painter respectively; Ludovic Halévy, librettist and writer; and Marie Braquemond, engraver and etcher. Durand-Ruel, who acted as Degas' banker as well as his increasingly successful dealer, appears to have enjoyed a close relationship with the artist, and a number of younger painters, such as Paul Gauguin, Mary Cassatt and Suzanne Valadon, benefited from Degas' encouragement and advice.

In spite of the warmth of his dealings with fellow artists and friends, Degas was susceptible to phases of morbid introspection and even severe depression. Ever since the Franco-Prussian war he had suffered from serious eye trouble and, as his letters show, he sometimes felt that he was about to go blind. He found certain light conditions, like bright sunshine, intolerable and he was forced to work indoors in a controlled environment. At times, Degas' bachelor state and his eye problems, his frustrated artistic ambitions and his occasional health problems all crowded in on him and prompted him to write letters of heartbreaking poignancy to his friends. When we look back at the work of the early 1880s, we seem to be looking at some of the crowning achievements of Degas' career, but a letter of 1884 tells a different story: 'If you were single, 50 years of age (for the last month) you would know similar moments when a door shuts inside one and not only on one's friends. One suppresses everything around one and once all alone one finally kills oneself, out of disgust. I have made too many plans, here I am blocked, impotent . . .'

Late maturity and old age

In 1886, when Degas was fifty-two, the eighth and final exhibition of Impressionism took place in Paris. Several of his personal friends participated, including Braquemond, Forain, Gauguin, Pissarro and Rouart, and Degas himself submitted a group of pastels of female nudes washing themselves and engaged in various aspects of their toilette. These pastels, with their dense layers of textured colour, their vivid hatchings and their bold and unusual viewpoints, have become some of the most widely admired of Degas' pictures, yet they effectively mark the end of an important phase in Degas' career as a public artist. With one exception, he was never to exhibit contemporary work on this scale again and he increasingly seemed to prefer the solitude of his studio to the busy artistic society of Paris.

The pastel nudes, while clearly based on living models and on the observed habits of contemporary women, also represented for Degas an essential link with traditional art. Degas loved to insist on the links between his own art and the great art of the past and when he said, '. . . two centuries ago I would have been painting *Susannah bathing*, now I just paint *Woman in a tub* . . .', he was stressing the continuity of tradition as much as its disruption. In his conversation Degas continually stressed the need to study and respect the past and, in his case, to revere the art of M. Ingres. In fact, Ingres became an obsession with him and it is clear that he told and re-told the story of his youthful encounter with the great master to anyone who would listen to it. Ingres' emphasis on discipline, on draughtsmanship and on complete dedication to his art find close parallels in Degas' life, though his relative disinclination towards colour has to be modified in the light of Degas' brilliant later pastels.

One of the reasons that Degas stopped exhibiting was that his pictures were selling steadily, mainly through the successful dealings of Durand-Ruel, and he had achieved a welcome prosperity in his later life. As the artist's letters and the diaries of Daniel Halévy show, Degas became an avid collector, buying for himself works by Delacroix and Ingres, as well as pictures by his contemporaries Cézanne, Van Gogh and Gauguin. He was able to indulge his long-established passion for travel, undertaking many journeys and excursions within France, as well as trips to Naples, Madrid and Morocco. Travelling appears to have had a private significance for Degas, corresponding to his restless personality and his delight in movement and activity. When he wrote in 1886 to Henri Rouart, 'It is the movement of people and things that distracts and consoles . . .' he offered a rationalization of many of the activities of his middle age: the visits to the countryside to visit the Valpinçon family, the long journeys by carriage and railway, and his legendary 'ambulomania' when he would walk

for miles through the streets of Paris, even in his old age.

One of his best documented and most entertaining journeys was that undertaken in the company of his old friend Bartholomé in 1890. The two of them decided to hire a tilbury, an open, horse-drawn carriage, and travel from Paris in easy stages to Diénay in Burgundy, to visit their mutual acquaintance Jeanniot. From start to finish, the expedition was good humoured and even farcical; one account describes how the two travellers painted zebra-stripes on their white horse and delightedly watched the faces of the local population as they galloped along. Degas sent back a rapid succession of postcards and telegrams to friends in Paris, notably Ludovic Halévy, emphasizing the pleasures of the open road and the attractions of good country cooking. Characteristically for Degas, however, this time was not wasted, and the rapid progress of the carriage through the landscape suggested to him a series of boldly experimental coloured monotypes which he started to execute in Jeanniot's studio when they arrived at Diénay.

Such bursts of enthusiasm for a new idea or process were typical of Degas' later years. Some of his letters describe how he spent another holiday struggling with a clay statuette, or experimenting with photography soon after he had bought his first camera. Photography became a major obsession in the 1890s and Degas, as might be expected, produced some arresting and highly experimental pictures of his favourite subjects: friends, family, ballet dancers and nudes. Other enthusiasms, such as lithography and wax sculptures of nudes, were tackled with imagination and great freshness of vision, reminding us that Degas retained his original approach to imagery and technique at every stage of his long career.

Degas' interest in photography appears repeatedly in his letters and other documents of the 1890s. His touching letters to his sister Marguerite and her family in Buenos Aires include the announcement that he has dispatched a complete camera outfit to them so that they can send him pictures of themselves and their house. His gesture was almost too late, since Marguerite died soon after and Degas was left with just a few pictures of the much-loved sister whom he was never to see again. His reaction to bereavement is movingly recorded by Daniel Halévy, who becomes increasingly important as a chronicler of the artist's activities and conversation from the late 1880s onwards.

Daniel Halévy was the son of Degas' close friend Ludovic Halévy and he grew up to become a distinguished man of letters in his own right. 'In my eyes Degas is the incarnation of all intelligence,' he noted in 1888, and he continued to write down everything he could remember of the after-dinner discussions that took place almost weekly at his house. Halévy's journals capture an important aspect of Degas' personality: the opinionated, well-informed, good-humoured conversationalist with a great affection for his adopted family, as well as strident views on all matters related to art. Because of the circumstances in which the journals were written, they have an immediate, authentic ring to them, though perhaps coloured at times by Daniel's reverence for the Master. Other acquaintances of the artist's, for example Valéry, George Moore and Jeanniot, have left equally vivid accounts of his views and his behaviour, though many of them were written down some years after the events described. Even his models, such as the pseudonymous 'Pauline', felt impelled to note down their recollections for publication, often making up in colourful anecdotes what their accounts might lack in historical precision.

Degas' later letters are often brief, pointed and personal to the point of pathos. Apart from his increasing isolation, as his friends and family died or moved away from him, he complained regularly about his health and unreliable eyesight. He was obliged to experiment with special glasses to compensate for the eye-defects which had troubled him since the early 1870s, and he took to visiting a variety of health resorts to benefit from their mineral waters every year. As old age advanced, his remaining friends increased in importance to him and letter-writing, despite the limitations of his eyesight, continued to play an important role in his life. His notes to Henri and Alexis Rouart, to Bartholomé and to Durand-Ruel can still be touching, witty and frank, even when he describes himself as '. . . a blind man, who wants to pretend that he can see.'

Although Degas' own activities as a writer were curtailed by old age and ill-health, he was fortunate to be surrounded in his last decades by a number of highly literate and appreciative younger artists and companions. Even as the words from his own pen dried up almost completely, the notebooks and diaries of another generation began to fill with the aphorisms, opinions and reflections of the great man. Much of this material is, of necessity, one stage removed from the original, but it shows a remarkable consistency. Some of his views on the modern age, and his increasingly reactionary position in politics, must seem as puzzling and cantankerous to us as they did to his young contemporaries, but his extraordinary dedication to his art continued to drive him back to his studio and onwards into his remarkable late work.

In spite of his isolation and ill-health, and regardless of changing fashions in the art world around him, Degas continued working until about 1912, when he was forced to abandon his old studio for new premises. He died in 1917, in the middle of the war that he was hardly aware of and at a time when his funeral was able to go almost unnoticed, perhaps a fitting end for an artist who claimed, 'I would like to be illustrious and unknown!'

The apprentice years 1850s–c1870

As a young man, Degas was able to take advantage of his family's prosperity and travel widely, preparing himself over a period of several years for the exacting career of the professional artist. In the course of many visits to Italy, he made notes on hundreds of paintings, sculptures and buildings he had seen, using both written descriptions and a variety of drawing techniques including pencil, ink and watercolour. In the same notebooks, Degas kept a fragmentary diary of some of his journeys, jotting down his reactions to places visited, his encounters with strangers and friends, and his own rather melancholy reflections. The result is an impressionistic sequence of glimpses, a verbal and pictorial collage that cumulatively evokes the young, passionately serious painter coming to terms with his surroundings and with his inherited artistic tradition.

Very few of Degas' letters survive from this period, but the exceptions are both substantial and illuminating. His correspondence with Gustave Moreau shows Degas in an unusually introspective mood, torn between his loyalty to his Italian relatives and his longing to re-join his friend. Moreau was eight years older than Degas but was, like him, beginning to reconcile his devotion to the art of the past with the sensibility of his own age. In Moreau's case, the delights of colour and exotic subject-matter predominated and for a while Degas undoubtedly came under his sway. Degas' notes for his own painting The Daughter of Jephtha, showing an unexpected and unorthodox attention to colour, suggest the influence of Moreau, as does the obscure subject of the Old Testament general Jephtha, depicted as he realizes that he must sacrifice his own daughter.

In one of these letters to Moreau, Degas writes 'How sad it must be not to have someone in the family you can trust' and it is clear that Degas' own family were of great importance to him at this time. From the beginning, his brother René and his favourite sister Marguerite provided patient and inexpensive models for his portraiture and Degas' letters to his family illustrate his continuing affection for them. His most ambitious early portrait is of his Uncle and Aunt Bellelli with his two cousins, and his visit to Naples in 1860 was, characteristically, inspired by a combination of his love for his family, his wish to visit museums and his appetite for travel.

The notebook entries from the Naples journey, which include landscape studies of considerable accomplishment as well as vivid verbal descriptions, also remind us of Degas' increasing artistic maturity. In the early 1860s he was at work on his series of large-scale history paintings, intended to display the fruits of his travels in Italy and to launch his public career. As events turned out, Degas' career proceeded in a quite different direction. Already, in a notebook from a visit to Normandy in 1861, we find the artist turning his attention to his immediate surroundings and introducing a subject that was to become an obsession – the racehorse; and in a group of notes from the end of the decade there appears a virtual catalogue of themes from everyday life which he was later to make his own: the colour of human skin and hair, facial expression, different kinds of artificial light, women and their dress, and the portrait.

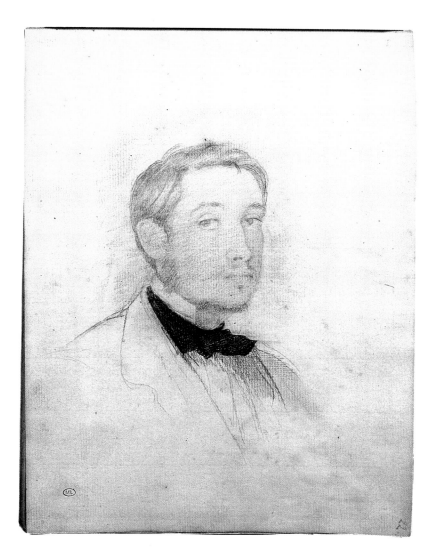

SELF-PORTRAIT

Today 18 January 1856, I had a long conversation with M. Soutzo. What courage there is in his studies. It is essential – one must never make bargains with nature. One certainly needs courage if one is to approach nature head-on in its grand planes and lines and it is cowardly to do it by means of facets and details. It is a struggle . . .

It seems to me that if one wants to be a serious artist today and create an original little niche for oneself, or at least ensure that one preserves the highest degree of innocence of character, one must constantly immerse oneself in solitude. There is too much tittle-tattle. It is as if paintings were made, like speculations on the stock markets, out of the friction among people eager for gain. One has, so to speak, as much need of the mind and ideas of one's neighbour to make anything whatsoever as these businessmen have of the capital of others if they are to make a penny. All this trading sharpens your mind and falsifies your judgment.

. . . The heart is an instrument which goes rusty if it isn't used. Is it possible to be a heartless artist?

. . . The people we love most are those we could hate the most.

NOTEBOOKS 5 AND 6

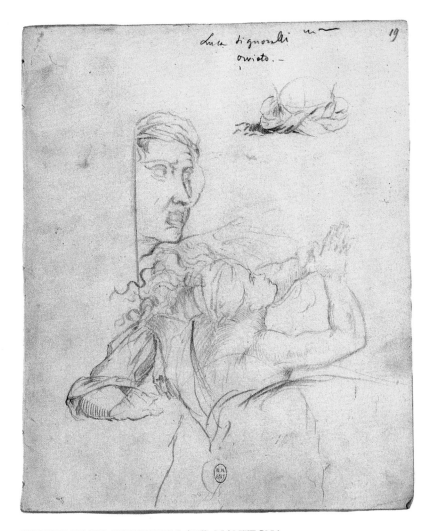

STUDIES FROM SIGNORELLI AND MANTEGNA

24 July, I leave Rome 6.45 arriving at a height beyond Ponte Molle – superb plain, the Italy of our dreams! Yellow plain, corn cut – mountains grey with night falling at their feet, hazy mountains truly azure blue . . .

. . . 7.30 – All is grey except the foreground – yellow. Very tiring night. I can make out volcanic terrain, rocks with clusters of trees – and we pass there beneath Sutri – caves.

Capranica – up and down. I am astonished when I enter Viterbo – you would think you are in Avignon – the resemblance struck me. Cathedral, only the remains – ruins on the left and right – on the right under the small arch what a beautiful view over the town – that silence, so Italian and so typical of the papal towns (it is somnolence!).

I go back indoors at the angelus – coming out at 5 o'clock. It is Sunday – round every street corner, houses, gothic porches.

St Matthew's gate, ramparts, just like Provence – Church of Santa Maria della Verità. Superb frescoes by M. Lorenzo da Viterbo.

In the left transept, fresco of a Virgin. The wall has remnants of paintings. Again pretty angels lifting curtains. The ceiling of the Church is like a basilica and the roof is made of majolica tiles. It is so Italian and in such charming taste.

I am going back to Lorenzo da Viterbo's chapel – really superb. Startling heads.

I follow the walls up to the Paradiso – Jean Sebastian del Piombo. It is amazing how much I feel as if I were in Avignon.

10 o'clock in the evening. I leave for Orvieto – moonlight. I can make out the landscape and the mountains. Superb terrain – Montefiascone – mountains – daybreak. Fog over the plain – we descend into the plain of Orvieto – the Cathedral appears above the fog – we climb up the steps, a real eagle's nest . . .

Sublime Cathedral, I am quite startled – façade so rich and so tasteful. The mosaics too fresh – one so dreadfully decadent – I recognize the sculptures – I go in and run to Luca Signorelli.

It always seems that there must be, in the most beautiful monuments, this mixture of tastes . . . I don't know what to say – I am in a dream which I don't know how to recall.

Dante's subjects, ingenious, thrilling – arabesques with a sort of rage – contrast between Luca Signorelli's movement and love of bustle with the peace of Beato Angelico which is there, especially in the Christ – more beautiful then ever. Ah! He is indeed Michelangelo's man.

I go round the Church – I return to the hotel ready to fall asleep. I sleep until noon – lunch – I write to my Uncle Achille.

I go to St Patrizio's Well.

Superb view from the Porta della Fortezza over the valley with the Tiber in the distance – I am going to the Cathedral – I start to draw a seraph – something from *La Traviata* is being played at full blast on the organ – what a mockery!

I walk on the ramparts. Everywhere in the streets medieval houses. The sun behind Monte Cimino

I don't feel like going out to draw from nature. Luca Signorelli fascinates me. I must think about figures above all else, or at least I must study them when thinking only about backgrounds . . .

Near the Well I look down to the plain – superb spectacle to be remembered for a lifetime.

The dried-out Tiber and the sun setting over the road to Florence – all these beautiful ranges of mountains. What moment of the day could be more beautiful? I am thinking about France which is not as beautiful, but the love of home and of working in a small corner override the desire to enjoy forever this beautiful nature.

There are such pretty women and girls . . .

It is the grace of the Florentines. Still a little of the Roman savagery.

Dinner – the tedium of departure. Departure for Perugia in rain and lightning. We are in the mountains, up and down – moonlight – 29 July, 5.30 in the morning arrival at Città della Pieve, on a little hill in a beautiful plain surrounded by mountains, with a few white clouds obscuring the summits.

At the Cathedral, beautiful Perugino behind the altar . . .

Church outside a gate, on the right – when going in, beautiful painting, apparently by a follower of Francia. One could believe oneself in the countryside around Naples, so much of nature is fertile and cultivated.

I go back to the hotel to spend the day there as I feel tired and I don't know what to do . . .

I write to Rouget.

At 4.30 I go for a walk by the lake – this lake is Lake Chiusi. There is a storm in the distance.

If one wants to travel alone one must visit areas full of life or else full of works of art. Boredom soon overcomes me when I am contemplating nature. Everywhere priests out for a walk.

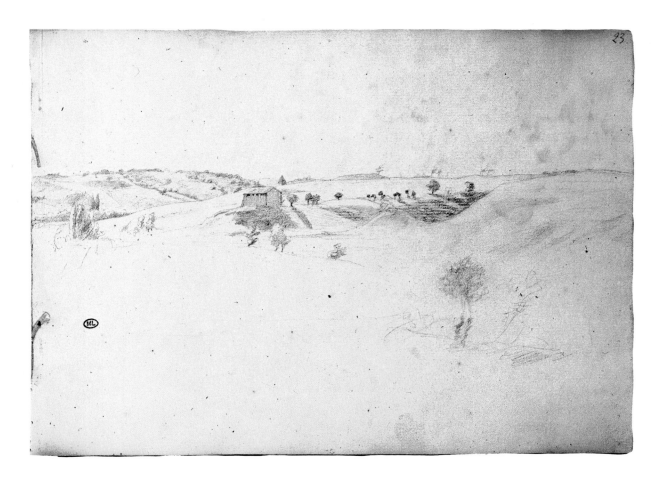

LANDSCAPE STUDY

All the women look like Peruginos! Is it an illusion?

At last 10.00 p.m. departure for Perugia.

Six inside – arriving at Perugia at 3.45 pulled by oxen on the hill to Perugia . . .

Splendid impression – 2 lines of pilgrims crossing the main street in front of the governor's palace, singing and going to sit on the steps of the Cathedral.

The day is only just breaking – the beautiful tones of these figures sitting on the stairs . . .

The old palace is very high – it is almost necessary to include the top to render the space surrounding the figures.

Hotel de la Corona – at 8.30 I start to rush around. Cathedral full of pilgrims who are as noisy as if they were in a house.

Perugia looks grand – it is completely new to me. Interior of the Cathedral restored in the most unspeakable manner I have ever seen – unrecognizable!

The Descent from the Cross by Romano the best I have seen by him. An enormous talent, but nothing moving – a painting by Luca Signorelli – the Virgin with the Child, St Lawrence and a saint with a chasuble.

Superb colour. Looks just like those at St John Lateran. It is raining – stormy weather, heavy.

STUDIES FROM PAINTINGS AND FIGURES

I am rambling a little. I arrive through Monte Luce – superb view over the valley.
It is not as defined as it is near Rome.

St Domenico completely defaced, but still splendid.

In the Church the choir window is being repaired – little chapel on the left – 3 Beato
Angelico in the vestry – another Beato Angelico, part of the same ensemble as the 3 – adorable
angel of the Annunciation.

Salla del Cambio – I already knew the compositions – but what beautiful colouring –
it is Perugino's most beautiful work.

Chapel – Giannicola – very beautiful colouring – Sybils Lybica and Erythrea are more ample
than usual – also Raphael's arabesques. This little chapel is most delightfully harmonious –
self-portrait of Perugino – lively. There is energy there. 1453 – Conestabili Palace the most
adorable virgin by Raphael – what a divine paint-brush – the child's arm is wonderful.

San Pietro Fuori Di Mura, Sacristy – head of a Dosso Dossi Christ, five figures by Perugino –
magnificent St Benedict, a copy by Raphael from Perugino on a black background.

The sky is completely black. One cannot see any more in the Church.

I must not forget the beautiful effect I saw on the way between the Carmine and Sole gates –
the clouds covered the plain in shadow and only the hill of Assisi was lit by the sun.

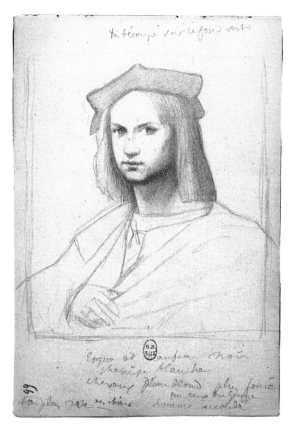

STUDY FROM A RENAISSANCE PORTRAIT

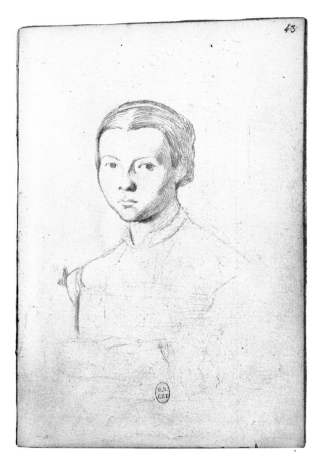

STUDY FROM A PORTRAIT BY BRONZINO

Saturday, 31 July, the weather is not very settled. At last I leave, on foot, at 7 o'clock. At 10.30 I am at Santa Maria Degli Angeli.

Full of pilgrims – large Church.

The organ played during the Grand Mass – the sound of human voices was superb. During the Elevation it played. I felt really very moved. I am not religious, at least not in the practising sense – but I had a moment of emotion.

The music, which was very beautiful, must have touched me more than the sight of the pilgrims beating their breasts with fervour.

The Overbeck fresco is a beautiful thing – but why so much refinement?

The climb up to Perugina finishes me off – it's like a ladder – the pleasure of seeing the church keeps me going because a 12-mile walk without any shade would tire out those stronger than me.

At last I find the Locanda Di Cafonelli indicated by my guide. I have a little rest but I am exhausted. My face is sunburnt – and I have a headache – hope it's nothing.

S. Francesco, the Upper Church. I have never seen a more authentic church.

Stained glass windows.

Sublime movements in the *Life of St Francis*. As soon as I am back in Paris, I must go to the

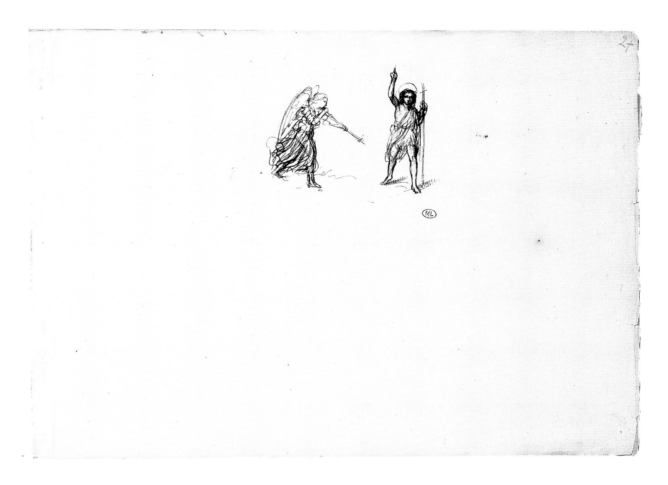

STUDY FOR JOHN THE BAPTIST AND THE ANGEL

Bibliothèque.

I haven't time to stop – since I am also afraid of having caught a brain fever.

Lower Church. At the portal I remember the painting by Granet. I stand where he did – but the middle window at the back is dazzling me. The sun is shining through. For this reason the middle seems too dark.

I feel remorse for having seen so many beautiful things already – I am going to leave.

Everything breathes an atmosphere of prayer.

Everything is beautiful, the details, the whole.

I would rather do nothing than do a rough sketch without having looked at anything. My memories will do better.

There is an expression and an astounding drama in Giotto. He is a genius.

Here I saw the strangest spectacle. The peasants, as part of their strange devotion, singing and shouting the name of their patron saints, started to run around the altar rail. They continued with increasing frenzy-like dervishes – an explanation for the crusades.

Brother Pascal Marie translated 'Fabiola' by Wiesseman.

On hearing one Franciscan talking in French to another I came closer to him and asked him the reason for all this.

We talked – he is a Parisian. He took me on to the terrace where there is a view up to Spello.

He used to be a man of the world. What a charming man. He seems to pity those who chase after life. He is to be ordained a subdeacon tomorrow morning. I will go to St Apollinare.

He showed me to his cell. We talked for a long time – I am going out for dinner.

Sunday morning – Giotto – sublime movement of *St Francis Expelling the Demons* . . .

I have never been so moved – I will not stay as my eyes are filled with tears. At 8 o'clock I went to the Church of St Apollinare where Father Pascal was to be ordained subdeacon . . .

I was moved. Tears came to my eyes – so many thoughts came to my mind. If only they could materialize!

The altar-boys were dressed in black with a surplice and a little black hooded cape down to their shoulders.

What courage to make sketches.

If I were fifty, alone, without children or unmarried – I would come here to settle, perhaps in the monastery.

When going into the Upper Church – on the left – above the cornice – 2 figures of female saints with the beauty of Pompeian paintings – pious, but with an antique appearance.

In the choir, Franciscan heads on the wooden panelling.

I go below – I cry – Ah! these people here feel life, life, they have never renounced it. Le Sueur seems of their kind – I wish I were! If I become a sufficiently committed and settled character to produce paintings as worthy as sermons – at least, if I am not to be a religious painter, may I feel the way they do. I am almost saying a prayer, I am so moved!

At last, after staying $3\frac{1}{2}$ hours in the Church, I went to see Father Pascal who was having a rest in his cell after the emotions of the morning – we talked. I will remember his conversation enough not to have to write it down. What uncertainty I have. I must leave Assisi in order to send my luggage to Perugia via the Florence coach. And I want to come back to Assisi – I am afraid of it though, I am afraid of giving in to daydreams which may one day be beneficial but which destroy all industry in me. (I think I heard 'de Rivière' [as Father Pascal's name] when, during the ordination, the Bishop's Chaplain read the covenant.)

He takes me to the Englishman whose wife I saw the previous day at Church and during the ordination in the morning. They speak very good French – the gentleman studied with Delaroche – I even find myself saying that I am going to come back, I like Assisi so much. The evening descends. I am finally at Gli Angeli at 7.00.

For 9 francs I manage to find a carriage. (Pretty girls in the back of the carriage in front of us – one of them was my coachman's girl.)

His horse cannot get to St Giovanni any more; he passes me over to a dubious, highly suspect urchin. It is night – but I can see that it doesn't help to be afraid – we arrive – this girl who climbed for a short while between the coachman and myself.

I was so inclined to go back to Assisi. I had so many pleasant dreams about the time I would have there, that I discussed the return fares with the coachman – I send him back – at the door of the hotel I agree on 50L. to go tomorrow morning to Assisi.

Monday 5.30 a.m. I have my luggage brought to the coach – I am about to leave – in the end I stay. I am so undecided – I must make up my mind – I order 3 donkeys to go down to Arezzo via Cortona and to leave at 8.00.

First I rush to the Church of the Camaldules – fresco by Raphael – there is something of Fra

Bartolommeo – I think only of Assisi which attracts me like a magnet. Nevertheless I want to leave.

At the sacristy Pisanello, exquisite delicacy – Perugino always the same.

In front of the hotel I see Clère and Delaunay. I throw my arms around their necks – fierce argument with some cabmen – the most ruthless people there can be.

All three of us are leaving on Wednesday morning for Arezzo – and tomorrow I go to Assisi. I leap for joy – I will see Father Pascal again and Assisi which I find so seductive – which I wanted to escape from for this reason – where the Church was the only thing that moved me, those painters who I adore, that beautiful plain and those hills which emanate love, happiness and feeling and where perhaps I would be so happy, one day.

I am waiting for the approach to the Monastery with great impatience – on Mount Santa Maria degli Angeli, with its cypresses and its beautiful galleries – I am not mad about this well-known picturesque Italy – but what is touching is no longer just a fashion – it is an eternal style.

The English gentleman and his wife – I am pleased to see them again. There was happiness in their home. Couldn't I find a good little wife, simple and quiet, who understands my oddities of mind, and with whom I might spend a modest working life! Isn't that a lovely dream?

I am going to return to the bustle of Paris – who knows what will happen – but I shall always be an honest man.

I hope my memory will make up for the little I am writing which is not even a summary of what I have been thinking.

I gave up making the slightest sketch.

So many changes in the landscape in such a short time – storm in the distance. The mountain of Assisi in the dark – Foligno in the light.

On the other side many ranges of hills – so many different views.

Leave here at 5.00 a.m. – Spello – delightful Church. Ciborium above the altar – graceful Pinturicchio – it is more delicate than Perugino. At St Andrew – beautiful Pinturicchios.

NOTEBOOK 11

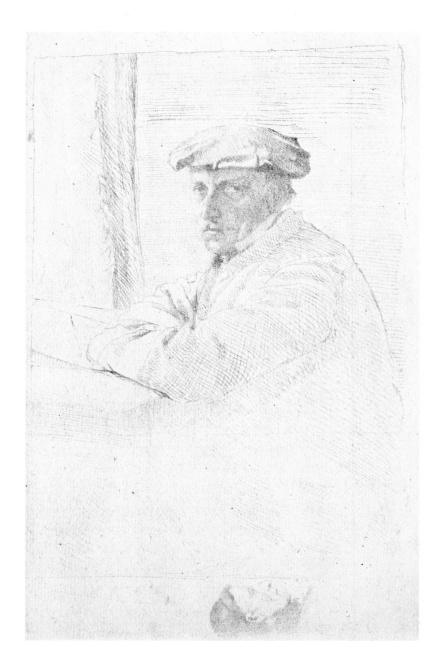

THE ENGRAVER JOSEPH TOURNY

Florence, 21 September 1858

MY DEAR MOREAU, I can see that in order to have news from you I have to ask
you for it. I trust you are well, and very busy with your family and with colour. If I am writing
a little note to you, it is to help me wait more patiently for your return by expecting or
receiving a letter from you rather than to tell you what has become of me. Nothing much has
become of me. I get rather bored, being on my own. In the evening I am rather tired after the
day and I would like to talk a little. I have no opportunity to open my mouth. Pradier, who is
here, is not a very encouraging example. Blard is surrounded by Englishmen I don't know. So,
after I have had an ice-cream at the Café Doney, I come back home before 9.00 p.m. Sometimes
I write, as I am doing now, usually I read before and after going to bed, then you know the rest.

My aunt has not arrived yet. My grandfather's death has kept her in Naples for a while. There are moments when I am so irritated by my isolation and worried about my painting that, if I were not held back by the desire – which as you know is strong – to see my aunt and my little cousins again, I would abandon this beautiful Florence and the pleasure of your return.

I am only speaking to you of myself and yet I was saying to you just now that I did not want to. You will not realize that I am reading with interest the *Lettres Provinciales* in which we are recommended to detest the self.

One more word about myself, and then no more: I have finished my sketch of the Giorgione; it took me nearly three weeks. I have made a virtual copy of Veronese's angel from his sketch and I have started Giorgione's landscape (*The Judgment of Solomon*) the same size; I might put in the figures. I have done a few drawings. On the whole, I have been less courageous than I was hoping to be. I don't want to give up before I have achieved something, however. Having nothing else to do here, the best I can do is to study my craft. I could not undertake anything of my own. It takes a lot of patience to pursue the hard path I have chosen. I used to have your encouragement; as if I were missing it, I am starting to despair a little the way I used to in the past. I remember the conversation we had in Florence about the sadness which is the lot of those involved with art. There was less exaggeration than I thought in what you were saying. This sadness has indeed no compensations. It increases with age and progress and youth doesn't exist any more to console you with a few illusions and hopes. However much love one has for one's family and however much passion for art, there is a gap which even those cannot fill. I am sure you will understand what I mean even though I don't express it well.

I am talking about being sad, to you who must be happy. For the love for your family must completely fill your heart. You probably will read what I am writing the way I listened to you, with a smile.

Still about me. But what else could a man say, as lonely and abandoned as I am? He has but himself before him, he only sees himself, only thinks about himself. He is a great egoist . . .

Tourny is going to arrive one of these days. But unfortunately he will set off again immediately for Siena and Rome.

You will tell me something about or show me something by Carpaccio won't you? Here, I will lead you to a Botticelli, at the Academy of Fine Arts, which I am sure you won't know. It is an allegory. But I would rather tell you nothing about it and make your mouth water. Mr. Beaucousin has been talking about Carpaccio as being a very original and remarkable painter. The Louvre has a St Stephen by him which you will no doubt remember.

Your hat and your box are well – I will not forget to do your shopping in Livorno. I will probably go to meet my aunt there in about ten days . . .

. . . Farewell. With a friendly handshake.

All yours, E. DE GAS

Florence, 27 November 1858

MY DEAR MOREAU, I would have written long ago if I had known that you would
be so long in coming. I was afraid that you and my letter would cross. I know now, through
Delaunay and Gaudais who have come safely into port, that you will leave Carpaccio in about
two weeks at the latest in order to hurry a little. If it is possible I will tell you that it is time for
you to come to draw in Florence, that you have sufficiently indulged your penchant for colour,
and that I am going to leave soon. This last reason is very pressing for me; because I have a
great longing to see you again before I go back to France, and you had promised me you would
not be away for so long . . .

My family is looking after me too well for me to work the way I would like to. I am busy
with a portrait of my aunt and my two little cousins. I will show you this on your return. I am
doing it as if I were making a *picture*; it must be like that, I want to leave this souvenir and I
have an inordinate desire to fill canvases, so that everything revolves around the picture, which
is a very forgivable dream for a child, as you call me. I have had to give up my studies at the
Museum, and I don't budge from the house any more. Once I am back in Paris I promise myself
not to give in to the family as I've been doing here. Anyway, as one should see the good side of
everything, I hope that the love that I am expending here will be repaid to me later in pleasing
ideas in whatever I do. I think you will make out what I am trying to say . . .

So, Delaunay arrived the day before yesterday in the evening, all hot and boiling, with the
discouraged Gaudais. This poor old Gaudais found in the post a letter telling him of his
grandfather's death: he has had to wipe away his tears immediately to write to the solicitor.
How sad it must be not to have someone in the family you can trust. His uncle, it appears,
is trying to rob him of anything he can. Finally he has received news through his solicitor.

I must tell you for your guidance that Delaunay and Gaudais, having sent their roll of
canvases with their luggage, found that they had to pay duty and encountered all sorts of
difficulties. So they are now thinking about sending it to Rome. So you will have to take your
roll with you and get it through discreetly.

Delaunay talked to me at length about Venice, Carpaccio, you, and a tiny little bit about
Veronese. It appears that the Chapel of St George was requisitioned and that life was jolly
there. The illustrious Lionnet showed me some little blue monks on a little background
resembling an establishment in the Antilles, then the reception of some ambassadors, then
another reception of ambassadors, then another one still, I think, by the same Carpaccio.
I am mocking, but as you know, it is a form of admiration.

It is true, isn't it, my dear Moreau, that there is a way of making light, beauty, feeling, line
and colour out of a lot of love for what one does, out of the desire to learn and a deep conviction
of the 'excellence of painting' (as Vasari says)? I was a little discouraged when I wrote. I am
grateful for your reply. It must be said that I was on my own while you were with your parents
and in company.

Tourny has just spent a few days here; he left on Monday morning. Lévy was well and
looked happy. De Courcy too. The latter asked Tourny to embrace you for him. I believe he
has a heart of gold. As far as the good Lévy is concerned, I have nothing new to tell you. Poor
Tourny! When will I see him again? If it had not been for my aunt, his departure would have
been a lot more painful to me.

But let us get back to the subject. I have two little cousins coming for a meal. The older one

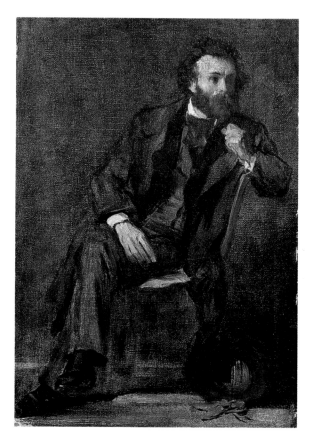

PORTRAIT OF GUSTAVE MOREAU

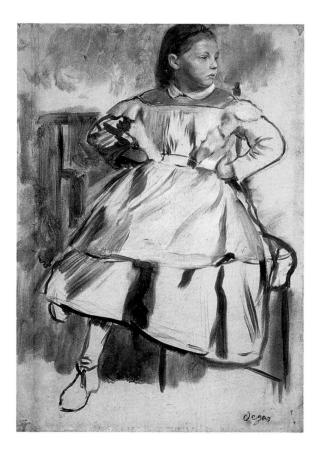

PORTRAIT OF GIULIA BELLELLI

is a real little beauty; the little one has the disposition of a devil and the kindness of a little angel. I am painting them in their black dresses and their little white aprons which make them look charming. Backgrounds keep running through my head. I would like a certain natural gracefulness with a sort of nobility which I don't know how to define. Van Dyck is a great artist, Giorgione also, Botticelli also, Mantegna also, Rembrandt also, Carpaccio also. Try to see other than fire here, if you can. Do like I used to when I rubbed myself against your shoulder like a bear to show that I understood you.

I am in rather a hurry, but that is for the best . . . One puts what one can into the moment and in what one is doing, and one does it in that moment. One does something else with another thought. All that is mere twaddle. You will be putting up with a lot more when you return. Anyway, you too have a ready tongue and you will make me silent.

Come on, roll up those famous St. Georges, and the little pieces after Carpaccio, and come and draw a little here. Delaunay has written to you to come through Padua. It is on your way.

I embrace you with all my heart,

All yours, E. DE GAS

My uncle thanks you for your best wishes and my aunt will be delighted to see you.

I am sealing my letter this morning of the 28th. I have seen Delaunay: he has withdrawn his roll from the customs without further trouble than having to pay two or three francs. No estimate of the value had to be given from the moment he unrolled it and proved that they were studies, also unfinished.

Paris and Genoa, 1859

MY DEAR MOREAU, Here I am, back in my native land. Though I have been here
for about twenty days I am still feeling dazed. I assure you it is a big change. Papa is still the
same; but the rest of the family is unrecognizable. René is a young man, he is very tall for his
age. I am impressed by my two sisters and I feel an awful lot smaller. I hope your trip was as
good as mine. I did not want to annoy you by going to the station that morning; for I under-
stood you were right to prevent me from doing so. The following day I even begged my aunt
not to leave the house. Poor woman; it was a difficult moment. She wanted to stop me from
leaving that same day because of the wind. But I could no longer endure that pang that had not
left me for several days. When I arrived in Livorno, the boats were not leaving because of the
weather. I had to spend the night, and the next day I got on board a small Sardinian boat that
took me to Genoa in pretty good time, around six in the morning. The boat was full of
volunteers, there were more than a hundred of them. I can assure you that there was no more
bragging and that these poor chaps knew clearly what they were undertaking.

Genoa, beautiful and superb town! Ah! what beautiful Van Dycks! Go to the Brignole
Palace, if you go through Genoa on your way home, and have a good look at the Countess
Brignole on her own, then at a lady of the family with her daughter, a Veronese, and a portrait
of a Venetian lady, all in light tones. Nobody ever rendered the charm and finesse of woman,
the elegance and chivalry of man, nor the distinction between the two, like Van Dyck. Dear
friend, as you were saying one day, there is more to that great genius than a natural dis-
position. I think that, very often, he must have reflected on his subject and let it pervade him
the way a poet does. Was it the place which contributed so much to the illusion and which was
still clinging so strongly to its previous masters, or else was I a little dead in advance, I cannot
tell; but I did have an hour of real enthusiasm.

In Turin there is a beautiful Museum. I don't like the large Veronese very much; you will
see a head of Philip IV by Velázquez and some Van Dycks, thought more or less highly of, but
always as beautiful to me. Do you remember agreeing with me when I said to you that one
loves an artist's temperament in such a way that both good and bad thoughts always attract
us equally . . .

At night I went over the Mont Cenis. Once on the other side everyone was talking French.
I was in Savoy and almost home. I left St Jean de Maurienne half an hour after noon; from the
snow I moved on to Lake Bourget where my guidebook reminded me Rousseau once lived.
At 7.30 I was in Mâcon. At 6.30 a.m. I was in Paris and at 7.00 a.m. I woke up the household . . .

The war is probably going to take place. There is absolutely no danger for you and your
family in staying in Rome. Wait a little to see how things turn out before you undertake to go
to Naples. The King is about to die, if he hasn't already. If there is a revolution it will be a very
short and very quiet one. Don't lose your temper; things are going to turn out so well for you
that you will be surprised.

I should have told you earlier that I have met de Courcy several times. You may well
congratulate yourself for having found in him a very devoted friend. He is well. His painting is
much better than I expected. There are many leanings towards Poussin.

Lévy is well. I have only been able to meet him once. He is doing some ceilings at the Hotel
Purbado.

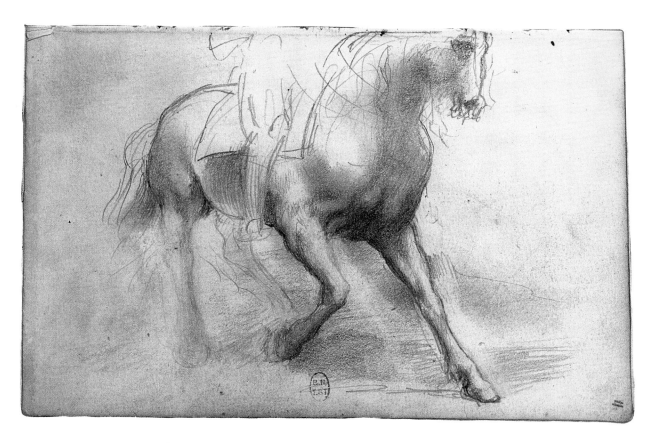

STUDY FROM VAN DYCK'S EQUESTRIAN PORTRAIT OF CHARLES V

I think Fromentin almost has pride of place in the Exhibition. Unfortunately, when he wants to tighten his execution a little, he makes it duller. There is a *Danse de Bateleurs Nègres dans un Tribu* and a *Lisière d'Oasis pendant le Sirocco*, both masterpieces. Next to them, everything else seems like brown sauce.

Remember me to your dear parents. Write to me, rue Mondovi 4, as soon as you have a moment. I am going to write to Tourny, although he has not replied to me. Congratulate him on his exhibition. What a pity that M. Thiers has not allowed his large drawing to be displayed.

I embrace you. Best wishes to Delaunay, Bonnat – Lamothe is more foolish than ever.

E. DE GAS

Van Dyck's portrait of Paolina Adorna, Genoa, 1859

Brignole Palace 2.30, 2 April . . .

Am I attracted by the story of Van Dyck's love for Countess Brignole, or do I just find it adorable without any preconceptions? Nothing could be more of a woman, a more supple or more distinguished hand.

I am really taken by it. There is perhaps more than a natural disposition in Van Dyck.

She is straight and light like a bird. Her head has blood and life as well as grace and finesse.

A small firm nose, a tight-lipped and turned-up mouth. Piercing, smiling eyes. It really is my beautiful Genoese and from a good family.

Her dress falls straight down like serge with two beautiful, supple folds behind on the step. There are more under her feet: two steps or three.

The floor blends in with the dress.

NOTEBOOK 13

A visit to Naples, 1860

Naples, Saturday, 24 March

MY DEAR RENÉ, . . . You probably received my note written last Sunday from Marseilles – I got on the boat at 9.30 p.m., we left at 10.30 p.m. Splendid weather. I really did get into a bed, I mean with just my shirt on, and I found it very good. At dawn you could see nothing but land and water. Around 4 in the afternoon we were near Cap Corse and the following day two hours after midnight at Cività Vecchia. – Most of the passengers got off there. At 9 in the morning those still on board left for Naples, where we arrived at 8 in the evening. It was 11 o'clock before I could disembark. My overnight case in my hand, I ran till I was out of breath to Aunt Fanny's house, where I burst in like a bombshell. They were all in the hall about to leave.

Everyone is very well – but I found Thérèse a lot thinner. Marguerite has put on what her sister has lost. Uncle Henri was the only one not there. When I got to his house I caught him by surprise in bed: surprise is not too strong a word, for he remained for a while open-mouthed.

The following day I ran to Aunt Rosina and Argia. – Adelchi was in bed with a slight fever, probably due to his excessive dancing.

I am sleeping in Grandad's room. Poor man! He was still there when I last came to visit and I had kissed him first when I arrived.

I'll try to use my time in the best possible way. It is scarcely possible for us to leave for another ten days.

VIEW OF CAPODIMONTE

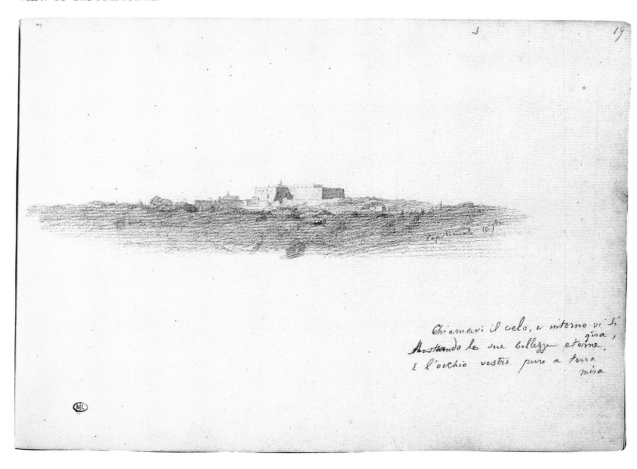

I went yesterday to pay a visit to Mme de Ste Marie, but she had left two days earlier.

Imagine, it was only yesterday evening that Hélène let me kiss her. Camille was tamed on the second day. – They remember you perfectly.

I don't have the patience or the time to write at great length. – I am going to the Museum this morning.

You are missed by all. – Be patient; you are going to see your parents again in twenty days.

I went out in a carriage on Wednesday with Thérèse and Marguerite. We went to Posilipo. – The air was so pure you would have thought it was summer.

If I were speaking to you I would tell you enough to write a book, but in writing I can only write you a short letter.

The only topic of conversation (this is for Papa) is the excommunication of the King of Piedmont. – On the boat there was an old retired soldier who was going to Rome with hardly any luggage, convinced that he was going to witness it. He knew his subject. – It appears that there are a great number of curious English who are filling up hotels and will rent windows.

Goodbye for the present, I embrace you,

<div style="text-align: right">Your brother – E. Degas</div>

Adèle is unchanged. She sends her love to you and her best wishes to Reine. – Marguerite sang last night at Auntie Fanny's with an almost justified success.

VIEW THROUGH A WINDOW

A visit to Naples, 1860

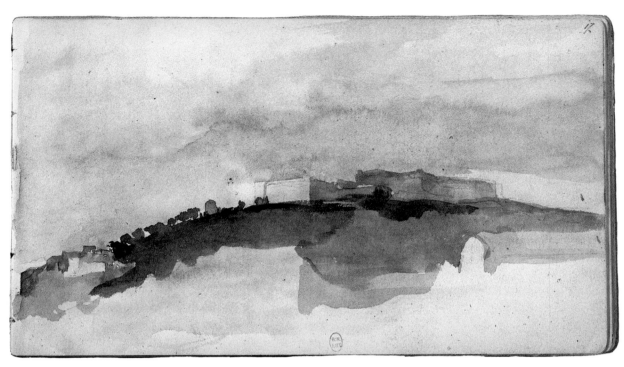

THE CASTELLO SANT' ELMO, NAPLES

Cap Circe, 4 o'clock. A small piece of lava or iron ore would give some idea of it. Parts where the rock is bare and others where it is covered in a sober and broken green. In a moment, half was in shadow cast by banks of light clouds.

. . . What a horrible thing yellow is . . .

There is an air of Greece here – landscapes and silhouettes are rounded and sharp. Some dolphins glisten, curve and plunge through the waves. On leaving Città Vecchia the sea is blue . . .

. . . Later, at noon, it is apple green with a few touches of indigo at the horizon.

Tuesday 2.30 we have just left Port d'Anzio and Castel Fusano – the hills of Frascati and Albano stand out. Velletri, the sea is silvery blue.

The boat leaves behind it a foaming trace in the middle of which is a wake of bronze.

The Pontine Marshes stretch out reddish-brown, behind them the Apennines with their snow-capped peaks.

This reddish-brown is just like a little branch of dead pine laid in the sunshine. Far away on the horizon, a line of small lateen-sailed boats look like a flight of seagulls, in tone and in shape.

As we progress, whitish intervals like cliffs separate the reddish line of the Pontine Marshes from the sea. The outline of the Apennines is very sinuous and the lines interweave as in a basket.

The foam which marks the ship's wake is like that made by a woman washing in running water, layered in little steps. Beneath the foam it looks like bubbling snow; the intervals have a greenish-blue depth which makes one giddy.

From memory: at about 5 o'clock in the evening, Castel Sant' Elmo and the town on a slope . . . the Castel dell'Ovo stood out against the pinkish slopes of Vesuvius, which was green and black as in winter. Mosaics in the Museum; how can one forget that the Antique, which is the strongest art, is also the most charming? Colourists like Veronese, audacious and always harmonious.

The shadows are full of play. What resourcefulness in their relation to each other.

Thus a deep blue sky behind a face is worked up to infinity by tones of turquoise, lilac, pink – what variety.

This mosaic near the window representing a man sitting on a ram crossing the water, with a woman raising an exquisite arm, is a delightful and skilful sketch.

Truly I can think of nothing which gives a better idea of this harmony than a beautiful and vivid Veronese, grey as silver and coloured like blood. If I had my box of pastels I would learn a lesson from it which would last me a lifetime. It is Phryxos – and Hellé his sister.

I recall that as I was passing through Crau I came across everything I imagined a desert to be, the warm grey ground dotted with stones covering a little grass.

Tiny ponds green as an unripe lemon. The slightly troubled sea was greenish-grey, the foam on the waves silver – the sea was disappearing into a haze. The sky was grey, the Castello dell'Ovo stood out in a mass of golden green. The boats on the sand were specks of dark sepia.

It had a northern atmosphere but in it one sensed these sunny climes. Therein lay all its charm.

The grey was not the cold grey of the Channel but rather that of a pigeon's breast. (Just as the sea in the Demosthenes by Delacroix is true in tone. It comes to my mind as I look at this one.)

Through the mass of green oaks patches of the sea were visible. I have never seen a green so powerful and so sober at the same time, nor a grey sea and sky so pink and clear-looking. It was perfectly suited to an epic poem. I will never forget this pearly grey and powerful dark green of the trees.

One evening before dinner as I was returning by way of Santa Lucia, hazy pearl grey sky above, throughout its expanse merging imperceptibly into a blue-grey tone with a hint of amethyst. The sea highlighted it, being a greyish green, but not like a mirror, more like shagreen. Here and there in the distance a few touches of silver.

In the foreground the sea with bluish-green waves.

The silhouette was more Acropolis-like, simpler and more angular. At night, from the palace square, the Castel Sant' Elmo in silhouette. The castle was dark grey, reddish, the convent a milky white. The green hill – a mildew tone – sky a bluish grey. Leaving Naples the town receded into a haze – the English ships almost created the effect of English marine paintings – in the distance the pink speck of the granary.

NOTEBOOKS 18 AND 19

A visit to Normandy, 1861

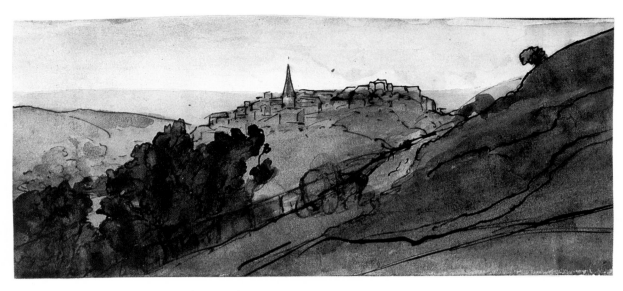

A LANDSCAPE IN NORMANDY (EXMES?)

. . . Walk at Haras du Pin.

La Gurenne – left the road to Argentan and headed with Paul straight for Exmes.

Exactly like England. Small and large meadows, all closed in by fences. Damp paths, ponds.

Green and umber. It is completely new to me; at St Valéry the countryside seems to me a lot less rich and leafy than here.

Continually going up and down over green hillocks. Arrived at a road nearly flooded over. A track temporarily closed on the hillside. I remember the backgrounds in those pictures of English genius, such as *The Gate* or *The Rider's Shadow*, *The Wolf and the Lamb* etc. Everywhere there are woods. Passed by some small farms. Arrived at M. Leriche's estate. At the moment I am reading *Tom Jones* and nothing would make a better background setting for its characters. Going up towards Exmes.

It is really a typical clean market town with its church and its brick houses. Down below, meadows in the foreground. I am thinking of M. Soutzo and of Corot. Only those two would give this quietness a little interest.

Exmes, old Church – how can anybody live here? Along steep and woody paths – after half an hour suddenly emerge into an avenue in a park, with gates. Beginning of the autumn, dead leaves cry out underfoot. We wait for the appearance of the horses.

Suddenly we arrive in a great avenue which leads to the Château – it is the Avenue of Maisons-Laffitte. The Haras dates from Louis XV. In front two main buildings like the stables at Versailles. From the terrace at the back of the Château, a view over the countryside just like the ones in English coloured prints of racing or hunting scenes.

NOTEBOOK 18

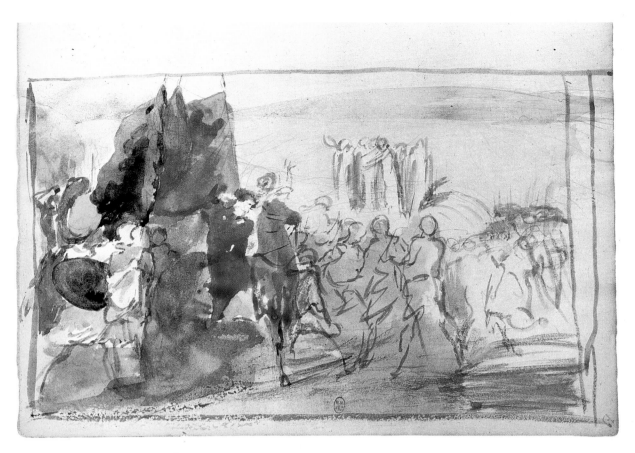

STUDY FOR THE DAUGHTER OF JEPHTHA

Almost no green – hills in a half-light like Delacroix with a grey sky – for an effect like the tones of the heads by Veronese (*Feast in the House of Simon, Salon Carré*) against the background – the girl would be the lightest tone in the background. Clothes – cabbage green and blackish green stripes, the green wider than the black – add some necklaces. A man in the foreground blowing a trumpet and almost on tiptoe with the effort. The girl like a young statue of Victory. The group of women around the girl surround her in a terrified movement at the sight of her father turning away. This is the opportunity to create a fine group. Pinkish and bluish draperies on neutral grey grounds and black cypresses.

I must do something with the figure of Vauvenargues which I set my heart on. Not forgetting to do René full length, with his hat on, as well as a portrait of a woman in her hat, putting on her gloves and ready to go out, quite graceful and simple, despite M. Beaucousin.

Quiver in chestnut with green stripes. Striped drapery, faded pinkish red and brownish white. The red of Jephthah's dress like the reds in ancient Egyptian paintings, some reddish brown, slightly pinkish.

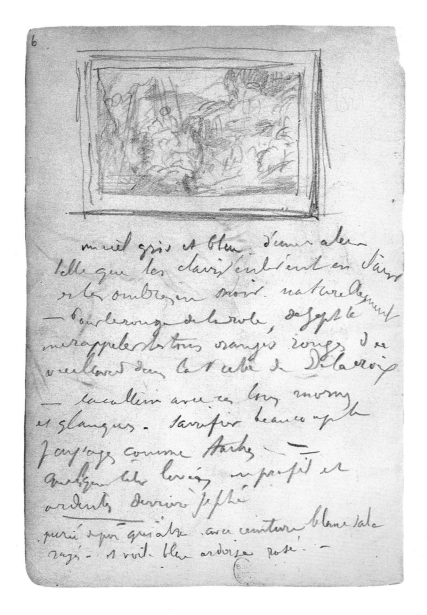

NOTES FOR THE DAUGHTER OF JEPHTHA

Light and warm emerald green breast-plate, simulating scales. Cloth rolled round the waist in the Egyptian fashion. Golden necklaces. Blackish wood like a coconut; in front of the donkey, do a third girl, carrying an urn of oriental alabaster. Definitely, don't show any sky in the corner above the flags. The woman sitting on the donkey to be wrapped in a warm pink drapery. On the donkey a lion's skin – give the young man who waves the flags a crown of laurels.

Palms as symbols of joy among the women, one at the feet of the girl who holds it – (now a symbol of martyrdom).

Put a harp in the hand of the daughter of the captive King.

The vase held by the man in front of the horse: blue. Lower border – golden lines – alternate gold and red inlaid work – then, above, green like little Egyptian gods; pick out the two characters behind the arch on the silver grey rocks . . .

The women's feet almost in silhouette.

. . . I saw an oriental horse exactly the colour of pink marble slight y dappled reddish-brown violet. – It was rounded like a bronze.

A grey-blue sky of such a tone that the lights can be picked out in light colours and the shadows simply in black. For the red of Jephthah's gown, I must remember the orange-red tones of the old man in Delacroix's picture. The hillside with its dull and blue-green tones. Reduce much of the landscape to patches . . . A few heads raised in profile and vivid behind Jephthah.

Greyish pea-green with dirty white striped belt – and a pinkish slate blue veil. – Show the conquered man embracing his daughter.

I don't know if I would change my fate for his for all the gold in the world. In the trophies against the dark sky a lot of harmonies – gold shields with light blue drapery – silver ones – dark blue breast-plates displayed in a bluish olive green . . .

Look for Mantegna's spirit and love and Veronese's colouring. The belt on the young man bending down, prepare it in a yellowish grey, then glaze it in green earth. Streak it with dark bluish green.

The man carrying a vase, short dark greyish-blue tunic.

Graduated blue sky – a few white fleecy clouds. The ground at the front in a grey-violet shadow. Middle ground in the light, hills interlocking, chalky and covered in reddish-brown grass, quite high.

On the girls' companions, emerald-green belts and white dresses. Make the first flag more lilac pink. Look for some turquoise in the blue of the young man in the foreground. Russety veil with blackish-brown streaks at intervals. I would like the little hill separating the army from the town to be like a wave, with undulations in its silhouette and in the falling away of the terrain.

Find a light dull tone for the grass.

Shade it to suggest that the girls will go up into the mountains to weep while looking at their homeland lying beneath them.

I think it is better to pick out the girls as silhouettes against the white town. Do the landscape in my picture in a greenish tone like cut grass – this will suggest more effectively the readiness of a quiet town spared by the war.

NOTEBOOKS 14, 14A, 15 AND 16

STUDY OF A WOMAN'S HAIR

What is certain is that setting a piece of nature in place and drawing it are two very different things.

There are good people who are badly turned out; there are, I think, even more bad ones who are well turned out.

One doesn't like to hear people say, as if to children, concerning rosy and gleaming flesh: Ah! what life, what blood. Human flesh is as varied looking, especially among our people, as the rest of nature, fields, trees, mountains, water, forests. It is possible to encounter as much resemblance between a face and a stone as between two stones, since everyone knows that you often see two faces which are more or less alike. (I am speaking from the point of view of colouring, for the question of form is not at issue, since you often find so many points of similarity between a pebble and a fish, a mountain and a dog's head, clouds and horses etc.)

Thus it is not instinct alone which makes us say that it is in colouring that one must look everywhere for the affinity between what is living and what is dead or vegetal. I can easily bring to mind certain hair colouring, for example, because it struck me as being the colour of varnished walnut or tow, or like horse-chestnut bark, real hair with its suppleness and lightness or its hardness and heaviness. And then one paints in so many different ways, on so many different surfaces that the same tone will appear as one thing here and another there. I am not speaking of contrasts which would distort it in an entirely different way.

What a great 'artist manqué' this Géricault is! He sensed that he could never be one even with his fortune, all his firmness of hand and the rest. There is something of Bandinelli in this unfortunate Gaul

STUDIES OF HEADS

Moreau's painting is the dilettantism of a man of feeling, if you consider only the subject, and that of a man of intellect if you see only the manner of execution.

Oh Giotto! Let me see Paris, and you, Paris, let me see Giotto!

Make of the *Tête d'expression* [the academy style of the time] a study of modern feeling – it's like Lavater, but a more relative Lavater in a way. – Study Delsarte's observations on those movements of the eye inspired by feeling. – Its beauty must be nothing more than a specific physiognomy. Work a lot on the effects of, say, a lamp, a candle etc. The point is to not always show the source of light, but its effect. This aspect of art can become immensely important today. Is it possible not to see it?

Draw a lot. Oh! the beauty of drawing!

Think about a treatise on ornament for or by women, according to their way of observing, combining, sensing the way they dress and everything else. – Every day they compare a thousand more visible things with one another than a man does.

When I get up in the morning I can still salvage everything from my highly compromised life . . .

Make portraits of people in typical, familiar poses, being sure above all to give their faces the same kind of expression as their bodies. Thus if laughter typifies an individual, make her laugh. – There are, of course, feelings which one cannot convey, out of propriety, as portraits are not intended for us painters alone. How many delicate nuances to put in.

NOTEBOOKS 22 AND 23

SELF-PORTRAIT

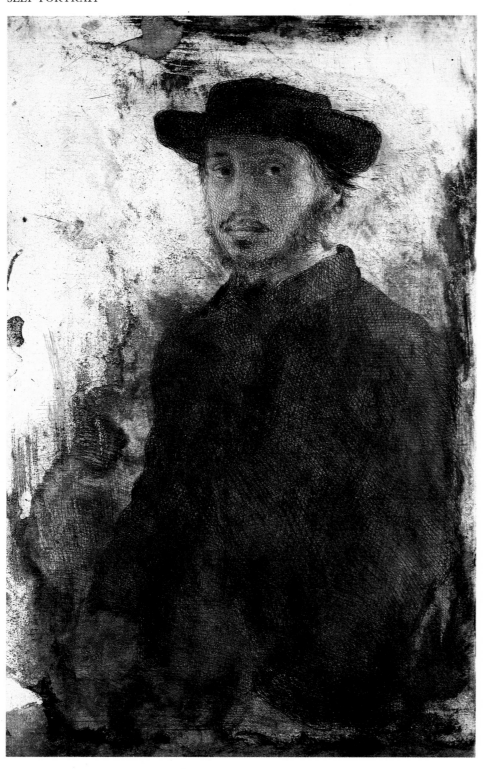

PORTRAIT OF RENÉ DE GAS

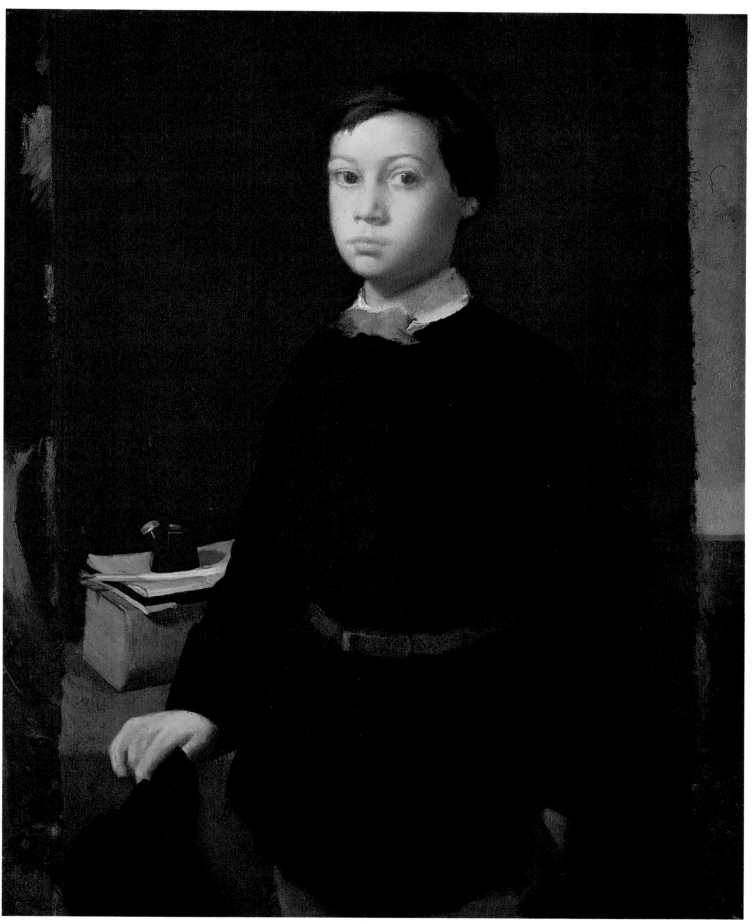

A SKETCHBOOK PAGE, NAPLES AND ROME

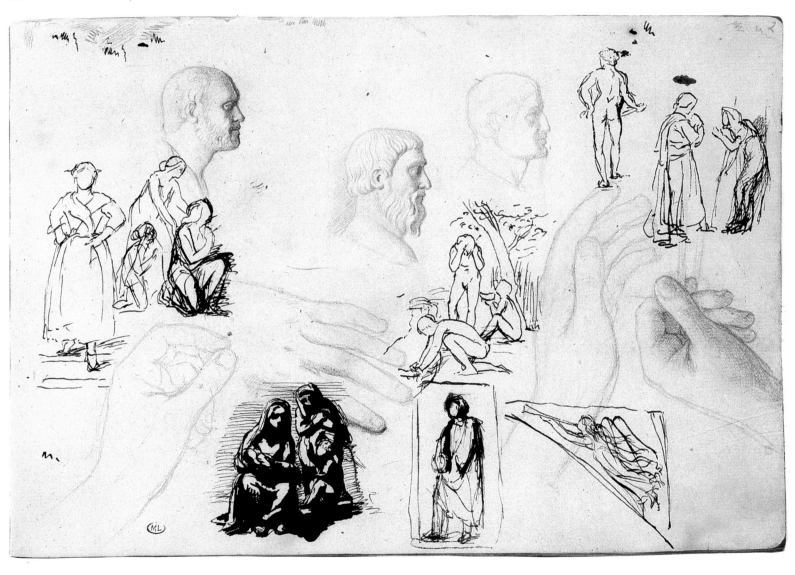

A DRAWING FROM A ROMAN PAINTING (HERCULES AND TELEPHOS)

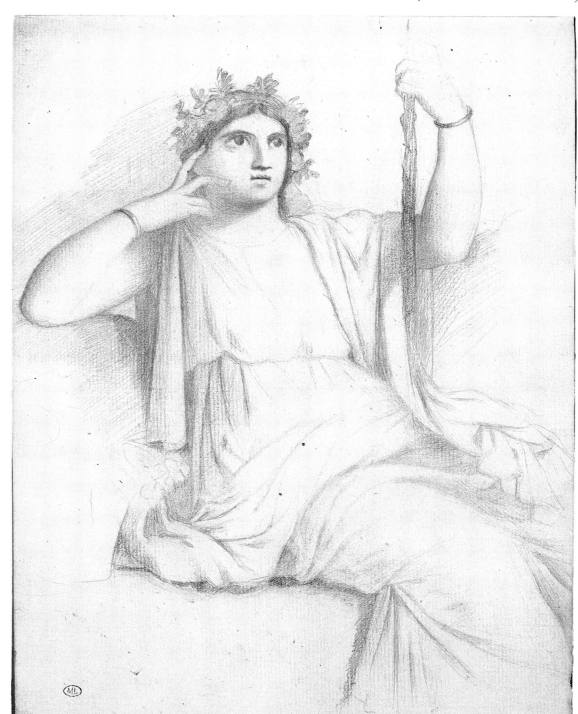

ANGEL WITH A TRUMPET

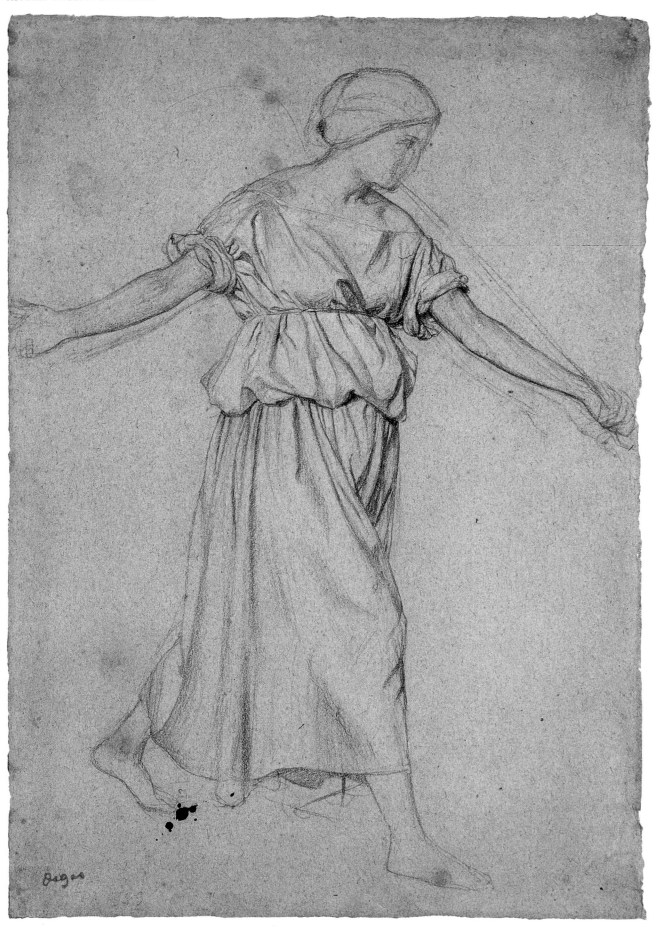

Degas

1855—1860

COPY AFTER BOTTICELLI, THE BIRTH OF VENUS

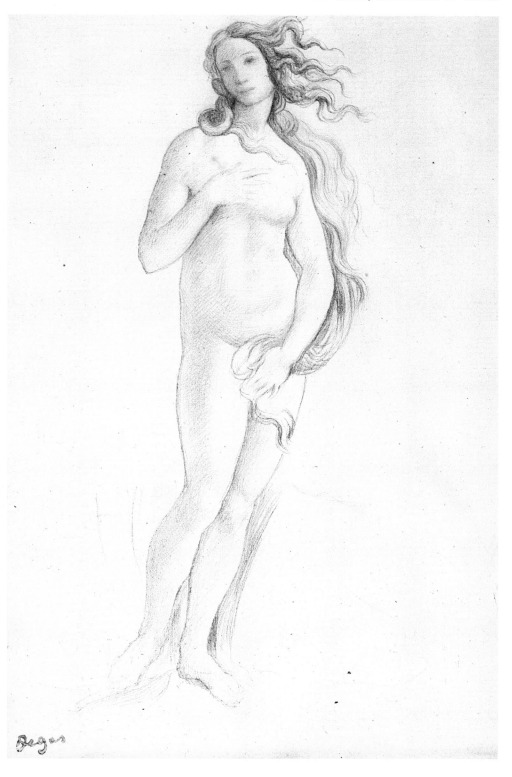

Degas

LANDSCAPE WITH DISTANT TOWN

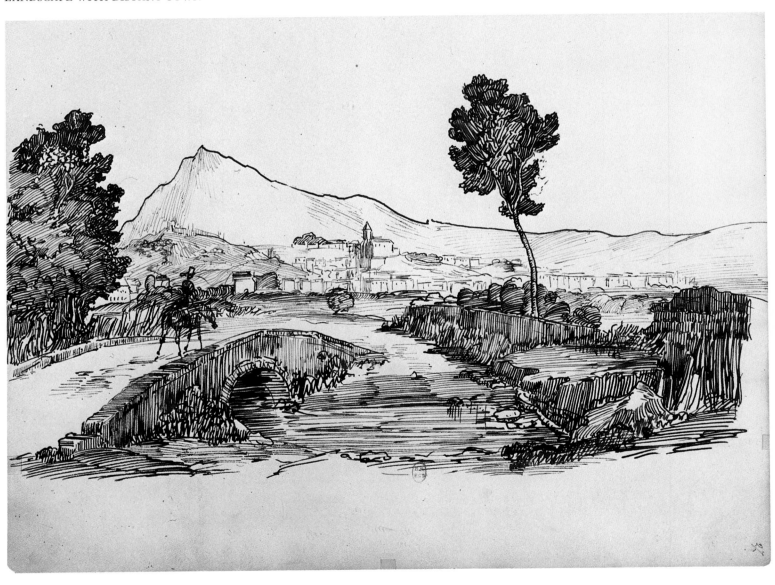

VIEW OF NAPLES

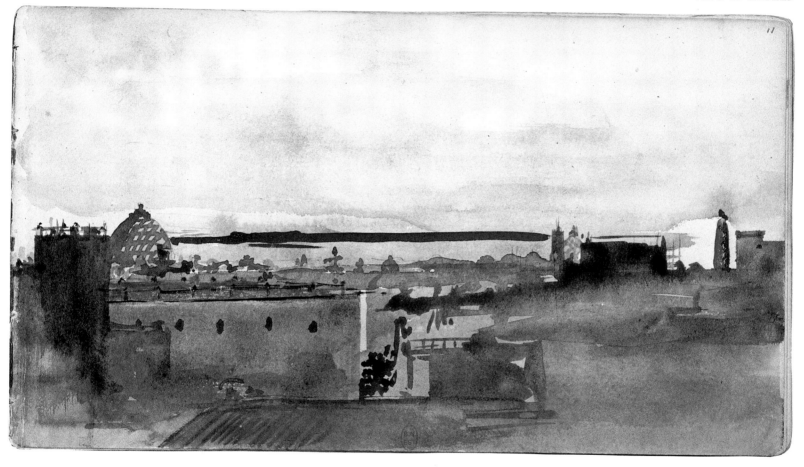

LANDSCAPE STUDIES AT HARAS-DU-PIN, NORMANDY

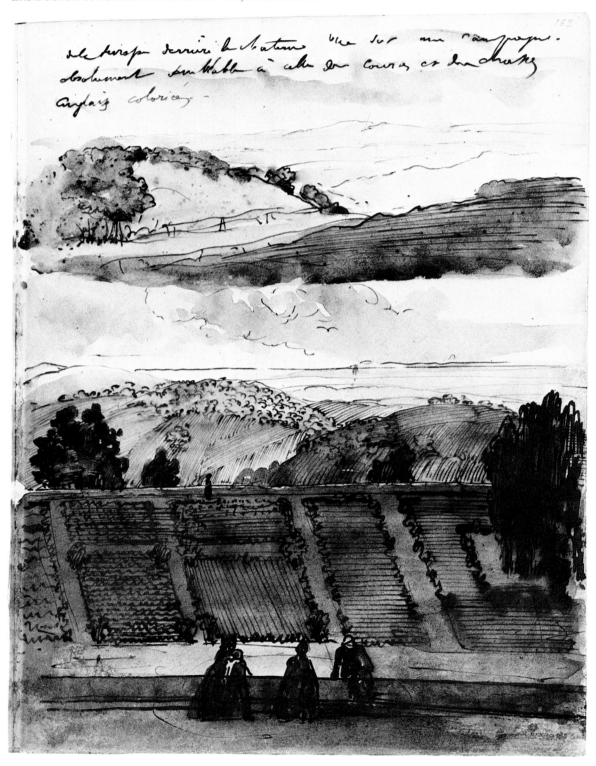

A LANDSCAPE IN NORMANDY

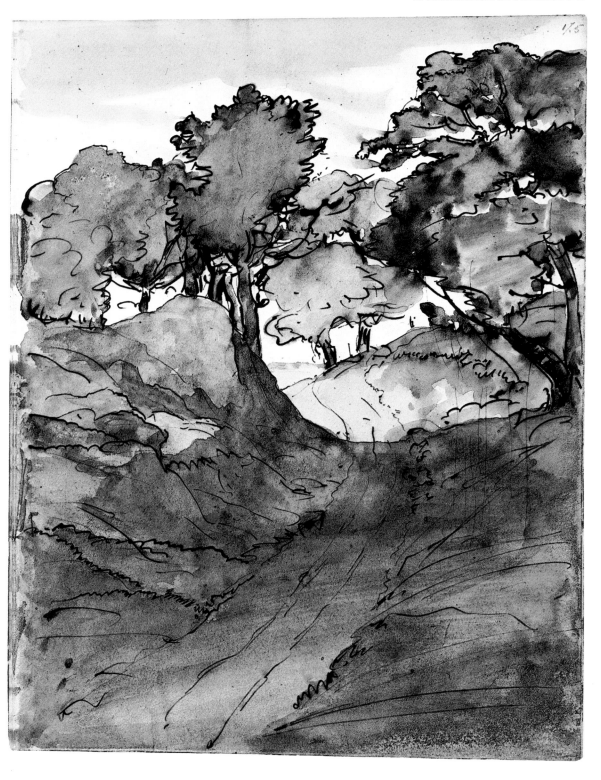

STANDING FIGURE, DRAPERY STUDY

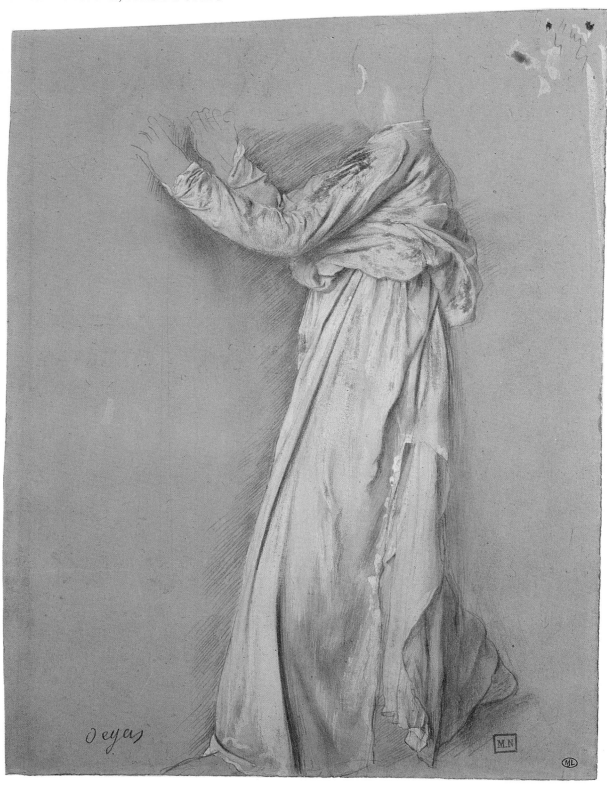

STUDY OF A HORSE WITH FIGURES

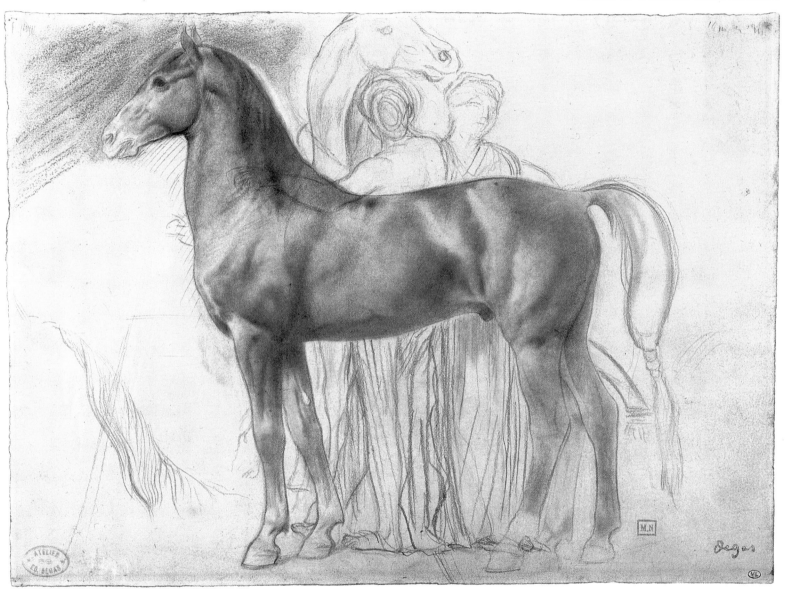

THE YOUNG SPARTANS EXERCISING

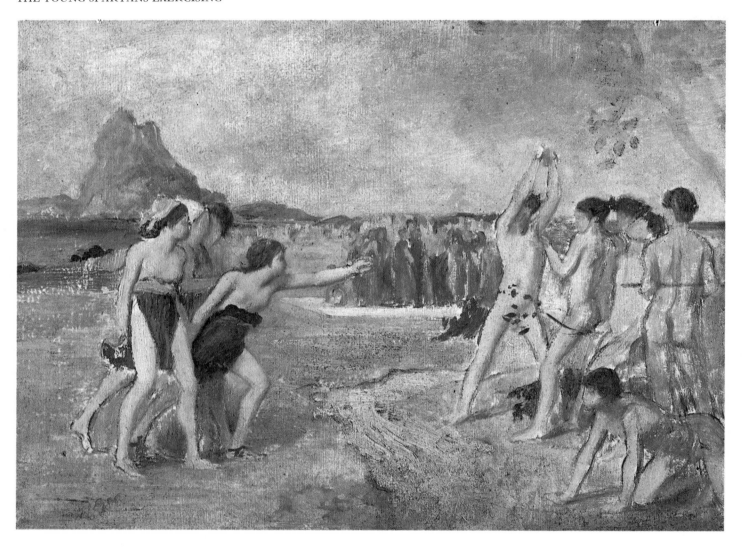

THE YOUNG SPARTANS

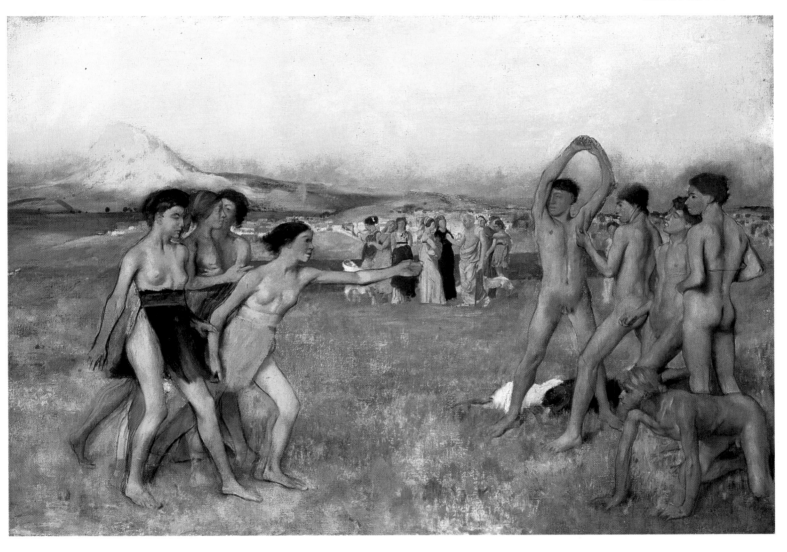

THE DAUGHTER OF JEPHTHA

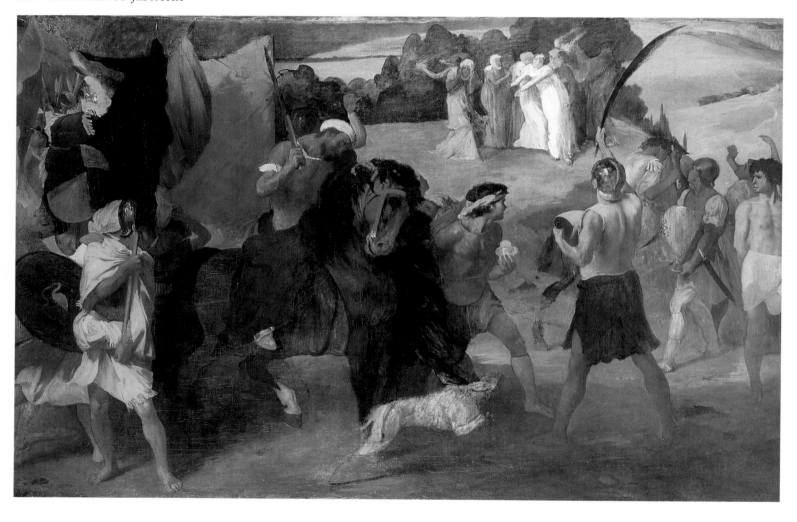

DAVID AND GOLIATH

NUDE LYING ON HER BACK

STUDY FOR WAR SCENE IN THE MIDDLE AGES

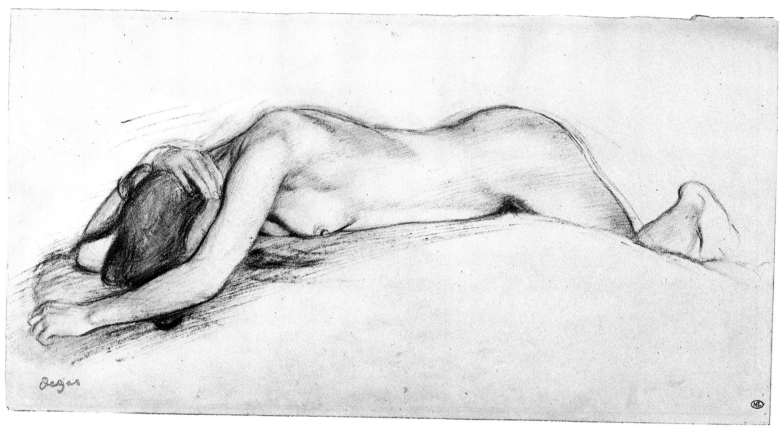

STANDING NUDE LEANING TOWARDS THE LEFT

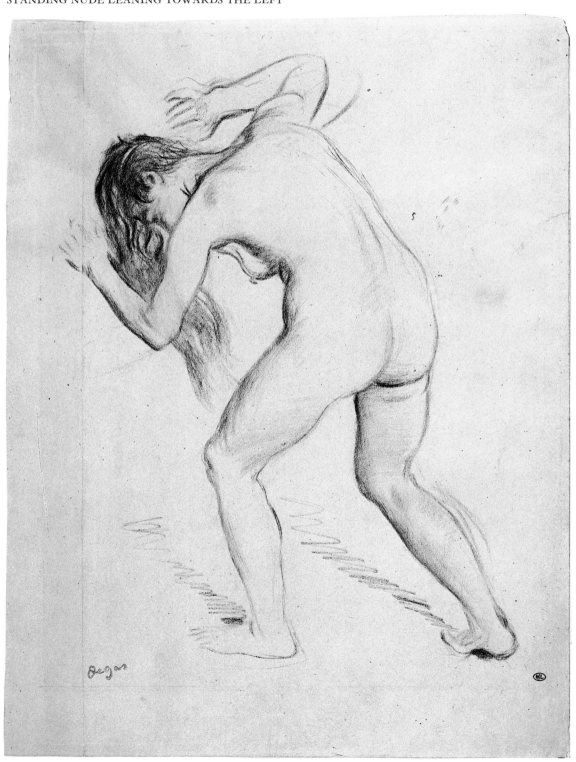

WAR SCENE IN THE MIDDLE AGES

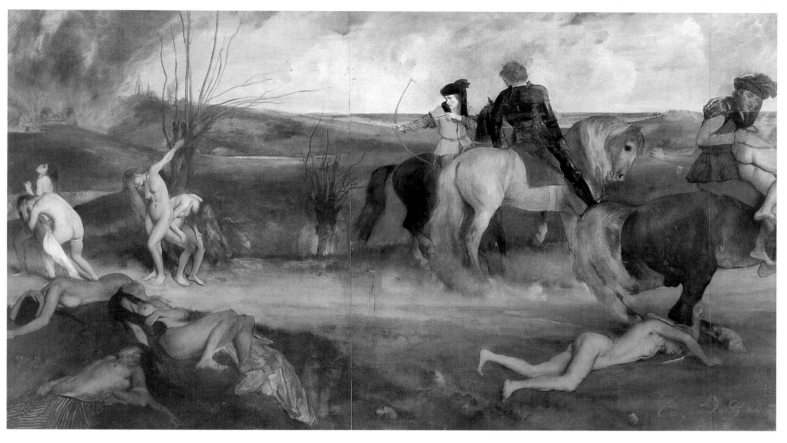

PORTRAIT OF THE BARONESS BELLELLI

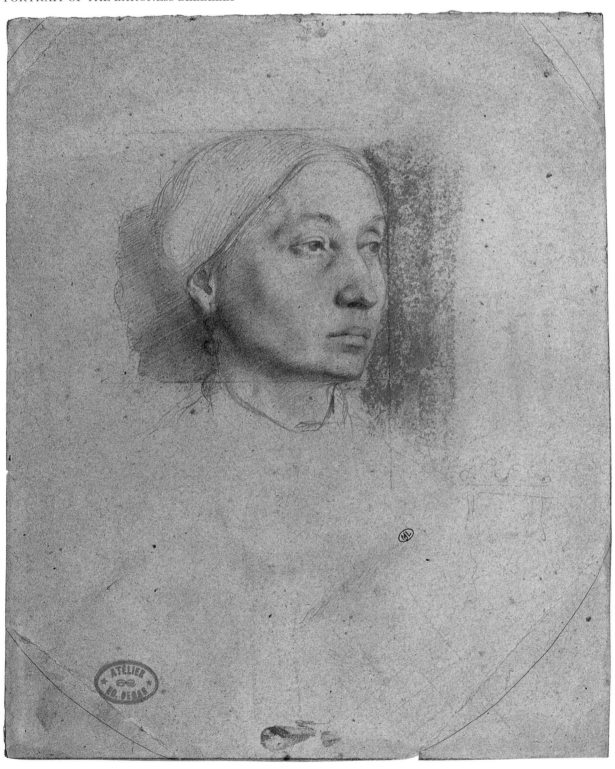

PORTRAIT OF GIOVANNINA BELLELLI

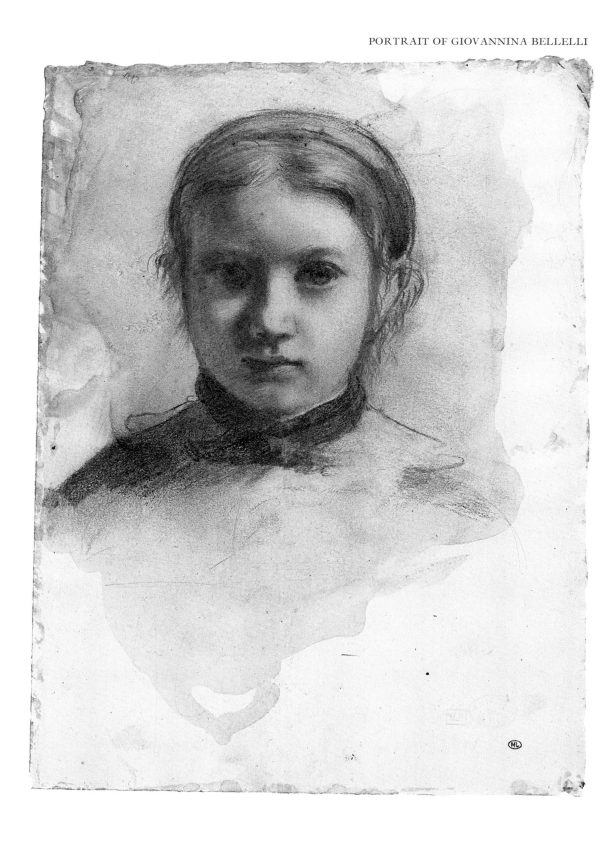

THE BELLELLI FAMILY

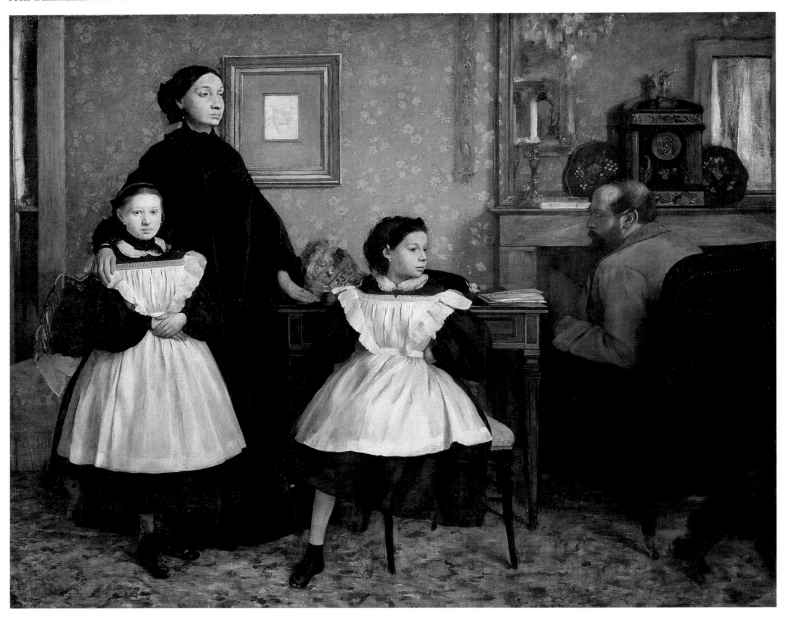

STUDY OF HANDS

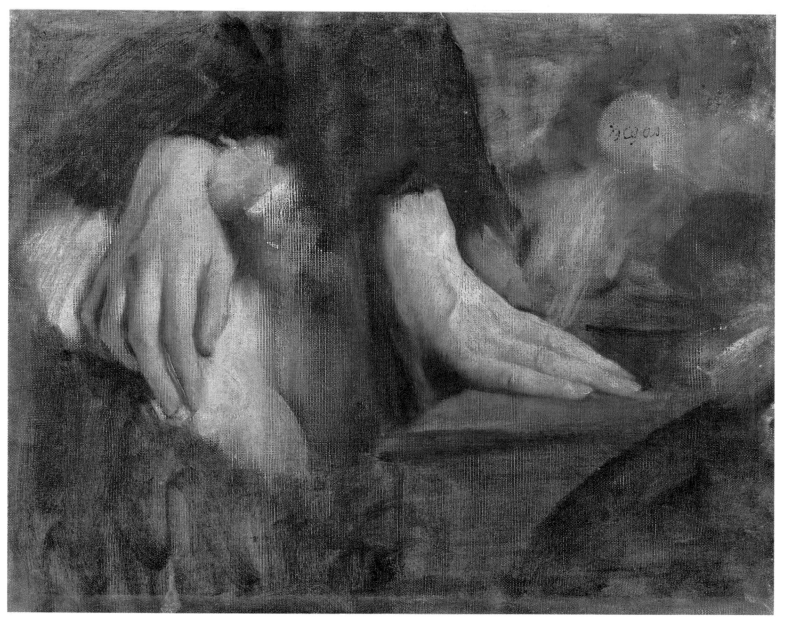

STUDIES OF HEADS

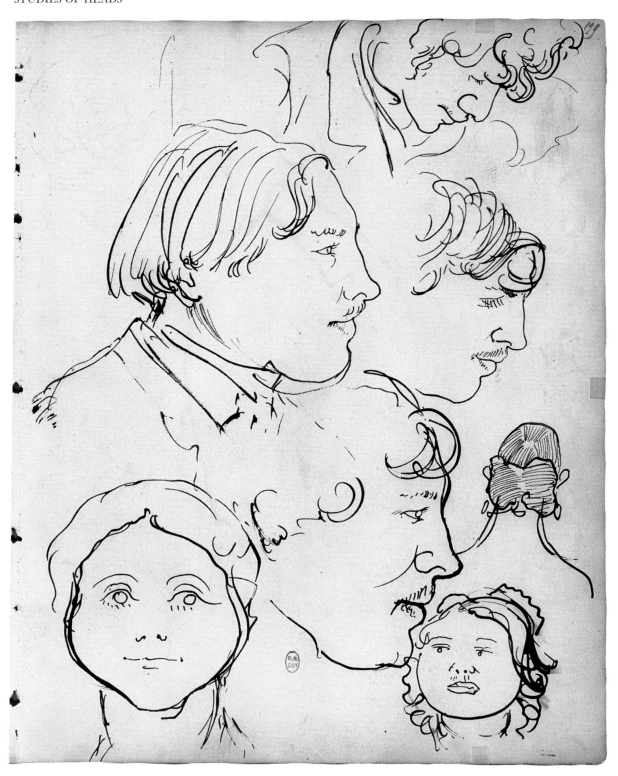

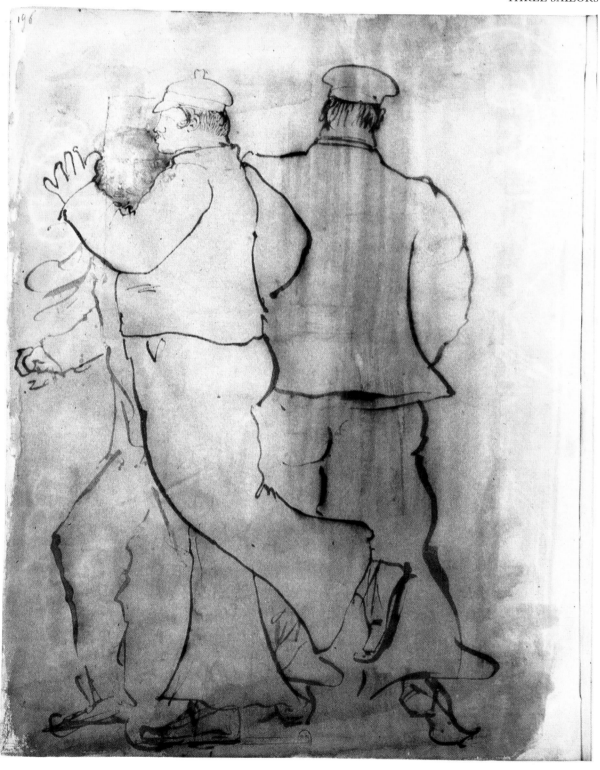

STUDY FOR MME HERTEL (A WOMAN WITH CHRYSANTHEMUMS)

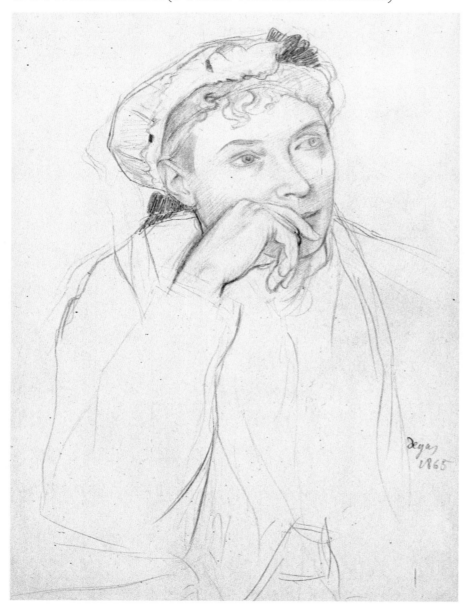

A WOMAN WITH CHRYSANTHEMUMS

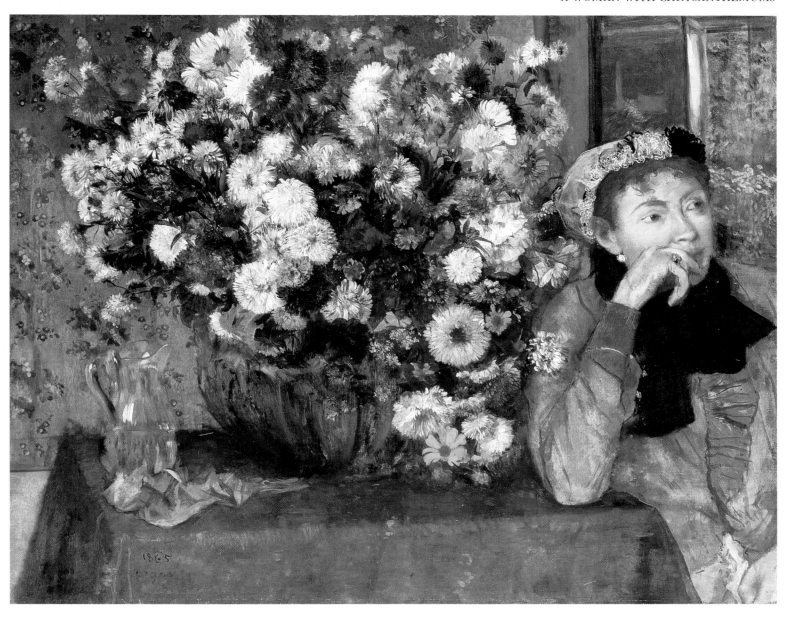

JOSÉPHINE GAUJELIN

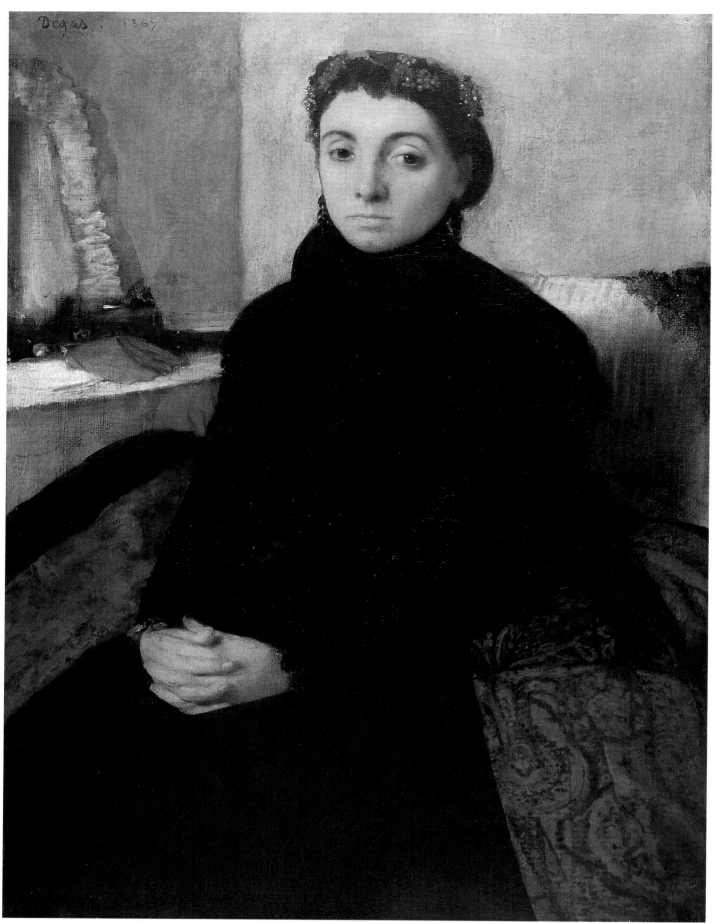

STUDY FOR THE PORTRAIT OF JOSÉPHINE GAUJELIN

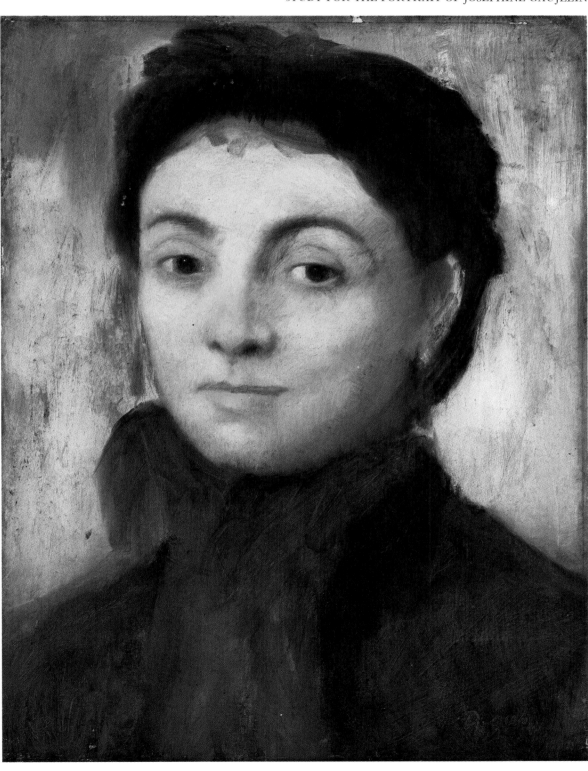

PORTRAIT OF A LADY IN GREY

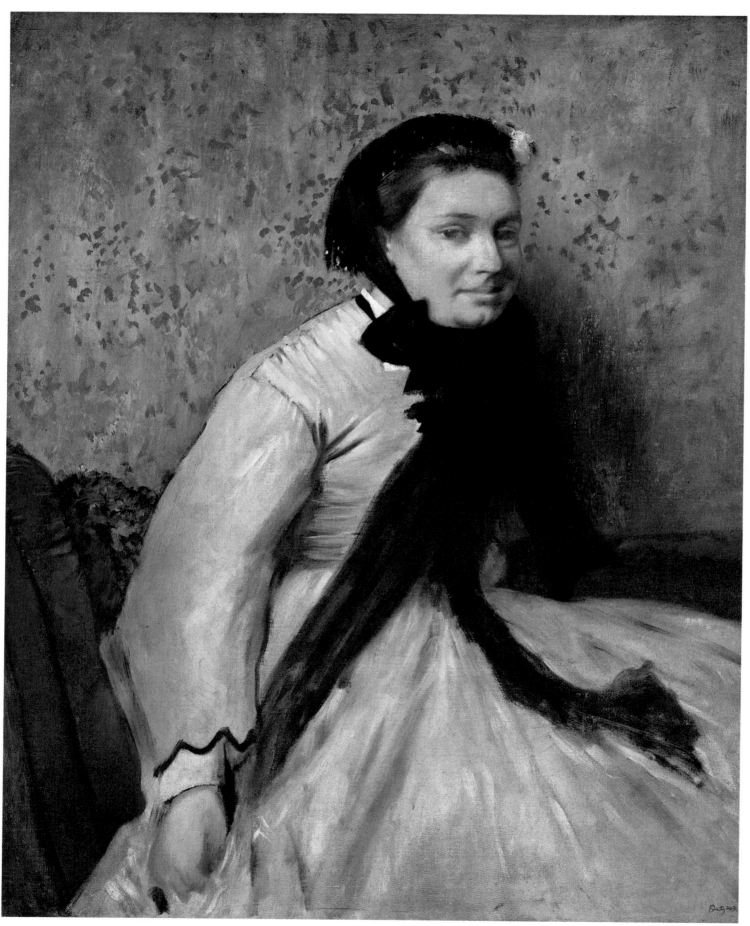

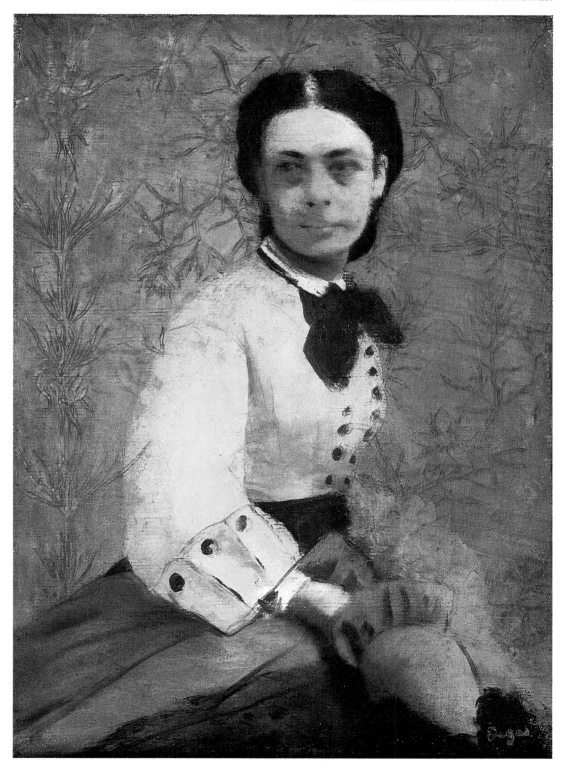

THE DUKE OF MORBILLI

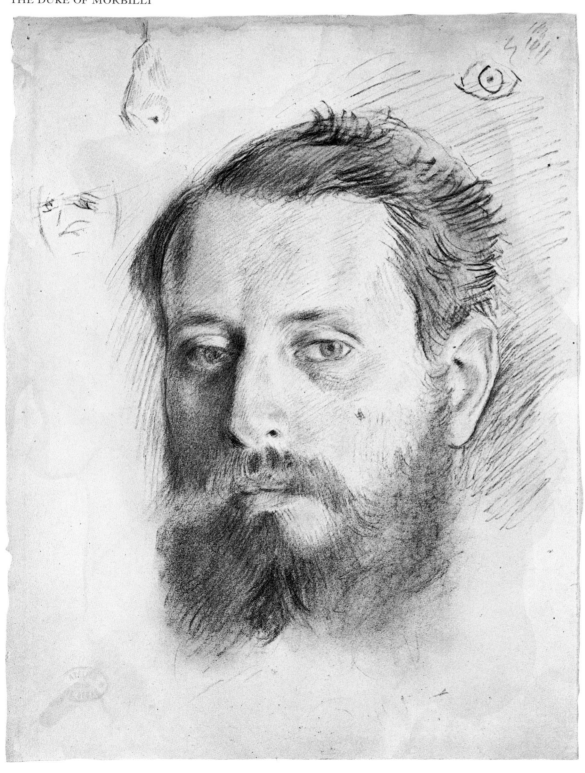

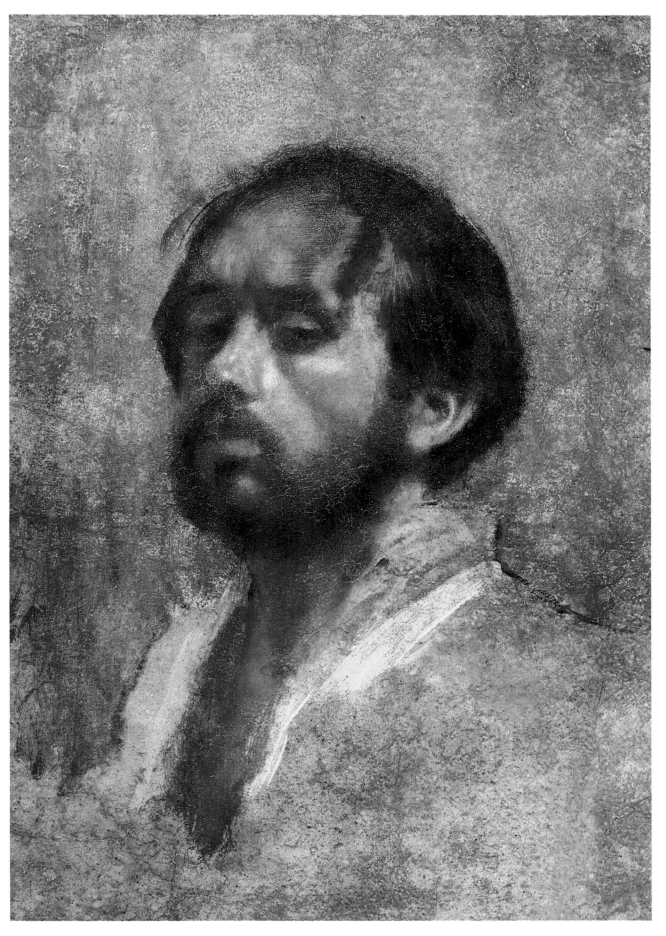

MANET SEATED, TURNED TO THE RIGHT

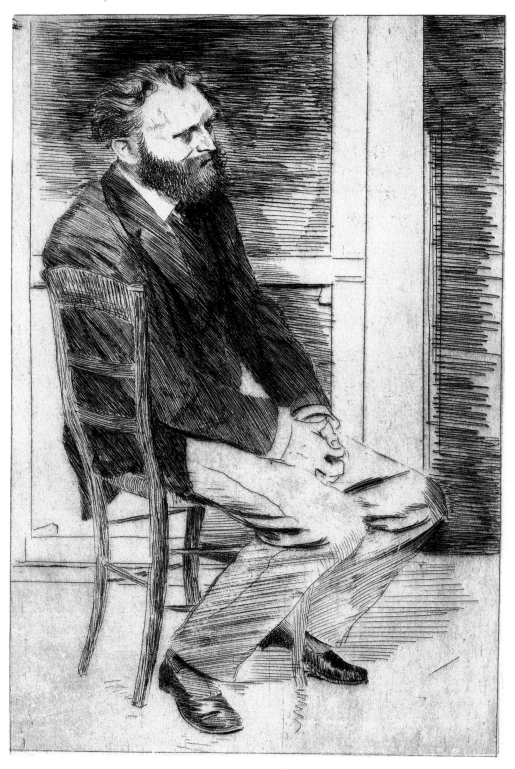

PORTRAIT OF PAGANS AND AUGUSTE DE GAS

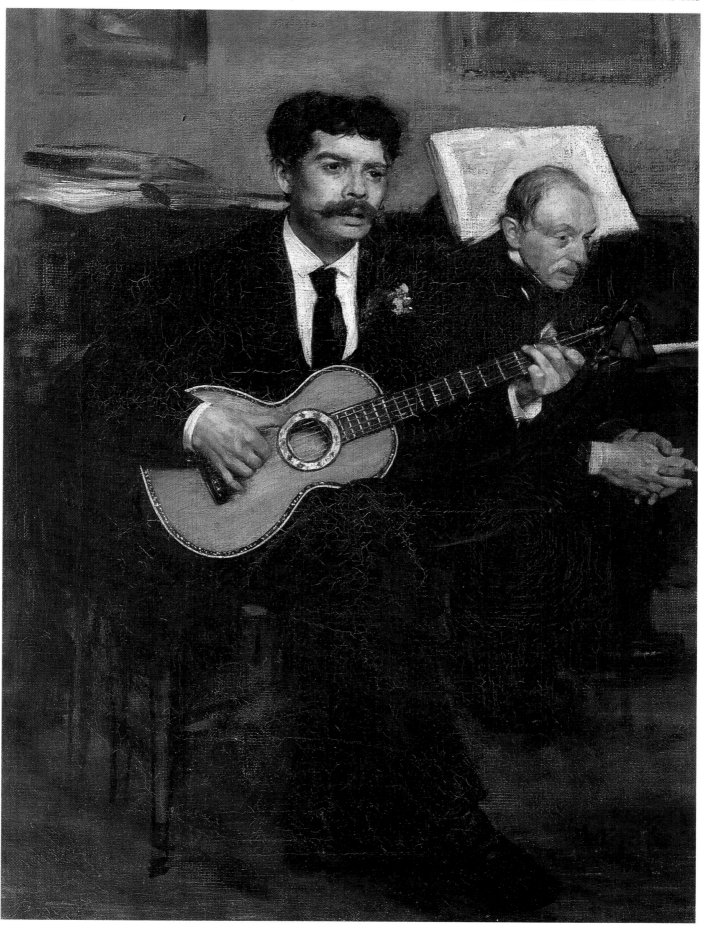

STANDING FEMALE FIGURE WITH BARED TORSO

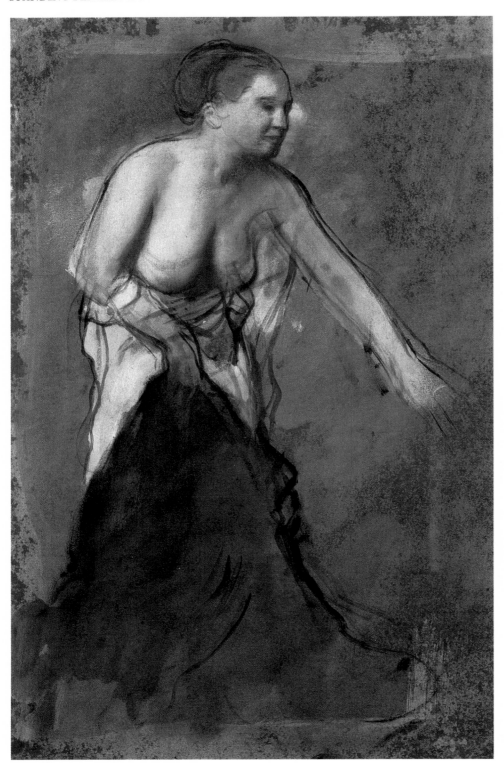

1860—1867

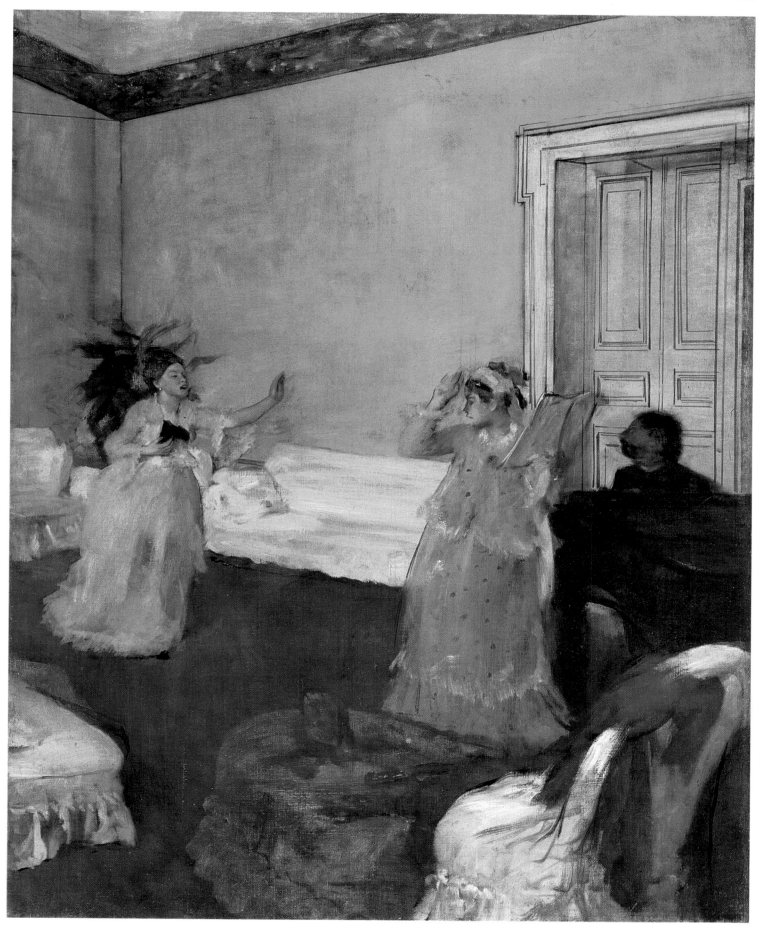

MADAME CAMUS WITH A FAN

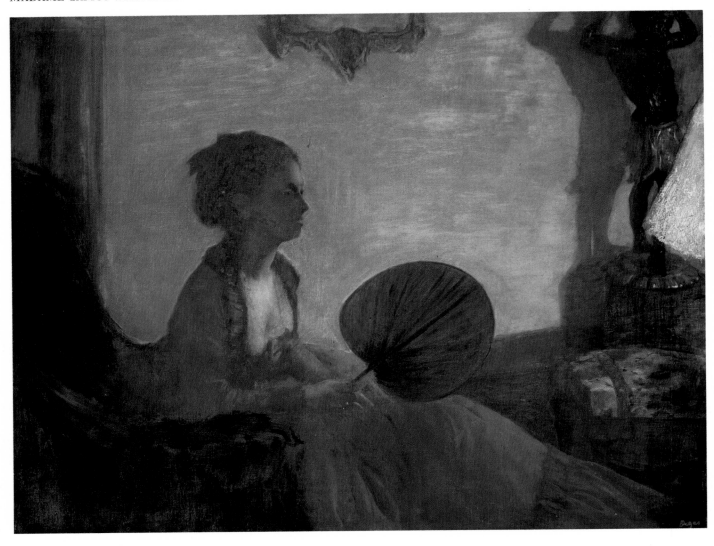

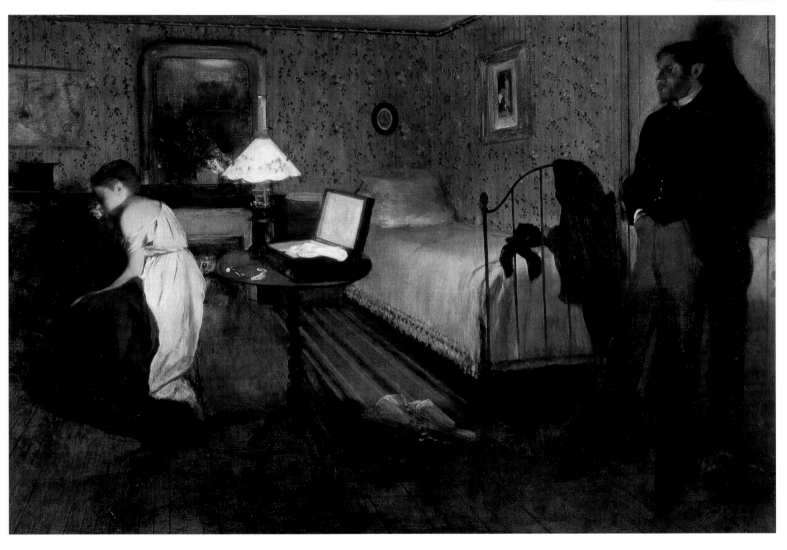

ON THE RACECOURSE

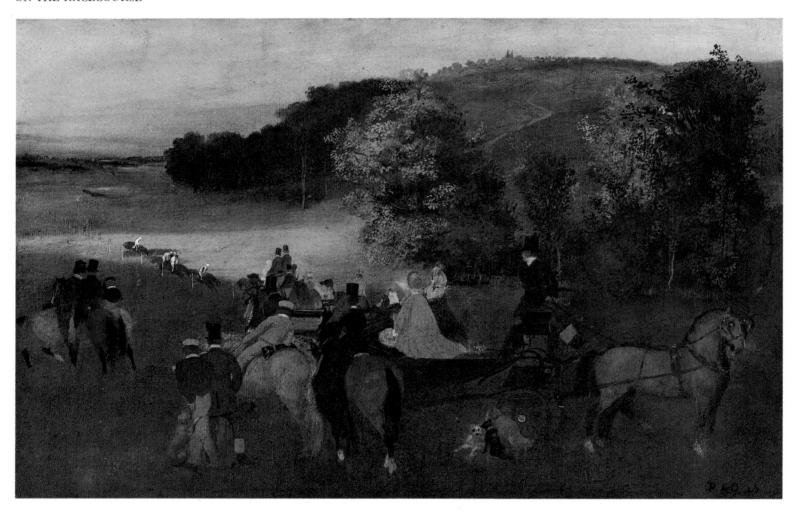

CARRIAGE AT THE RACES

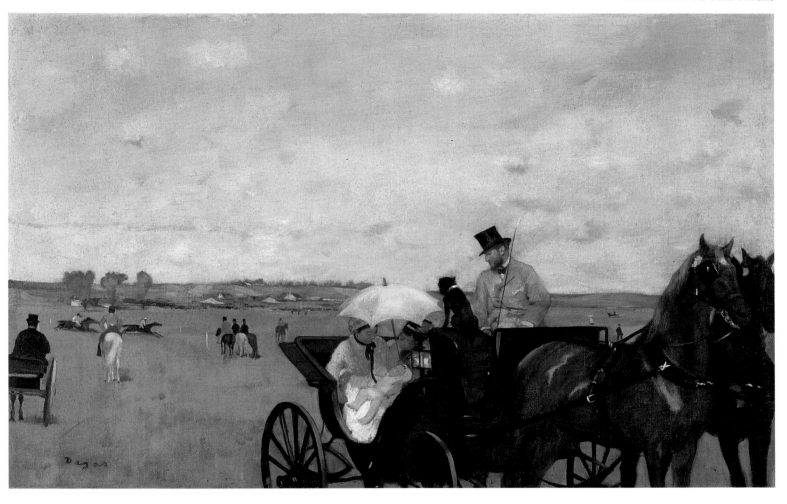

THREE STUDIES OF HORSES' HIND LEGS

HORSE AND RIDER

TWO RIDERS BY A LAKE

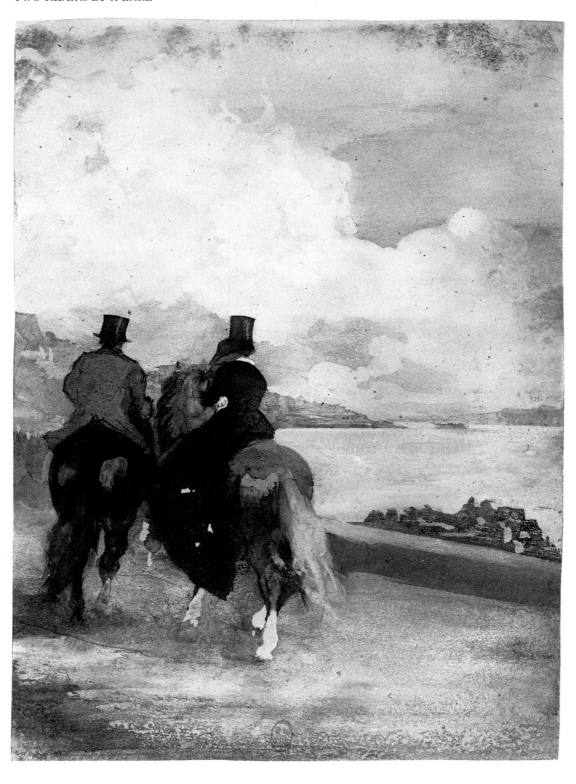

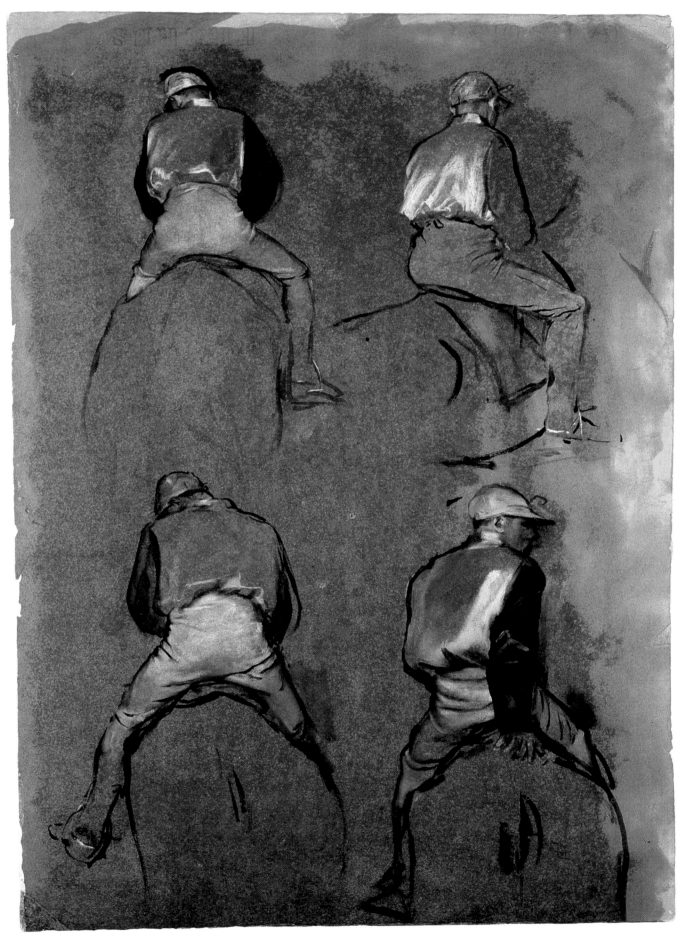

WOMEN AT THE RACES

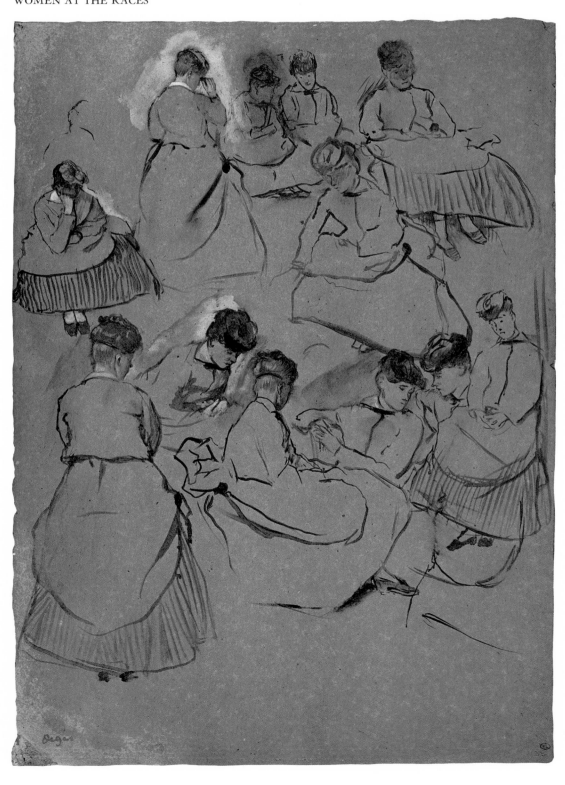

WOMAN WITH BINOCULARS

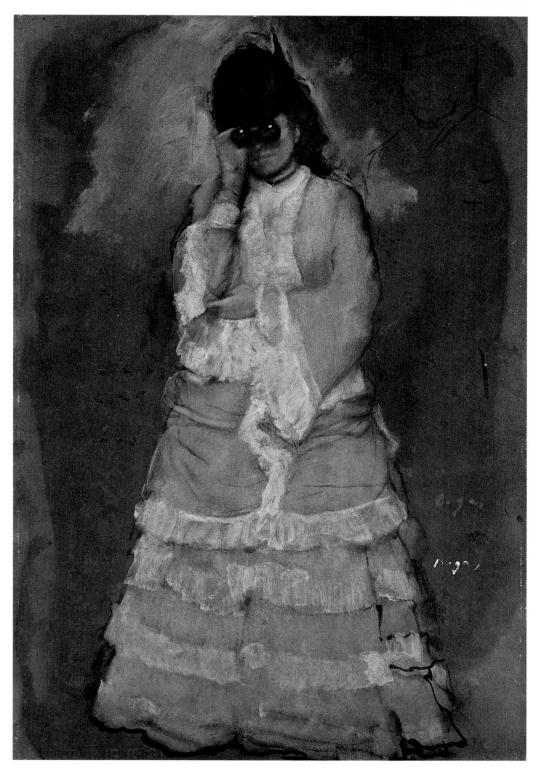

HOUSES BY THE SEASIDE

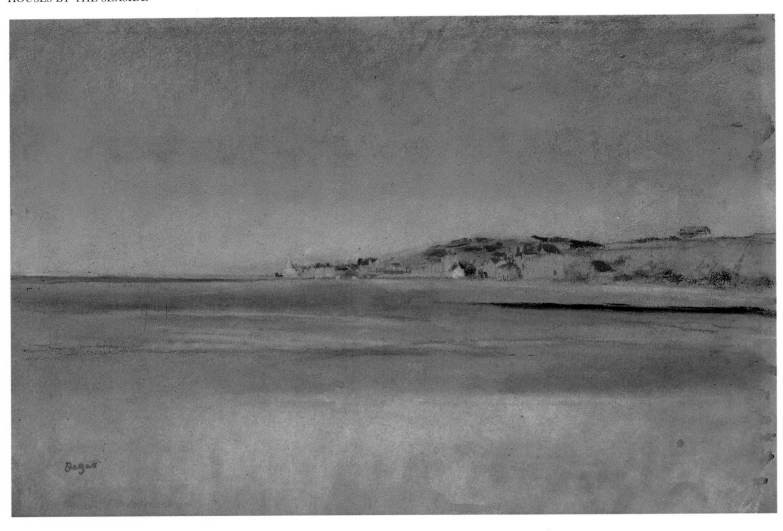

CLIFFS AT THE SEASIDE

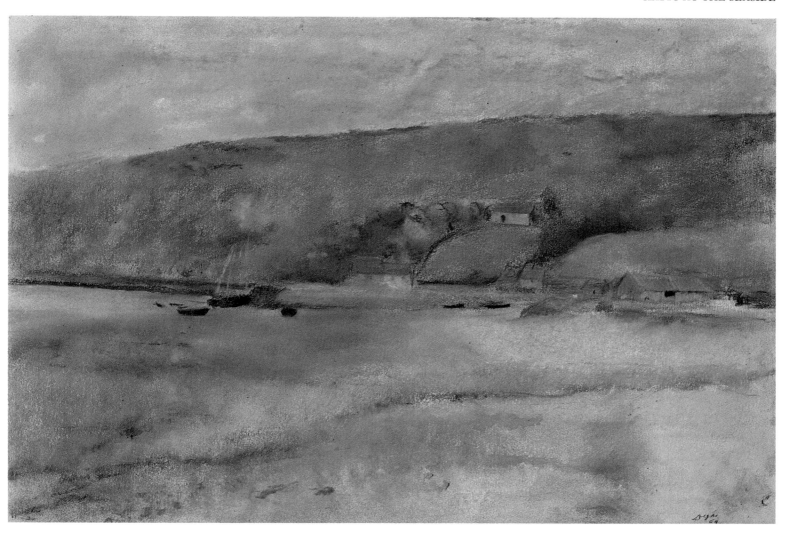

The Impressionist era 1870 – c.1885

After his orthodox and tentative early years, Degas emerged in the 1870s as a mature artist with a distinctive range of subject-matter and a confident, even combative, approach to the art world. We find him writing to a newspaper to challenge the organizers of the official Salon, pestering his fellow painters to participate in the Impressionist exhibitions held between 1874 and 1886 and cultivating picture-dealers and private collectors. His letters also show that he was, by this time, mixing with many of the most prominent young artists of the day; James Tissot, the painter of highly detailed and lucrative scenes of bourgeois life; Edouard Manet, an artist who had earlier been so influential in Degas' career but whose personal relations with him were sometimes strained; Camille Pissarro and Mary Cassatt, with whom Degas worked on a journal to be illustrated with their own etchings; and even a group of London artists, including Millais, Whistler, and Morris, whom Degas encountered on his visits to England.

In spite of his increasingly public and gregarious existence, Degas remained independent in his art and in his judgment. His letters, with the exception of those written on his visit to America, become more cryptic and businesslike, though he is still capable of great warmth in his notes to close friends. The months spent in America produced relatively few paintings, but his letters to acquaintances in Europe remind us of his continuing artistic preoccupations. He writes to Dèsiré Dihau, a bassoonist in the orchestra of the Paris Opera and discusses music and the ballet; looking around him in New Orleans, he notes the crowds and the colours and considers their suitability as subject-matter; he observes the appearance and the idiosyncrasies of his female companions and, in a telling phrase, longs for the sight of a Parisian laundress.

Degas' association with women was profoundly paradoxical, both in his life and in his art. In a letter from New Orleans to Henri Rouart, he considers the possibility of marriage for himself, and it is clear that he enjoyed the company of women. Apart from his countless pictures of dancers, milliners and laundresses, Degas' letters show that he actively encouraged a number of female artists. He urges Marie Braquemond and Berthe Morisot to exhibit with the Impressionists and expresses his admiration for the work of Suzanne Valadon and Mary Cassatt. Degas, however, clung to his bachelor existence and he was capable of terrible frankness about women both personally and in his art; his letters to Mme Dietz-Monnin, for example, show his politeness almost at breaking point while his contemporary pictures of prostitutes are both pitiless and unsentimental.

In 1884 Degas reached his fiftieth year and the celebrated era of the Impressionist exhibitions had almost come to an end. His own art was as spectacular and inventive as ever, but the momentum of the group enterprise had faltered and many of its adherents had gone their separate ways. Degas, by this time selling pictures regularly through Durand-Ruel, was able to take regular breaks in the country in the company of his friends. When he reflected on his career, he worried about his health, his eyesight, his lonely existence and the multitude of his unfulfilled aspirations.

D. Watts & Co., Cotton Brokers
140 Pearl St
New York

24 October 1872

DEAR PAPA, Here we are, both having arrived in very good shape.

We leave this evening for New Orleans; but it is possible that I, by myself, may have to stay at Bay St Louis for 8 days because they say there is still a little yellow fever in town.

We are also expecting Achille to answer yesterday's telegram on that subject.

Immense town, immense activity. Many more similarities in feature and appearance with us than with the English.

Crossing on board an English boat is dull. It was even uninteresting for me who could not take advantage of the few acquaintances René made, half dumb as I am. My ear is already getting used to the language; in a few days I will introduce myself into the conversation.

No more seasickness with René than with me. My appetite even lessened once on terra firma. His doesn't change; but it was inferior to mine on board . . .

Until January! In the meantime I will try to let you know what becomes of me.

I embrace you,

Your son, E. DE GAS

René, behind me while I am writing, is talking cotton with M. Watts.

I embrace the children and Marguerite. Best wishes to Henri and all our friends.

PASSENGERS ON BOARD SHIP

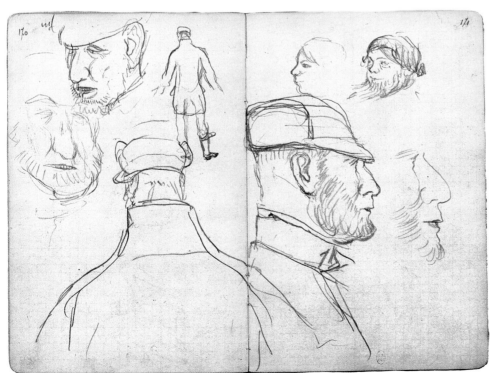

De Gas Brothers, New Orleans, 11 Nov. *1872*

MY DEAR DIHAU, Thank you for your good letter. It is the first. Already they are forgetting me over there. Please forgive me; I should have guessed your promptness in writing to me and have at least written to you from New York. All the same I am expecting a second edition from you before you receive this.

We had an excellent journey. Ten days at sea is a long time; particularly on an English boat where there is so much reserve. If we could have taken the French boat of 10 October we should have found some travelling company in which the women at least would have helped us to kill time. No more seasickness for the one than for the other and for my part an appetite such as I had never known and which had every appearance of permanency; it is falling off here; I eat next to nothing. 30 hours wait at New York. Left Thursday at 6 o'clock, we were due at New Orleans at 11 o'clock on Monday with several hours' wait at Louisville, as fresh and fatter than when we left. You must have heard of the Wagons-Lits; but you have never seen one, you have never travelled in one and so you cannot imagine what this marvellous invention is like. You lie down at night in a proper bed. The carriage, which is as long as at least 2 carriages in France, is transformed into a dormitory. You even put your shoes at the foot of the bed and a kind negro polishes them whilst you sleep. – What luxuriousness you will say. No, it is a simple necessity. Otherwise it would be impossible to undertake such journeys at a stretch. And then the ability to walk all round your own coach and the whole train, to stand on the observation platforms, is immensely restful and diverting. Everything is practical and very simply done here, so simply that the trains leave almost without warning. – Well I was with René who is from these parts and I did not miss anything . . .

Ah! my dear friend, what a good thing a family is; we were met at the station. My uncle

ESTELLE MUSSON DE GAS

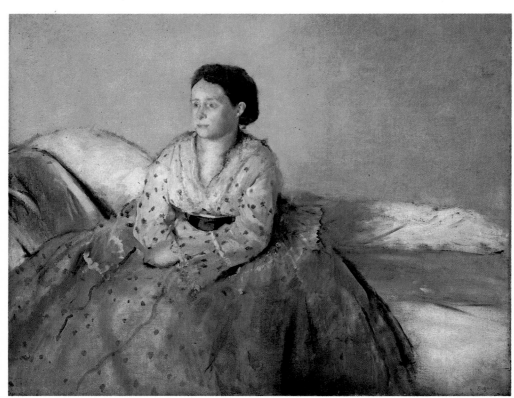

looked at me over his spectacles; my cousins, their six children were there. The surprise that René had planned for them by not saying that I was with him failed; as there had been some talk of yellow fever still persisting at New Orleans he had telegraphed to Achille asking if that meant there would be any danger for a stranger and the cat was out of the bag. All day long I am among these dear folk, painting and drawing, making portraits of the family. My poor Estelle, René's wife, is blind as you know. She bears it in an incomparable manner; she needs scarcely any help about the house. She remembers the rooms and the position of the furniture and hardly ever bumps into anything. And there is no hope! – Pierre, René's son, is superb; he is so self-possessed and the mixture of English and French is so quaint! – Odile, his little girl, is 12 to 15 months old. Jane the eldest, his wife's daughter, has a real feeling for music; she is beginning to sing the sol-fa in the Italian manner. There is also a little Carrie, daughter of Mathilde, the youngest of my cousins. Mathilde also decided to have another young boy called Sydney and a little brat of 2 months called Willy. – This whole band is watched over by negresses of different shades. We are awaiting the arrival, today or tomorrow, by the ship *Le Strasbourg*, of a French nurse whom René engaged in Paris . . .

Greetings to Piot, Demarquette, Ziegler etc. and to the distinguished patroness. – What you tell me about Madier gives me great pleasure. Here in the French company we have a Mlle Winke who was a dancer at the Français and whom Madier wanted me to meet in Paris because of my dance picture and of the roguish air of the lady. I regret very much not being quite introduced.

Goodbye, believe in my friendship. – If you see Clotilde ask her to write and tell me what is happening at home.

DEGAS

WOMAN SEATED ON A BALCONY, NEW ORLEANS

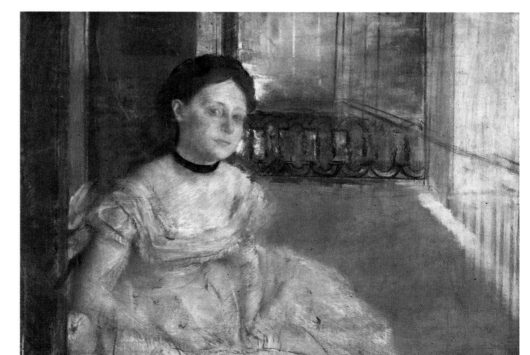

The visit to America, 1872–1873

MY DEAR TISSOT, What do you say to the heading? It is the firm's notepaper. Here one speaks of nothing but cotton and exchange. Why do you not speak to me of other things? You do not write to me. What impression did my dance picture make on you, on you and on the others? – Were you able to help in selling it? And the one of the family at the races, what is happening to that? Oh, how far from so many things one is here.

Excellent journey. New York has some charming spots. We spent scarcely two days there. What a degree of civilization! Steamers coming from Europe arrive like omnibuses at the station. We pass carriages, even trains on the water. It's England in her best mood.

After four days in the train we arrived at New Orleans. You cannot imagine a wagon-lit 'sliping car' [sic]. A real dormitory. Behind curtains one can undress down to one's chemise if one wants to, and then climb into a real apple-pie bed. Everything is done simply and except for some points of taste, one says to oneself: it's true, it's just what I needed . . .

Villas with columns in different styles, painted white, in gardens of magnolias, orange trees, banana trees, negroes in old clothes like the junk from *La Belle Jardinière* or from Marseilles, rosy white children in black arms, charabancs or omnibuses drawn by mules, the tall funnels of the steamboats towering at the end of the main street, that is a bit of local colour if you want some, with a brilliant light at which my eyes complain.

Everything is beautiful in this world of the people. But one Paris laundry girl, with bare arms, is worth it all for such a pronounced Parisian as I am. The right way is to collect oneself, and one can only collect oneself by seeing little. I am doing some family portraits; but the main thing will be after my return.

René has superb children, an excellent wife who scarcely seems blind, although she is, almost without hope, and a good position in business. He is happy, it is his country perhaps even more than France.

And you, what news is there since the 700 pounds? You with your terrible activity would be capable of drawing money out of this crowd of cotton brokers and cotton dealers, etc. I shall not attempt to earn anything here.

May this letter of mine cross something from you. Did you get my photographs? Here I have acquired the taste for money, and once back I shall know how to earn some I promise you.

If you see Millais, tell him I am very sorry not to have been able to see him and tell him of my appreciation for him. Remember me to young Deschamps, to Legros, to Whistler who has really found a personal note in that well-balanced expression, mysterious mingling of land and water.

I have not yet written to Manet and naturally he has not sent me a line. The arrival of the mail in the morning really excites me. Nothing is as difficult as doing family portraits. To make a cousin sit for you who is feeding an imp of two months is quite hard work. To get young children to pose on the steps is another job of work which doubles the fatigues of the first. It is the art of giving pleasure and one must look the part.

A good family: it is a really good thing to be married, to have good children, to be free of the need of being gallant. Ye gods, it is really time one thought about it.

Goodbye. Write to me. I shall not leave the country before the middle of January

Your friend, DEGAS

De Gas Brothers, New Orleans, *27 Nov. 1872*

TO LORENZ FRÖLICH It is only today, 27 November, that I receive your affectionate letter, my dear Frölich . . .

The ocean! how vast it is and how far I am from you. The *Scotia* in which I travelled is an English boat swift and sure. It bought us (I was with my brother René) in 10 days. The *Empire City* even takes 12 from Liverpool to New York. What a sad crossing. I did not know any English, I hardly know any more, and on English territory, even at sea, there is a coldness and a conventional distrust which you have perhaps already felt.

New York, great town and great port. The townsfolk know the great water. They even say that going to Europe is going to the other side of the water. New people. In America there is far more disregard of the English race than I had supposed.

Four days by train brought us here at last. – Borrow an atlas from your dear little daughter and take a look at the distance . . . How many new places I have seen, what plans that put into my head, my dear Frölich! Already I am giving them up; I want nothing but my own little corner where I shall dig assiduously. Art does not expand, it repeats itself. And if you want comparisons at all costs, I may tell you that in order to produce good fruit one must line up on an espalier. One remains thus all one's life, arms extended, mouth open, so as to assimilate what is happening, what is around one and alive.

Have you read the *Confessions* by J. Jacques Rousseau? I am sure you have. Then do you recall his manner of describing, his wealth of humour, after he has retired to the île du Lac de St Pierre in Switzerland (it is towards the end) and that he is telling how he used to go out at daybreak, that whichever way he went, without noticing it, he examined everything, that he started on work that would take 10 years to finish and left it without regret at the end of 10 minutes? Well that is my case, exactly. Everything attracts me here. I look at everything; I shall even describe everything to you accurately when I get back. I like nothing better than the negresses of all shades, holding in their arms little white babies, so white, against white houses with columns of fluted wood and in gardens of orange trees and the ladies in muslin

CHILDREN ON THE STEPS,
NEW ORLEANS

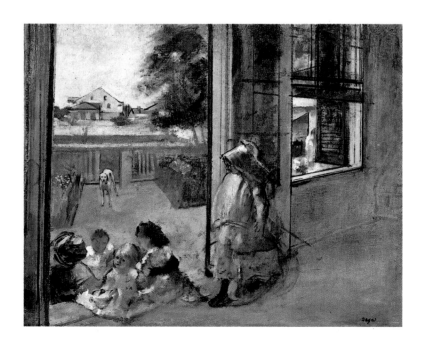

against the fronts of their little houses and the steamboats with two chimneys as tall as factory chimneys and the fruit vendors with their shops full to bursting, and the contrast between the lively hum and bustle of the offices with this immense black animal force, etc. etc. And the pretty women of pure blood and the pretty 25-year-olds and the well set up negresses!

In this way I am accumulating plans which would take ten lifetimes to carry out. In six weeks' time I shall drop them without regret in order to regain and never more to leave *my home*.

My dear friend, thank you a hundred times for your letters and for your friendship. That gives such pleasure when one is so far away.

My eyes are much better. I work little, to be sure, but at difficult things. The family portraits have to be done more or less to suit the family taste, by impossible lighting, very much disturbed, with models full of affection but a little *sans-gêne* and taking you far less seriously because you are their nephew or their cousin. I have just messed up a large pastel and am somewhat mortified. – If I have time I intend to bring back some crude little thing of my own but for myself, for my room. It is not good to do Parisian art and Louisiana art indiscriminately, it is liable to turn into the *Monde Illustré*. – And then nothing but a really long stay can reveal the customs of a people, that is to say their charm. – Instantaneousness is photography, nothing more . . .

I shall probably be back in January. I shall travel via Havana. But you, you will soon be leaving us you say? – I do hope it is for your old mother's sake, in which case it is a duty. – However we shall see a lot of each other until the spring. Your little daughter will play for me – I need music so much. – There is no opera here this winter. Yesterday evening I went to a rather monotonous concert, the first of the year. A Madame Urto played the violin with some talent but rather monotonously accompanied and there is not the same intimacy at a concert, here especially where the applause is even more stupid than elsewhere . . .

You only knew Achille, I believe, and only met him for a moment. My other brother, René, the last of the three boys, was my travelling companion, even my master. I knew neither English nor the art of travelling in America; therefore I obeyed him blindly. What stupidities I should have committed without him! He is married and his wife, our cousin, is blind, poor thing, almost without hope. She has borne him two children, she is going to give him a third whose Godfather I shall be, and as the widow of a young American killed in the war of Secession she already had a little girl of her own who is 9 years old. Achille and René are partners; I am writing to you on their office notepaper. They are earning very nicely and are really in an exceptionally good position for their age. They are much liked and respected here and I am quite proud of them.

Politics! I am trying to follow those of my native France in the Louisiana papers. They talk of little but the super-tax on houses, and they give Mr. Thiers experts' advice on republicanism.

Goodbye, your proverbs are nearly as abundant as those of Sancho; given his gaiety you would increase them threefold. How healthy a thing is laughter, I laughed at them a lot . . .

You can write to me when you get this; your answer will still find me at Louisiana. – A kiss for your little one. I clasp your hand and thank you for your friendship.

DEGAS

My regards to Manet and his family.

I have reread my letter. It is very cold compared to yours. Do not be angry with me.

New Orleans, 5 Dec. 1872

To Henri Rouart You will receive this, my dear Rouart, on New Year's Day.
You will then wish Mme Rouart a Happy New Year and embrace your children for me,
including the new-born. Out of this you will also take a bit for yourself.

I shall certainly be back in January. To vary my journey I intend going back via Havanna,
the French transatlantic lines dock there. I am eager to see you again at my house, to work in
contact with you. One does nothing here, it lies in the climate, nothing but cotton, one lives for
cotton and from cotton. The light is so strong that I have not yet been able to do anything on
the river. My eyes are so greatly in need of care that I scarcely take any risk with them at all.
A few family portraits will be the sum total of my efforts. I was unable to avoid that and
assuredly would not wish to complain if it were less difficult, if the settings were less insipid
and the models less restless. Oh well, it will be a journey I have done and very little else. Manet
would see lovely things here, even more than I do. He would not make any more of them. One
loves and gives art only to the things to which one is accustomed. New things capture your
fancy and bore you by turns. The beautiful, refined Indian women behind their half-opened
green shutters, and the old women with their big bandanna kerchiefs going to the market can
be seen in a different light to Biard. But then what? The orange gardens and the painted houses
attract too and the children all dressed in white and all white against black arms, they too
attract . . .

I see many things here, I admire them. I make a mental note of their appropriation and
expression and I shall leave it all without regret. Life is too short and the strength one has only
just suffices. – Well then, long live fine laundering in France . . .

I have had a slight attack of dysentry for the last two days, and that tires me no end. Nitrate
of bismuth will get rid of that. Also, devil take it, we are having temperatures in December
which we would be pleased to have in June, 24 or 25 degrees at least, not to mention a sirocco
that kills you. Climate that must be unbearable in the summer and is somehow deadening
during the other seasons. One has to be of the country or in the everlasting cotton, otherwise
beware.

A fortnight ago Mr. Bujac dined at our house. Naturally we talked of you and all the good
that was said surprised nobody. He looks very sad and worried, poor man! And he has good
cause. – One day I shall go to the glass factory with him.

So you are scarcely more of a writer than I am. Why did you not write a few words yourself?
In the morning when the post comes there is very rarely a letter for me and I cannot get used
to that.

You see, my dear friend, I dash home and I commence an ordered life, more so that anyone
excepting Bouguereau, whose energy and makeup I do not hope to equal. I am thirsting for
order. – I do not even regard a good woman as the enemy of this new method of existence.
– A few children for me of my own, is that excessive too? No. I am dreaming of something well-
done, a whole, well organized (style Poussin) and Corot's old age. It is the right moment, just
right. If not, the same order of living, but less cheerful, less respectable and filled with regrets.

 . . . The lack of an opera is a real privation. Poor Estelle who is a musician was counting on
it. We should have hired a box for her and she would never have missed going except during
the actual confinement. Instead we have a company for comedy, drama, vaudevilles, etc. where
there are some quite good people and a great deal of Montmartre talent.

The women here are almost all pretty and many have even amidst their charms that touch of ugliness without which, no salvation. But I fear that their heads are as weak as mine, which *à deux* would prove a strange guarantee for a new home. Alas, I have just let out something which is nothing and yet could earn me an atrocious reputation. Beware Rouart, on your honour never to repeat in such a manner that it might be reported to people from here or to people who know people from here that I told you the women of New Orleans were weak-minded. This is serious. There is no joking here. My death would not wipe out such an insult and Louisiana must be respected by all her children and I am almost one of them. If in addition I were to tell you that they must also be good, the insult would be complete and by repeating that as well you would have delivered me up once and for all to my executioners. I am exaggerating a little, the Creole women really have something attractive . . .

Goodbye, I wanted to fill four pages, be grateful for that, I wished to please you; if I have not succeeded punish me in the same way. And then I am in the office of the De Gas Brothers where it is not too bad for writing. De Gas Brothers are respected here and I am quite tickled to see it. They will make their fortune.

In conclusion I repeat my wishes for a happy New Year to Mme Rouart, I embrace your children once again and clasp your hand.

Your devoted DEGAS

Greetings to Levert, to your friends, to Martin, to Pissarro with whom I shall have some long talks about here . . . I was forgetting your brother and Mignon.

There is a person here called Lamm who has invented an instrument said to be rather ingenious, which sets buses in motion at the top of the town by means of steam with which it supplies itself. There was a lot of talk about tramways in Paris, I shall bring you a description of this contraption.

*

De Gas Brothers, New Orleans, 18 Feb. 1873

TISSOT, MY DEAR FRIEND, I intended, I was going to reply to your good letter in person. I should have been in London or Paris about the 15 January (such a distance has become immaterial to me, no space must be regarded as great except the ocean). But I remained and shall not leave until the first days of March. Yesterday my trunks and Achille were ready but there was a hitch which stopped everything. One misses the train here exactly as at Passy. The *Saint-Laurent* is leaving without us.

After having wasted time in the family trying to do portraits in the worst conditions of day that I have ever found or imagined, I have attached myself to a fairly vigorous picture which is destined for Agnew and which he should place in Manchester (for if a spinner ever wished to find his painter, he really ought to hit on me), *Intérieur d'un bureau d'acheteurs de coton à la Nlle Orléans (The Cotton Office, New Orleans)*.

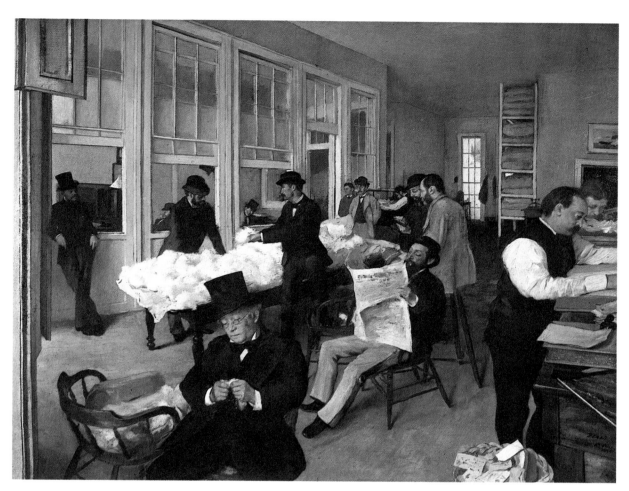

THE COTTON OFFICE, NEW ORLEANS

In it there are about 15 individuals more or less occupied with a table covered with the precious material and two men, one half leaning and the other half sitting on it, the buyer and the broker, are discussing a pattern. A raw picture if there ever was one, and I think from a better hand than many another. (Canvas about 40 it seems to me.) I am preparing another, less complicated and more spontaneous, better art, where the people are all in summer dress, white walls, a sea of cotton on the tables. If Agnew takes both from me all the better. I do not, however, wish to give up the Paris plan. (This is my present style.) In the fortnight that I intend spending here I shall finish the said picture. But it will not be possible for it to leave with me. A canvas scarcely dry, shut up for a long time, away from light and air, you know very well that that would change it to chrome-yellow no. 3. So I shall not be able to bring it to London myself or to have it sent there before about April. Retain the good will of these gentlemen for me until then. In Manchester there is a wealthy spinner, de Cotterel, who has a famous picture gallery. A fellow like that would suit me and would suit Agnew even better.

But let's be cautious how we talk about it and not count our chickens too soon.

You are getting on like a house on fire! 900 pounds, but that's a fortune? Ah! if ever! But why not? What a lot of good this absence from Paris has done me in any case, my dear friend. I made the most of it. I have made certain good resolutions which (you will laugh) I honestly feel capable of carrying out. The exhibition at the Academy will have to do without me and I shall mind more than it will. Millais does not understand my little Anglo-American excursion. Anyhow we shall get along all right in spite of that. How much I shall have to tell you about art. If I could have another 20 years' time to work I should do things that would endure. Am I to finish like that after racking my brains like one possessed and after having come so close to so many methods of seeing and acting well? No. Remember the art of the Le Nain and all Medieval France. Our race will have something simple and bold to offer. The naturalist movement will draw in a manner worthy of the great schools and then its strength will be recognized. This English art that appeals so much to us often seems to be exploiting some trick. We can do better than they and be just as strong.

I really have a lot of stuff in my head; if only there were insurance companies for that as there are for so many things here, there's a bale I should insure at once. This youthful head-piece of mine is really my greatest asset.

I am very much afraid that Deschamps did not succeed in selling any of my pictures. For the sake of my relationship with Durand-Ruel it is high time that something positive appeared on the debit side of the free-realist stock. From Hirsch I heard that Fantin's picture *Les Parnassiens* was sold in London. All the better, he has skill and talent, has Fantin, but too little taste, too little variety, too few ideas. You keep on insisting that over there the place is prepared for a certain number of us. I do believe you, but in my opinion one should go over there oneself to sweep the said place a little and clean it by hand.

What lovely things I could have done, and done rapidly if the bright daylight were less unbearable for me. To go to Louisiana to open one's eyes, I cannot do that. And yet I kept them sufficiently half open to see my fill. The women are pretty and unusually graceful. The black world, I have not the time to explore it; there are some real treasures as regards drawing and colour in these forests of ebony. I shall be very surprised to live among white people only in Paris. And then I love silhouettes so much and these silhouettes walk.

Goodbye, see you soon. The moment I get to Paris I shall write. I intend to take a French boat which docks at Brest. If I take an English one I disembark at Liverpool, in which case I shall see you in London.

That fellow Whistler really has something in the sea and water pieces he showed me. But, bless me, there are quite different things to be done!

I advise you to paint motifs of varied nature and intensity.

I think we are too fond of the *demi-plein mince*.

I often lecture myself about this and am passing it on to you.

Ever your DEGAS

Regards to Millais whom I do not know. Love to Legros, Whistler and to Deschamps if you see him.

Ah! but I nearly forgot something. Go at once to Deschamps. If he still has the *Danseuses* and if Durand-Ruel gives his permission and if there is still time get him to send them to the Paris exhibition, before the 20 March. It is the only picture I could exhibit.

From the *Paris-Journal*, 12 April 1870

TO THE JURY OF THE 1870 SALON Come now, gentlemen of the Jury, don't be discouraged.
There is more to come.

So you are now in charge of the organization of an Exhibition. I hear you are very confused.
Thank Heaven! The administration was even more so for a long time. It worked though.

Something which any exhibitor has an unquestionable right to, and which has never been
mentioned in written plans or secret meetings: it is a place to his liking.

He already has it in industry. A shoemaker, however little space he is given, exhibits as he
wishes. A painter does not. Space, it is not that we lack. One is able to arrange this Palais, made
of iron and thin partition walls, just like a theatre. Money, we don't need a lot of it for such a
simple entertainment, the entrance fees are there. But your time, your attention, and a little of
your duty, gentlemen, that is what is required.

Cochin the engraver, often was, in the last century, the exhibitions' *tapissier*. Diderot used to
give him that title, which has been totally lost since. Take it up again.

It seems to me that the organization of the Salon requires a few changes. You could effect
these, in all good faith.

One or two among you, once the decisions are taken, would be in charge of supervision.
Some festival organizers, Belloir and Godillot for instance, would perhaps be honoured to be
selected as contractors and involved with the administration of Fine Arts. I am going to put it
all to you, gentlemen, quite simply.

1 To have no more than 2 rows of pictures and to leave between them a space of at least 20 or
 30 centimetres, without which they detract from each other.

2 Set aside some drawing galleries to accommodate those pictures that this first measure
 eliminates.

3 Set up large and small screens like the English had at the Exposition Universelle, to
 accommodate the homeless drawings in the two large rooms called 'dumps', or elsewhere.
 You can see the advantages of this very simple method. The drawings are taken out of their
 desert and mixed with the paintings, which they deserve.

 Indeed, I believe we could accommodate a number of paintings on these screens if we
 pushed away the benches and set these up in the ordinary rooms. Leighton, who enjoys in
 England at least as good a reputation as Cabanel does at home, had a painting displayed on
 a screen, and it did not look at all like a slight.

4 Any exhibitor will have the right to withdraw his work after a few days; for he must not in
 any way be obliged to leave on view something that he might be ashamed of, or that could
 be harmful to him. And then, he is not part of a trophy. Symmetry has no place in an
 exhibition. After one has been removed, the remaining pictures will just have to be brought
 closer together again. I believe those few days are a reasonable period, and that after that
 time nothing should be removed.

5 With only 2 rows of pictures, the following is bound to happen: the exhibitor will indicate
 on his form on which of the two rows he wants to appear. The '*Cimaise*', the detestable line,
 this bone of contention will no longer be a favour, the luck of the draw. We will choose it
 for this picture, we will do very well without it for that one. One painting is better seen
 high up, another one better low down.

 As we know, the pictures which require to be hung on the line are, on average, about

one metre high, even less, frame included. When asking for the second row, one will simply be asking to be hung at 2 or 2½ m above the ground.

6 Large marble sculptures, which are heavy and awkward to handle, may stay below; but we beg you to arrange them without symmetry. As for the medallions, busts, small groups etc., they should be displayed higher up, on brackets or screens. If the usual space is not sufficient, have other rooms opened. You will not be refused such a thing.

I could go on.

There was a rumour that you divide pictures into three categories: the first one to be hung on the line, the second one above and the third one above that still. It is only a bad joke, is it not?

Gentlemen, you must know we expect a lot from you; above all, a lot of innovations. It is not possible that we should be badly looked after by our colleagues. – The question of art has but little to do with such a vast exhibition.

The curiosity of the public, who are foolish and wise at the same time, and who above all must be left alone, is the only thing you must take care of, out of consideration for them and for us: we are their humble servants.

Finally, once your pride as judges is satisfied, just be good *tapissiers*.

Yours faithfully, DEGAS

*

Paris, 30 Sept. 1871

TO TISSOT Tissot, why the devil did you not send me a line? They tell me you are earning a lot of money. Do give me some figures.

Within the next few days I may possibly make a flying visit to London with Achille. But it is not yet certain. In the meanwhile honour me with a few details. . . .

Stevens never stops telling us that he is doing masterpieces and that this year he will easily exceed one hundred thousand francs.

I have seen something new of Manet's, of medium size, well finished, done lovingly, in a word, a change. What talent the fellow has.

I exhibited my *Orchestre de l'Opéra* in the rue Laffitte. The crowd . . . no, I shall say nothing: that would be Courbet.

I have just had and still have a spot of weakness and trouble in my eyes. It caught me at Chateau by the edge of the water in full sunlight whilst I was doing a water-colour and it made me lose nearly three weeks, being unable to read or work or go out much, trembling all the time lest I should remain like that.

Give me some idea how I too could gain some profit from England. Goodbye, answer my letter. Jacquemart has just returned and was worried about you.

And what about the marriage? . . .

Detaille wanted to buy your house. Rumour had it you wished to sell it. Is it true?

Warmest greetings, DEGAS

Remember me to Whistler, Legros. Astruc has this moment come to fetch me to see his lovely water-colours.

77, rue Blanche, *Paris*, Saturday, 1873

MY DEAR TISSOT, Here I am back again. I shall go and see you soon. We can talk more comfortably. In the meantime write to me and tell me something about my future with Agnew. Here Durand-Ruel assures me of his devotion and swears he wants everything I do.

But Agnew really intrigues me. I spoke about him casually to a few people and what they told me is absolutely fascinating. They urge me to place myself in his redoubtable hands. Did you tell him the picture I described to you from back there was coming? In a word entertain me with some juicy ideas and some veritable sums of money, for me. I feel absolutely capable of doing my best and of earning an honest living. . . .

I hear you have published an album of children. Tell me where.

I shall pay you a surprise visit very soon and spend 48 hours talking.

I did not exhibit. It is better for me to do good work and one fine day to exhibit a whole collection.

My eyes are fairly well but all the same I shall remain in the ranks of the infirm until I pass into the ranks of the blind. It really is bitter, is it not? Sometimes I feel a shiver of horror.

I have too much to say to be able to write.

Goodbye, write soon,

Your friend, DEGAS

STUDIES OF HEADS

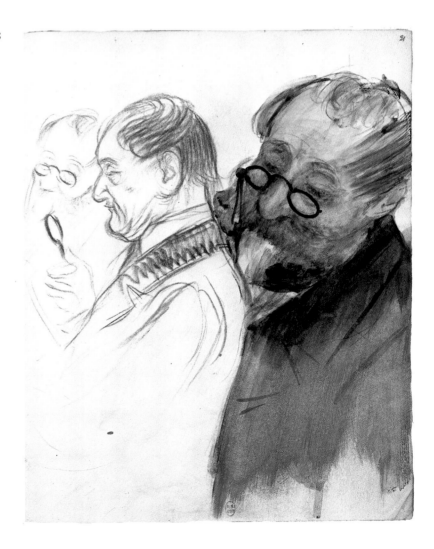

Friday, *1874*

TO TISSOT Look here, my dear Tissot, no hesitations, no escape. You
positively must exhibit at the Boulevard. It will do you good, you (for it is a means of showing
yourself in Paris from which people said you were running away) and us too. Manet seems
determined to keep aloof, he may well regret it. Yesterday I saw the arrangement of the
premises, the hangings and the effect in daylight. It is as good as anywhere. And now Henner
(elected to the second rank of the jury) wants to exhibit with us. I am getting really worked up
and am running the thing with energy and, I think, a certain success. The newspapers are
beginning to allow more than just the bare advertisement and though not yet daring to devote
a whole column to it, seem anxious to be a little more expansive.

The realist movement no longer needs to fight with the others – it already *is*, it *exists*, it must
show itself as *something distinct*, there must be a *salon of realists*.

Manet does not understand that. I definitely think he is more vain than intelligent.

So exhibit anything you like. The 6 or 7 is the deadline but unless I am very much mistaken
you will be accepted after then. So forget the money side for a moment. Exhibit. Be of your
country and with your friends . . .

My eyes are very bad. The oculist . . . has allowed me to work just a little until I send in my
pictures. I do so with much difficulty and the greatest sadness.

Ever Your, DEGAS

*

Paris, Sunday, 22 *Aug. 1875*

DEAR DESCHAMPS, You will receive the painting at the end of the week, or early
next week. It will leave on Thursday or Friday. It required a frame and this has taken some
time – sell it as you promised me, quickly and well. Make sure it is placed where it does me a
little justice. I need it, as you know.

The formidable Faure is going to reappear. I am working myself to death, through fear of
him. – I started his large painting all over again, at one go, as I should do with everything.

You will also have something of mine for your autumn exhibition, if you allow me. As you
can tell, it is time for me to make headway in England, and I am counting on you to give me a
good start. Time goes by, one is getting old, eyes are failing. Let us make haste. May Tissot
learn, however late, that I can fight for myself.

I will bring you the painting or paintings myself in one month.

Did you fish to your heart's content? I wish you and Madame Deschamps to know how much
I was moved by your welcome when I came to London. – Would you remind Macbeth and
Morris that they appeared interested in exhibiting with us this winter, and the Tademas that
they indeed promised to do so. Now about Dalou (this is between ourselves, I beg you), I trust
there will be no political impediment to his sending us something and to our exhibiting it. –
Would you also pass on my apologies to Morris, whom I had promised to visit. Sincere
apologies also to Whistler, for whom I have so much admiration.

Until we meet again,

your devoted DEGAS

1876

MY DEAR FAURE, I am going to return the *Robert le Diable* on Saturday and *Les Courses* on Tuesday. I had to earn my dog's life in order to devote a little time to you; in spite of my daily fear of your return it was essential to do some small pastels. Forgive me if you still can. And then, very bad weather for the eyes.

Sincerely yours, E. DEGAS

*

Friday, *1876*

MY DEAR FAURE, You said that at the end of this week you would finish paying for the picture even though it is unfinished. It is too early and I am not yet in need of this money.

But if you could let me have another 500 frcs by tomorrow you would give me great pleasure. I shall finish paying everything I had promised to pay by last Saturday.

You are singing tonight, I believe. Do not forget to remind Merante about the photographs he offered me yesterday. I am eager to see them and to work out what I can make of this dancer's talent.

Hoping to see you soon, E. DEGAS

*

March 1877

MY DEAR MR. FAURE, I received your letter with great sadness. I prefer writing to seeing you. Your pictures would have been finished a long time ago if I were not forced every day to do something to earn money.

You cannot imagine the burdens of all kinds which overwhelm me.

Tomorrow is the 15th. I am going to make a small payment and shall have a short respite until the end of the month.

I shall devote this fortnight almost entirely to you. Please be good enough to wait until then.

Sincerely yours, DEGAS

*

50, rue Lepic, Wednesday, 31 Oct. *1877*

MY DEAR FAURE, You will have *Les Courses* on Monday. I have been at it for two days and it is going better than I thought. What is the use of dragging out the chapter of reasons which made me so behindhand? That would do you no good at all.

Sincerely yours, DEGAS

The *Blanchisseuses* will follow immediately.

Notes for the painting *Robert le Diable*, 1872

Shadow carried from the score on to the rounded back of the rostrum – dark grey background – bowstring brightly lit by the lamps, head of Georges in silhouette, light red shadows – flesh tones.

In the receding arches the moonlight barely licks the columns – on the ground the effect pinker and warmer than I made it – black vault, the beams indistinct . . .

The tops of the footlights are reflected by the lamps – trees much greyer, mist around the receding arcades – the last nuns more in flannel colour but more indistinct – in the foreground, the arcades are greyer and merge into one another . . .

The receding vault is black, apart from a little reflection in the centre . . .

The theatre boxes a mass of dark lacquered brick red – in the director's box, light red pink face, striking shirts, vivid black.

Near the lamp a dancer from behind on her knees, light falls only on her skirt. The back and the rest in quite deep shadow – striking effect.

NOTEBOOK 24

THE BALLET SCENE FROM ROBERT LE DIABLE

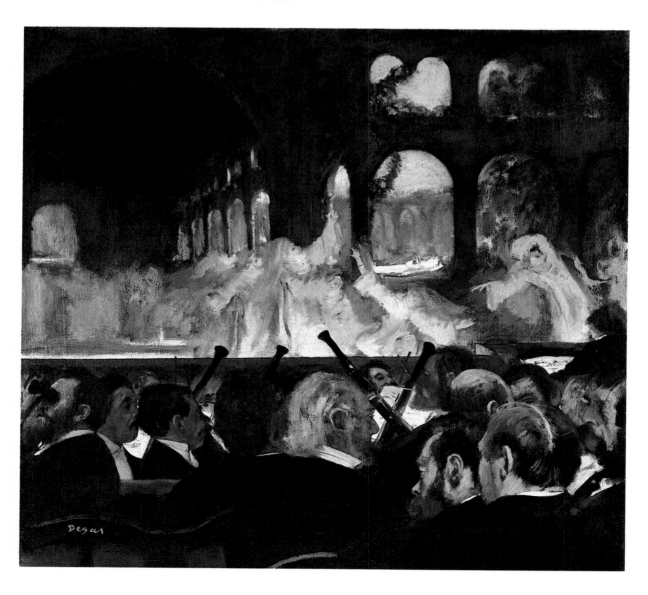

We go on stage, he walks across the hall, followed by his staff: he takes a place in the middle with the jury. The whole hall in darkness, large green-grey cloths covering the boxes and the stalls. Six big gas lights on stands with large reflectors in the orchestra pit. It begins. The little boys in their little black or blue jackets, short trousers, white socks. Looking like urchins. Fr. Mérante standing on the left playing the violin. First group of little girls. Mme Théodore on the right with a violin playing quite out of tune. Second group, I recognize Guerra with Mme Théodore. Third, Mme Théodore standing on the right. It is the age when dancing is pretty, it is naïve, primitive, firm. The jury claps frequently. Fourth group. In a *pas de trois*, a dancer falls and remains on the ground, cries, she is surrounded, carried away by her arms and legs, sadness. Mérante, then Vaucorbeil, then Meyer, then, etc. climb on the stage by a little staircase by the corner of the orchestra pit. It seems like just a sprain. Mérante announces it. Everyone recovers. The exam is very successful, people clap often. Curious silhouettes around me, in front of me. Fifth group, Mme Mérante on the left, behind her a violinist and a viola player sitting, music stand behind which, since the beginning, Pluque has been sheltering from the footlights. A bow, it is over. People come back on the stage, everybody, parents, teachers, jury, etc. . . . excited dancers. The classes are set up. Thanks addressed to Vaucorbeil. We return. Mérante on familiar terms.

DANCERS ON STAGE

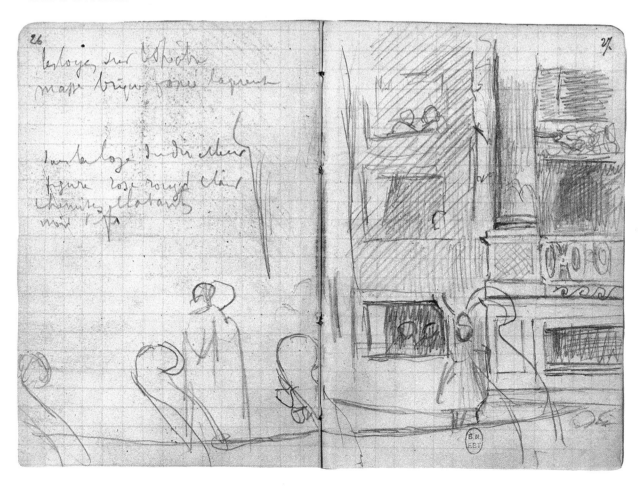

The ballet

A DANCER ADJUSTING HER STOCKING

19 bis, rue Fontaine St-Georges, Tuesday morning, *undated*

MY DEAR HECHT, Have you the *power* to get the Opera to give me a pass for the day of the *dance examination*, which, so I have been told, is to be on Thursday?

I have done so many of these dance examinations without having seen them that I am a little ashamed of it.

Warmest greetings, DEGAS

*

Undated

MY DEAR HECHT, I am still convinced that I put my address without my name. You were very kind to look everywhere for me. But what ceremony!

I thought I could slide into the Opera amongst the others with a slip of paper and you want to lead me in person to the feet of M. Vaucorbeil. Till Tuesday then, with many thanks.

E. DEGAS

*

Friday, *undated*

DEAR MONSIEUR HEYMANN, Let me go once more with the Italian and French dancers for lunch on Sunday at Boldinis. But for Sunday week let us swear on our lives, both of us, that we shall have neither dancers nor funerals nor anything whatever on that final day.

A thousand apologies, DEGAS

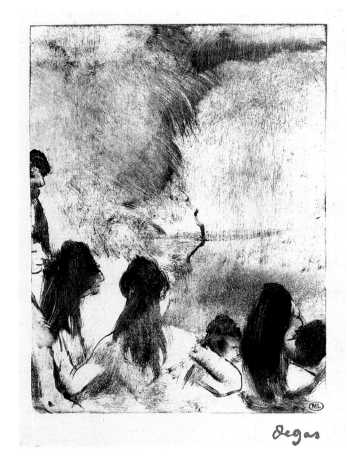

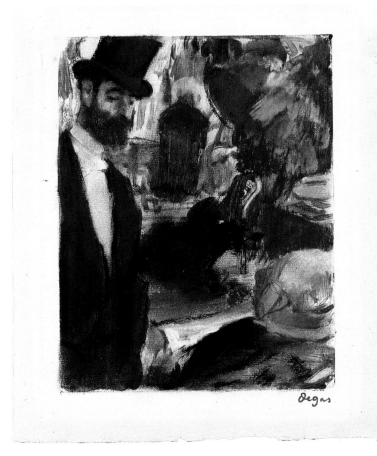

FIVE DANCERS

LUDOVIC HALÉVY AND MME CARDINAL

DEAR MONSIEUR BLANCHE, I shall enquire at the Opera if they have a seat free for the
three days. I shall take Monday as I always have done and you will make arrangements with a
friend for the other two days, like you told me. The seat will be in my name and I shall have
the right to go behind the scenes. – This is a first suggestion which I consider much too
agreeable for me and not enough so for you. Going behind the scenes attracts you and I am
preventing it. But perhaps you are the kind of man either to console yourself, or as art critic to
have permission in any case or simply as a spoilt child to demand it as a right . . .

Sincerest regards, DEGAS

*

Nov. 1883

MY DEAR HALÉVY, You must know what a dancer is like who wants you to put
in a word for her. She comes back twice a day to know if one has called, if one has written.
 Are you better? If you have the courage or the strength write a line to Vaucorbeil, to
Mérante, not about her engagements, which would be silly, but about her dancing and her past
and her future . . .

Greetings, DEGAS

Printmaking, 1879–1882

MY DEAR BRACQUEMOND, Mr. Ernest May is returning to the attack for your old drawing for which you asked 2000 francs. He has just offered 1500. What do you think about it? Let me know. I shall see him in a day or two. He is getting married, is going to take a town house and arrange his little collection as a gallery. He is a Jew, he has organized a sale for the benefit of the wife of Monchot, who went mad. You see, he is a man who is throwing himself into the arts. I advise you to accept.

Pissarro has just sent, via the Pontoise carrier, some attempts at soft ground etchings. – How annoying it is that you are so far away . . . when shall we see each other again?

Tell Haviland who was infatuated with a little picture of Mlle Cassatt and who wished to know the price, that it is a simple matter of 300 frcs, that he should write to me if that does not suit him and to Mlle Cassat, 6, boulevard de Clichy if it does.

Pissarro is delightful in his enthusiasm and faith.

Sincerely yours, DEGAS

*

1879–1880

TO BRACQUEMOND How I need to see you, Bracquemond, and how badly I let you down!

1st. Let me know if my friend Rossana could work in your Haviland house; he is a man of much talent, landscapist and animal painter, very sensitive, should be able to do flowers delightfully, grasses etc. I was supposed to have written to you about him a long time ago.

2nd. We must discuss the journal. Pissarro and I together made various attempts of which one by Pissarro is a success. At the moment Mlle Cassatt is full of it. Impossible for me, with my living to earn, to devote myself entirely to it as yet. So let us arrange to spend a whole day together, either here or at your house. – Have you a press at your place? Your wife is still preparing her exhibition, is she not?

See you soon, DEGAS

*

1880

MY DEAR PISSARRO, I compliment you on your enthusiasm; I hurried to Mademoiselle Cassatt with your parcel. She congratulates you as I do in this matter.

Here are the proofs: The prevailing blackish or rather greyish shade comes from the zinc which is greasy in itself and retains the printer's black. The plate is not smooth enough. I feel sure that you have not the same facilities at Pontoise as at the rue de la Huchette. In spite of that you must have something a bit more polished.

In any case you can see what possibilities there are in the method. It is necessary for you to practise dusting the particles in order, for instance, to obtain a sky of a uniform grey, smooth and fine. That is very difficult, if one is to believe Maître Bracquemond. It is, perhaps, fairly easy if one wants only to do engravings after original art.

This is the method. Take a very smooth plate (it is essential, you understand). Degrease it

MARY CASSATT AT THE LOUVRE:
THE PAINTINGS GALLERY

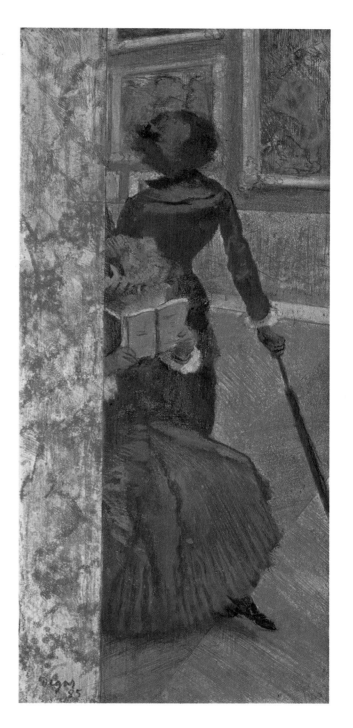

thoroughly with whitening. Previously you will have prepared a solution of resin in very concentrated alcohol. This liquid, poured after the manner of photographers when they pour collodion on to their glass plates (take care, as they do, to drain the plate well by inclining it) this liquid then evaporates and leaves the plate covered with a coating, more or less thick, of small particles of resin. In allowing it to bite you obtain a network of lines, deeper or less deep, according as to whether you allowed it to bite more or less. To obtain equal hues this is necessary; to get less regular effects you can obtain them with a stump or with your finger or any other pressure on the paper which covers the soft ground.

Your soft ground seems to me to be a little too greasy. You have added a little too much grease or tallow.

What did you blacken your ground with to get that bistre tone behind the drawing? It is very pretty.

Try something a little larger with a better plate.

With regard to the colour I shall have your next lot printed with a coloured ink. I have also other ideas for coloured plates.

So do also try something a little more finished. It would be delightful to see the outlines of the cabbages very well defined. Remember that you must make your début with one or two very, very beautiful plates of your own work.

I am also going to get down to it in a day or two.

Caillebotte, so I am told, is doing the *Refuges of the Boulevard Haussmann* seen from his window.

Could you find someone at Pontoise who could cut on very light copper some things traced by you? That kind of pattern could be applied on a line proof – touched up a little for effect – of etchings or soft ground etchings and then the exposed parts printed with porous wood coated with water colours. That would enable one to try some attractive experiments with original prints and curious colours. Work a little on that if you can. – I shall soon send you some of my own attempts along these lines. – It would be economical and new. And would I think be suitable enough for a beginning.

No need to compliment you on the quality of the art of your vegetable gardens.

Only as soon as you feel a little more accustomed try on a larger scale with more finished things.

Be of good cheer, DEGAS

*

1882

TO ALEXIS ROUART My dear friend, it was only yesterday that I had this little attempt with carbon crayon printed. You see what a pretty grey it is. One should have emery pencils. Do give me an idea how to make them myself. I could not talk about it with your brother on Friday. Thank you for the stone you gave me. It scratches copper in a most delightful manner. Is it a conglomerate like Denis Poulot makes? With the magnifying glass I read Delanoue the Elder.

On what could I use it as an etching point?

No time to do any really serious experiments. Always articles to fabricate. The last is a monochrome fan for Mr. Beugniet. I think only of engraving and do none.

Greetings, DEGAS

Monday, 1882

MY DEAR ROUART, You did well to write to me, I was going to go and dine with you tomorrow. A thousand good wishes for the travellers to Allevard. I should much like to see you about a matter of lithographs, which preoccupies me very much. Gosselin sent his son to tell me that he had 93 Gavarni proofs before letters (those of Lessore). I have seen them, the majority are very fine, and I told Gosselin that I could not make up my mind before you had seen them. And then I only want to take them gradually. He asks 550 francs for the lot, and I cannot spend such a sum all in one. Try and look at them. Examine them well, to see if they really are all proofs before letters, if there are not any with concealed letters, etc.

It is an excellent bargain, which will send my collection soaring up. You for your part, have you found anything?

Regards, DEGAS

*

Undated

MY DEAR FRIEND, I am not coming to dinner tomorrow. Halévy is starting his Tuesdays again and he made the whole band promise to be there for the re-opening. . . .

Wednesday morning I left everything to look by day-light, with a magnifying glass, and for a long time at the magnificent Gavarnis that you gave me.

I am keeping a special box for pieces of this class and I put beside each one an ordinary print which doubles my delight in the extraordinary one.

Do you understand, eh?

DEGAS

*

Tuesday

MY DEAR ROUART, It is six o'clock. I am too worn out with my cold and my aches and pains to go and dine with you, as I wanted to do. So I am remaining in the warmth and climbing up to my room to eat some soup, look at my lithographs and go to bed, thinking of them and of you.

Greetings, DEGAS

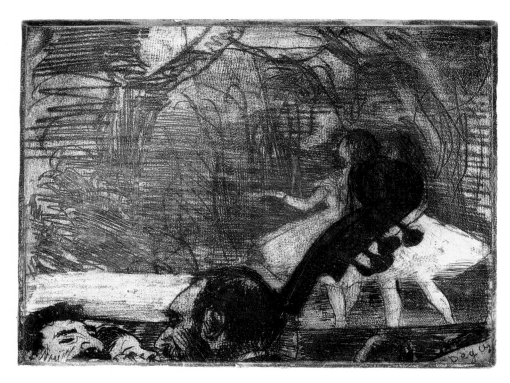

ON STAGE

For the *Journal*; a severely truncated dancer – do some arms or legs, or some backs – draw the shoes, the hands of a hairdresser, the built-up hairstyle, bare feet in the act of dancing etc. etc.

Draw all kinds of everyday objects placed, accompanied in such a way that they have in them the *life* of the man or woman – corsets that have just been removed, for example, and which retain the form of the body etc. etc.

Series on instruments and instrumentalists, their forms, the twisting of the hands and arms and neck of a violinist; for example, swelling out and hollowing of the cheeks of the bassoonists, oboeists, etc.

Do a series in aquatint on *mourning*, different blacks – black veils of deep mourning floating on the face – black gloves – mourning carriages, Undertakers' vehicles – carriages like Venetian gondolas.

On smoke – smokers' smoke, pipes, cigarettes, cigars – smoke from locomotives, from tall factory chimneys, from steam boats etc. Smoke compressed under bridges – steam.

On evening – infinite variety of subjects in cafés – different tones of the glass globes reflected in the mirrors.

On bakery, *Bread* – Series on bakers' boys, seen in the cellar itself, or through the basement windows from the street – backs the colour of pink flour – beautiful curves of dough – still lifes of different breads, large, oval, long, round, etc. Studies in colour of the yellows, pinks, greys, whites of bread.

Perspectives of rows of bread, delightful arrangements of bakeries – cakes – the corn – the mills – the flour, the bags, the strong men of the market. . . .

Neither monuments nor houses have ever been done from below, close up as they appear when you walk down the street. . . .

Still-life – cook cleaning her copper utensils – a pink range of utensils reflected in one another, reflecting everything, linen, windows, arms, apron, etc . . .

STUDY OF A ROOF,
FOR MISS LALA AT
THE CIRQUE FERNANDO

ROOFTOPS

2 panels on birth – delicate mother, fashionable – food – large wet-nurse – large behind – enormous ribbons, large behind. Lilac coloured dress fluted like a pillar. . . .

There is a kind of shame in being known especially by people who don't understand you. A great reputation is therefore a kind of shame. It is a very good thing to aim for the middle way, but certainly better than being like the Institute, at both extremes of something. One will enjoy oneself, as knowingly as possible.

Recipes. Oil the plate a little and sprinkle with powered copal, that forms a particular grain. Warm sufficiently.

Once a grain has taken, soap the plate well and wash well afterwards. You can paint on acid without it running so much. Apparently by leaving some Spanish white in the holes you can bring out the varnish and even re-bite the grains again.

After having done portraits seen from above, I will do some seen from below – sitting very close to a woman and looking up at her. I will see her head in the chandelier, surrounded by crystals – and perform simple operations such as drawing a profile which wouldn't move, moving myself, going up or down, the same for a whole figure, a piece of furniture, an entire lounge.

Draw a series of arm movements of the dance, or of legs which wouldn't move, turning around them oneself – etc. Finally study from all perspectives a face or an object, anything.

For this one can use a mirror – one wouldn't have to move from one's place. Only the position would lower or incline, one would turn around it.

Workshop plans; set up tiers all round the room to get used to drawing things from above and below. Only paint things seen in a mirror so as to become used to a hatred of *trompe-l'œil*.

For a portrait, pose the model on the ground floor and work on the first floor to get used to retaining forms and expressions and to never drawing or painting *immediately*.

NOTEBOOKS 30 AND 34

19 bis, rue Fontaine St Georges, Monday, *c. 1878*

DEAR MME DIETZ-MONNIN, Would you like me to come on Wednesday at 1.30? I am writing at the same time to M. Groult. Let me know if this suits you. – I think the umbrella is rather unnecessary. But M. Groult, if he found something, might change my mind.

The boa, on the contrary, is very good and so are the long, wide and gathered suede gloves.

I am therefore, Madame, entirely at your service and very much looking forward to this sitting.

All my best wishes, DEGAS

*

Undated

To MME DIETZ-MONNIN, Let us leave the portrait alone, I beg of you. I was so surprised by your letter suggesting that I reduce it to a boa and a hat that I shall not answer you. I thought that Auguste or M. Groult to whom I had already spoken about your last idea and my own disinclination to follow it, would have informed you about the matter.

Must I tell you that I regret having started something in my own manner only to find myself transforming it completely into yours? That would not be too polite and yet . . .

But, dear Madame, I cannot go into this more fully without showing you only too clearly that I am very much hurt.

Outside of my unfortunate art please accept all my regards.

*

Monday, *undated*

To MME BARTHOLOMÉ (NÉE DE FLEURY) Be good enough to grant me yet another little leave of absence for Wednesday. Something surprising has happened. A painter Henri Lerolle, whom I know to be quite well off, has just invited me to dinner. The right he has is still recent, but fairly weighty. In agreement with his wife, who is said to manage him, he has just, at a moment like this, bought a little picture of mine of horses, belonging to Durand-Ruel. And he writes admiringly of it to me (style Saint-Simon), wishes to entertain me with his friends and although most of the legs of the horses in his fine picture (mine) are rather badly placed, yet, in my modesty, I should very much enjoy a little esteem at dinner. Just this once, dear Madame, permit me to become intoxicated with the perfume of glory, from the other side of the water, behind the Invalides, avenue Duquesne. If nothing happens to intoxicate me, not even the wine, why should I not go and present myself to you for a moment, about 10.30, with an air of success.

Your friend, DEGAS

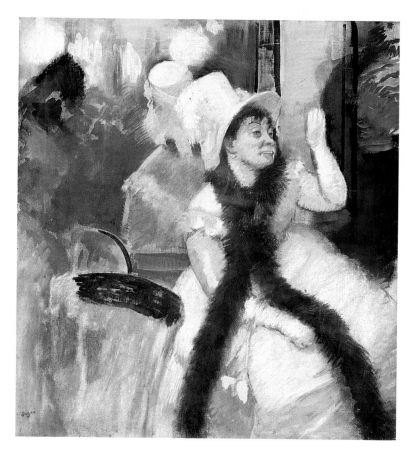

Paris, Tuesday, 26 Oct.

TO HENRI ROUART

Thank you for your pencilled letter, my dear Rouart. The sirocco, it appears, dries up the ink as it does oil colours and the vitality of the painters. Ah! how I regret not having been able to go down there with you to see these dear friends. And then, to tell you at once, it is comparatively rare, I am in the mood to love grand nature a little. You would have had as companion a changed being and one strong enough to vibrate like anyone else. The result might have been some fine drawings or pastels done by a frenzied Grevin beside himself. And the sublime would doubtless have been just as good for me as for any sage.

We can hardly see at all here. The afternoons in particular it is night. I should like to finish Ephrussi's picture and even though the canvas and the drawings are up to date it is scarcely progressing at all. And yet there is some good money at the end of it, which is eagerly awaited.

Bring me back some fine outline drawings as you can do them. Did you take pastel with you? Water-colour is thin . . . and yet Delacroix!

At Burty's there is a tiger by him in pastel which under glass looks like a water colour. It is pastel put on very lightly on a slightly glossed paper. It is very vibrant, it is a lovely method.

I am going to write to Cherfils, I neglect him too much. And yet one does not often meet such affectionate and intelligent beings as he is.

The Cassatts have returned from Marly. Mlle Cassatt is settling in a ground floor studio which does not seem too healthy to me. What she did in the country looks very well in the studio light. It is much stronger and nobler than what she had last year. I shall be seeing you soon, with your articles before us in the rue Lisbonne we can talk more freely. I am writing for fear of your malediction.

I am just off to the Boulevard Voltaire to dine with your brother. Mud, mud, mud, umbrellas. In the evening hours it is nevertheless very beautiful!

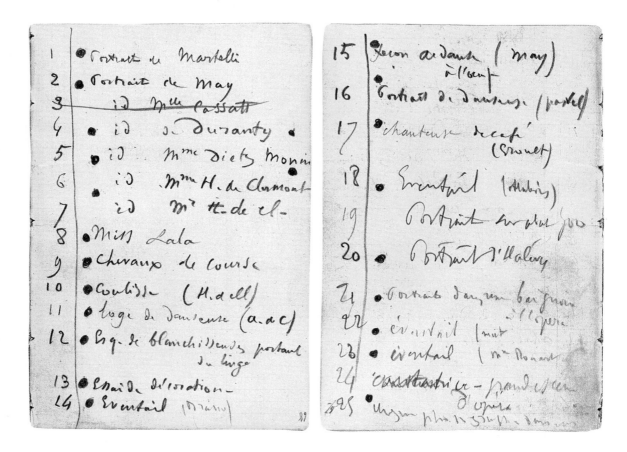

LIST OF PICTURES BY DEGAS FOR THE FOURTH IMPRESSIONIST EXHIBITION

Wednesday, 15h. *1879*

MY DEAR BRACQUEMOND, Why did you write to me at such short notice? I arrived as you were leaving, I found your letter at the same time as your card. Why did you not return? You should have realized that however much I did my drawings in town I should be working at the studio even if only for two or three hours a day. And then I lunch every day (with only rare exceptions) at the café de la Rochefoucauld in front of the little market, at the corner of the rue Notre-Dame de Lorette and of the rue Rochefoucauld. That beast of a concierge should really have told you; so it is understood I am there between 12.30 and 1 o'clock.

It is essential to have a talk, there is nothing to equal that. In the meantime for Mme Bracquemond nothing could be easier. All the cartoons will be placed and well placed. No need for her to worry about that. . . .

There is one room with fans, do you hear Mme Bracquemond, up to now, Pissarro, Mlle Morisot and I are depositing things there.

You and your wife should contribute too.

Etc. Etc. Etc.

Hope to see you soon, DEGAS

The Company Jablockof proposes to do the lighting with electric light. Etc. Etc.

50, rue Lepic, Wednesday, *1879*

MY DEAR BRACQUEMOND, I shall go and see you one of these days when I have finished two articles which are in the process of making and firing. – In the meantime, I should have done better to go and see you a little while ago than to write to you, I am going to ask you if you could employ in the Haviland house a decent man who has been well recommended to me. But he is also a man who from his childhood has been associated with pottery. Would you like me to send him to you? You must not tell him that I delayed at least a week before mentioning him to you.

I have a great need and a great desire to go and talk to you about the exhibition. The large composition is superb. What a charming arrangement of types and materials. – I assure both Mme Bracquemond and yourself that I was fascinated by it. – It is essential to talk about it to say all that one thinks of it.

Sincerely yours, DEGAS

*

1880

MY DEAR BRACQUEMOND, It is opening on April 1st. The posters will be up tomorrow or Monday. They are in bright red letters on a green ground. There was a big fight with Caillebotte as to whether or not to put the names. I had to give in and let him put them up. . . . Mlle Cassatt and Mme Morisot did not insist on being on the posters. It was done the same way as last year and Mme Bracquemond's name will not appear – it is idiotic. All the good reasons and the good taste in the world can achieve nothing against the inertia of the others and the obstinacy of Caillebotte.

In view of the frenzied advertisement made by de Nittis and Monet (in the *Vie Moderne*) our exhibition promises to be quite inglorious. Next year I promise you, I shall take steps to see that this does not continue. I am miserable about it, humiliated.

Start bringing your things. There will probably be two panel screens, one in the centre of the room with the four windows and the other in the entrance room. You will be able to arrange your entire stock of engravings on them.

See you soon, DEGAS

If you insist and Mme Bracquemond insists too her name can be put on the second thousand posters during the exhibition. Answer.

<div align="right">Paris, 5 Aug. 1882</div>

TO BARTHOLOMÉ I have surprised you my dear friend. It is true I am down and up again very quickly.... Eight days at Etretat, it was a long time for me. Halévy is good but mournful, I can neither play piquet nor billiards nor do I know how to be sociable nor how to work after nature nor simply how to be agreeable in society. I think I weighed a bit heavily on them and that they had thought I was more resourceful....

When are you coming back? For I am alone here. Paris is charming and is not work the only possession one can always have at will?...

<div align="center">*</div>

<div align="right">Undated</div>

TO M. AND MME BARTHOLOMÉ Monsieur Degas, much touched, presents his compliments for the New Year to Monsieur and Madame Bartholomé. He also finds himself forced to admit that he has no visiting cards and that when he does not find people at home he writes his name on the margin of the concierges' newspapers; he is given an envelope. The delicacy and finesse of friendship in others gives him infinite pleasure. May the others continue!

<div align="center">*</div>

<div align="right">2 May 1882</div>

TO HENRI ROUART Lafond sends me a few words. He is going to come here to see his charcoal drawing at the salon only to return immediately to his lyceum at Pau. The fine weather is coming to us and doubtless to you too? Sunday great exhibition opening. An astonishing Whistler, excessively subtle but of a quality! Chavannes, noble, a bit of a rehash, has the bad taste to show himself perfectly dressed and proud, in a large portrait of himself, done by Bonnat, with a fat dedication on the sand where he and a massive table, with a glass of water are posing (style Goncourt). Manet, stupid and fine, knows a trick or two without impression, deceptive Spanish, painter . . . in a word you will see. Poor Bartholomé is ruffled and is asking naïvely to have his two things back.

<div align="center">*</div>

<div align="right">Wednesday, Spring 1883</div>

TO BARTHOLOMÉ Change of air, that must do you good even in this filthy weather! That must cure you of not being warmed all day by a stove, warmed also by painting. I really must force myself, now that the days are growing longer, only to remain half the day, either morning or afternoon, in my studio, and to go for walks. *Ambulare*, here is a new motto, *postea laborare*.

Manet is done for. That doctor Hureau de Villeneuve is said to have poisoned him with too much diseased rye seed. Some papers, they say, have already taken care to announce his approaching end to him. His family will I hope have read them before he did. He is not in the least aware of his dangerous condition and he has a gangrenous foot.

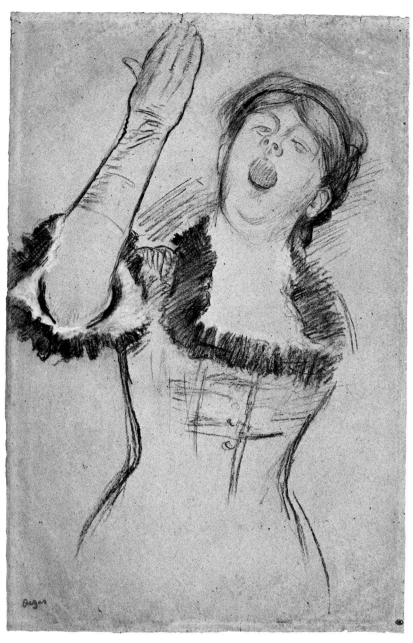

CAFÉ-CONCERT SINGER

4 Dec. 1883

To Henri Lerolle My dear Lerolle, go at once to hear Thérésa at the Alcazar, rue du Faubourg-Poissonnière.

It is near the conservatoire and it is better. It has already been said, a long time ago – I do not know what man of taste said it – that she should be put on to Gluck. At the moment you are all absorbed in Gluck. It is the right moment to go and hear this admirable artist.

She opens her large mouth and there emerges the most roughly, the most delicately, the most spiritually tender voice imaginable. And the soul, and the good taste, where could one find better? It is admirable.

Greetings, Degas

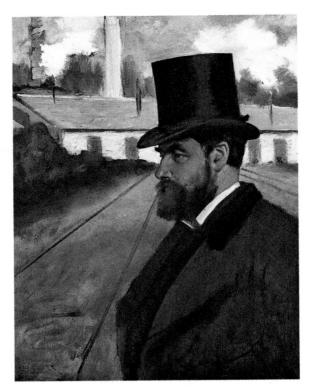

HENRI ROUART IN FRONT OF HIS FACTORY

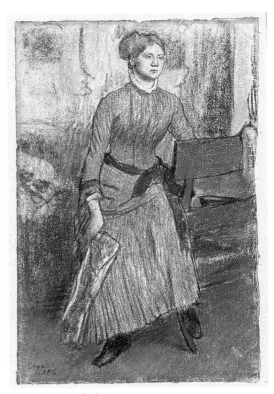

STUDY OF HÉLÈNE ROUART

Château de Ménil Hubert, Gacé (Orne), 22 Aug. *1884*

TO HENRI ROUART My dear friend, the other day Mme Rouart's letter was brought to me in the cab which was taking me to Normandy, your concierge will have confirmed this . . .

And now the weather is magnificent, weather *for you* (at heart I am not really wicked), but I have no real confidence in the aneroid barometer which says that it is to continue. One should believe in nothing but rain, in France. Here we are in a hollow. Large park, very high dense trees and water which rises everywhere from under your feet. There are some pastures where it is like walking on sponges. Why do the animals that feed and do their business in these damp pasturing grounds not get rheumatism and why do they not pass it on to us who eat them?

I am trying a little to work. The first days I felt stifled and dazed by the amount of air. I am recovering, I am trying to eat little. Well, however do you manage to arrive in a country, quite unprepared and work the next day at 6 o'clock in the morning, the same day if you travel at night? You love nature more than I do, you will reply. Meanwhile it is I, not you, who is face to face with nature. And in spite of all I am a little beside myself. I am attempting work which would take 10 years to finish and I leave it after 10 minutes without regrets, said Rousseau in the île de St-Pierre.

Well it is a long time since we saw each other, my dear friend. My absence has been excessive, it will soon be over.

I can feel that your wife is angry with me, that I have not behaved well to you, that I arranged my departure badly to coincide with your arrival. It is true. I shall do better another time.

As I shall still be facing nature for another short week and as I did not reply to your good letter from Mans, I am counting on a word from you, who are never angry with me. Your daughter, who already had such a pretty complexion before, must be quite dazzling now, she should come out.

A thousand greetings, DEGAS

Ménil Hubert, Monday, *15 Sept. 1884*

TO BARTHOLOMÉ . . . If you wish me to tell you why I am still here I shall do so –
'So you are doing nothing of Hortense?' said her mother to me. 'Then who do you imagine will
do anything?' And so as to occupy myself I set to work on a large bust with arms, out of clay
mixed with small pebbles. The family follows my work with more curiosity than emotion. In a
word one only amuses oneself with things one cannot do if one is as ill-balanced as I am. And
except for my legs which are boring into my body and my arms which by dint of stretching are
tiring my stomach, things are not too bad. I shall certainly be back in Paris by the end of this
week, and after a few weeks spent in earning my bread it will be necessary to return to
Normandy with a moulder to supervise the casting and assure the durability of the work . . .

*

Château de Ménil Hubert, près Gacé (Orne), Summer 1884, Wednesday

TO DURAND-RUEL My maid will go and fetch a little money from you. She sent
me this morning a threat of seizure from the Revenue. I had paid more than half. It appears
that the state wants the remainder immediately. – Fifty francs will suffice. But if you could give
her a hundred she could keep something for herself. I left her with very little and I am
prolonging my stay here a little where it is so beautiful. Ah well! I shall stuff you with my
products this winter and you for your part will stuff me with money.
 It is much too irritating and humiliating to run after every five franc piece as I do.

Warmest greetings, DEGAS

*

Dieppe, Saturday, Oct. 1884

DEAR MONSIEUR DURAND-RUEL, I received your mandate safely. If you could send me another
for 50 francs I should be provided for. I reckon to be back on Wednesday during the evening.
Enough of idling.
 You are quite right. What lovely country. Every day we go for walks in the surroundings,
which will finish up by turning me into a landscapist. But my unfortunate eyes would reject
such a transformation.
 I sympathize deeply with you in your Paris prison. And yet you will see with what serenity
I shall return.

Kind regards, DEGAS

*

Monday morning, *undated*

TO HENRI ROUART My dear friend, I know quite well that you are returning
soon and that I could easily not write to you. And then I have so little to tell you. As a matter
of fact though, one often writes to one's friends to tell them nothing and that nevertheless
implies that one was so pleased to receive something from them, to know that they are

thinking of one and to be their friend . . .

 . . . how can one listen seriously to the misfortunes of others when one considers oneself so much above them in that respect. Really it is too much, so many necessary things are lacking at the same time. In the first place my sight (health is the first of the worldly goods) is not behaving properly. Do you remember saying one day, we were speaking of someone I cannot remember whom, who was growing old, that he could *no longer connect*, a term applied in medicine to impotent brains. This word, I always remember it, my sight no longer connects, or it is so difficult that one is often tempted to give it up and to go to sleep for ever. It is also true that the weather is so variable; the moment it is dry I see better, considerably better, even though it takes some time to get accustomed to the strong light which hurts me in spite of my smoked glasses, but as soon as the dampness returns I am like today, my sight burnt from yesterday and bruised today. Will this ever end and in what way?

<div align="center">*</div>

<div align="right">16 Oct. 1883</div>

To Henri Rouart My dear friend, this letter will reach you at Venice. So the separation that Mme Rouart wished for will be less complete than necessary.

 On Saturday we buried Alfred Niaudet. Do you remember the guitar soirée at the house, nearly a year and a half ago? I was counting up the friends present, we were 27. Now four have gone. The Mlles Cassatt were to have come, one of them is dead. That would have made it five. Let us try and stick to this earth however republican it may be. . . . Do me the favour of leaving your two friends for a moment to go, when it is dry, to the Palazzo Labia to see, partly for yourself and partly for me, the frescoes of Tiepolo. Forain, yes Forain, gave me a glimpse of them on the table at the Café La Rochefoucauld, which he terminated by comparing them to a poster by Chéret. It is his way of admiring them. Perhaps it is no worse than any other. . . .

 Had I accompanied you I should have given a prelude to the portrait of your daughter, in the heart of Venice, where her hair and her complexion were once famous. But I remained here because there are such things as rents.

<div align="center">*</div>

<div align="right">16 Aug. 1884</div>

To Bartholomé So you are going to proceed by way of confiscation, my dear friend? What will you confiscate in the horrible human heart? I do not know where my friends can sit down in it, there are no more chairs; there is the bed which cannot be confiscated and where I really sleep too much, for this morning at 7 o'clock, after having left it for a moment to go and open the window and set about writing to you before the postman left, I remained there in order to enjoy the morning more deeply. Yes, I am getting ungrateful, and I am getting so in a state of coma, which makes this illness irremediable. After having cut art in two, as you remind me, I shall cut my own beautiful head in two, and Sabine will preserve it for its shape's sake in a jar.

 Is it the country, is it the weight of my fifty years that makes me as heavy and as disgusted as I am? They think I am jolly because I smile stupidly, in a resigned way. I am reading *Don Quixote*. Ah! happy man and what a beautiful death. . . .

I am cracking coarse jests for you and I have not the taste for them. Ah! where are the times when I thought myself strong. When I was full of logic, full of plans. I am sliding – rapidly down the slope and rolling I know not where, wrapped in many bad pastels, as if they were packing paper.

Goodbye, my sincere regards all the same to your excellent wife and to you.

DEGAS

*

21 Aug. 1884

TO HENRY LEROLLE

If you reply, my dear Lerolle, you will most certainly tell me that I am a queer specimen. Why did I not write to you, before your departure, and after having received the box of sugared almonds, really I hardly know. If you were single, 50 years of age (for the last month) you would know similar moments when a door shuts inside one and not only on one's friends. One suppresses everything around one and once all alone one finally kills oneself, out of disgust. I have made too many plans, here I am blocked, impotent. And then I have lost the thread of things. I thought there would always be enough time. Whatever I was doing, whatever I was prevented from doing, in the midst of all my enemies and in spite of my infirmity of sight, I never despaired of getting down to it some day.

I stored up all my plans in a cupboard and always carried the key on me. I have lost that key. In a word I am incapable of throwing off the state of coma into which I have fallen. I shall keep busy, as people say who do nothing, and that is all.

I write you all this without real need to do so, it would have sufficed to ask your pardon very humbly for my rudeness . . .

My kind regards to your wife.

Sincerely yours, D.

*

MUSICIANS IN THE ORCHESTRA

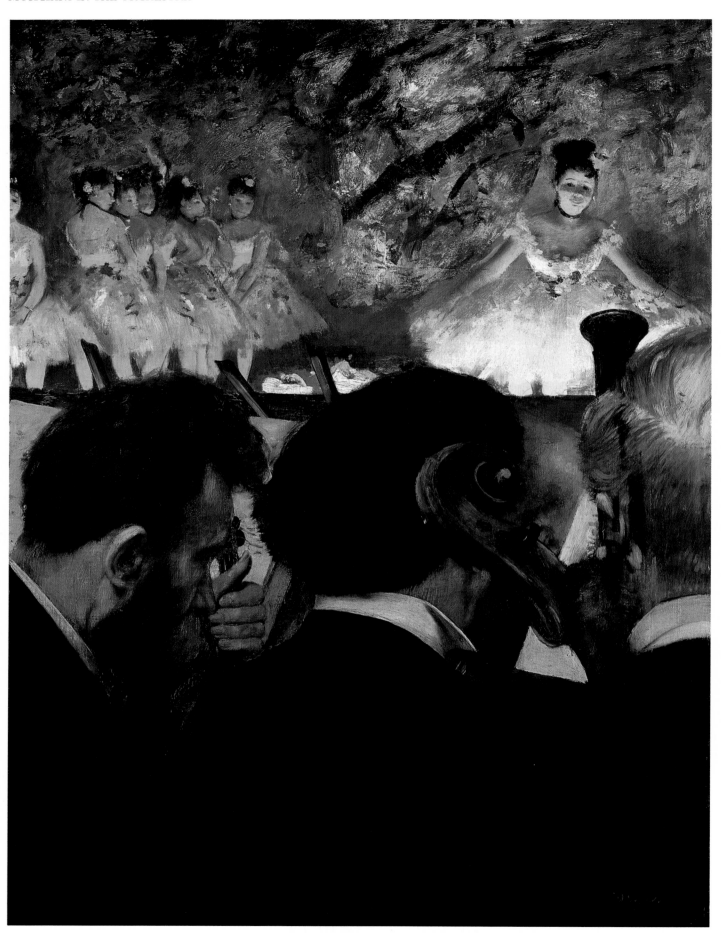

MUSICIANS IN THE ORCHESTRA: PORTRAIT OF DESIRÉ DIHAU

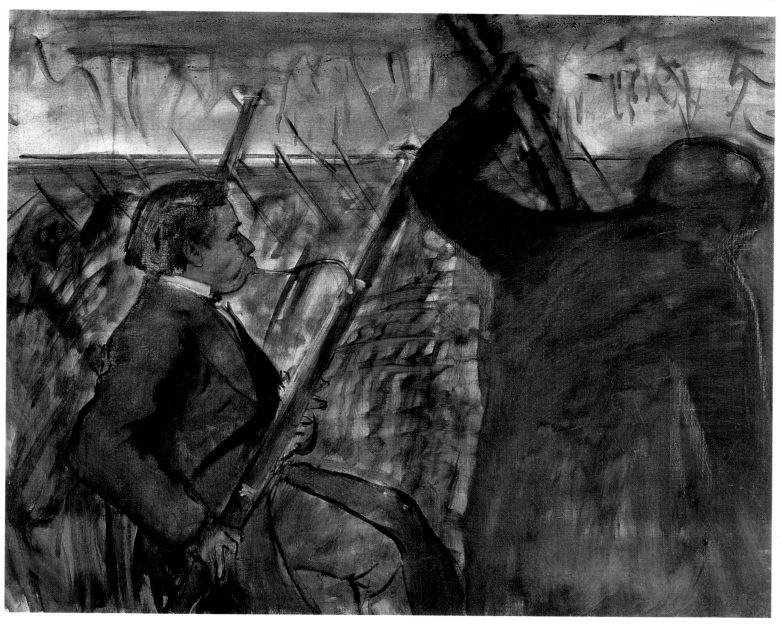

A STUDY OF M. GOUFFÉ

THE VIOLINIST

VIOLINIST AND YOUNG WOMAN

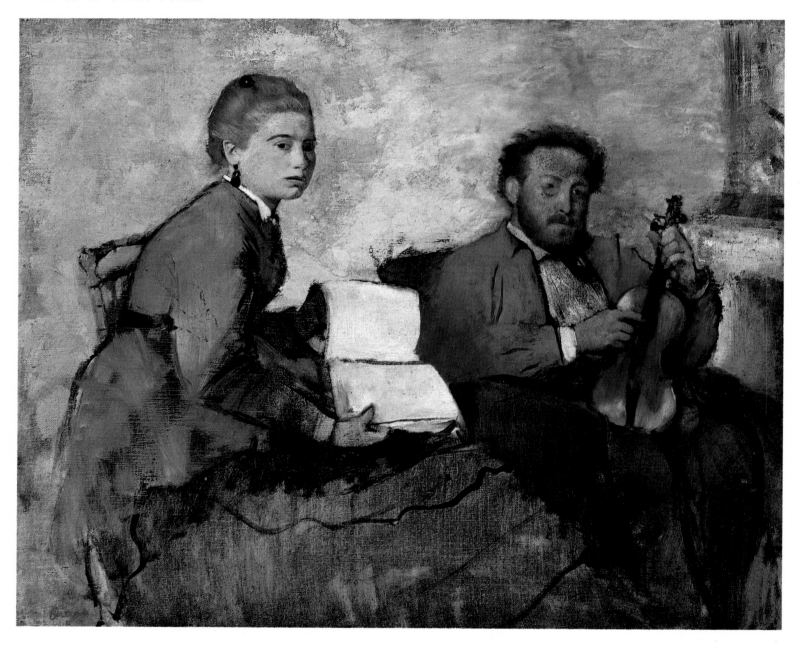

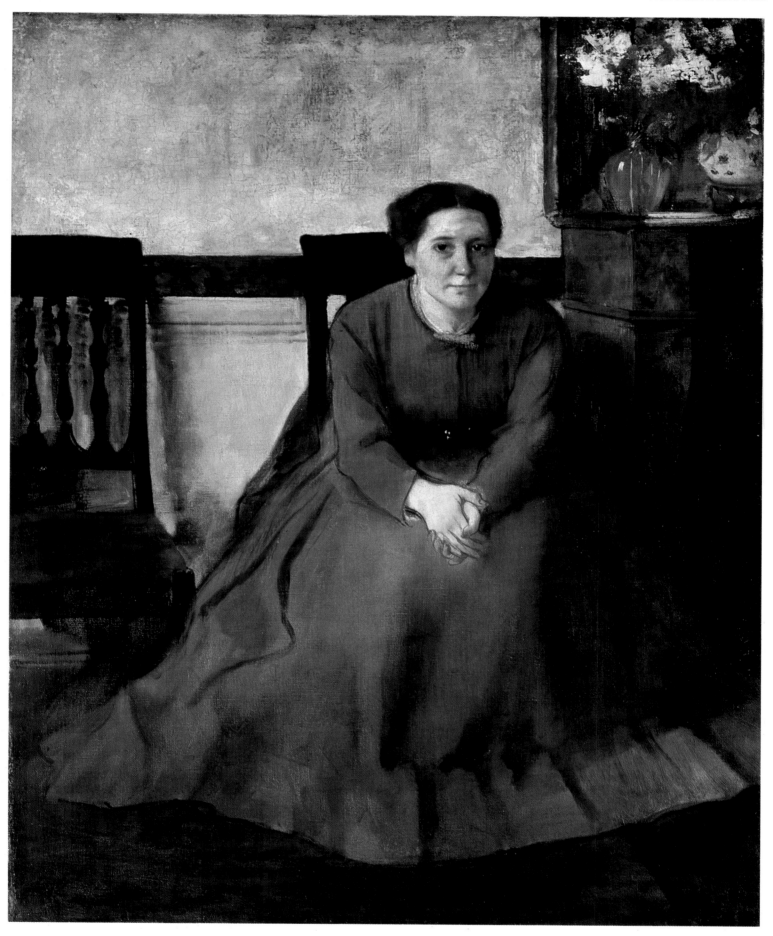

AT THE OCULIST

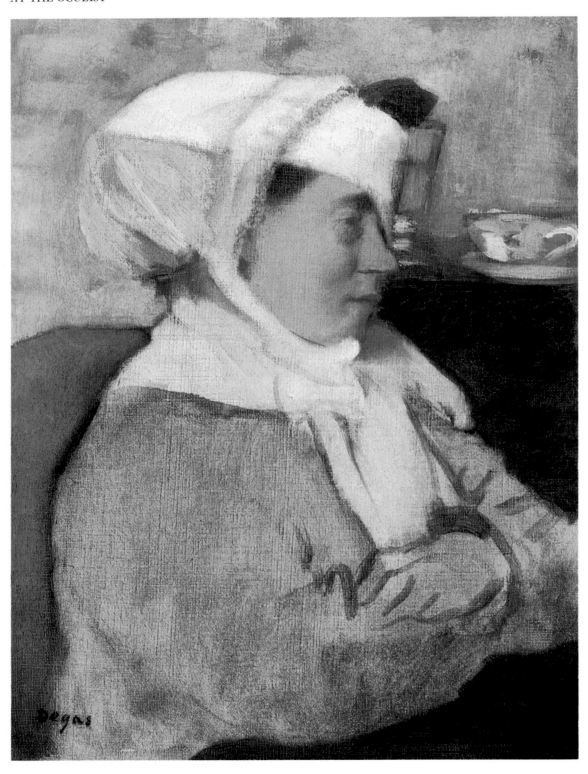

MADEMOISELLE MARIE DIHAU

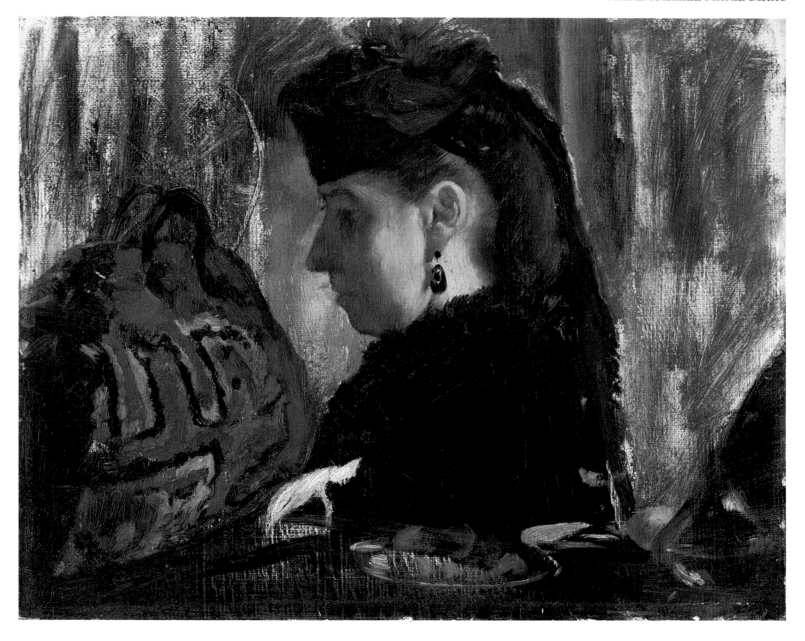

SULKING (THE BANKER)

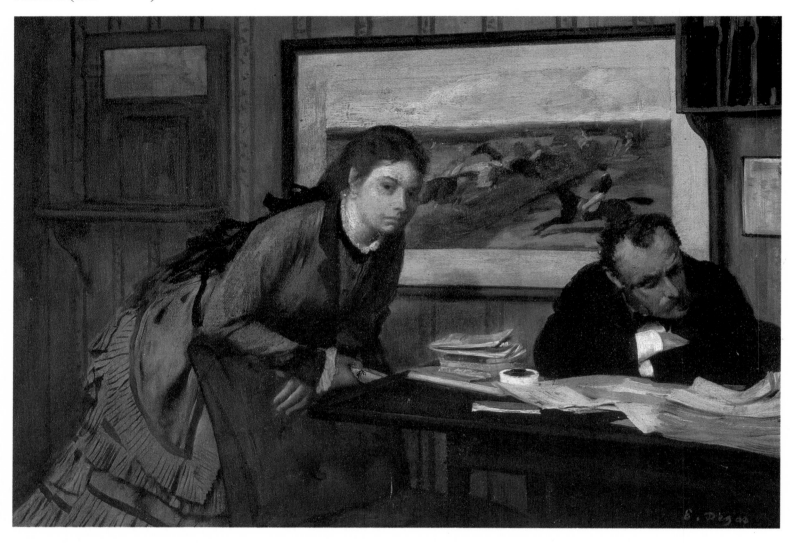

PORTRAIT OF JEANTAUD, LINET AND LAINÉ

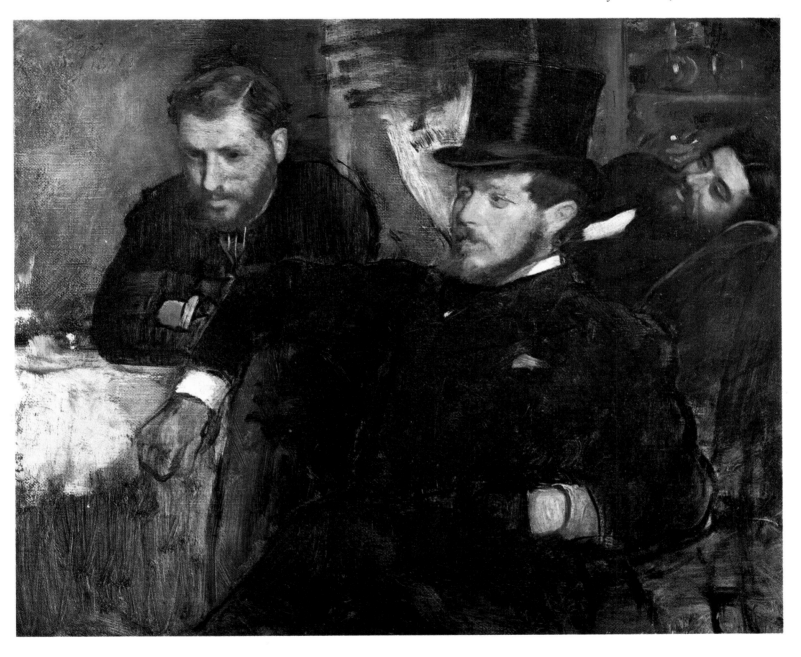

THE AMATEURS (PAUL LAFEND AND ALPHONSE CHERFILS EXAMINING A PAINTING)

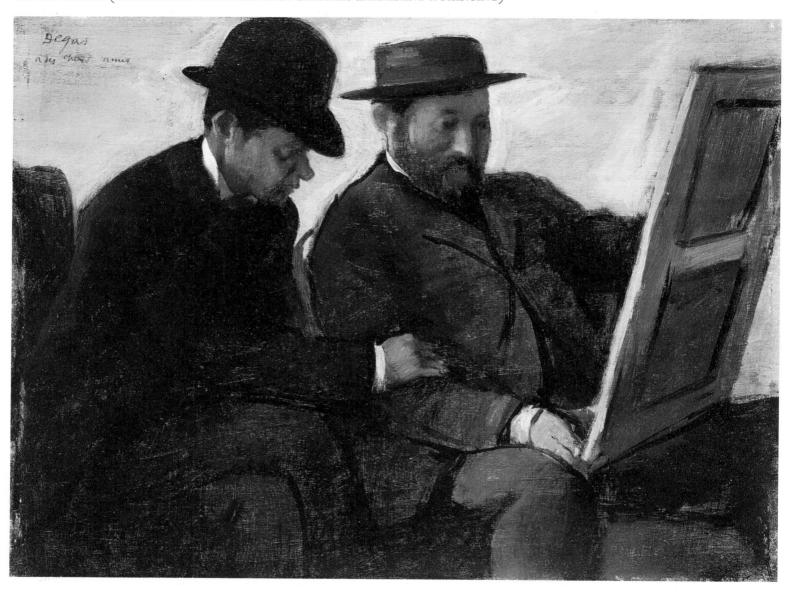

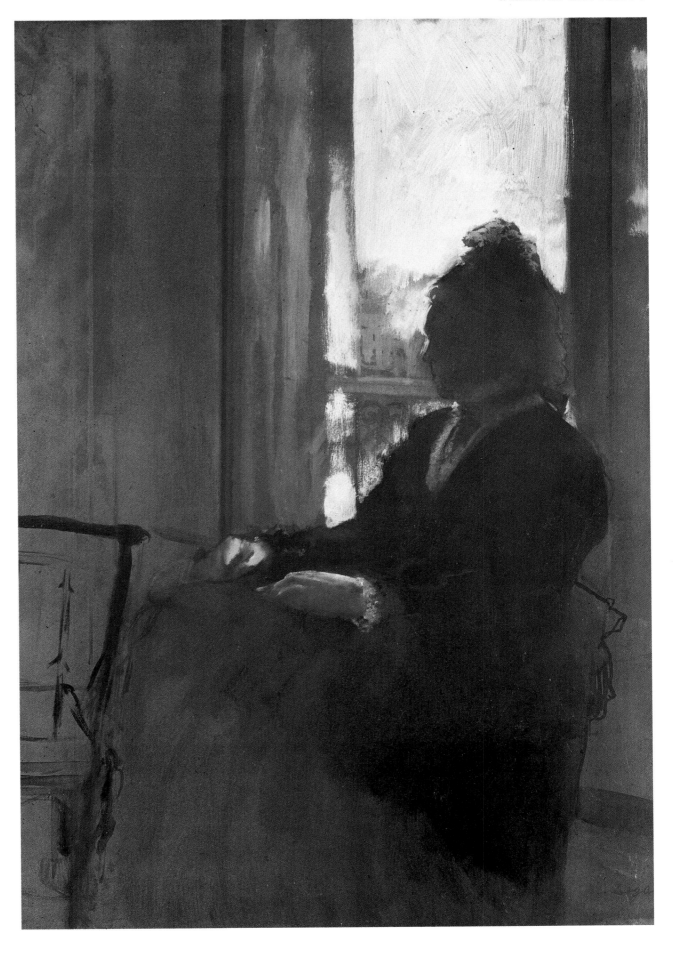

PEASANT GIRLS BATHING IN THE SEA AT DUSK

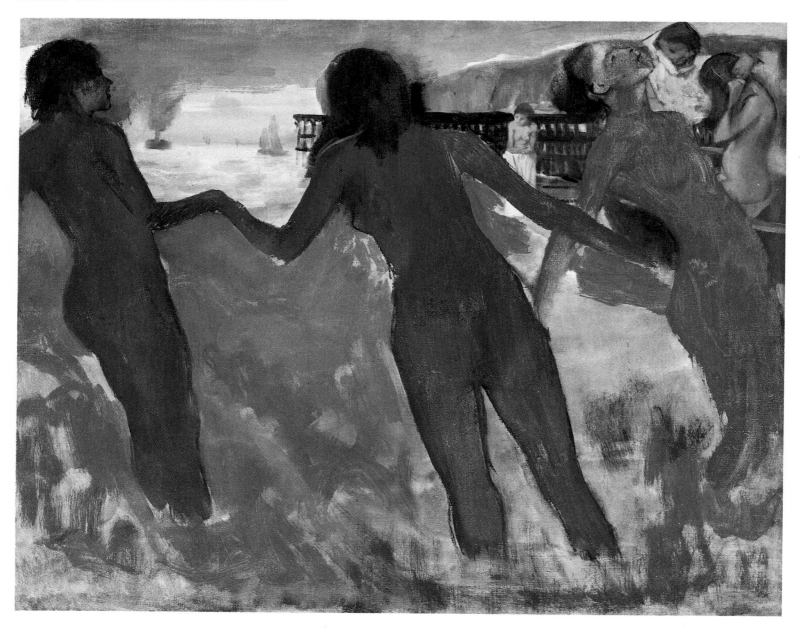

GIRLS COMBING THEIR HAIR

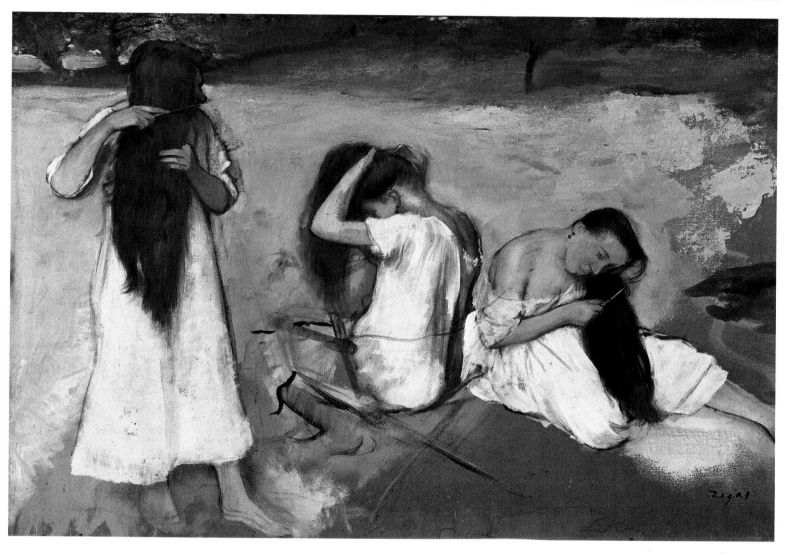

PORTRAIT OF HENRI MICHEL-LÉVY

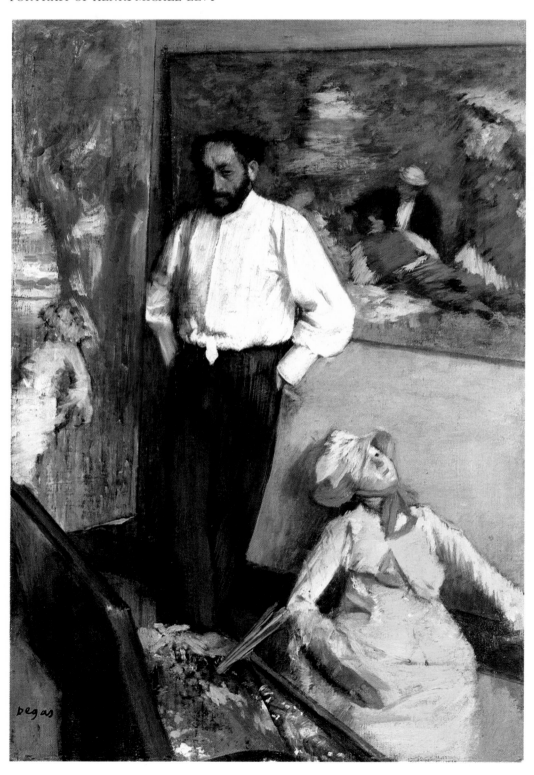

ELLEN ANDRÉE

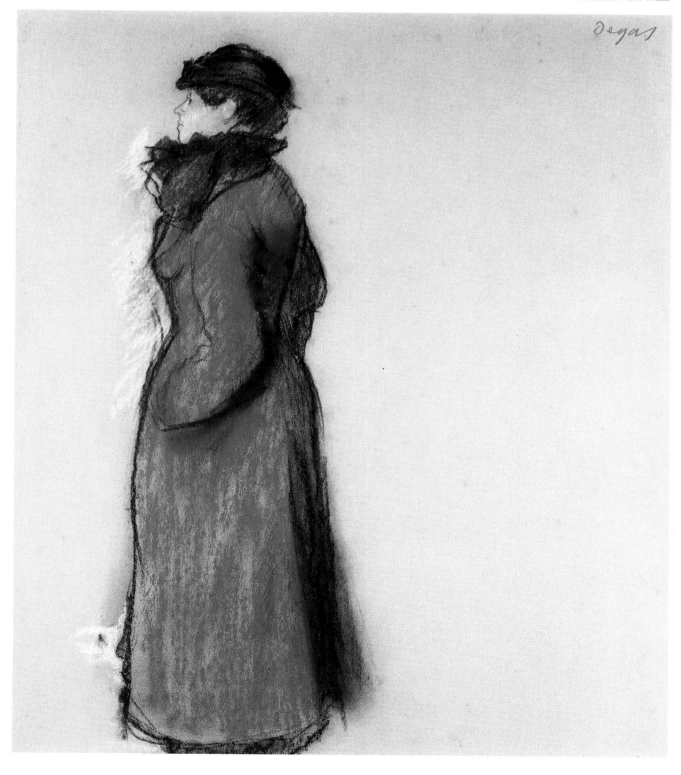

IN THE TUILERIES GARDENS

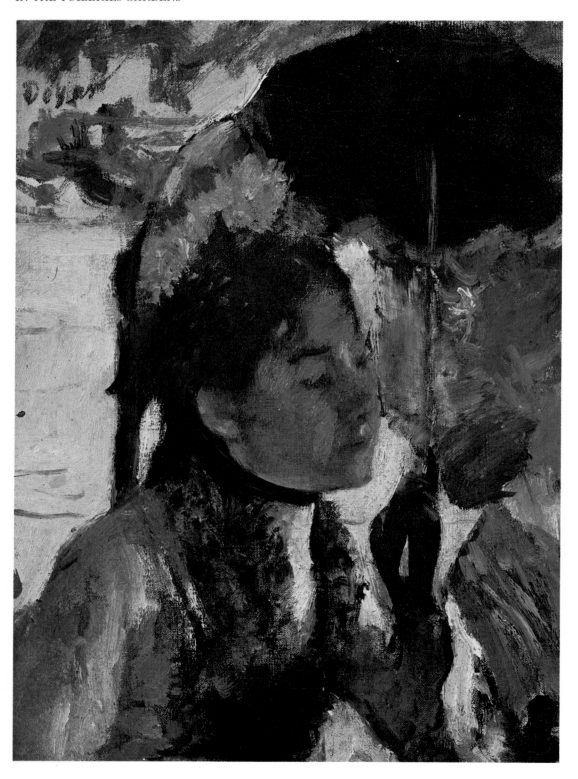

WOMAN WITH A PARASOL

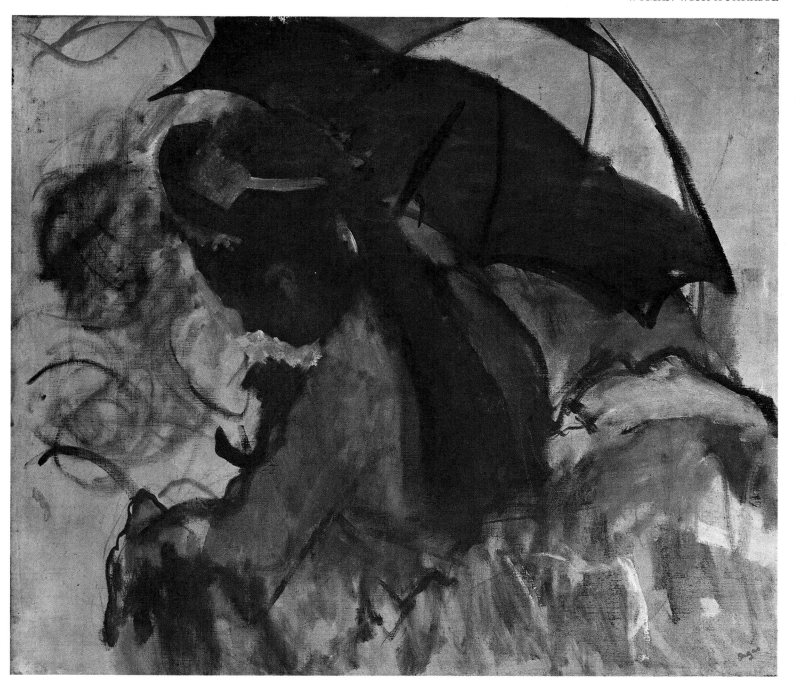

AT THE CAFÉ

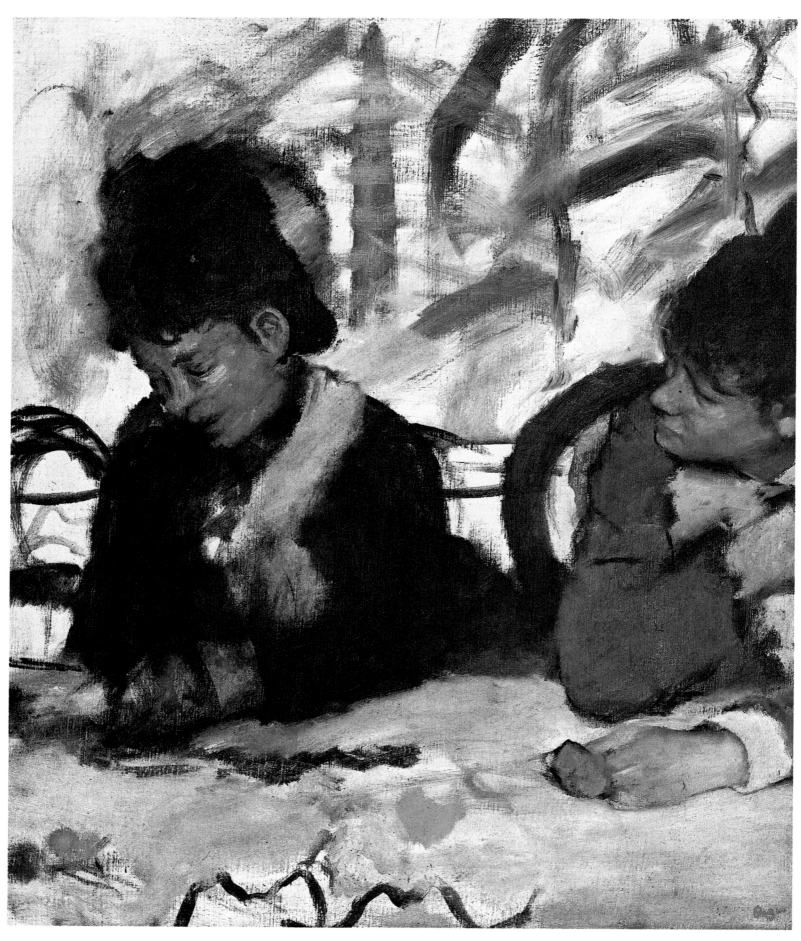

MLLE MALO

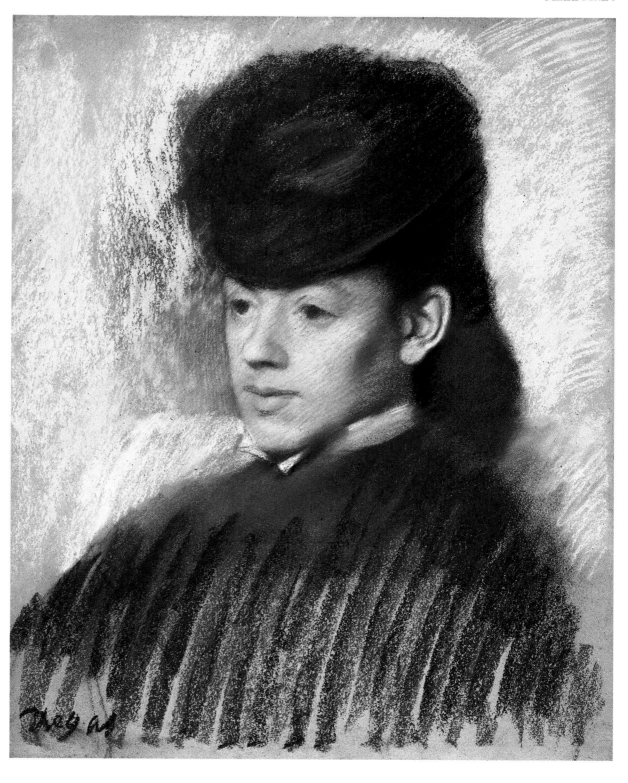

STUDY FOR PORTRAIT OF DIEGO MARTELLI

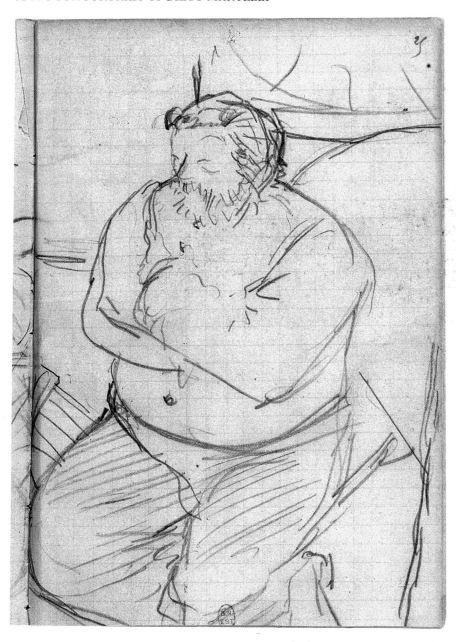

PORTRAIT OF DIEGO MARTELLI

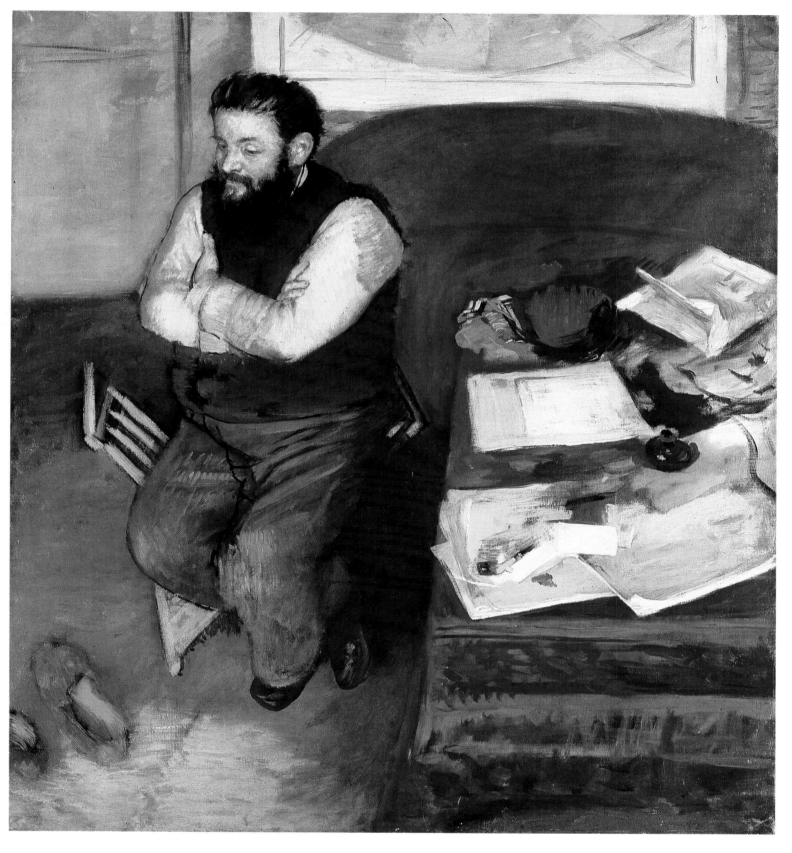

THE DANCING CLASS

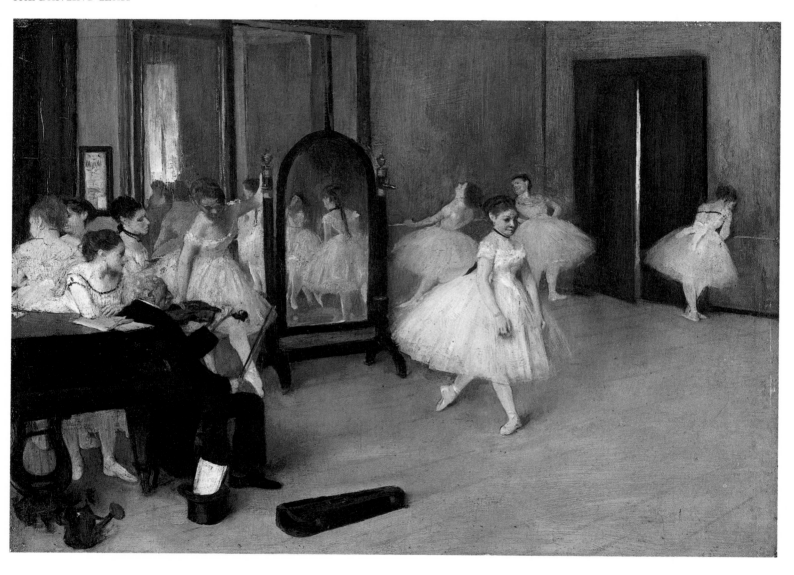

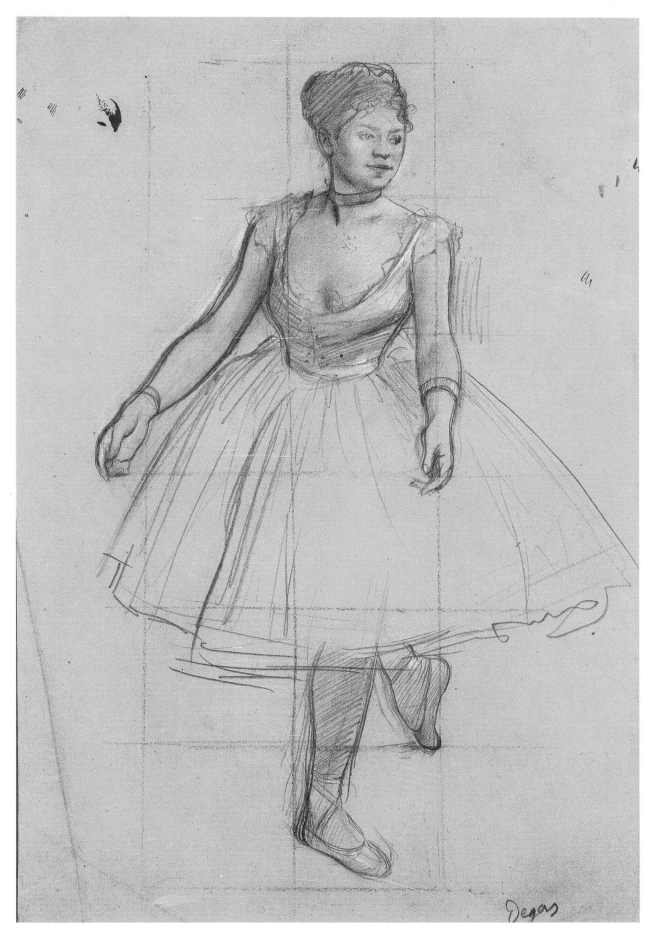

BALLET REHEARSAL

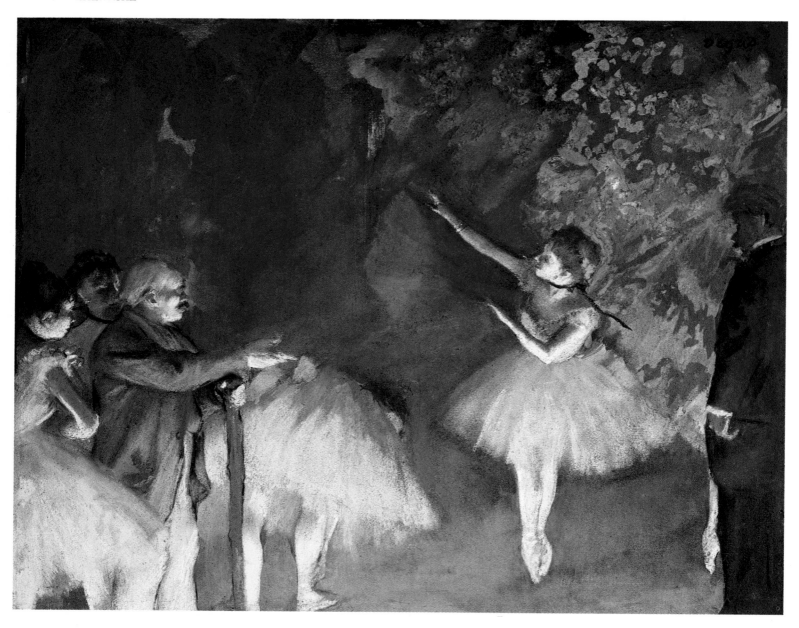

DANCERS BACKSTAGE

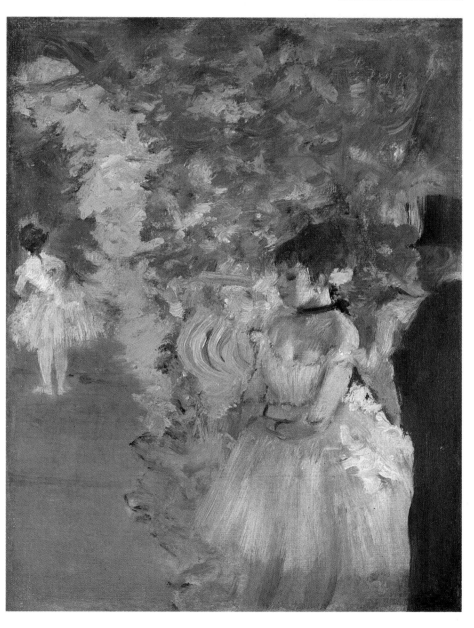

THE STAR : DANCER ON POINT

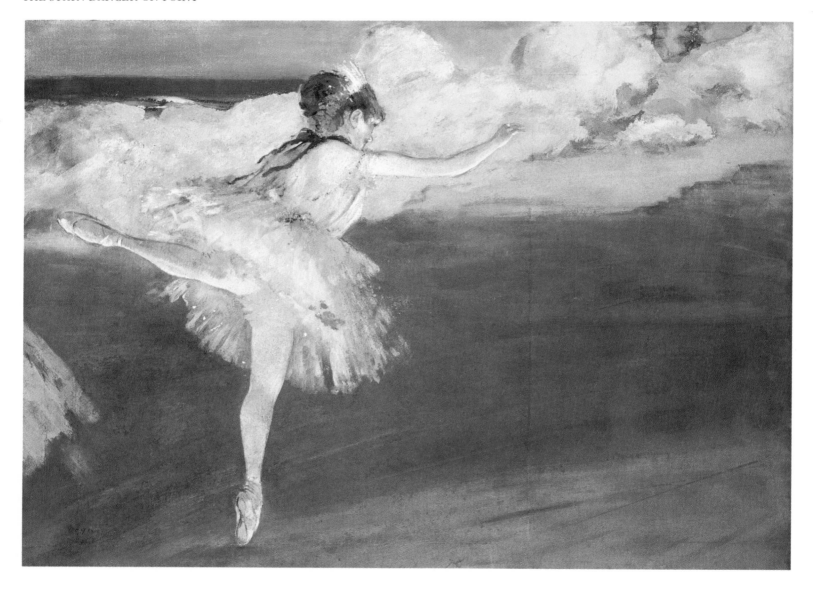

DANCER ADJUSTING HER TIGHTS

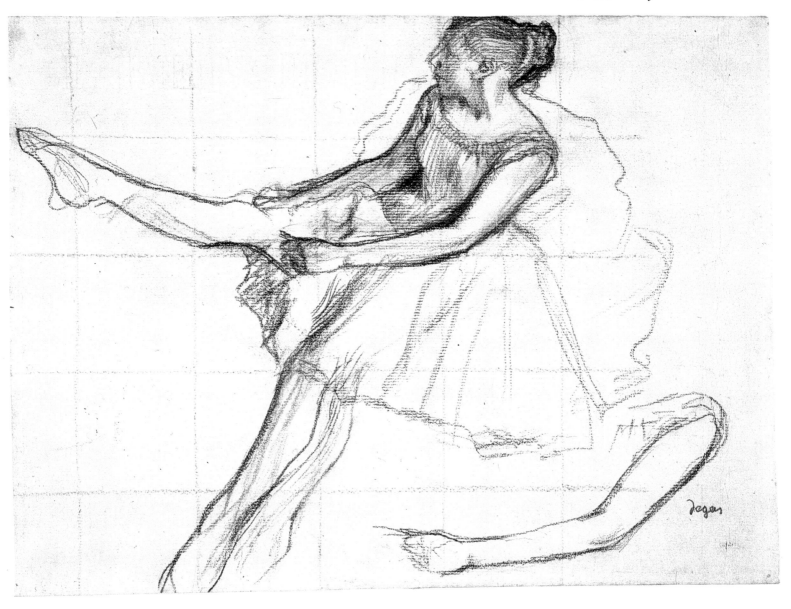

THE REHEARSAL

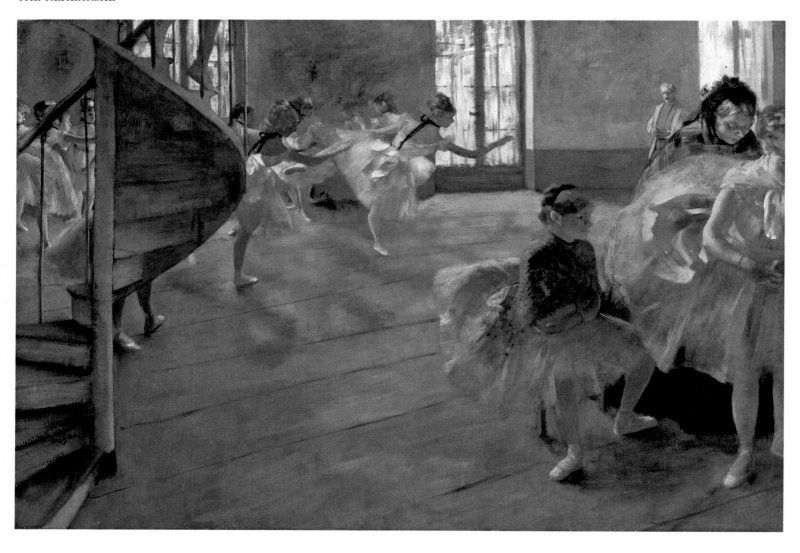

BEFORE THE EXAM

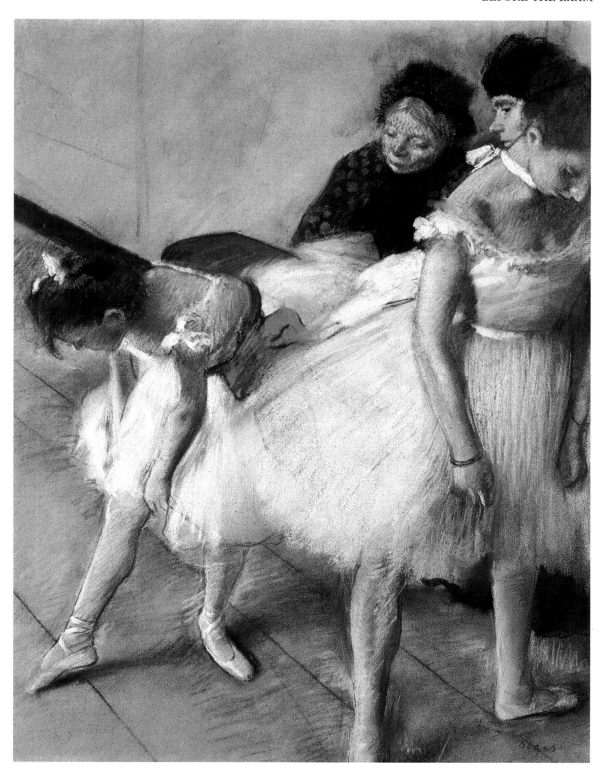

REHEARSAL OF A BALLET ON THE STAGE

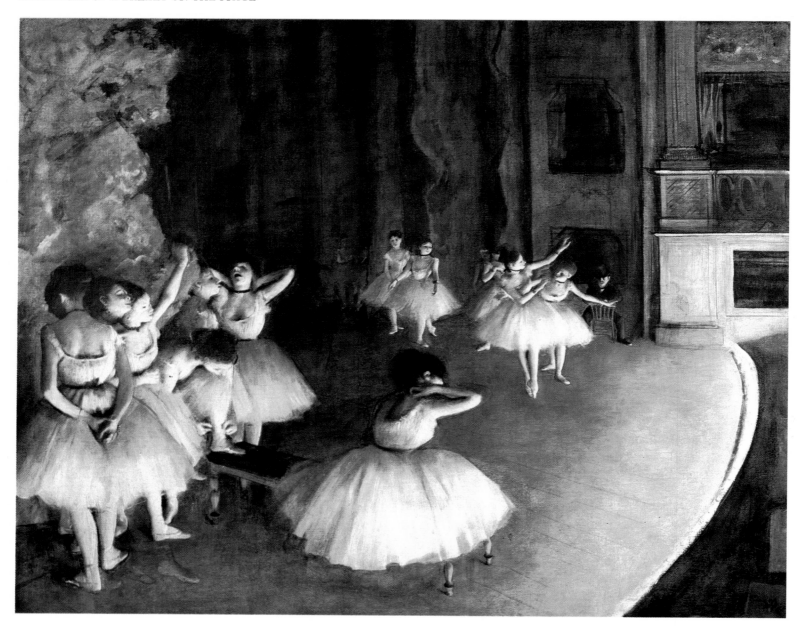

TWO DANCERS

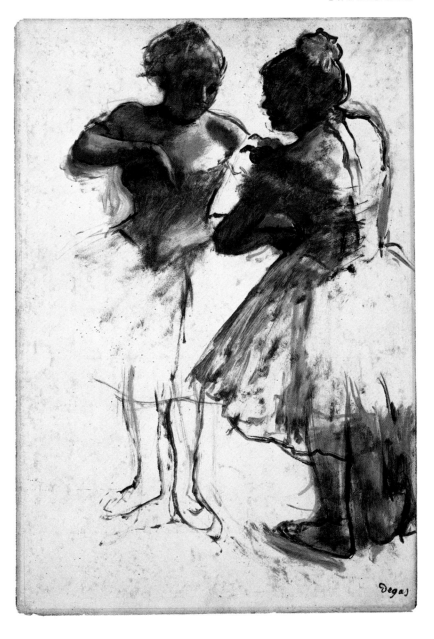

SPANISH DANCER AND STUDIES OF LEGS

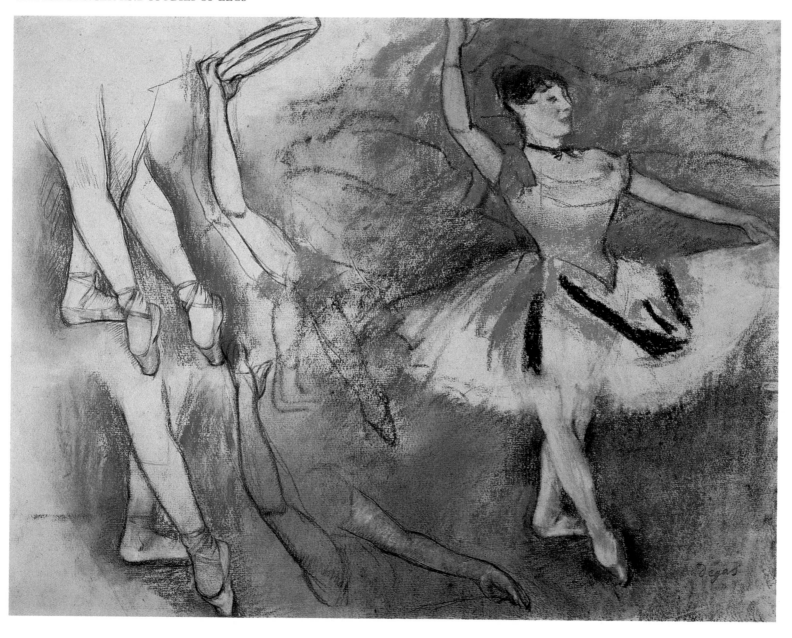

DANCER AT THE BAR

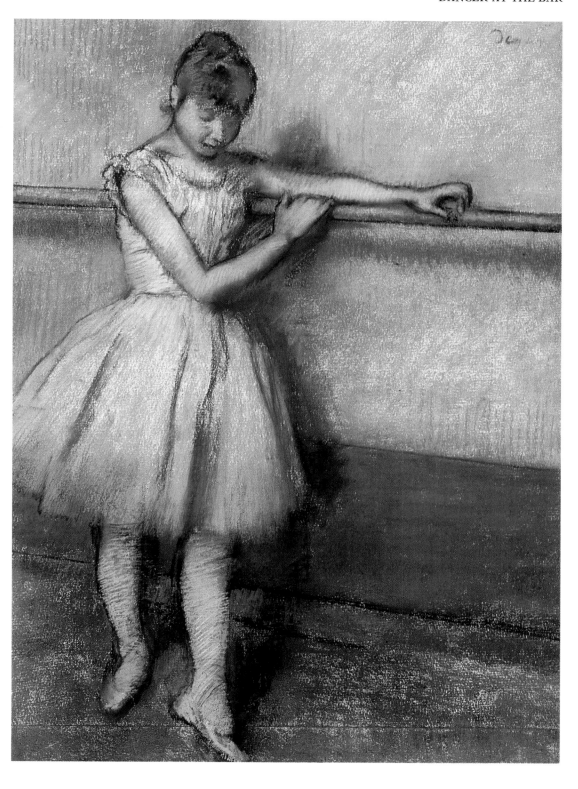

TWO STUDIES OF A JOCKEY

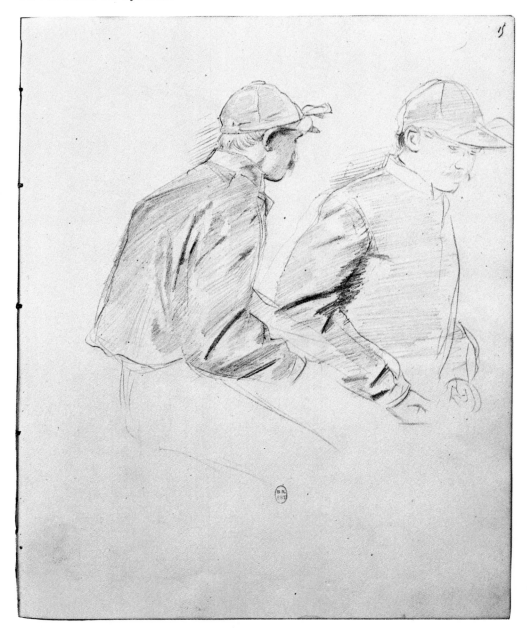

RACEHORSES AT LONGCHAMP

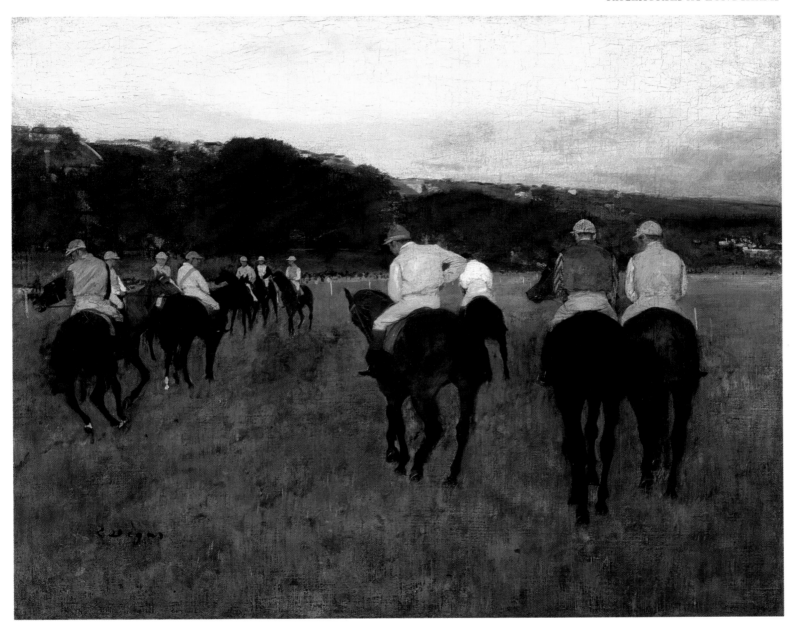

THE JOCKEY

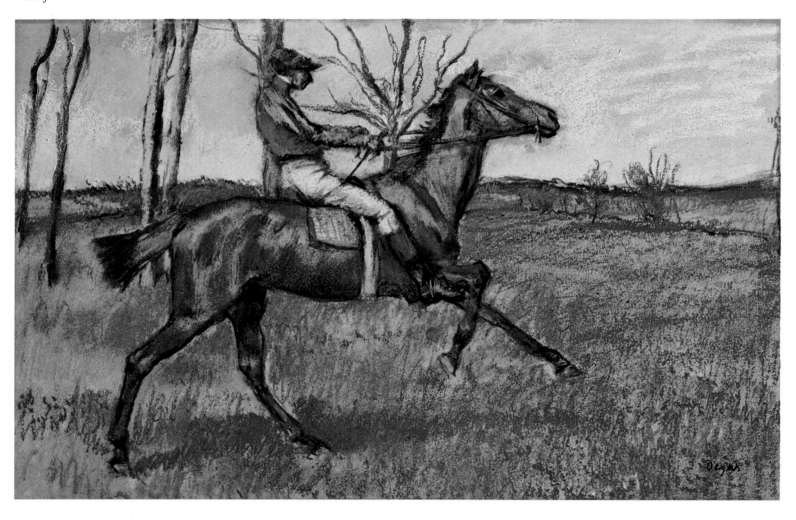

RACEHORSE AND JOCKEY

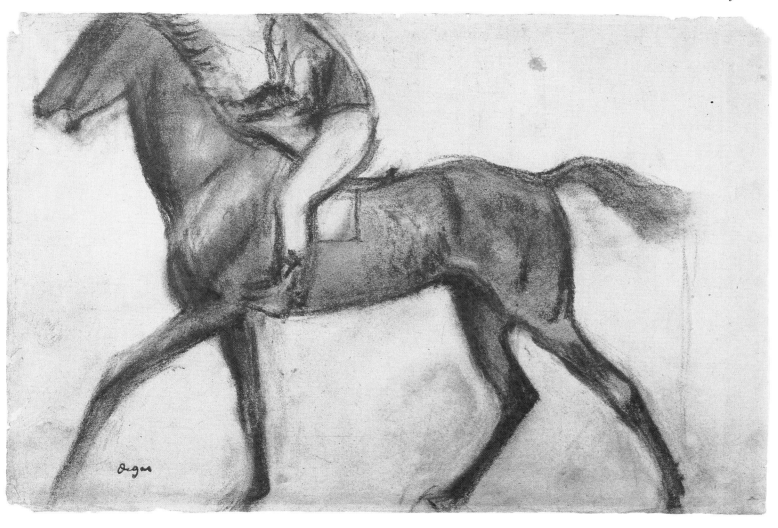

THE LAUNDRESS

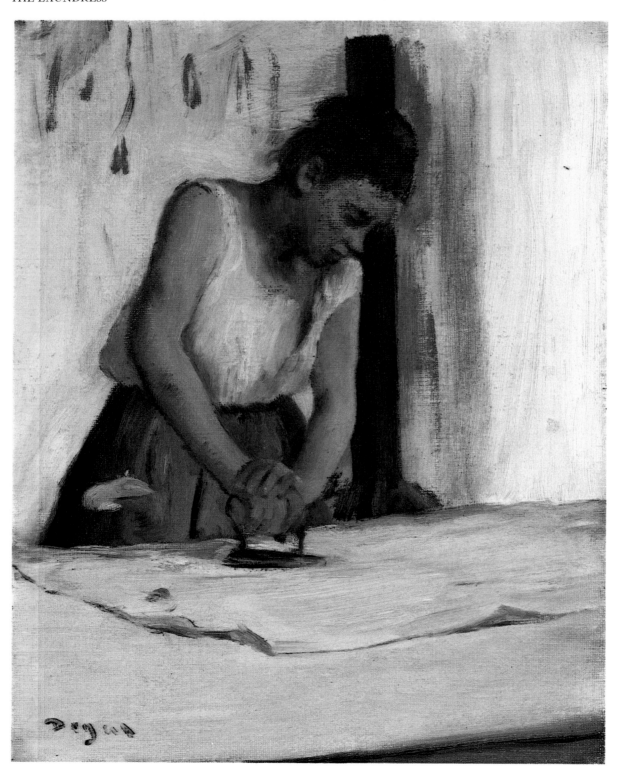

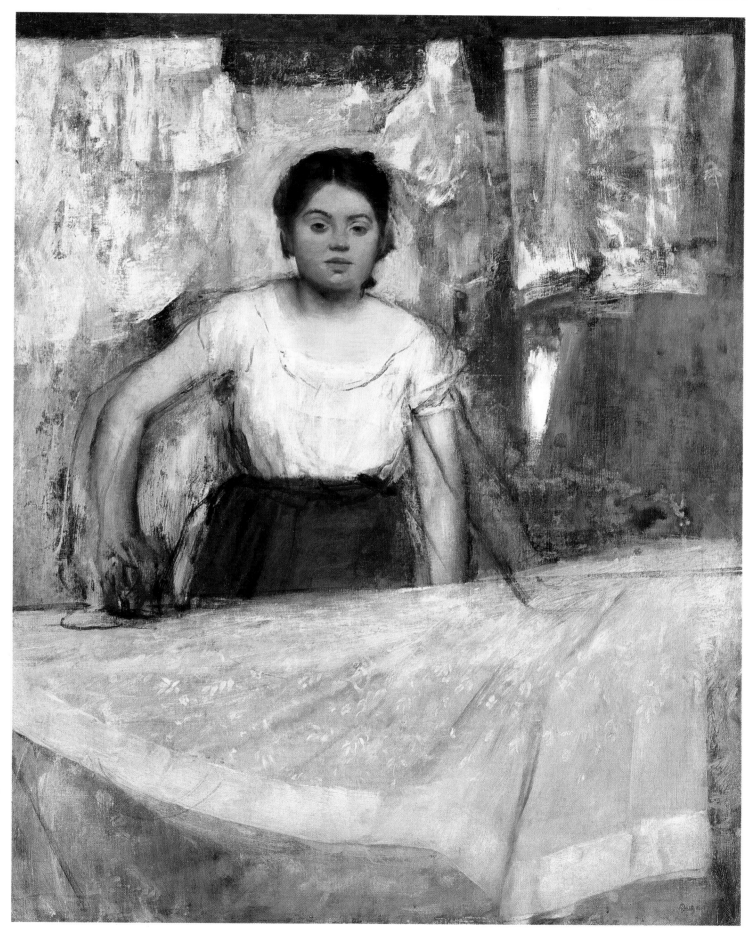

THE IRONERS

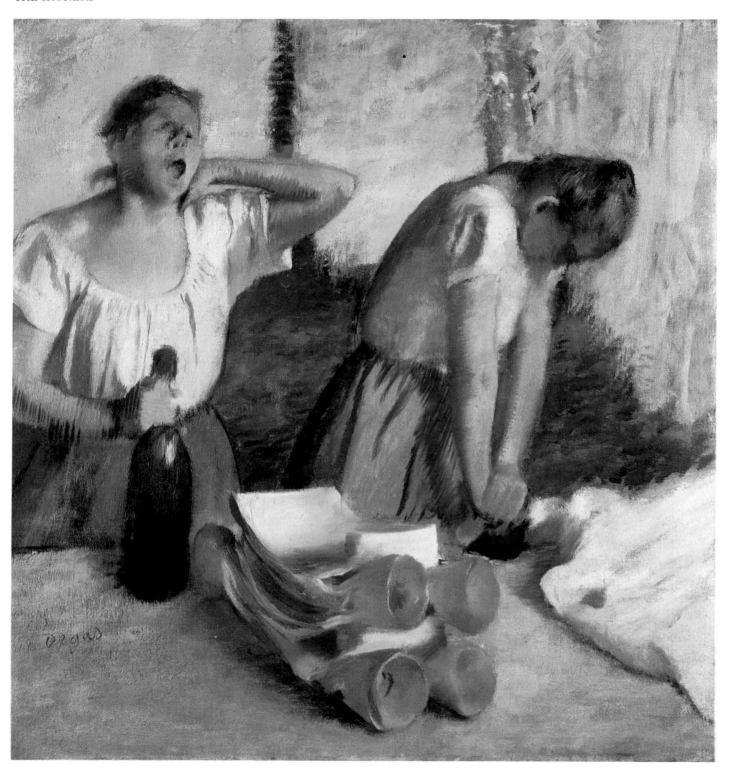

THE IRONERS

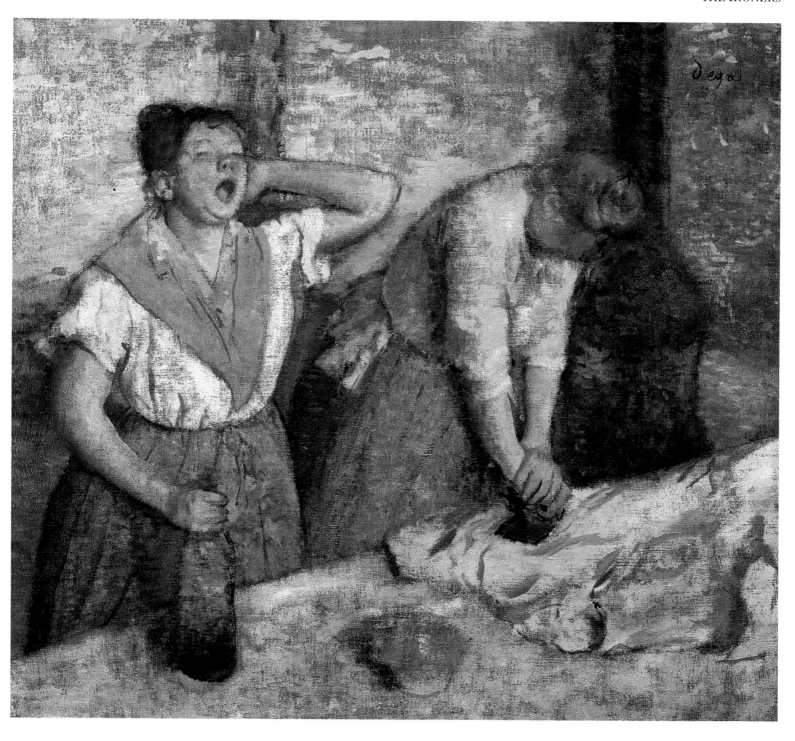

WOMAN TYING THE RIBBONS OF HER HAT

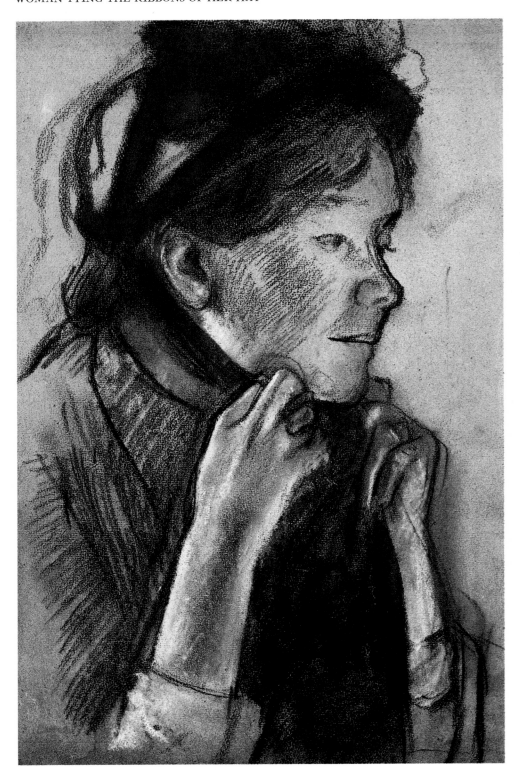

*c.*1870—1885

AT THE MILLINERS

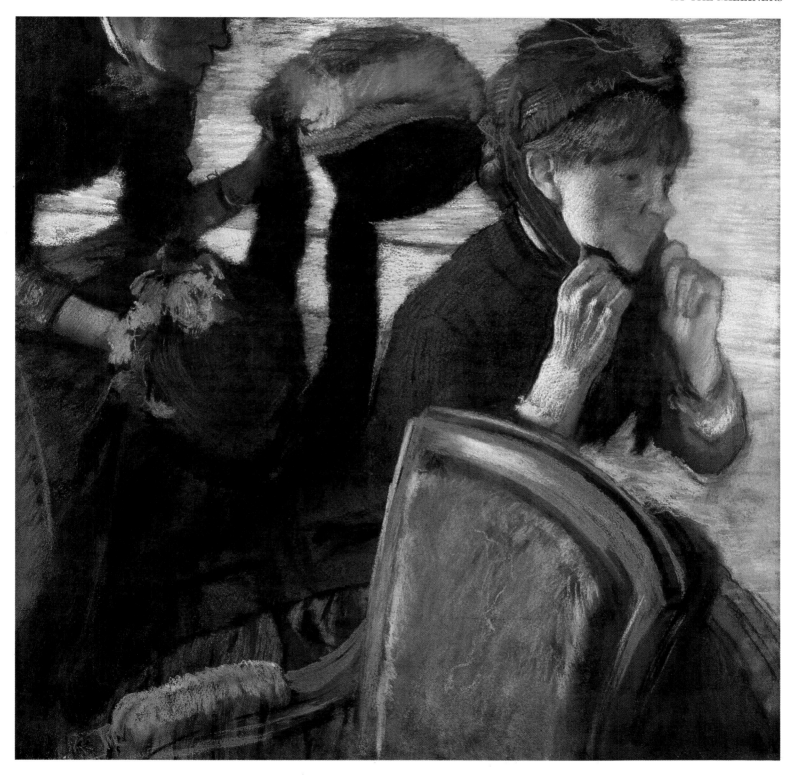

THE HAT SHOP

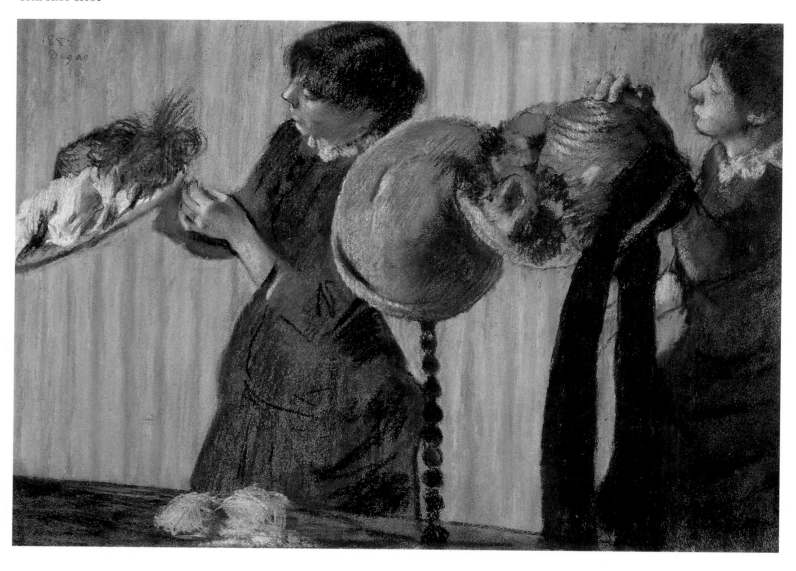

WOMAN COMBING HER HAIR BEFORE A MIRROR

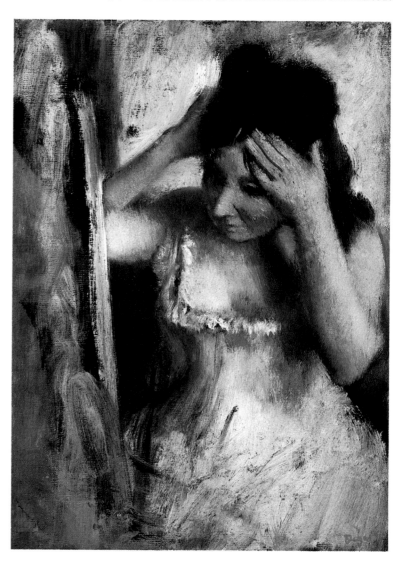

CAFÉ-CONCERT SINGER

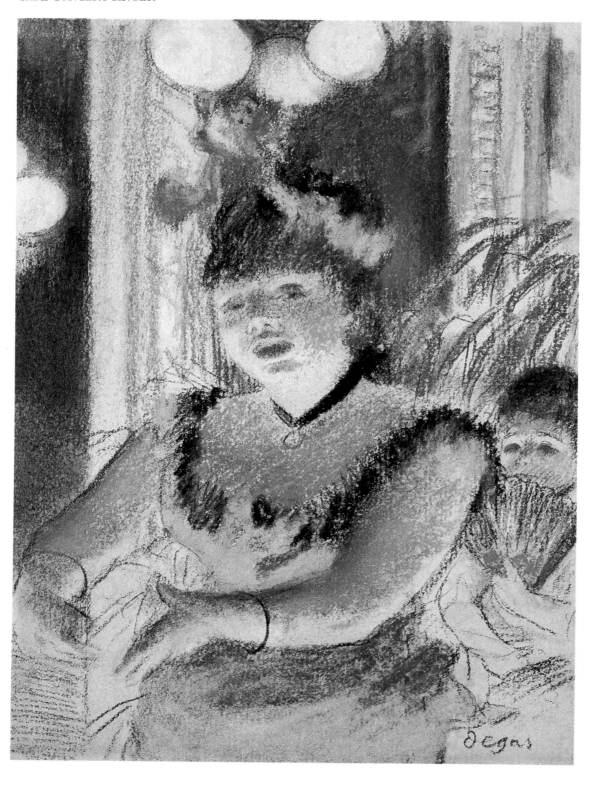

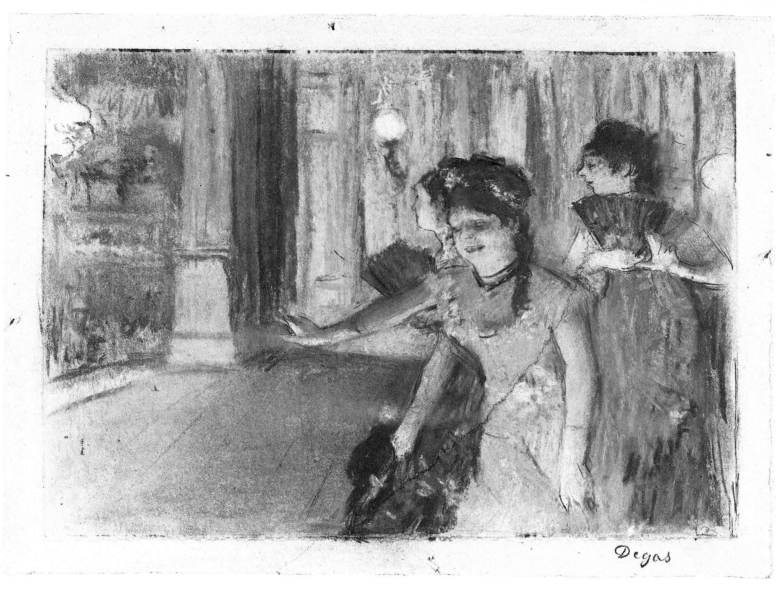

SINGER WITH A GLOVE

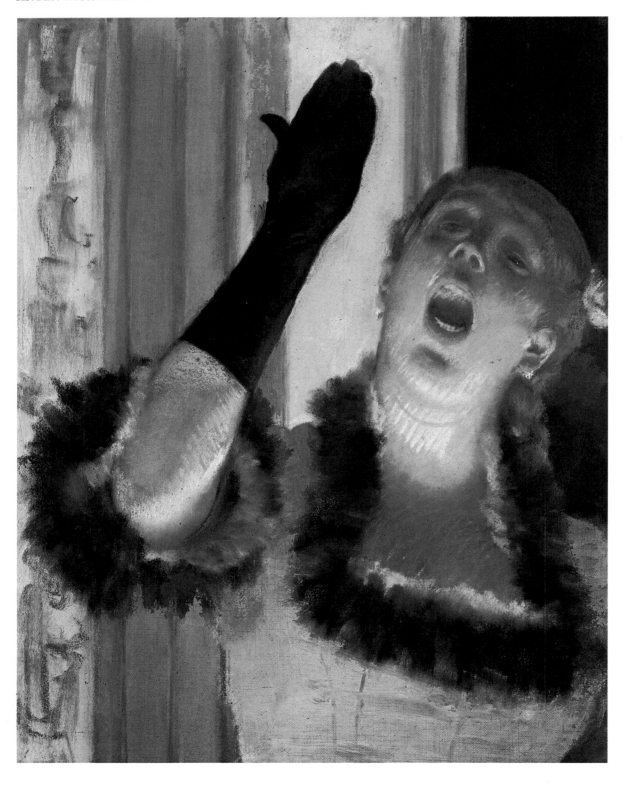

CABARET

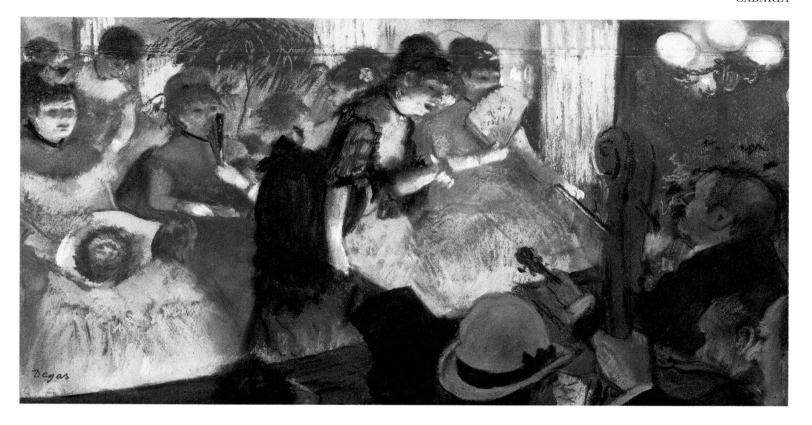

MLLE BÉCAT AT THE CAFÉ DES AMBASSADEURS

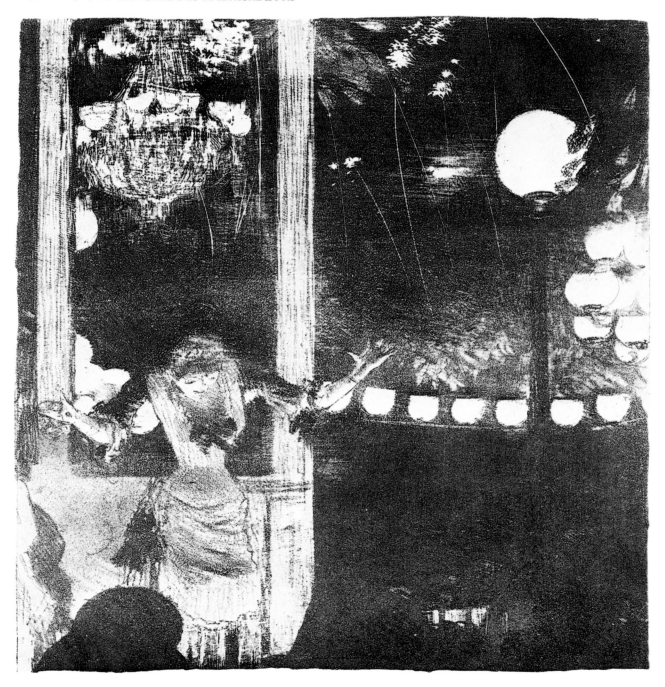

AT THE CAFÉ DES AMBASSADEURS

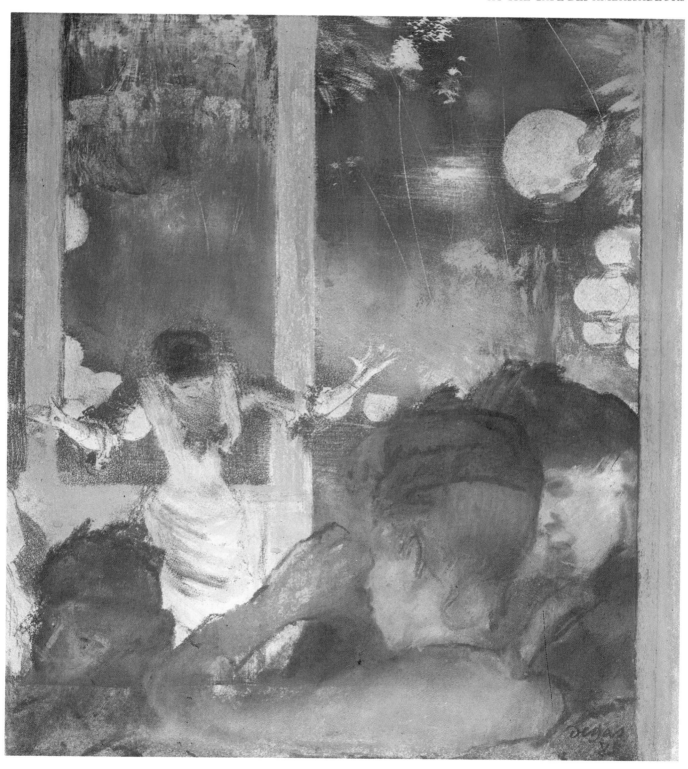

A SKETCHBOOK PAGE

A CAFÉ-CONCERT SINGER (MLLE BÉCAT?)

BEFORE THE CURTAIN CALL

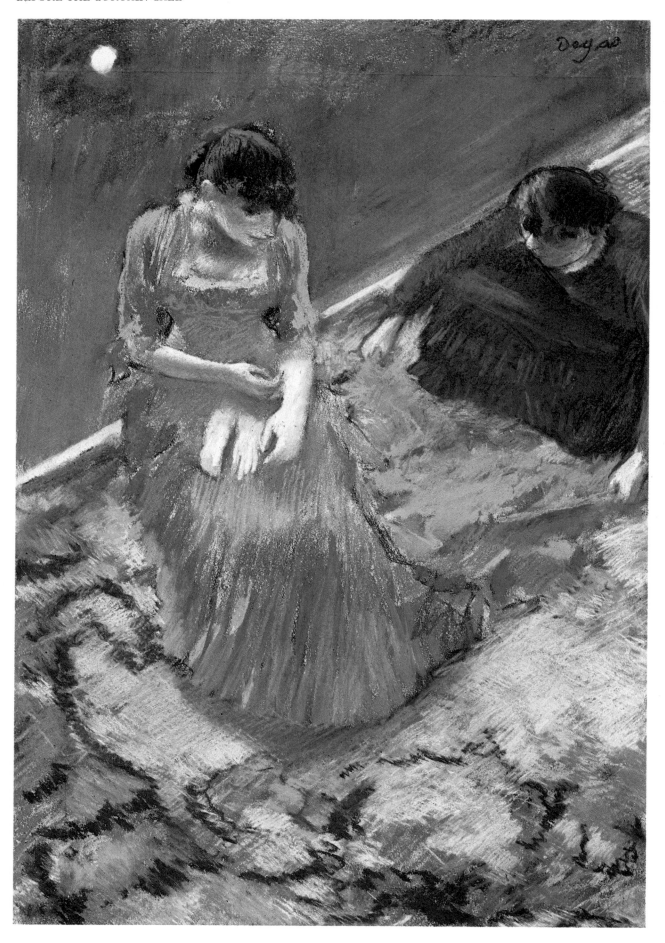

c.1870–1885

THE CHORUS

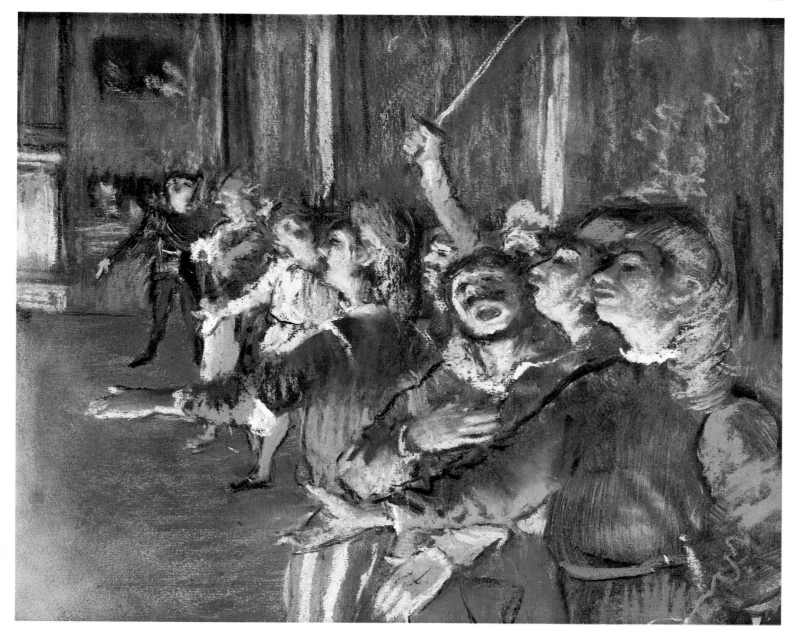

STUDY FOR MISS LALA AT THE CIRQUE FERNANDO

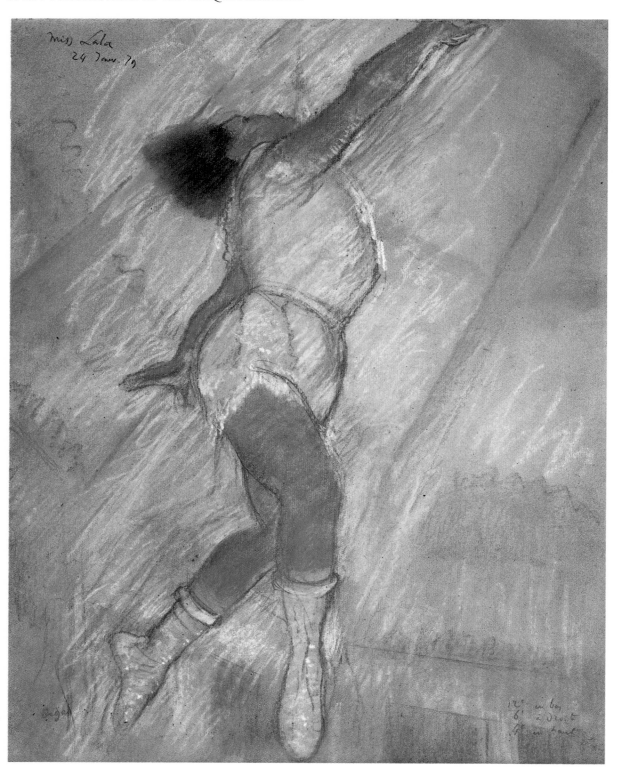

STUDY FOR MISS LALA
AT THE CIRQUE FERNANDO

WOMAN LEAVING HER BATH

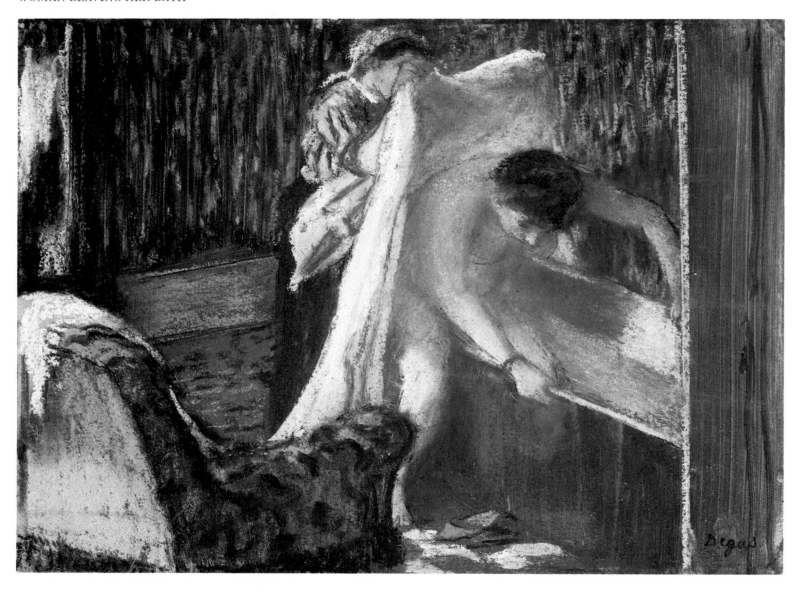

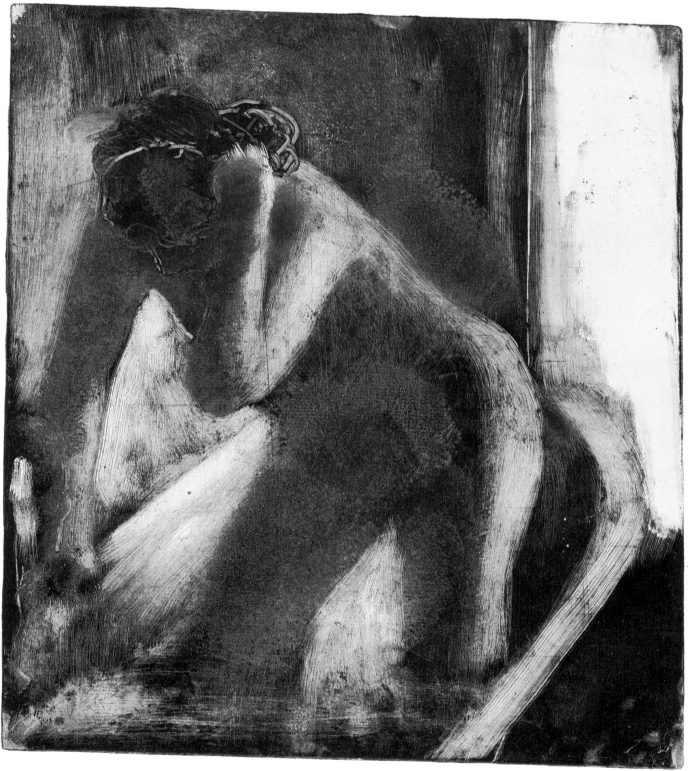

ON THE BED

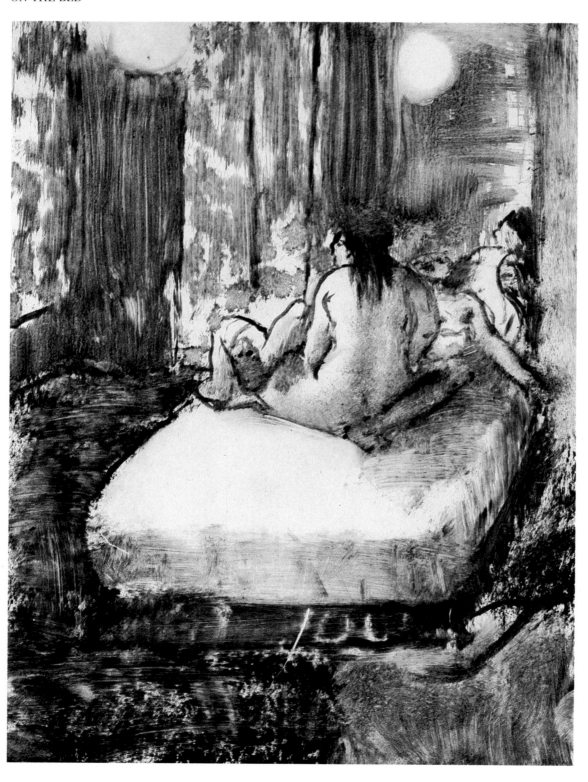

THE CUSTOMER

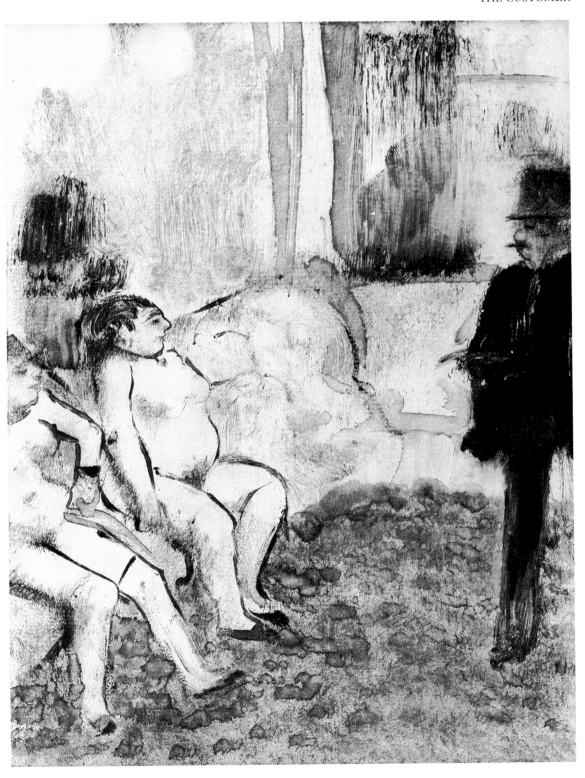

GETTING INTO BED

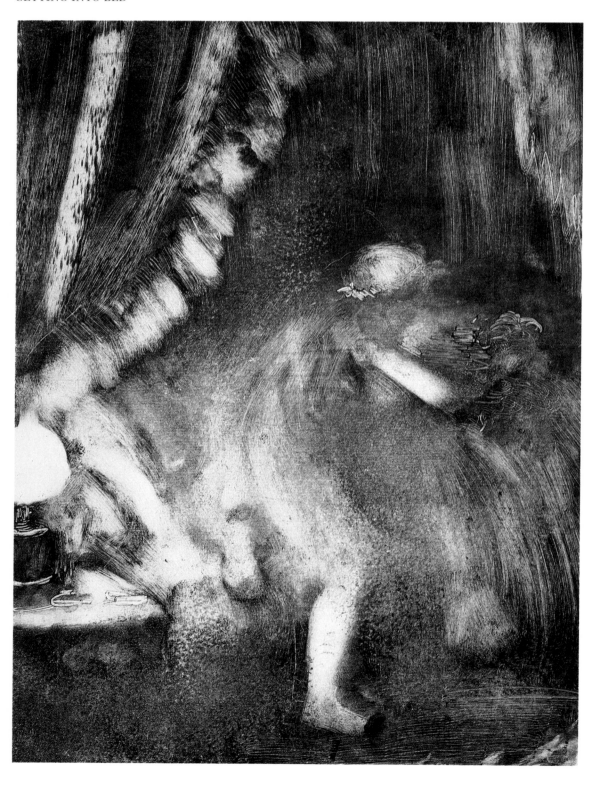

SEATED WOMAN PUTTING ON HER STOCKINGS

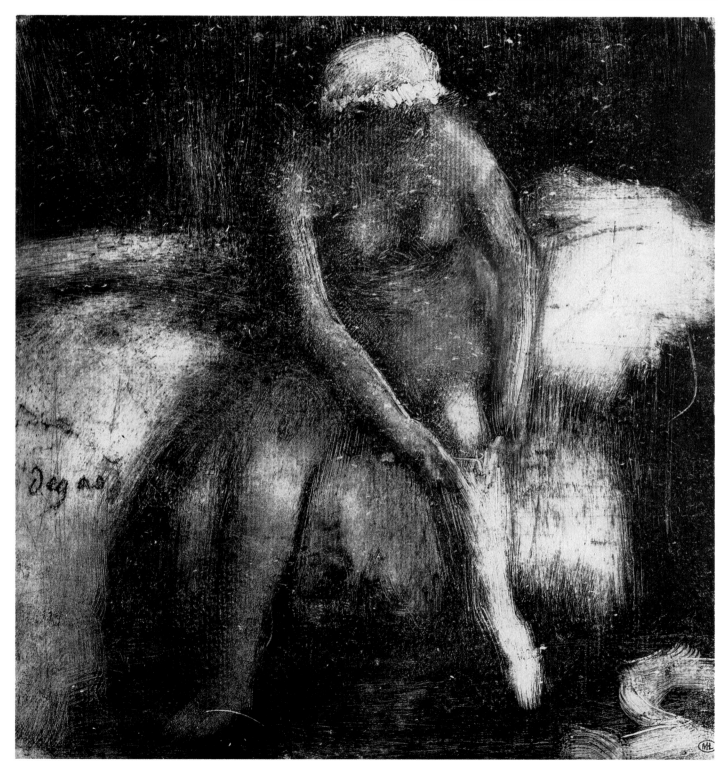

WOMAN SQUATTING

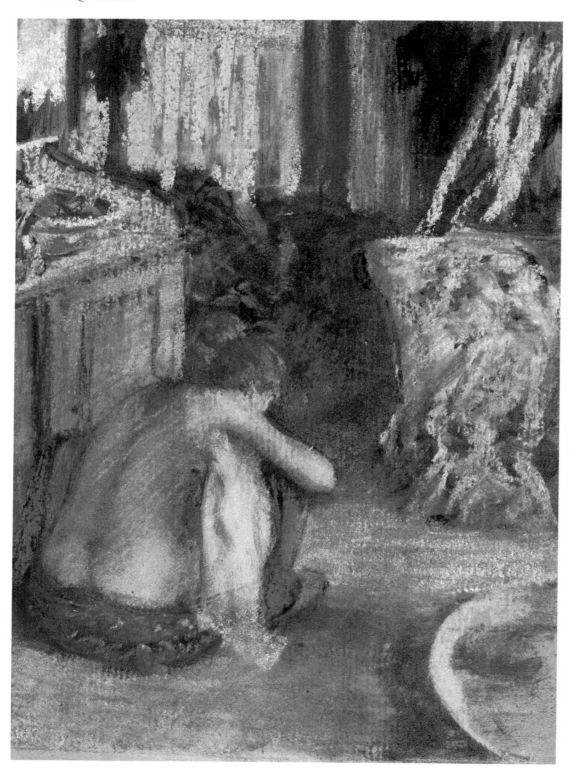

*c.*1870–1885

AFTER THE BATH

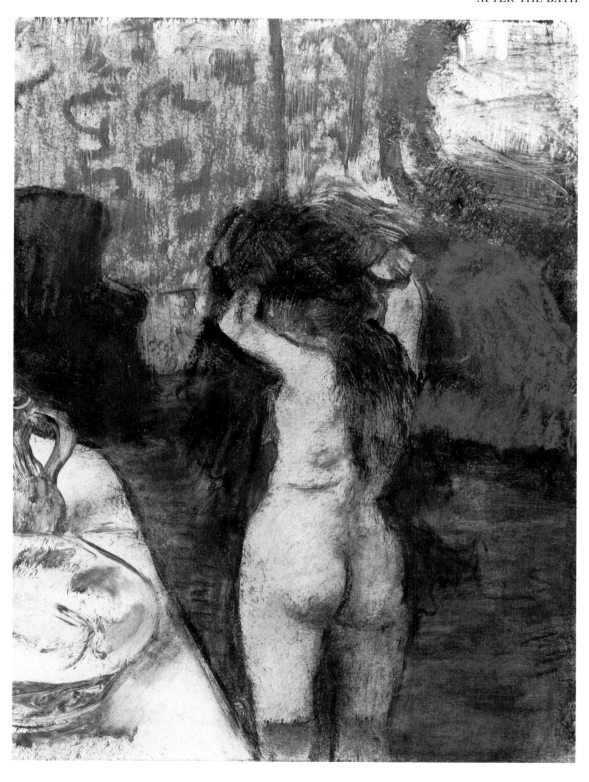

THE TUB

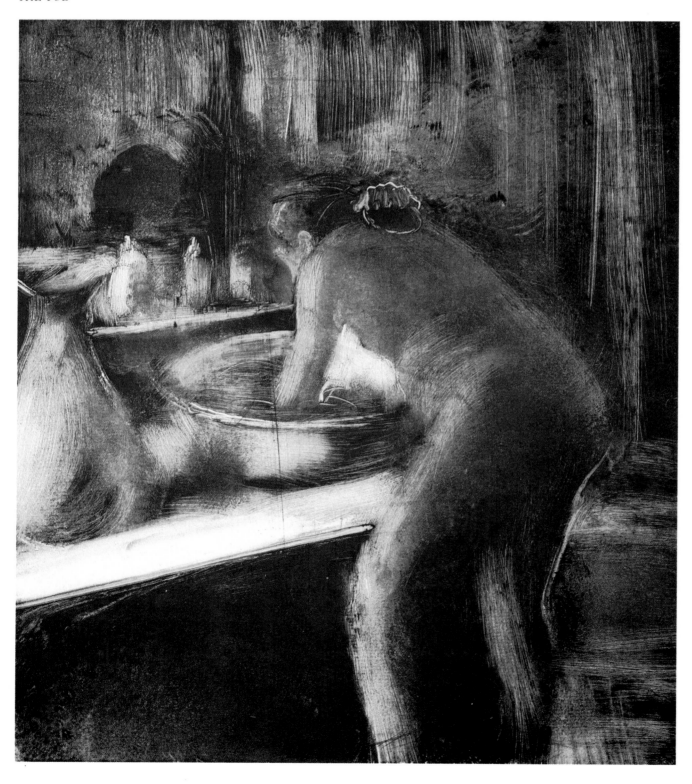

*c.*1870—1885

WOMAN AT HER TOILETTE

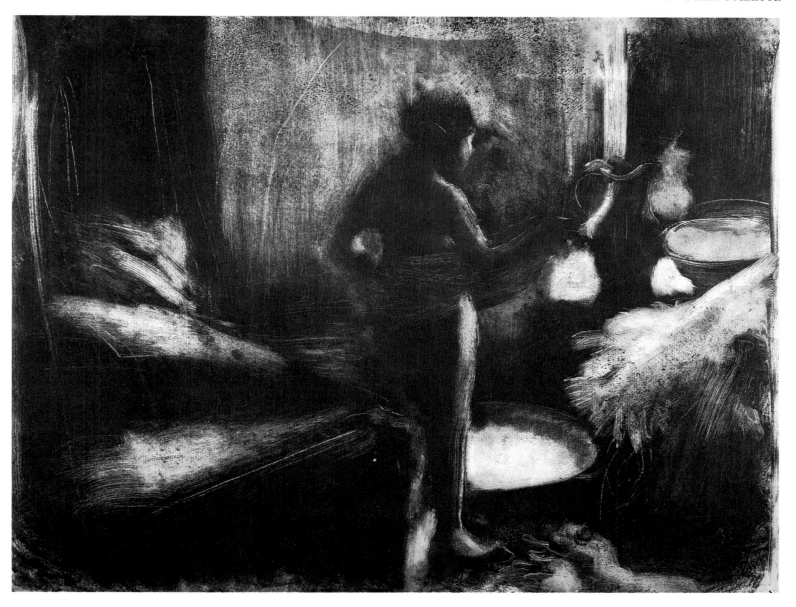

TWO DANCERS

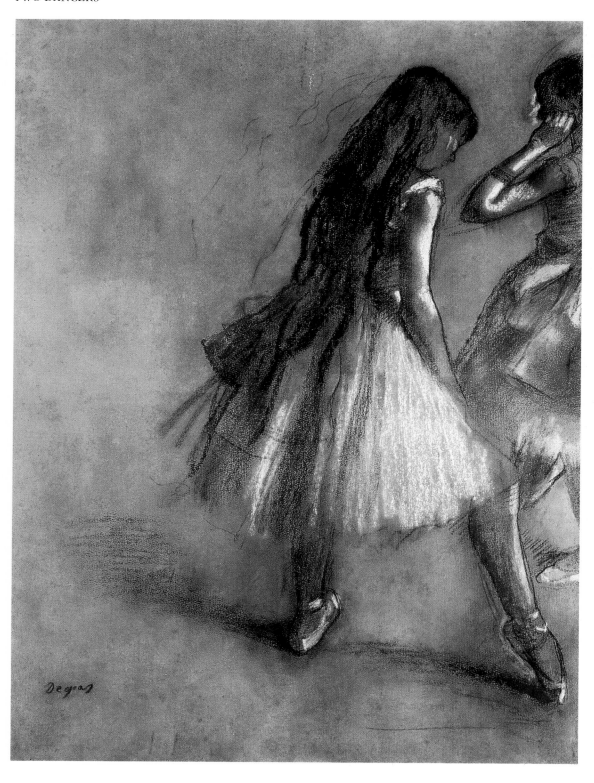

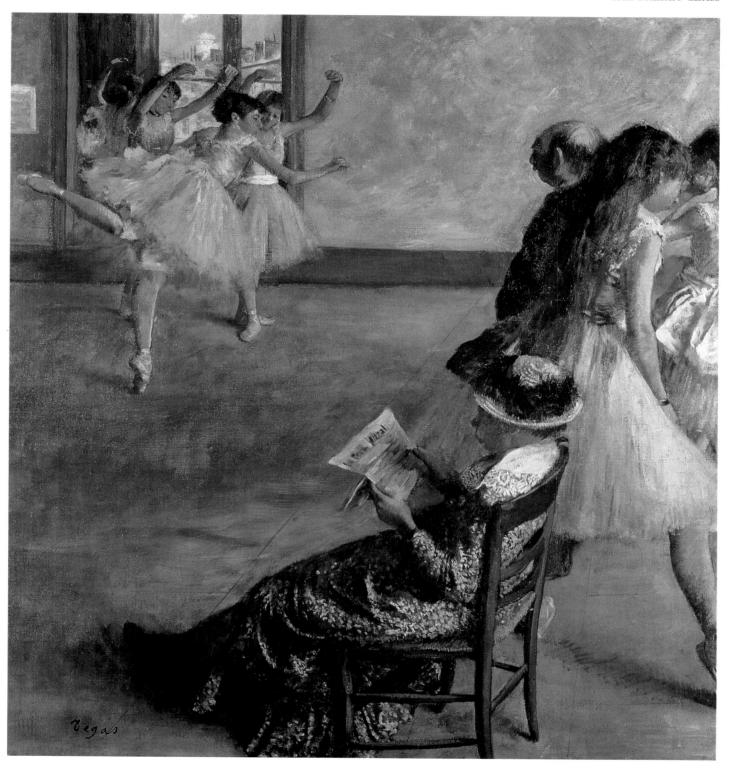

STUDY FOR TWO DANCERS AT THE BAR

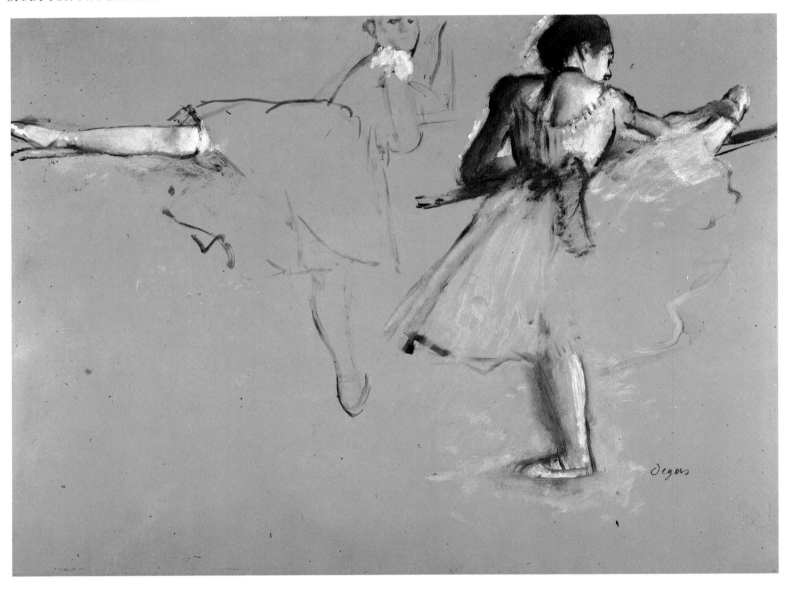

STUDY OF A RIBBON

FAN

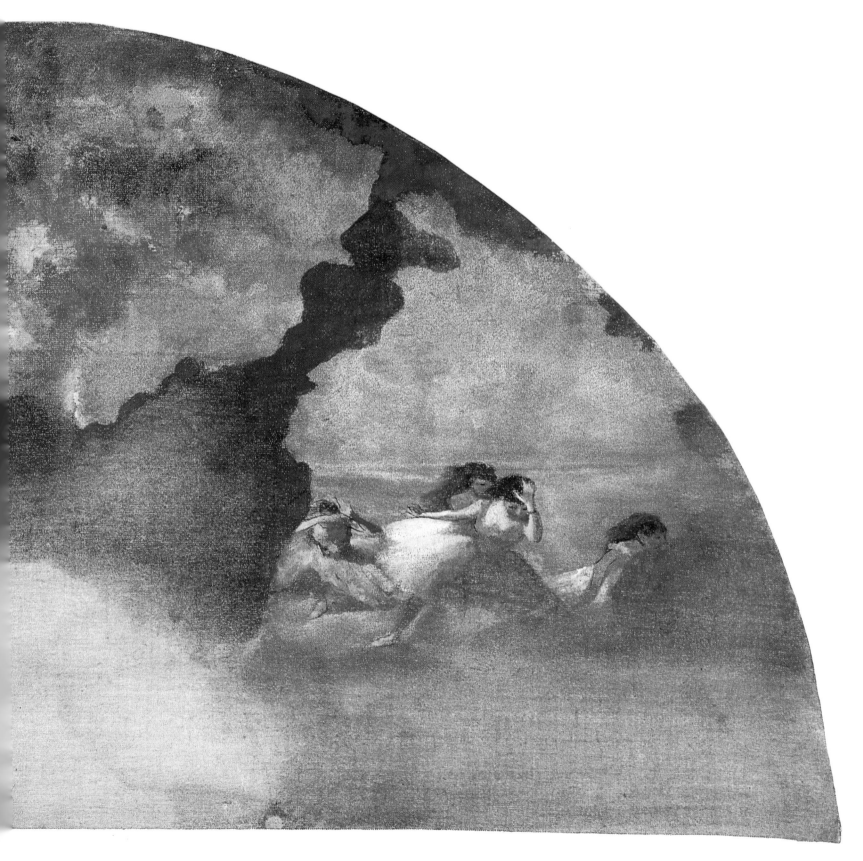

AT THE THEATRE: WOMAN WITH A FAN

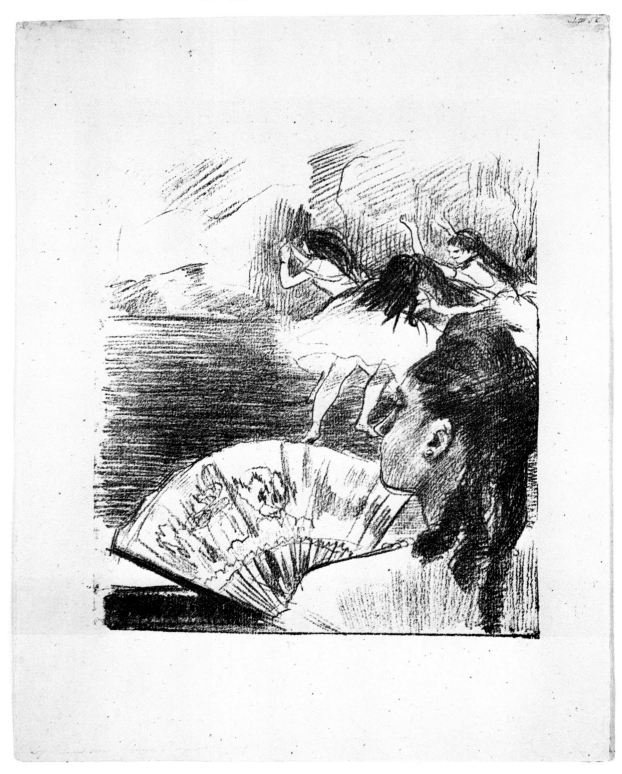

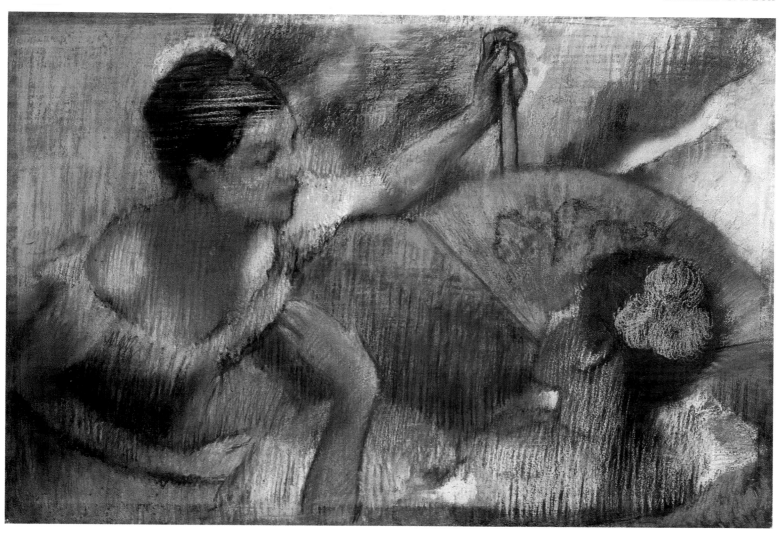

DANCERS AT THE OLD OPERA HOUSE

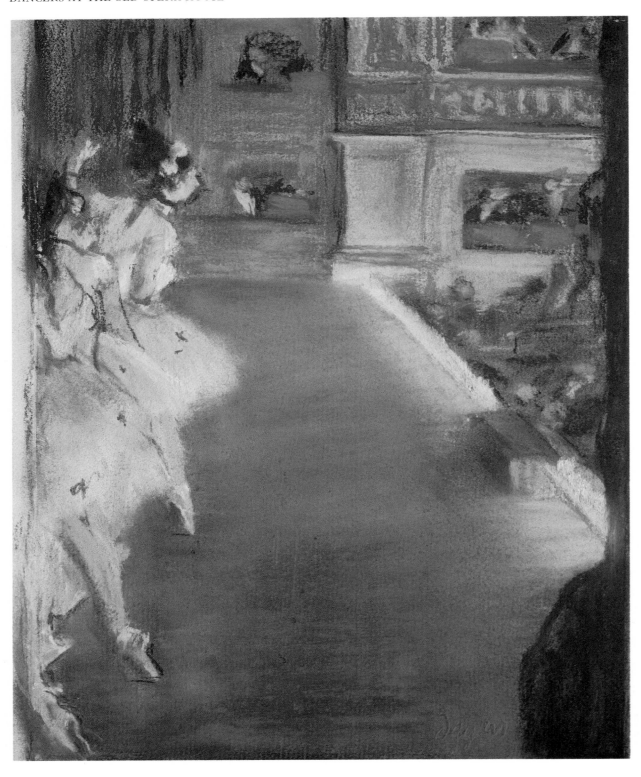

DANCER ON STAGE

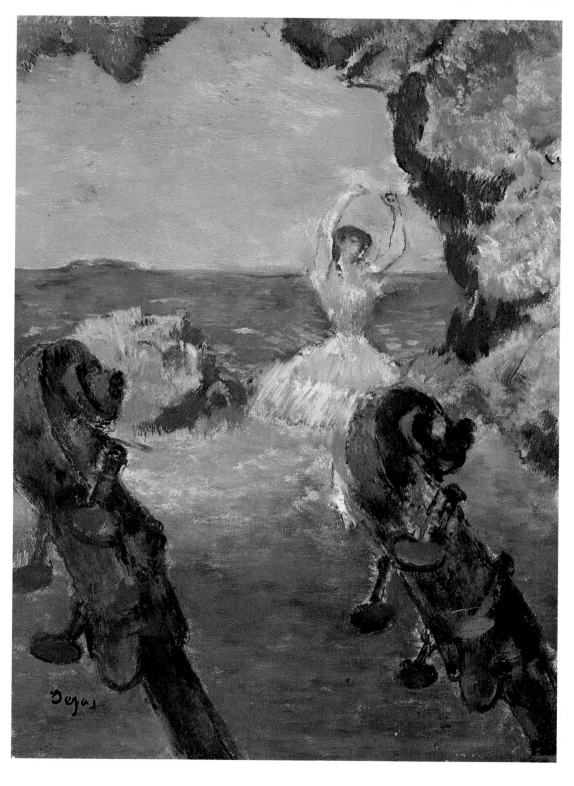

STUDY FOR THE LITTLE DANCER OF FOURTEEN YEARS (NUDE)

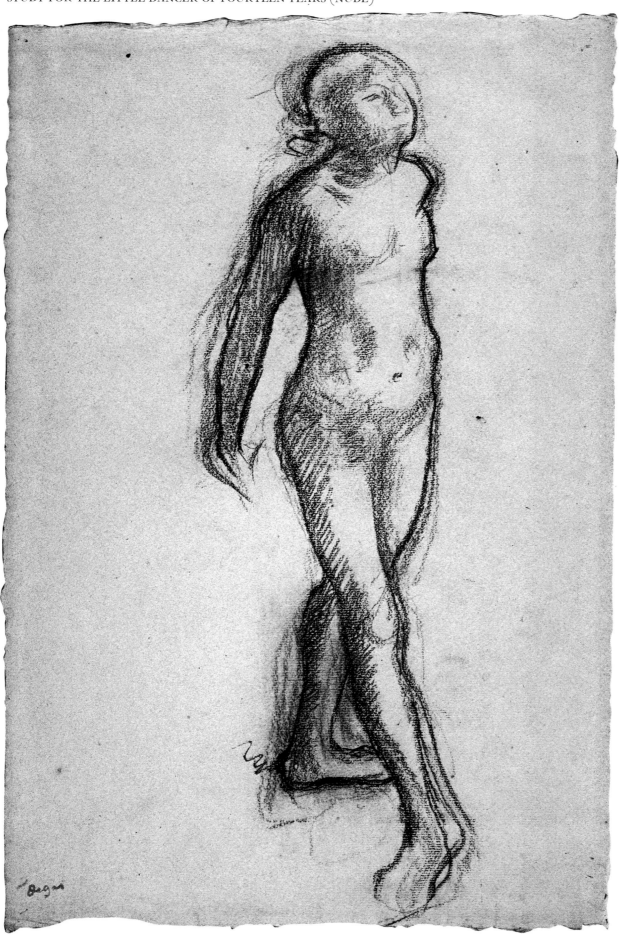

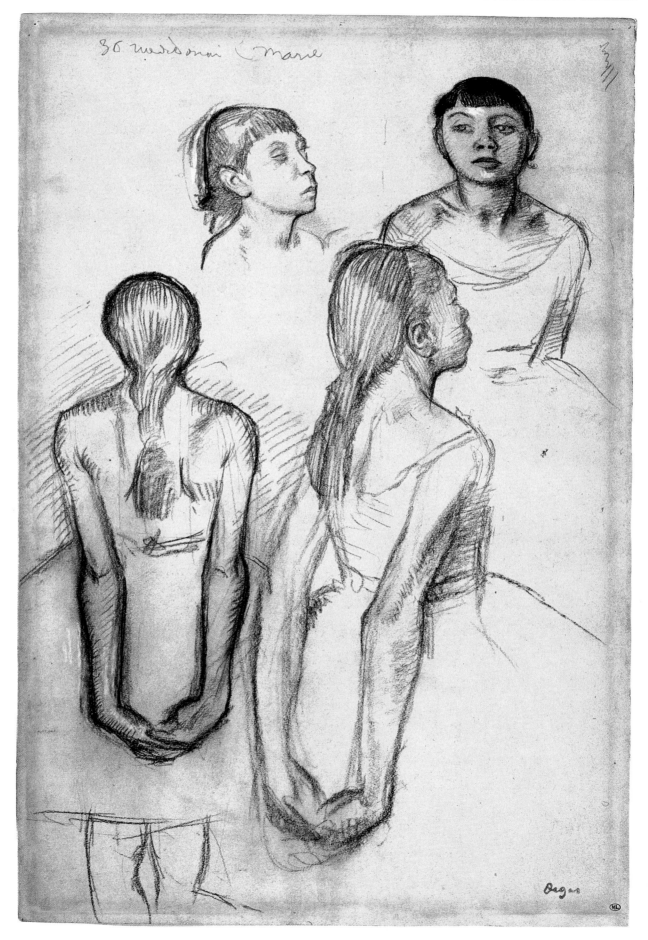

TWO DANCERS IN THEIR DRESSING ROOM

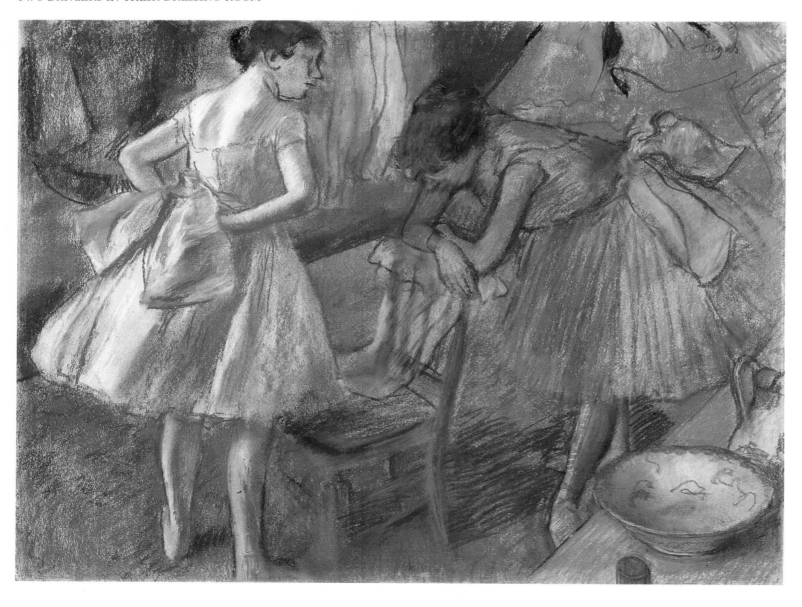

BALLET GIRL

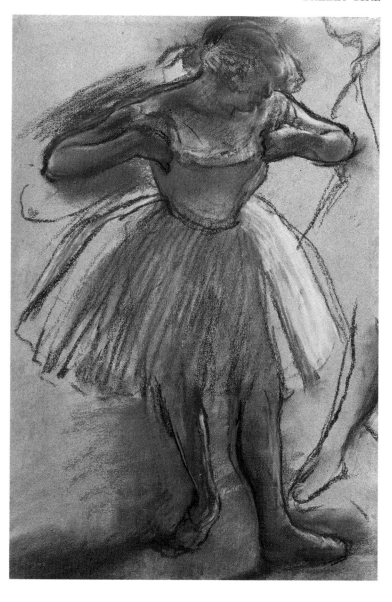

WAITING

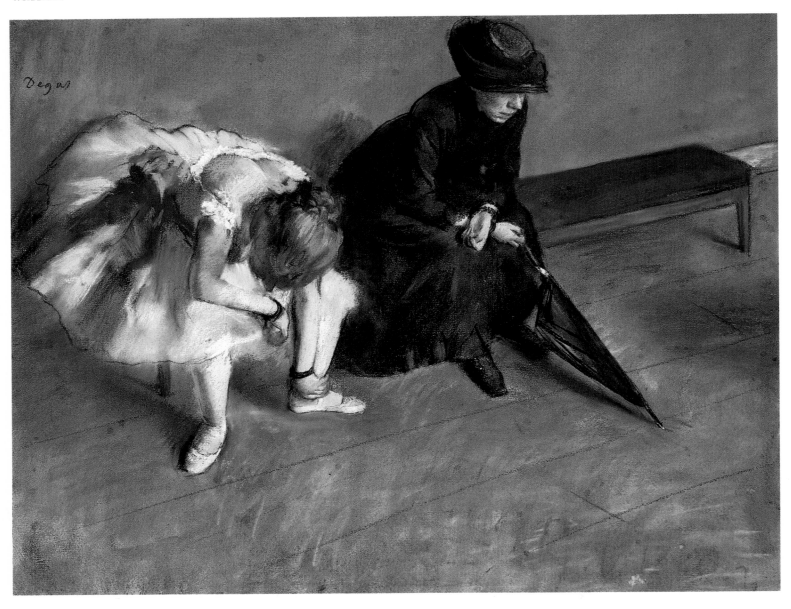

SEATED DANCER

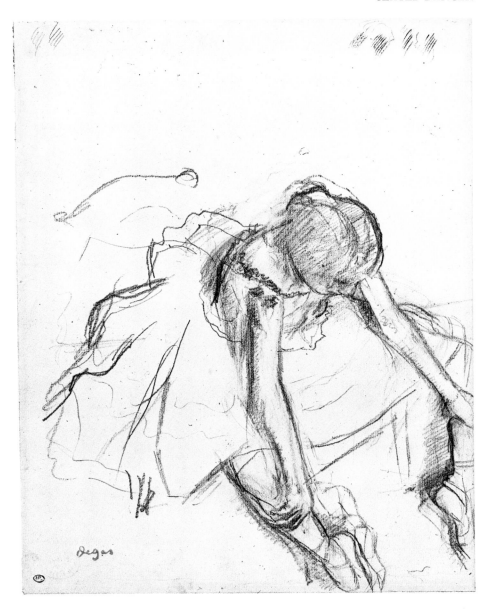

Late maturity and old age 1886–c1912

In the Eighth Impressionist Exhibition of 1886, Degas exhibited part of his extraordinary series of pastels of nude women washing, drying themselves and dressing their hair. By this time, pastel had become his preferred medium and he used oil-paint only occasionally; as his letters show, he also continued to experiment with a range of other techniques, including monotype, lithography, photography and sculpture in wax and clay. Some of these experiments, such as the coloured monotype landscapes, resulted in images of exceptional daring which look like products of the 20th century rather than the 19th century, while others led to frustration and failure.

Degas was a severely self-critical artist and his writings often show him disenchanted with his life and his achievement. His later years were dominated by a relentless routine of studio activity, protected against disruption by his implacable house-keeper Zoé and relieved only by his travels. The severity of Degas' judgments could also be brought to bear on contemporary issues, as his conversations show, and on his friends and acquaintances. On more than one occasion Degas had to write to his friends, such as Evariste de Valernes, to excuse his former harshness and to remind them of the real affection that was so often concealed beneath his abrupt manner.

Friendship and family ties took on a new significance for Degas in the relative isolation of his later career, and some of his letters can be both intimate and confessional. His delight in friendship is most colourfully demonstrated in the carriage-journey of 1890, when he and Bartholomé travelled to visit Georges Jeanniot in Burgundy; Degas despatched almost daily notes to Ludovic Halévy in Paris and other friends like Manzi and Forain journeyed to meet them at prearranged rendezvous. The journey also stimulated Degas' experiments with the colour monotype, a process which involved making a picture in inks or paints on a polished metal plate which is subsequently printed on to a sheet of paper by pressure from a printing press.

Ludovic Halévy, Degas' correspondent on this and many other occasions, was another intimate of the artist's later years. Halévy was a writer, whose fictional account of life back-stage at the Opera inspired some of Degas' monotypes, and also a librettist who collaborated on a number of contemporary operas. His house was a second home for Degas for many years and his son Daniel, who wrote down Degas' conversations after his frequent visits, accumulated one of the most important records of the artist's opinions and social behaviour.

In the early years of the 20th century, Degas was given to complaining about his ill-health and declining eyesight, his increasing isolation as his acquaintances died and the continuing difficulty of his artistic projects. His note to Durand-Ruel, the picture dealer, in which he threatens to raise his prices, must be seen against the increased demand for his work and the artist's obsessional accumulation of paintings by his predecessors and contemporaries. And the world-weary tone of his last correspondence must not detract from the startling, even violent, power of some of his late drawings, pastels and sculpture.

Naples, 7 Jan. 1886

TO BARTHOLOMÉ Dear and Excellent friend, I found your letter very much in evidence on my dressing-table when I reached Naples. Thank you very much. Your heart is full of goodness towards me, and you are always careful to let me know it quickly. I wish I were already back. Here I am nothing more than an embarrassing Frenchman. The family is going away. All the world, almost, is divided. May they soon return me to my palace of flames like the Valkyrie, that is to say to my studio heated by a good stove. . . .

Happy New Year to your wife and to you. I have just forced myself to write and even when writing to you I get no ideas. I shall write you a long letter another time. And do you know what I am going to do before dinner, to rest and get a little air? No, you do not know that I am going to walk down as far as the Palazzo Gravino, that is to say the post office, to send off four letters of four pages each – then in a tram reach Posilipo via Santa Luce as if it were the Trocadero.

Warmest greetings, DEGAS

*

Naples, 17 Jan. 1886

TO BARTHOLOMÉ Today, Sunday, I was to have gone to Pozzuoli, to Lago Fusaro, to Baia etc. to do a tour, my dear friend, to see what I had never seen in my journeys to Naples! It is raining and I am writing, which is not in any way disagreeable seeing it is to you that I am writing. Your wife, recognizing my handwriting, will open this one too while you are busy with the commissions you do so well. . . .

They are not forgetting me in Paris, you are not the only one to write to me, my good friend. But no one writes better or more affectionately than you do, not even the women. . . . I am speaking of other times, for with the exception of the heart it seems to me that everything within me is growing old in proportion. And even this heart of mine has something artificial. The dancers have sewn it into a bag of pink satin, pink satin slightly faded, like their dancing shoes.

I am anxious to see your picture. How pretty the photographed drawing is that you gave me! But it is essential to do the same subject over again, ten times, a hundred times. Nothing in art must seem to be chance, not even movement.

*

Paris, Thursday, 1886

TO HENRI ROUART Your sad and good letter did not need to be sent on. I am still in Paris, my dear friend. In about a week's time I may go and spend a short time with my old bourgeois of the Orne, and I need to do so more for the sake of my eyes than of my mind. It is not too bad in town if one likes it. And, at heart, you know quite well I do rather like it.

One must continue to look at everything, the small and the large boats, the stir of people on the water and on the dry land too. It is the movement of people and things that distracts and even consoles if there is still consolation to be had for one so unhappy. If the leaves of the trees

did not move, how sad the trees would be and we too! There is a tree in the garden of the neighbouring house which moves at each breath of wind. Well, it's all very well my being in Paris in my almost dirty studio, I say to myself that this tree is delightful . . .

*

Paris, Saturday, *Sept. 1886*

TO LUDOVIC HALÈVY My dear friend, Stevens and I are very concerned about an unfortunate girl who posed a lot for us. She is in the last stages of consumption. One could say a lot about poor Valerie Romi's kindness and honesty. She is dying a victim of her home, of her mother and sisters who used her as a Cinderella. This Cinderella is giving up the young Prince and wishes to go and die in a Nursing Home. Steven tells me that there is a home for consumptives founded by your friends the Rothschilds. Would you be able to get her in there? Give me an answer.

Best wishes to everyone,

Kind regards, DEGAS

*

Thursday morning, *16 June 1886*

MY DEAR MONSIEUR FAURE, I receive your friendly summons and am going to start right away on your *Courses*. Will you come here towards the end of next week to see how it is progressing? The unfortunate thing is that I shall have to go and see some real racing again and I do not know if there will be any after the Grand Prix.

If it is finished I shall set to work on the *Blanchisseuse*.

In any case you will be able to see something of your own next Saturday, 24 June, between 3 and 6 o'clock.

Kind regards, DEGAS

*

Friday evening, *2 July 1886*

MY DEAR MONSIEUR FAURE, I shall need a few more days to finish your big picture of the Races. I have taken it up again and I am working on it.

A rather nasty trick that has been played on me has just monopolized me for eight days on something other than your things. It was necessary to stop up a gap at once.

A few days more and you will have satisfaction.

DEGAS

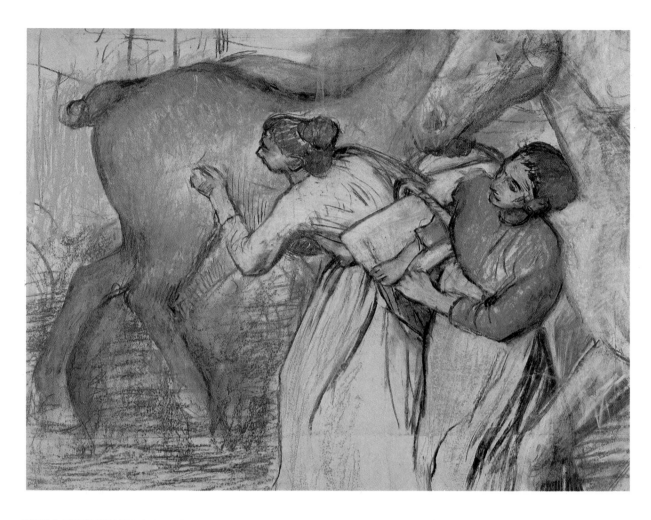

TWO LAUNDRESSES AND HORSES

2 Jan. 1887

MY DEAR MONSIEUR FAURE, I received the other day on an *open* telegram your request for a reply to your last letter. It is getting more and more embarrassing for me to be your debtor. And If I do not terminate my debt it is because it is difficult for me to do so. This summer I set to work again on your pictures, particularly the one of the horses, and I had hoped to bring it to an end rapidly. But a certain Mr. B. judged it right to leave me saddled with a drawing and a picture that he had ordered from me. In full summer this dead loss overwhelmed me. It was necessary to put aside all the things belonging to Mr. Faure in order to fabricate others which would enable me to live. I can only work for you in my spare moments and they are rare.

The days are short, little by little they will grow longer, and if one earns a little money one will be able to take up your work. I could enter into long explanations. The ones I give you are the simplest and most irrefutable.

I beg you therefore to have a little more patience, I shall have some in finishing things which must swallow up my poor time gratuitously and which love and respect for my art forbid me to neglect.

Accept, my dear Monsieur Faure, my sincere regards.

DEGAS

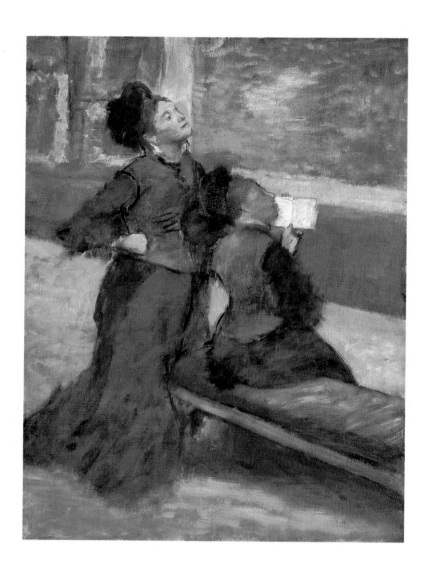

VISIT TO A MUSEUM

To M. le Comte Lepic
Supplier of good dogs, at Berck

Dear Monsieur, I have been twice too satisfied with your deliveries not to turn to you once again. Could you not either from your kennels and apartments, or from your friends and acquaintances, find me a small griffon, thoroughbred or not (dog or bitch), and send it to me to Paris if an opportunity arises, or by carrier. As regards the price I shall not consider that any more than you did. However if you should wish to draw on me for a sum exceeding 50 centimes, I should be grateful if you would warn me some months in advance as is always the custom in these parts.

Please accept, Monsieur le Comte, my sincere regards.

E. Degas

I think it in good taste to warn you that the person who desires this dog is Mlle Cassatt, that she approached me, who am known for the quality of my dogs and for my affection for them as for my old friends etc etc. I also think that it is useless to give you any information about the asker, whom you know for a good painter, at this moment engrossed in the study of the reflection and shadow of chairs or dresses, for which she has the greatest affection and understanding . . .

This distinguished person whose friendship I honour, as you would in my place, asked me to recommend to you the youth of the subject. It is a young dog that she needs, so that he may love her.

By sending with the dog, if you do send the dog, you would give an appreciable pleasure to your requester, by sending with this dog some news of your health and of your noble pursuits.

Hotel de Paris, Madrid, 8 Sept. *1889*

To Bartholomé You could write me a line, my dear Bartholomé, to this
address for our return from Andalucia. For want of you, whose absence I, and even Boldini, feel
to such a degree, that at every moment we say 'if Bartholomé were here, how happy he would
be!' you could tell us how your brother is, what possibility there still is for you to join us.

Arrived this morning about 6.30. (You would have liked to arrive at a time that suited you
better, for instance 4 o'clock, but you would not have been able to). From 9 o'clock until about
midday, visit to the museum, back at the hotel and lunch (since we have been in Spain we have
eaten admirably and people always spoke of food poisoning), a heat that presages something
incredible at Andalucia. The bullfight, for which we are preparing, will not take place until
4.30. They themselves expect that the sun will not wither them. Nothing, no nothing can give
the right idea of Velázquez. We shall speak of it all the same on my return, with other things.

I beg you once again, my dear friend, try and join us in Madrid. You could economize more
than we do, you are tougher and less exacting than we are. Reckon it out with the timetable,
and I bet that with 300 francs you could get a return, travelling second class. We should imitate
you. Boldini keeps the accounts and you can form some idea of the need he feels to spend. I shall
send you a wire from Seville, so that you can mark us on the map.

It seems possible to set foot in Morocco, but only for a few hours.

I am going to sleep a little, which I did too little last night (18 hours from Irun to Madrid).
Met Bonnat on the outside of the omnibus at Biarritz.

Sincerely yours with all my heart,
Degas

*

Continental Hotel, Tangiers, Morocco, 18 Sept. *1889*

To Bartholomé One can do nothing less than write to you, my dear
Bartholomé, from such a spot. Can you imagine me on a mule, taking part in a cavalcade that
was led by a guide in a violet silk robe on the sand of the sea, in the dust and along the paths of
the surrounding countryside, and then across Tangier?

Another year will we be able to do the same journey that you gave me the sorrow of doing
alone, or very nearly? The guide in the silk robe knows French, but it is not yours.

One loves in nature those people who have not been unworthy to appreciate it. I tell you
this because Delacroix passed here.

The boat brought us here under a grey sky, but there were all the same in this grey more
pearls than slate.

I have nothing to tell you, I am writing to you to date my friendship from Tangiers. In a
week at the most I shall be in rue de Chaillot. Tomorrow, return to Cadiz, from whence we
leave Friday at 5 o'clock from Granada. After this last effort one can re-read *Thousand and One
Nights*. I read in a book that here the families still preserve their landowners' titles in Spain and
the keys of their houses through the centuries through which I am passing in such bad company.

Kind regards to rue de la Pompe and very sincerely yours with all my heart.

Degas

From the diaries of Daniel Halévy

Monsieur Degas has just lunched here. And Degas lunches are for me the greatest feasts imaginable. In my eyes Degas is the incarnation of all intelligence.

Today he defined education as follows: 'It consists in making a man unfit for any number of occupations by which he might earn his living. In the past ballerinas were the daughters of *concierges*; now they are given diplomas by the government!'

And later he said, 'I now see that it is only late in life that a man can read. When you are young your aim is to finish the book. When you are old you want to slow down. Re-reading a book for the second or third time you are struck by the details. Every line has a fresh meaning.' And he ended by saying, 'You must have five favourite books and never abandon them.'

*

12 Nov. 1888

Monsieur Degas said today: 'There are some women who should barely be spoken to; they should only be caressed.' . . .

*

6 June 1890

. . . Jacques said that nothing seemed to him as precious as the friendship of a man as marvellous as Degas. He has lunched with us often lately and one day with George Moore. Good old Moore becomes silent the instant Degas appears and watches him with the eyes of a child. . . .

Mama said to Degas in speaking of his new apartment, 'It's charming, but do remove your dressing-room from your picture-gallery. It spoils the whole thing.' Degas replied firmly, 'No, Louise. It is convenient to me where it is; and I don't put on airs, do I? In the morning I bathe; and then I go back to bed in my nine-franc-fifty flowered dressing-gown. I am perfectly happy and I say to myself: This is the life of a worker.' 'But,' Mama persisted, 'your dressing-room is so funny.'

'No, no, Louise! No airs, nothing forced. For a poor man I am well off. Let me stay that way.' Moore said to him: 'You revolutionary painters . . .'

'Revolutionary! Don't say that,' said Degas. 'We are *tradition* itself. It can't be said too often. And perhaps Titian will say a few words to me as he steps into his gondola.'

*

30 Dec. 1890

. . . Degas talked about Lourdes which he had recently passed through. My grandmother interrupted him in a critical tone of voice.

'Lourdes,' she said, 'can you enjoy the spectacle at Lourdes?'

'Bah,' Degas replied. 'I saw all kinds of people, all kinds of things. A tall young man dressed like a stretcher-bearer, waiting, extremely bored, for some invalid to hire him. I imagine that he had promised to work for a fortnight to please some old aunt who was leaving him something in her will. And then, too, I saw women kneeling, their faces transfigured by faith. I saw lots of things at Lourdes.'

SIX FRIENDS OF THE ARTIST
(SICKERT, DANIEL AND LUDOVIC HALÉVY,
BLANCHE, GERVEX AND CAVÉ)

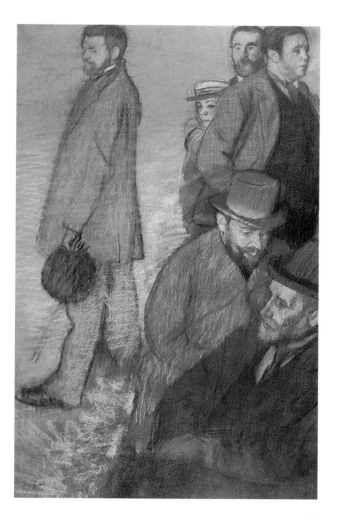

But my grandmother insisted, 'If someone said that you had lost your mind you know you wouldn't like it!'

'If someone said I had lost my mind,' Degas replied, 'don't you think I'd be pleased? What use is my mind? Granted that it enables me to hail a bus and pay my fare. But once I am inside my studio, what use is my mind? I have my model, my pencil, my paper, my paints. My mind doesn't interest me.'

*

9 Jan. 1891

Lots of Degas these days. He came to lunch Wednesday; and à propos of Madame Howland, who still has *shoulders*, he sounded off. 'What difference does it make to us if they have shoulders when their faces are old and their necks wrinkled? Women expose themselves quite naked, twisting from side to side to show that they still have shoulder-blades! How the Orientals must laugh at us.

'One day at the Opéra,' Degas continued, 'two ladies were resting their great, fat arms on the velvet railing of their box. Suddenly, from up in the gallery, came the cry "Down with that ham!" Nobody understood. Again the plaintive voice from the gallery: "Down with that ham!" The audience began to whisper, trying to understand. Finally they caught sight of the fat arms and hooted. The ladies were forced to withdraw.

'What would an Oriental say coming into a bourgeois salon and seeing naked cows sitting on chairs while their husbands, who have made a neat little fortune in business, stand by half-hidden in doorways? The mere fact of being a woman's husband obliges him to haul her from one salon to another quite naked. – If you could have seen Madame de Fleury that year at Diennay! I sat next to her at dinner one evening; she was *décolletée*! and even though I am rather surfeited with such things, I couldn't keep from looking at her arms, her shoulders, everything –. She said, "Are you staring at me?" "Good Lord, Madame," I replied, "I wish I could do otherwise".'. . .

. . . Degas attacked my uncle Taschereau who reads two books a day. 'Don't read,' he said. 'You only do it out of laziness to avoid thinking. A man should be able to spend hours by his hearth, watching the fire burn, thinking over cherished thoughts – one must have one's own personal thoughts.' – I tell it badly, but he spoke very emphatically with something of the fury of a blind man who *can't* read.

*

17 Jan. 1891

I am reminded of a remark of Degas to Gérôme who said to him: 'An artist is always objective.' 'Objective!' Degas replied. 'What about the Italian Primitives who represented the softness of lips by hard strokes and who made eyes come to life by cutting the lids as if with a scissors; and what about the long hands, the thin wrists of Botticelli? Where is your objectivity in art?'

*

22 Jan. 1891

Yesterday at dinner Jacques Blanche, Taschereau, Meilhac, Degas, us – delightful. Four is the maximum for dinner guests. After dinner Degas talked to us about Ingres. Abraham Dreyfus, who came in during the evening, wondered whether the phrase *good* writer or *brilliant* writer should be put on a tombstone.

'Do you want me to tell you a little story about the word *good*?' Degas asked. 'It was the only time I talked to Ingres. I was sent to go and ask him for the loan of a picture for an exhibition. And I took advantage of the opportunity to tell him that I was doing some painting, that I was in love with art and would like his advice. The pictures that hung in his studio are still photographed in my mind. "Draw lines, young man," he said to me, "draw lines; whether from memory or after nature. Then you will be a good artist."' . . .

Then Degas spoke with admiration of Ingres' wit: 'It's curious. There is Delacroix, an admirable artist whose little pamphlets are so dull – you can't, on the other hand, quote a remark of Ingres that isn't a masterpiece.' And standing in front of Jacques he repeated:

'"Form is not in the contour; it lies within the contour."

"Shadow is not an addition to the contour but makes it."

"A reflection on the shadows of the contour is unworthy of the majesty of art."

"One must master the inner structure in order to express the planes."

"Muscles I know; they are my friends. But I have forgotten their names."'

'It was in 1855. I had a friend in Père Valpinçon, who owned *L'Odalisque au Turban*, you know, the upright one with her back to us. Well, one day, I went to say hello; "I saw your god, yesterday," he said to me. "Yes, M. Ingres came to ask me to entrust him with my *Odalisque* in order to exhibit it in the wooden hut where his work is to be gathered. Well, I gave him to understand that I was not prepared to put my picture at risk: I refused."

'This selfishness sickened me and I told Père Valpinçon that a man such as M. Ingres should not be slighted in that way, and I expressed my indignation to him so warmly that I was faced with a confused and upset man. "Well then," he said, "tomorrow I will tell M. Ingres that I changed my mind; call for me; we will go together to his house." The following day I come punctually to the appointment. M. Valpinçon and I arrive at the Quai Voltaire; we go up, ring the bell and the Master appears. My old friend apologizes for his meanness; then, having introduced me, declares that it is thanks to me that he went back on his decision and that he will lend the picture in question. We talk for a few moments, then we take leave. Lo and behold, while seeing us to the door, the portly man slips, I don't know how, on the parquet floor and, crash, there he is, stretched out on the ground. I rush to him: his head is covered in blood and he says nothing. He has lost consciousness and only comes to very slowly. A sudden fit of giddiness must have been responsible for this fall.

'I then left M. Valpinçon with him and ran to the rue de Lille to let Mme Ingres know. I told her what happened as well as I could, and brought her back with me. As we crossed the threshold of the house, M. Ingres, supported by M. Valpinçon and the concierge, was just climbing into his visitor's carriage to get back home. We turned him over to his companion and our adventure came to an end.'

'I met M. Ingres some time after that,' our talker went on. 'That day he had organized in his studio a little exhibition in the manner of the old masters – I came there incognito with a friend who knew him and got him talking. There were there, among others, three paintings that struck me because of the remarks they attracted. First an *Homère* leaning on I don't know which companion, the subject of which the Master explained to us. My friend congratulated him for rendering the antique with so much perspicacity. The compliments were received with complacence. Others about the portrait of Mme Moitessier were accepted just as easily.

'Finally, catching a glimpse of a round version of the *Bain Turc*, "Oh!" my companion said, "that is yet another style," – "But," M. Ingres said, "I have several brushes!"' M. Degas repeated this "I have several brushes" three or four times, laughing. – 'Isn't that delightful?'

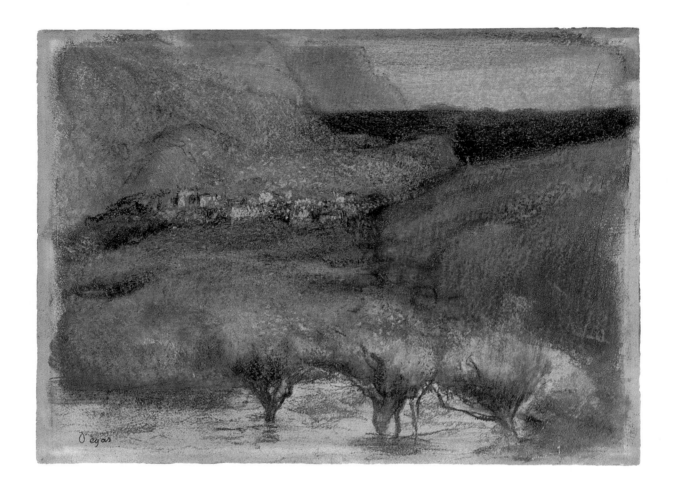

OLIVE TREES AGAINST A MOUNTAINOUS BACKGROUND

Sunday morning, *1890*

TO GEORGES JEANNIOT The time is approaching; a white horse is crossing the forest
of Senart, drawing behind him two old men, one of whom, still a little younger, is holding a
whip, seated a little higher. He, it appears, knows just where he is going. He does not believe
the peasants, who never tell the truth about the way. He says that he who knows how to read a
map should travel with his eyes closed. For a whole week maps had been struck on the walls of
the studio, and he studied them with a little rolling instrument in a dial, which was to prepare
the varied route. He who has drawn a straight line and who wishes to follow it will not drink,
say the scriptures.

We shall leave about midday. The white horse is intact, so is the tilbury, so are the two men,
but less so, thank heavens! . . .

He who scorches the roads with a white horse at the rate of ten leagues an hour, say the
scriptures, is certain to arrive in a short week at the place unknown to the horse and familiar to
the two old men. Of all the people in the secret of this displacement not one hesitated to
proclaim the good sense of the two friends that you, dear Madame, and also your captain have
the good fortune and the inconvenience of possessing. Notices sent out en route will enable you
to follow us on the map and to see us approaching perfectly happy.

A visit to Burgundy, 1890/A group of letters to Ludovic Halévy

Everything goes like clockwork. He appeared this morning without animation at half past six. He left feebly. There was nothing wrong with him. He had slept too much. Near Valence and in the wood we passed some charabancs (one of them a cart, in which a Louis XV chair upholstered in red contained an old man) full of people in black who must have been a funeral party seeing that they all looked exceedingly happy. He himself, he sensed Montereau from more than a league away, old stager that he is. . . .

Everywhere praise of the horse, particularly in the stables. He is guaranteed to us from hour to hour. 'You have had him a long time,' said the stable boy to Bartholomé. 'He was born at my place,' he replied. Alas! we have only had him for two days! What would we not have done already if we had had him in our days of maturity! Left at 4 o'clock for the continuation.

*

Sens, 2 Oct. 1890

Montereau, Hôtel du Grand Monarque
(the real one)

LUNCH

Sheep's foot
Fried gudgeon
Sausage and mash (admirable)
Beef steaks with cress
Cheese, fruit, biscuits (admirable)

The horse made a fine descent on Montereau.
Left at 3.30 for Villeneuve-la-Guyard.

DINNER

Panada with milk
Brains in melted butter
Jugged hare
Leg of mutton, mixed beans (splendid)
Salad
Mixed dessert
Light red wine

Left this morning at 7 o'clock.
No more thoughts, one eats too much. Each meal 3 francs.

A visit to Burgundy, 1890

Saint-Florentin, 3 Oct. 1890, Friday, 1.30

No possibility of eating a cutlet in the province, what is good on a cutlet goes to Paris. Bartholomé is the right man. Beneath that Trappist's beard of his is the heart of a coachman. En route for Flogny.

*

Flogny, 3 Oct. 1890, Friday evening

One needs to have been sad and serious for a long time to enjoy oneself so much. It is useless to be horrified at having such emotions. Our coachman is carrying the horse in his arms. The forelegs might betray us – 42 leagues done with a real expert's touch.

*

Tanlay (Yonne), 4 Oct. 1890

. . . If I was the lunatic who thought of this journey, Bartholomé is the wise man who will finish by carrying it through.
18 litres of oats a day, is it enough? Your turn now, write to the Jeanniots at Diénay . . .

*

Aignay-le-Duc, 5 Oct. 1890

Always to the minute. Amazing! We are lunching chez Copain where we have found some incredible gherkins . . . Over there is the Seine where our horse has had a leg bath. There is only one country, it is ours, Monsieur.

*

Molay (Côte-d'Or), 6 Oct. 1890

Go and learn a little geography, thanks to us. Almost arrived, seeing that we are only 11 kilometres from Diénay, we tell you that the real traveller is the man who never arrives.

*

Diénay, 7 Oct. 1890

Arrived here at 4.30, a quarter of an hour too early for the ceremony. At the insistence of a person sent to meet us, we waited for the three quarters to strike. Then a real policeman (Jeanniot) on horseback came and demanded our papers. A sub-prefect in uniform (Couturier) advanced with a dish and two keys and a speech, interrupted by the ladies as if from a cannon, who scattered the flowers of honour. General ecstasy, joy everywhere, a joy of good hearts. – Received your letter this morning.

We were warned of the exact time at which the white horse was to appear on the road. All our friends were there, the young girls with their baskets of flowers, Edmond Couturier, as an inspector carrying the keys of the village on a silver dish. I myself, as a policeman, represented the public services. When the moment came the young girls advanced with their flowers, with which they covered the horse and the travellers. The keys were offered to Degas who was very touched by it. Our little band, escorting the carriage, entered the village slowly, with all the dignity worthy of the occasion. . . .

'And now, take me to your studio,' Degas said to me as we were leaving the table.

As he walked in, an expression of pleasure and well-being appeared on his face. And yet this country studio, installed in the garret of our house, really was very simple. In short, an attic with a few antique chairs, two or three easels, a settee with cushions, an etching press, a stove and everything necessary for making prints.

'That's the spirit!' he cried out, 'we are going to be able to work in your Swiss clockmaker's workshop, you have paper, ink, the printer's brush with your initials on! Heavens! Then it is serious. This pad is superb and fits well in one's hand. Let's get on! Have you a smock?'

'Yes, and it is a printer's smock, brand new.'

'Your press must be hard work, with only one gear-wheel.'

'Yes, quite hard, but we have muscles!'

'Your studio is charming.'

I put the smock on him, he had taken off his jacket and rolled up his sleeves.

'Do you have copper or zinc plates?'

'Here you are. . . .'

'Perfect! I will ask you for a piece of cloth to make a pad for my own use; I have been wanting for so long to make a series of monotypes!'

Once supplied with everything he needed, without waiting, without allowing himself to be distracted from his idea, he started. With his strong but beautifully-shaped fingers, his hand grasped the objects, the tools of genius, handling them with a strange skill and little by little one could see emerging on the metal surface a small valley, a sky, white houses, fruit trees with black branches, birches and oaks, ruts full of water after the recent downpour, orangey clouds dispersing in an animated sky, above the red and green earth.

All this fell into place, coming together, the tones setting each other off and the handle of the brush traced clear shapes in the fresh colour.

These lovely things seemed to be created without the slightest effort, as if the model was in front of him.

Bartholomé could recognize the places they had gone through, following the gait of the trotting white horse.

After half an hour, no more, Degas' voice suggested:

'If you don't mind, we'll print this proof. Is the paper wet? Have you got the sponge? You do know that semi-sized paper is the best?'

'Calm down, I have some strong Chinese.'

'He has got some Chinese! Let us see this Chinese. . . .'

I put down an imposing roll on the corner of the table. When everything was ready, the plate laid on the press, the paper on the plate, Degas said: 'What an anxious moment! Roll, roll!' It was an antique press with heavy cross-shaped spars. Once the proof was obtained, it was hung on lines to dry. We would do three or four in a morning.

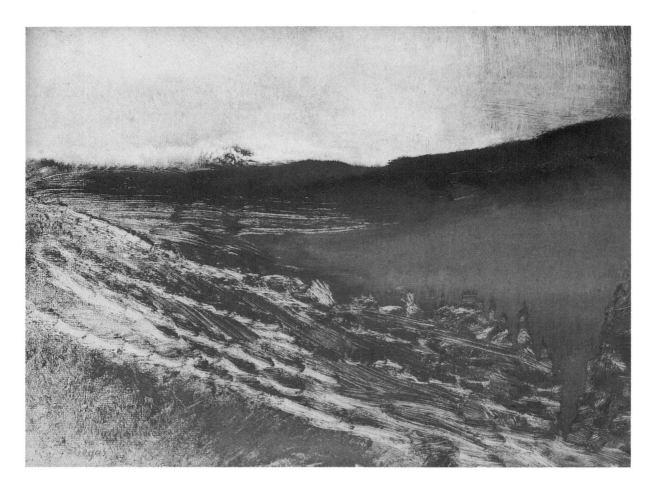

BURGUNDY LANDSCAPE

Then, he would ask for some pastels to finish off the prints and it is here, even more than in the making of the proof, that I would admire his taste, his imagination and the freshness of his memories. He would remember the variety of shapes, the construction of the landscape, the unexpected oppositions and contrasts; it was delightful! . . .

One morning at Diénay Degas said to me:

'I would like to show you how one should go about putting a picture together.'

The previous day, we had been to Gérard, Diénay's baker. In the billiards-room (for Gérard was also a publican), there were some seasoned players looking like poachers, colourful faces and heavy drinkers' eyes, of the type you find there. They were playing amidst pipe-smoke and in the warm, enlivening atmosphere of a sunny day . . .

I had done sketches of these strange characters. Degas, taking a canvas, said to me:

'Here you are, draw what we saw at Gérard's, and fix it in Indian ink in bold strokes.'

Once this was done, he took hold of the canvas and started to trace with a ruler some horizontal lines in lemon pastel and some vertical lines in vermilion.

The result: a flamboyant rectangle.

He asked for linseed oil, as old as possible, some spirit of turpentine, some siccative, making it into a mixture which he spread rapidly over the rectangle with the aid of a large brush. The white canvas became an orange surface under which, in black, appeared the drawing in Indian ink. He prepared five or six colours: a strong green, light and more blue than yellow; a Prussian blue; a cadmium orange; a flesh tone with white and mars orange to re-touch the black drawing on top of the orange.

'You understand,' he said to me, 'that this performance is intended to fix the procedure in the memory, and it may provide a little amusement as well.'

A visit to Burgundy, 1890/A group of letters to Ludovic Halévy

The journey was resumed yesterday at 3 o'clock. Follow on the map, from Diénay to Saint-Seine via Villecomte, where the two carriages, the one drawn by a donkey, with the families Jeanniot and Couturier, left us; via Francheville, Vornot, Prairay. First danger after Prairay, there was a sunset just like a painting; the silhouette of a calvary almost bowled us over . . .

*

Darcey, at Mme Bergeret, 13 Oct. 1890

Still unwell (did I tell you?) in spite of bismuth and doses of laudanum. Bartholomé, his hand swollen from a sting, swathed in antiseptic bandages, drives with his left hand. Nothing can stop the carriage from crossing Saint-Seine . . .

*

Tonnerre, 15 Oct. 1890

You will reproach me for not having invited you to lunch at the Lion d'Or? One does not eat like that once one is a member of the Academy you will tell me – with one hand, the right one, I am writing to you, with the other I am eating a dish in which things are happening that chicken and veal can produce only here. – Bartholomé's right hand is eating grapes. We are living . . .

I am re-immersing a biscuit into some white wine, and you will see us again after 182 kilometres, that is to say Monday, for lunch. There I shall eat no more.

*

Saint-Florentin, 16 Oct. 1890

Rain all night, but we were in bed. This morning the wind arose, chased away the clouds and blew us here in the dry. People clean their windows a lot in the province and they see nothing through these windows. That is what the man with the afflicted left hand says. If we arrive in Paris without leaving the animal on his knees, you can say that he is some coachman.

*

Melun, 9.30 18 Oct. 1890

One does not give Brie like that to Parisians! said Forain to the waiter. He arrived on his tricycle in a Garibaldian get up, he speaks of the destiny of speed. He is on his feet and speaking with a piece in his mouth.

*

Hotel de la Chasse, Montgeron, 19 Oct. 1890

. . . Soon each will be at home. We should have liked to find you here in good health and hurl ourselves at your table – we were rather quick from Melun, it seems to me. The coachman B. has a very bad hand. It is time he left the whip for a poultice.

MONSIEUR BOUVENNE, So you are the exhibitor of this little programme for the concert at the Quai Malaquais. It was with surprise and anger that I read your name on the catalogue. So you did not think that you lacked my consent. You were not, I very much fear, at the concert and it is not from there that you received the proof. It is more than probable that, over and above the copies ordered and paid for by M. Clemenceau who directed the fête, you had your copy printed. It was an excellent reason to keep it in a box, or not to take it out without my consent. I should not have given it to you, and the idea of being represented in this lithographic revue by this unique piece would have seemed like a joke to me.

I insist, on all occasions to appear, as far as possible, in the form and with the accessories that I like. I can scarcely compliment you on your strange *sans gêne*.

My friend M. Alexis Rouart, who is, I think, on the committee, did not think that he could exhibit a proof by Mlle Cassatt without writing to her. She replied that she would permit it. You did not show the same consideration.

Be good enough to have the six lithographic stones, that the maison Lemercier lent me some years ago for some proofs, fetched from 37 rue Victor-Massé. Very fortunately there is nothing at all on them.

I have the honour, Monsieur, to salute you.

<div align="right">DEGAS</div>

<div align="center">*</div>

<div align="right">Ménil Hubert, 16 Aug. 1892</div>

Here I must ask your pardon for a thing which often comes up in your conversation and more often still in your thoughts: it is to have been during our long relationship to art – or to have seemed to be – *hard* with you.

<div align="center">*</div>

<div align="right">Saturday, 27 Aug. 1892</div>

TO BARTHOLOMÉ Just imagine I am still here. And yet it is necessary for me to leave. I wanted to paint and I set about doing billiard interiors. I thought I knew a little about perspective, I know nothing at all, I thought that one could replace it by a process of perpendiculars and horizontals, measure angles in space by means of good will alone. I dug myself into it . . .

Paris, 26 Oct. *1890*

 I have been thinking constantly of you with the most affectionate feeling and I did not write to you, my dear de Valernes.

 I see again you and your little studio, where I gave the impression of looking too quickly. I see it again, as if it were in front of me. . . .

 Here I must ask your pardon for a thing which often comes up in your conversation and more often still in your thoughts: it is to have been during our long relationship to art—or to have seemed to be—*hard* with you.

 I have been unusually so with myself, you must be fully aware of this seeing that you were constrained to reproach me with it and to be surprised that I had so little confidence in myself.

 I was or I seemed to be hard with everyone through a sort of passion for brutality, which came from my uncertainty and my bad humour. I felt myself so badly made, so badly equipped, so weak, whereas it seemed to me, that my calculations on art were so right. I brooded against the whole world and against myself. I ask your pardon sincerely if, beneath the pretext of this damned art, I have wounded your very intelligent and fine mind, perhaps even your heart. . . .

 I found in you again the same vigorous mind, the same vigorous and steady hand, and I envy you your eyes which will enable you to see everything until the last day. Mine will not give me this joy; I can scarcely read the papers a little and in the morning, when I reach my studio, if I have been stupid enough to linger somewhat over the deciphering, I can no longer get down to work.

 Remember that you must count on me when the moment comes. Write to me.

I embrace you, DEGAS

*

 . . . I would be so pleased to see you again! If my project materializes, I plan to spend a few days with you. So we will go to work together at the place you have spoken to me about so often.

 Oh! If only I had had more time to paint from nature! . . .

*

6 July 1891

 You have guessed right, my old friend, I do not write on account of the fatigue of writing and, except for a few laconic words, my sister Marguerite is the only one to receive occasional letters from me.

 I see worse than ever this winter, I do not even read the newspapers a little; it is Zoé, my maid, who reads to me during lunch. Whereas you, in your rue Sadolet in your solitude, have the joy of having your eyes.

 Your friend M. le Marquis de Saint-Paulet came, nearly a month ago, to see me and speak at great length about you! I shall go on Wednesday (his at-home day) to return his visit. He must have there the portrait you did of him and with which he is very pleased.

 I have allowed time to slip by without thanking you for your present of the picture of the milliners, or rather the florists, which I remember perfectly, with a supple woman's hand and a

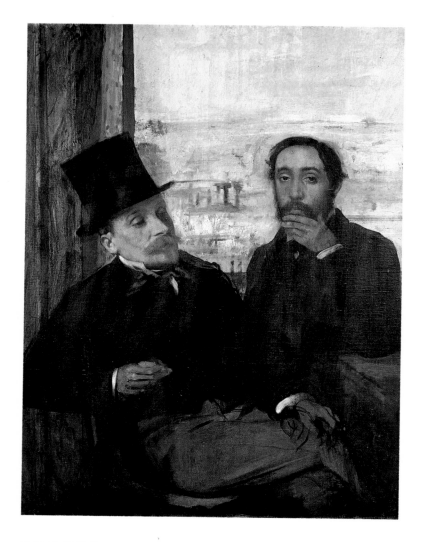

DEGAS AND VALERNES

romantic style that I can see from here. It is I who am at the moment doubly your debtor, first of all because of my promise, and secondly because of this nice present. — This summer for certain I shall go and see you and you may count on my not arriving with empty hands.

Ah! Sight! Sight! Sight!

My mind feels heavier than before in the studio and the difficulty of seeing makes me feel numb. And since man, happily, does not set a limit to his capabilities, I still dream of projects; I am hoping to do a suite of lithographs, a first series on nude women at their toilet and a second one on nude dancers. In this way one continues to the last day figuring things out. It is very fortunate that it should be so.

Will you have the courage to come to Paris one day? There will always be a *pied à terre* for you with your old friend. Desboutin, still young at 70 years, sits enthroned with his pipes at the entrance of a café, you will see him again with pleasure. And others too! Permit yourself this indiscretion and when I am at Carpentras during the holidays I shall make a more serious attempt to carry you off.

Goodbye, my dear old comrade, your letters give me great pleasure, write to me seeing that you have the good fortune to be able to do so better than I. . . .

See you soon, DEGAS

Saturday, *1892*

. . . Wednesday, the 10th of this month, barring serious accidents, I shall leave and am counting on bursting in on you at rue Sadolet on Thursday morning. A wire will confirm my departure. You will see me with a comparatively ominous looking contraption over my eyes. They are trying to improve my sight by screening the right eye and only allowing the left one to see through a small slit. Things are fairly all right for getting around, but I cannot get accustomed to it for working.

See you soon, DEGAS

*

Wednesday evening, *1893*

My old comrade, my kidneys make me grumble a lot, except at you, who have the goodness to think more of me than I do of you. Otherwise I am well and I am dreading a stay in my room, without work, without being able to read, staring into space. My sight too is changing, for the worse. I am feeling sorry for myself, so that you may know that you are not the only unhappy person alive.

With regard to writing, ah! my friends can scarcely count on me. Just imagine that to re-read, re-read what I write to you, would present such difficulty, even with the magnifying glass, that I should give it up after the first lines. And with it all I am cheerful, as you were able to ascertain yourself.

Towards the end of the year, you will see me arriving, my old friend, to rouse you for a moment.

I embrace you very affectionately, DEGAS

*

Saturday, *undated*

MY OLD AND NOBLE FRIEND, I am expecting fuller and more detailed news about your accident. M. Liébastres tells me you are calm, which does not surprise me.

I know you are awaiting death with pleasure, but that you will not leave life before your body wants to. You will therefore have to live, and not remain alone, in your small house built like a crow's nest.

I assume you still have with you that old servant, whose portrait you showed me, and who wanted so much to be with you.

And also, short of a good recovery, your school will be abandoned.

I don't know what the local Council will decide, and you even told me, I believe I remember it very well, that you would not accept the continuation of your salary. I don't want you, my dear fellow, to change your modest routine for the worse. You will therefore have to do me the honour, to give me the deepest mark of friendship, of allowing me to carry on with what Dr Michel had done.

You do understand me. I don't want you to be offended for one instant!

I embrace you then with all my heart . . .

DEGAS

From the diaries of Daniel Halévy

. . . At dinner, Degas was good, too. Jacques had told him that Mirbeau was going to launch a very distinguished painter called Gauguin, as he had launched Maeterlinck.

'Who is this Gauguin?' someone asked Degas.

'A lad who is dying of hunger and whom I esteem profoundly as an artist. But I don't understand how despair can drive a man to knock at the door of *Le Figaro*.'

And when there was talk of a woman whom Degas had found pretty:

'You liked her because she was ugly, admit it,' Mama said.

'Ah, yes, that's always the point. To be a woman, and not be pretty.'

'That happens frequently,' someone said.

'I said: be a woman,' Degas repeated, and added that the chief charm in a woman is to know how to listen.

He talked about someone who had gone to farm in Canada.

'I was very happy to see him escape from journalism.'

'Was he a journalist?'

'He might have become one.'

*

Last night Degas talked comparatively little. He spoke of Jacques Blanche's studio. 'Oh,' he said, 'what light! My eyes immediately felt rested. If only I could afford a separate studio.'

'But the light there is so soft because the windows are slightly frosted and tinted. You could do that.'

'Yes. There are people,' he said brusquely, 'who claim that tinted glass is bad because it changes the colour. No!! If I had the time and the means to write I would explain how stupid that is. – There is a painter called Humbert who takes pupils. He tells them: You must get the colour of the model. And he sets up the canvas right beside the model. To do a thing like that is so stupid that it isn't even worth thinking about.' He was silent for a while, and then he added quickly, 'What I mean is that everything in a picture is the inter-relationships. We paint the sun with the yolk of egg. Go put your canvas alongside the sun!'

*

'I like to see the families of the working-men in the Marais,' Degas said. 'You go into these wretched-looking houses with great, wide doors, and you find bright rooms, meticulously clean. You can see them through the open doors from the hall. Everybody is lively; everybody is working. And these people have none of the servility of a merchant in his shop. Their society is delightful.'

Degas also told us about his plans for work. 'For a whole year I shall devote myself to drawing.' I have often heard Degas express a (relative) contempt for everything that is preponderantly colour.

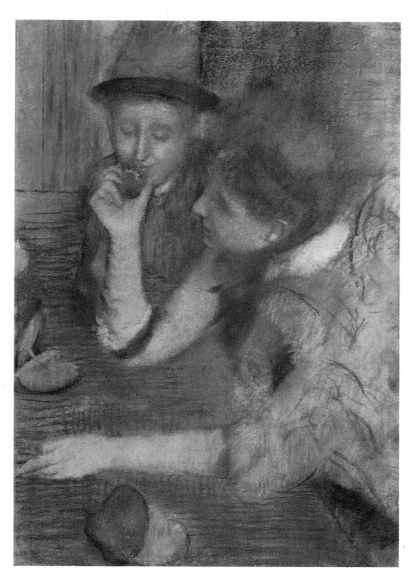

THE JEWELS

Thursday, 1 Oct. 1891

Degas: 'Women think in little packages. I understand nothing about the way their minds work. They put every subject into an envelope, label it and it's finished . . . little packages . . . little packages. – I had Forain for dinner the other day. He came to keep me company.'

'His wife, too?'

(Scornfully) 'She was unwell.'

'Wasn't she really?'

'How does anyone know? Women have invented the word "unwell", it doesn't mean anything.'

From the diaries of Daniel Halévy

Degas told us that Mallarmé came to see him the other day on behalf of Roujon, the new director of the Beaux-Arts, to sound him out and ask whether he would be willing to give a picture to the Luxembourg. He told us the charming way in which he responded to this approach.

'I said no, certainly not. Those people want me to believe that I am successful. Successful, what does that mean? Either you always are, or never. What is success? To be hung on the wall between a lady by Bouguereau and a slave market by Toto Girod? When each one of us sticks to his last and forms his own small group of admirers, why does the administration want to meddle in our affairs? I pay them my taxes. What have my pictures got to do with them? No. They have to interfere in everything. They have the fine-arts chessboard on their desk and we artists are the pieces. They shove this pawn one way, that one another. I am not a pawn. I don't want to be pushed.'

My father lost his temper and treated Degas as though he were a fool. 'Do you know what you act like? A man who is embittered and thinks recognition has come too late.'

'Bitter? But I am very happy. Everybody knows that.'

'Only those who know you personally.'

'You have no perspective in these things. The fact is that if I were hung in the Luxembourg I'd feel as though I were being arrested. *Success*! The end of progress! Success! What does it mean? How do you succeed?' (Later on Degas would say, 'In my day, people didn't "succeed".') 'I do not wish to be caught by the *beaux-arts* policemen or by that officer of the guard named Roujon.'

*

Degas came to lunch the other day as lively as a cricket. He was delighted by the spectacle of the dissension between painters which the Salon always produces. . . . My father used this as a pretext to tell him that Roujon was angry because Degas vilified him wherever he went. 'I saw him,' said my father, 'and he spoke to me rather bitterly, saying that he could see nothing criminal about having asked you for a painting. I replied that you were always like that and people laughed at you for it. But some day when Roujon is at the Opéra I'll take you there and introduce you to each other.'

'I ask nothing better,' Degas replied. 'But I don't want you to defend me the way you do by saying that I am a crazy old man. You must say that I am a philosopher. Not a madman, a philosopher, an old philosopher. Tell him, "Degas is considered an eccentric; if you tried to argue with him he would silence you in two words. He is a —"'

He intended repeating the word 'philosopher', but he was laughing so hard he couldn't speak. . . .

Sept. 1892

After dinner the conversation turned to the *Thousand and One Nights* and Degas asked me if I had any news of the English edition I was supposed to have found out about. I told him that it was in fifteen volumes and cost nine hundred francs . . .

'I'll buy this translation with my money, my nine hundred francs. What difference does it make to me? I'll do two or three more pastels and they'll pay for it. I'll pay them their nine hundred francs and then, at home, I'll look at my fifteen volumes and it will make me happy, very happy. Then you will see me coming here with a volume under my arm and you will read me some of it. I shall have them, I shall have them, and the joke is that I shan't even be able to read them myself.'

At that moment he would have bought them outright. But he asked Elie to find him a set at a reduced price in London, and this calmed him a little. 'But I could pay for them,' he said. 'I have twenty-one landscapes.'

We all protested. 'Twenty-one landscapes? But you have never done any! Not twenty-one?'

'Yes, twenty-one landscapes.'

'But how did you happen to do them?'

'They are the fruit of my travels this summer. I would stand at the door of the coach and as the train went along I could see things vaguely. That gave me the idea of doing some land-scapes. There are twenty-one.'

'What kind are they? Vague things?'

'Perhaps.'

'Reflections of your soul?' my father asked. 'Amiel said, "A landscape is a reflection of the soul." Do you like that definition?'

'A reflection of my eyesight,' Degas replied. 'We painters do not use such pretentious language.'. . .

*

Aug. 1893

Degas, who came to see our house, ran into his friend Rouart with whom Papa renewed his acquaintance. I talked music with Degas. 'He's a bore! He's a bore (naturally Wagner) with his Grail and his Father Parsifal. The human voice was not made to sing Greek roots.'

Rouart's younger son is studying painting under Degas. They went off to talk together. When he came back, Degas said, 'You see, you paint a monochrome ground, something absolutely unified; you put a little colour on it, a touch here, a touch there, and you will see how little it takes to make it come to life.'

To Marguerite Fèvre (Degas' sister) and her family

<div align="right">28 Nov. 1892</div>

. . . Gabriel is trying his hand at lithography, I have tried my hand at it too, and at very complicated processes. I must get a press of my own, a shrewd craftsman to prepare and also to resurface the stones, and quite a lot of money to fall back on so as not to be cleaned out by my experiments. It will happen in the end, but it is getting late for my brain and for my eyes . . .

<div align="center">*</div>

<div align="right">4 Dec. <i>1892</i></div>

I am taking great care of my bladder with turpentine, Contrxéville water, and by cutting out coffee, spirits etc. But my kidneys still hurt.

My eyes are failing . . .

I have had a little exhibition at Durand-Ruel of twenty-six imaginary landscapes which has been rather successful.

I embrace you all. Do write to me often.

<div align="center">*</div>

<div align="right">5 May 1894</div>

A letter must have got lost, and I only learned yesterday in a letter from your mother, my dear little Henri, that you had broken your left arm, my dear child. You give your family all sorts of pleasure, and we are keen above all that you don't hurt yourself.

Do you sometimes think about your old uncle? Meanwhile you don't write any of those kind letters, as you used to (when you talked about a little kiosk where, 'on Sundays, you could feel as if you were in France'). . . .

I embrace you,

<div align="right">Your uncle, Edgar</div>

<div align="center">*</div>

<div align="right">18 June, <i>Undated</i></div>

. . . I wish above all to remain alone, to work as quietly as possible with my poor eyes, and in order to obtain that quiet and that supreme good fortune, condemn myself also to die alone.

The other day, at La Trinité, I was a witness with Puvis de Chavannes for Durand-Ruel's daughter . . .

Some people, after having kept pictures of mine for a long time, decide to sell them for a large profit. It doesn't put even five francs into my pocket.

I will have to go and take the waters for my bladder. Cauterets is excellent only for the bronchial tubes. Forbidden to go there.

When will I go there? One must not make any plans, and then go suddenly.

I embrace you with all my heart,

<div align="right">Degas</div>

Mont-Dore, 15 Aug. 1895

Is it possible to continue without writing as long as we do? Come, we must make a sacred undertaking to put pen to paper on the 15th of each month, whether there is a lot to say or not, whether there is news to tell or just: 'Hello'. Otherwise, our hearts will be as far apart as they are on the map and we will end up far away from each other. . . .

As my bronchitis had relapsed, I was sent here for a cure.

Cauterets, with its sulphurous water, is dangerous for my damned kidneys. . . .

On the boat of the 20th from Bordeaux, this letter will accompany a box in which I am sending you a camera, usable for both long and instantaneous exposure with accessories, materials etc. . . .

This, I said to myself, is an infallible way of getting something. I reckon that after a month or less of practice, you will be able to send me (in place of letters, if you remain obstinate) a few good portraits of people, places, rooms – well wrapped for the post please – humidity is fatal. . . .

Yesterday, I tried a portrait – something went wrong with my little camera and spoiled the thing.

In another letter you will get your colossus in several poses. . . . I can hardly read now, even with a magnifying glass. I work all the same but on a large scale . . .

I embrace you all, till next time,

DEGAS

*

Mont-Dore, 18 Aug. 1895

This letter will try to catch up with the other one in Bordeaux, tomorrow, for the boat which is leaving on the 20th . . . At the last moment, I took this little photograph of Père Guyot yesterday on the doorstep of his hotel which I developed last night and which I have just printed and toned.

All this is provisional, for the negative is not very good, the person is not quite in focus. It's the window and the manservant that are all right. Also, toning was perfunctory and washing likewise. It will get to you slightly faded, I am afraid . . .

We must take it upon ourselves to correspond better.

Staying here seems to have improved me a lot. Is it the treatment or the altitude?

This morning, two characters entered the dining-room to have lunch, and walked straight up to me looking pleased. They were G. and his wife. You know he is in the business of pictures, an agent for the Maison Goupil in New York. We talked about all of you with real interest.

I am expecting some prints and even some negatives, which I will enlarge to see you better.

Beautiful Auvergne, terrible Auvergnats. Good food, good bed. In a flannel suit, trousers with footstraps, in goloshes. One hour every morning to sweat and breathe at twenty-eight and thirty degrees.

I'll rush to the Post Office and embrace you,

DEGAS

To Henri Fèvre

I have delayed too much – so I will not see her again, my poor Marguerite. Since the fatal black-edged letter, all her life, her gracefulness as a child, as a young girl, that motherly look, her voice, her attire. I could only think about them, to try and bring her back in front of my eyes.

It must seem to you, my poor Henri, my poor children, as if your soul has left you.

We are going to have to live without this heroic and delightful being . . .

And I was cursing the late dispatch of this camera. A month earlier, and I would have had everything. The photograph I have just received has comforted me a little; but it seems to me a little touched up, unless, as I have seen with Achille, youth was brought back to her too, when dead, my poor dear Marguerite.

The portrait of Gabriel could have been made from a doll.

Truth is never ugly when one can find in it what one needs.

What can I say to you? The greatest misfortune that could have threatened you has fallen upon you. And under that blow so many duties must be keeping you going.

I either wrote about our misfortune to our friends, or told them. All have at once understood our sorrow. And their thoughts are with you.

I wish you never to be separated ever again but in death.

Zoé has carried out the errands.

DEGAS

COMBING THE HAIR

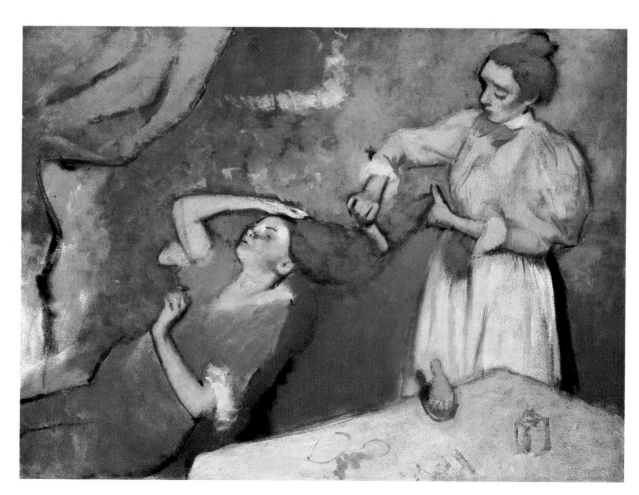

19 Jan. 1896

In order not to miss the boat of the 20th, as I promised you, I am writing a few words to you, my dear Henri. I received your letter and I will answer it better another time. I have not got it in front of me, it is at home and I am writing from the studio.

You deserve all admiration and all pity for your admirable energy . . .

Marguerite was so loved. People only talk about her with real emotion. This brave creature was really unique. I have taken a good photograph from the print of her dead, to send to Thérèse. And for myself I have had an enlargement done which I cannot look at without weeping.

I was expecting a letter from the children and some more portraits.

Do write to me often. I love you all a lot. I am not well and I am on a diet.

I embrace you all.

DEGAS

*

18 May *1896*

Poor Odile talks about herself and also about the others, about the scarcity of suitors, and the solitary life, and exile, and their old homeland.

One cannot resign oneself to so many deprivations, I do understand.

As long as daughters have dowries, men will get hold of their dowries. There is, I believe, a country where daughters inherit only a thirteenth part and where, if they are not married at a certain age, they have to be supported by their brothers.

People say here that if the ugly ones did not have money, they would never get married.

Therefore the pretty ones suffer on account of the ugly ones. What a performance!

It seems that the moral of it all is, that for men to marry penniless girls is the **most honour**able thing, a sort of dignity; and as far as the girls are concerned, it is woman's glory **to be** chosen for themselves.

But you know all this well.

Thank you for the photographs. It would take too long to tell you all the ideas they bring to my mind. I have an enlargement of Marguerite taken from the group. It has not turned out well. Who touched up everything? One should never touch up! It spoils it all . . .

I also feel very happy about what Odile tells me about Gabriel. He is doing all right, that boy, in all respects. His sisters see the man in him. Ah! nothing tempers like adversity!

Bartholomé has just been for a quick tour to Italy – and for quick tours, he is unique!

By night he travels, by day he visits – no bed but the banquette. I am too soft, I won't accompany this enthusiast, that's understood.

With my waters at Mont-Dore I haven't had a bad winter. And I am fully intending to go back there in the autumn. . . .

Send me some photographs, that is why I sent you the instrument. Your street looks just like any American street. Yet I was expecting something more special . . . Do take some views of the rooms.

I embrace you with all my heart.

DEGAS

From the diaries of Daniel Halévy

4 Nov. 1895

This year he has become enamoured of photography, and as his days are full he takes photographs in the evening. 'Daylight,' he says, 'is too easy. What I want is difficult – the atmosphere of lamps or moonlight.'

Degas did not come to the house for several days. The other evening the bell rang and we heard his slow, heavy footsteps. He stopped, looked at us and didn't speak for a while. Then he said, in a voice he was unable to control, 'I am not very cheerful. Marguerite is dead.'

Marguerite was his sister; a charming woman, a great friend of my mother's, an excellent musician. She used to sing old Italian songs for her brother. She was married to a M. Fèvre, an architect who speculated in building houses which he couldn't rent. Bankrupt, he left for Buenos Aires with his family where they have been living miserably.

Degas sat down on the sofa. 'For the past two months I have been worried,' he said. 'But I kept hoping. Three days ago I received a telegram. The poor creature is dead. When I bade her goodbye eight years ago I didn't think that it was forever. I always had the notion of going to see them down there. But one does nothing one wants to do. I have been unhappy, depressed the last few days. I haven't gone out. I stopped taking walks and have felt flushed and could so nothing the next day. Besides if I go to bed without taking a walk I think about poor Marguerite and I can't sleep. There will be no services. You remember there were none when our brother died. To have them for her would debase the memory of poor Achille. They will bring Marguerite back. I must find out about all that. Fèvre wrote to me that before she died she expressed a certain horror at the idea of staying down there. She was homesick. It was partly that that killed her I am sure. So they will bring her back. It happens that there is one place left in our vault. . . . I thought that place would be for me. It seems that I was mistaken. Now let's talk about something else.'

. . . Degas talked to me about the Louvre: 'What do I want? I want them not to restore the paintings. If you were to scratch a painting you would be arrested. If M. Kaempfen were to restore the *Gioconda* they'd decorate him. . . . Time has to take its course with paintings as with everything else, that's the beauty of it. A man who touches a picture ought to be deported. To touch a picture! You don't know what that does to me. These pictures are the joy of my life; they beautify it, they soothe it. To touch a Rembrandt! –' . . .

*

22 Dec. 1895

Went to see Degas this morning. . . . Two very pretty Restoration portraits were standing on two armchairs. I looked at him and said, 'What is this new acquisition?'

'Two Delacroix!' he said, all of a sudden awake and leaping out of bed. 'And thereby hangs a tale. They come, if you can believe it, from the *pension* Goubaux, a boarding school that was still in existence in my time. This Goubaux was a teacher and writer; he founded the College Chaptal. But between 1821 and 1835 he had a *pension*. He hired Delacroix, who was very young then, to paint for his reception room portraits of the pupils who won prizes in their general examinations. May I present to you M. Bussy d'Hédouville, second-form scholar, second prize for Latin theme, and this other young man, second prize for Latin translation? Isn't destiny a strange thing? Here are two young idiots immortalized because they won prizes in the general

examination! And look how pretty my portraits are – so cleverly, freely done . . .

While he was talking Degas dressed and while dressing he would take down from the wall or pick up from the floor a canvas or a woodcut to show me.

'Here is my new Van Gogh, and my Cézanne. I buy, I buy. I can't stop myself. The trying thing is that people are beginning to know it, so they bid against me. They know that when I want something I absolutely must have it. So they force me out on a limb. The other day that beast Chéramy bid against me. And when I got it there was my Chéramy coming out of his hiding place to stand beside me and say in his ham-actor voice, "Delighted, *cher Maître*, that this masterpiece belongs to you." I said to him, "Delighted, delighted, that's all very well! You made me pay a high price for it and you didn't get it. Nine hundred francs is an enormous price to pay."'

'Nine hundred francs for this portrait by Delacroix. But that's nothing. Are Delacroix as cheap as that?'

'Yes,' said Degas, enraptured, his voice very low as if he were afraid of being overheard.

*

29 Dec. 1895

. . . A fortnight ago Degas dined with us, with Uncle Jules, too, and the Blanches. After dinner he went to fetch his camera and I went with him. He talked all the time. In his studio I noticed a variety of little pictures from his youth, showing his sister and his brothers. He had been looking for them. After we returned he happened to say to Uncle Jules – I don't know how – 'It would have upset me to go alone, but Daniel kept me company.' The sadness of this remark struck me; and it certainly struck my uncle. Because yesterday when Degas left alone, my uncle got up and went with him.

They returned together and from then on the *pleasure* part of the evening was over. Degas raised his voice, became dictatorial, gave orders that a lamp be brought into the little salon and that anyone who wasn't going to pose should leave. The *duty* part of the evening began. We had to obey Degas' fierce will, his artist's ferocity. At the moment all his friends speak of him with terror. If you invite him for the evening you know what to expect: two hours of military obedience.

In spite of my orders to leave, I slid into a corner and silent in the dark I watched Degas. He had seated Uncle Jules, Mathilde, and Henriette on the little sofa in front of the piano. He went back and forth in front of them running from one side of the room to the other with an expression of infinite happiness. He moved lamps, changed the reflectors, tried to light the legs by putting a lamp on the floor – to light Uncle Jules' legs, those famous legs, the slenderest, most supple legs in Paris which Degas always mentions ecstatically.

'Taschereau,' he said, 'hold on to that leg with your right arm, and pull it in there, there. Then look at that young person beside you. More affectionately – still more – come – come! You can smile so nicely when you want to. And you, Mademoiselle Henriette, bend your head – more – still more. Really bend it. Rest it on your neighbour's shoulder.' And when she didn't follow his orders to suit him he caught her by the nape of the neck and posed her as he wished. He seized hold of Mathilde and turned her face towards her uncle. Then he stepped back and exclaimed happily, 'That does it.'

The pose was held for two minutes – and then repeated. We shall see the photographs

tonight or tomorrow morning, I think. He will display them here looking happy – and really at moments like that he is happy.

At half-past eleven everybody left; Degas surrounded by three laughing girls carried his camera, as proud as a child carrying a gun.

*

2 Jan. 1896

'Let us hope that we shall soon have finished with art, with aesthetics. They make me sick. Yesterday I dined at the Rouarts'. There were his sons and some young people – all talking art. I blew up. What interests me is work, business, the army!' . . .

I believe that his revolt originated with the opening of Liberty's shop in Paris. He went with his friend Bartholomé and said to him, 'So much taste will lead to prison.' This remark he repeated last year to Oscar Wilde. He saw Wilde at Aunt Geneviève's where they had a long, brilliant conversation. For example:

Wilde: 'You know how well known you are in England – '

Degas: 'Fortunately less so than you.'

All the attempts at artistic furnishing in the last few years exasperate him. At the Champ de Mars exhibition he was hailed by Montesquiou who was standing guard in front of an apple-green bed he had designed with Sallé. Degas delivered a great speech in front of about a hundred people. Unfortunately I have forgotten some of it.

'Do you think,' he said, 'that you will conceive better children in an apple-green bed? Watch out, M. de Montesquiou; taste is a vice.' And he turned his back on Montesquiou – whose reputation is not too good – this was after the Oscar Wilde affair.

Pederasty and taste – Degas makes no distinction between them. It seems that a 'Maison de l'Art Nouveau' has recently opened in which young women sell objects in good taste. Degas said, 'It is a good thing they used women clerks; if they had had men the police would already have closed the place.'

He stamped his foot this morning in the rue Mansard; 'Taste! It doesn't exist. An artist makes beautiful things without being aware of it. Aesthetes beat their brows and say to themselves, "How can I find a pretty shape for a chamberpot?" Poor creatures, their chamberpots may be works of art but they will immediately induce a retention of urine! They will look at their pots and say to all their friends: "Look at my chamberpot. Isn't it pretty?" No more art! No more art! No more art!'

*

21 Jan. 1896

Degas. The Ingres are bought. I went to his house this morning to spend ten minutes hearing about them. He insisted on keeping me there for three hours. We strolled along the rue Laffitte announcing the victory to the dealers . . .

'Yes, I shall give the Ingres portraits to my country; and then I shall go and sit in front of them and look at them and think about what a noble deed I have done.'

HENRI ROUART AND HIS SON ALEXIS

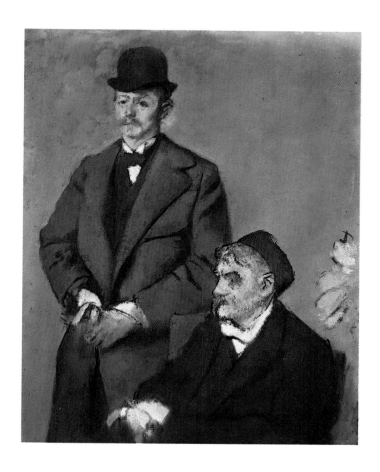

Paris, 28 July *1896*

TO ALEXIS ROUART . . . I should like . . . to go down to Montauban, by dint of pulling
strings, to get the keeper of the museum to show me the whole lot of Ingres' drawings. It will
be a matter of several days, listing, classifying, etc. Do you feel like joining in this sport?

I shall give you my address once I am housed at Mont-Dore and you can reply to me
there. . . .

I have not done badly as regards work, without much progress.

Everything is long for a blind man, who wants to pretend that he can see.

My regards to Mme Rouart and ever your

DEGAS

*

Grand Hotel du Midi. Montauban, 16 Aug. 1897

MONSIEUR LE MAIRE, With reference to our interview, you wish me to write you a
résumé of it. In view of the bad state of my eyes I am forced to be much briefer than with my
tongue. So I would ask you to put forward and if necessary to support my request to the
committee, which is to make an exchange of photographs with the Ingres museum. The
museum possesses some drawings relating to pictures by Ingres, that I have the good fortune to
own. I shall have photographs made in Paris of what I have, and the museum will permit me to
photograph what it has of relevance. I add that the reproductions that I am offering are
unpublished . . .

Thursday, *Nov. 1894*

Terrible Maria, yesterday at Lebarc de Bouteville, I wanted
to buy your excellent drawing, but he did not know the price. Come if you can tomorrow about
9.30 with your box, to see if you have something even better.

DEGAS

*

Saturday, *March 1895*

And now tomorrow I must go to Passy, terrible Maria. Do
not miss coming the next Sunday, if you can, with new drawings. Now that you are well, work
hard.

Greetings, DEGAS

*

8 Jan.

I have been in bed and am late in answering, terrible Maria.
And will it reach you, this little thank you for your good wishes and your continued
remembrance? Are you still in rue Cortot?
Come and see me with drawings. I like seeing these bold and supple lines.

Happy New Year, DEGAS

*

Sunday *1897*

Thank you for your good wishes, terrible Maria, all the more
because I have need of them. They tell me I am still delicate and must beware of cold on the left
side. It is necessary, in spite of the illness of your son, for you to start bringing me again some
wicked and supple drawings.

DEGAS

*

Saturday, *Jan. 1898*

I found your good wishes, terrible Maria, on my return from
Bartholomé who read us yours at table where they were brought up to him. I am not too bad
except for the entrails, and often stay indoors. You will give me pleasure and not disturb me as
you fear if you come one day, at the end of the day, above all with a box of beautiful drawings.

DEGAS

8 Jan. 1897

. . .'They are annoying, these young people. They want us to believe that we are old – that we are ill, have white hair, are no longer able to pay court to a dancer. What of it? There's more to life than that. We have the will to work, we are not old. We must always remember the remark that David made one day: "I don't know what's wrong with me – my hands let me down, I can't do anything. Yet my mind is active, I am full of ideas. – My eyes bother me, I no longer hear, but what's wrong with me? I don't understand." Whereupon he sank into a chair and died.'

*

7 Feb. 1897

Last Tuesday Degas was very brilliant and lively. I went there to read him Antonin Proust's recollections of Manet. 'Proust gives him an attitude that I don't like,' he said. ' Manet was ever so much nicer, ever so much simpler. But writers always have to make people pose. It is like those statues of soldiers that you see everywhere, stiff-legged, their arms raised high. They are not like that. A soldier is a serious-minded man. I would like to see them with hands clasped behind their backs, heads bent in meditation.' . . .

He day-dreamed for a while and then exclaimed, 'What times we live in! I went to that exhibition this afternoon. There was a catalogue and a preface to the catalogue. – In the old days they beat the drum outside the encampments; today they play the lyre in picture galleries. What poetic boredom!' . . .

*

20 Feb. 1897

Degas during the first half of dinner, slightly sleepy, grumbled about everything and kept repeating himself so much that Gregh finally took him to task: 'You abuse the right to be aggressive, Monsieur Degas.'

'No, no, it's not that. But this art that is invading us exacerbates me. Such talk, such – '

'But it has always been like that, Monsieur Degas. Only in the past we saw nothing but the works themselves. Now we see the means by which they are produced, the *cuisine* so to speak. And that is always rather low.'

'Listen,' said Degas, awakened by the attack. He thought for a moment, then: 'At the end of antiquity, when all the deities, all the legends had grown a little stale there was a man who wanted to revive them. I mean Ovid. He redid all these fables in verse, and the result was a hothouse full of artificial flowers. And Ovid was sent among the Scythians there to bemoan his false flowers. Well, everything that's done today, everything that's thought is as false as those flowers – without leaves, without stems, without roots. It's artificial.'

'Monsieur Degas, Monsieur Degas,' Gregh rejoined. 'You are so right that one doesn't know how to reply to you; and besides you put things so prettily – '

'What I have just said is not pretty,' Degas answered. 'It is a thought.'

'A thought not lacking in form,' Rivoire added.

'What do you expect?' Degas continued. 'I can't stand all this poetry, this sophistry, and these young men in long-tailed morning coats holding lilies in their hands while they talk to women. Look, when you talk to a woman you need both hands, don't you?' . . .

23 Feb. 1897

Last night I read to Degas the second part of Antonin Proust's recollections of Manet, published in the *Revue Blanche*. I found him alone in his little dressing-room. That is where he eats.

'Oh, it's you!'

'I have brought you the Manet.'

'Read it.'

I opened the magazine. He saw a drawing, took out his magnifying glass, and looked at it. It was a *café-concert* singer.

'That Manet,' he said. 'As soon as I did dancers, he did them. He always imitated. Read on.'

I read. I had been reading for some time when I came to a brief sentence about the *Déjeuner sur l'herbe* and *plein air*. Degas stopped me.

'That's not true. He confuses everything. Manet wasn't thinking about *plein air* when he painted the *Déjeuner sur l'herbe*. He didn't think about it until he saw Monet's first paintings. He could never do anything but imitate. Proust confuses the whole thing. Oh, literary people! Always meddling! *We do ourselves justice so adequately*. Read some more.'

I continued reading, and he interrupted from time to time with little technical corrections. I finished. 'That's all,' I said.

Degas was silent for a moment. He leaned back in his chair, looked around him, and then, in the beautiful, sad, intimate voice that I love, not in the combative one which has now become almost like a challenge to a duel, he said, 'Oh, the critics! They won't leave you in peace. What a fate! To be handed over to writers!'

During the day I had been to see Degas' pictures shown at the Luxembourg. 'Would it make you unhappy,' I asked him, 'if I talked to you about your pictures at the Luxembourg?'

'Not at all. Go ahead.'

'You told me this morning that you were dissatisfied with them, that the selection wasn't representative. I don't agree with you. Granted there are none of your large pictures. But you can't expect small pictures to be anything but small pictures, and the ones that are there are really as perfect, as beautiful, as small pastels can be.'

'It's a long time since I've seen them. Perhaps I would like them better than I think. But I haven't any very clear idea of them.'

'The specially good thing is the great variety. Your whole work is very successfully represented. There is the dancer tying her slipper which is simply a drawing, an admirable drawing. There are the women in front of a café – '

'Yes, a café on the boulevard with the crowd going by in the background.'

'That one rather on the cruel, cynical side. Beside it is that ballerina dancing all alone – grace and poetry embodied.'

'I did lots of women like that. And the chorus of *Don Juan*, too. All of them are more or less rapid sketches. If you have to go to the Luxembourg, it is annoying to go in such impromptu style. I haven't been there. I don't know whether I have the courage to go. Yesterday I went to Boutet de Monvel's, that nice boy – right next door. The museum was closed, but even if it had been open I don't know whether I could have gone in. I was told that there were lots of people. Is that so? Why, why, good Lord, should there be so many people? Can't they leave you alone? No. They regiment you; they grab hold of you. People say to me: "At last, you are there!" Where? Where am I? They are the people who, when they were starting their careers,

dreamed of occupying Bouguereau's place. "You are there!" Shouldn't we have been there forty years ago? They bought all the second-class medals. "At last!" I am told that I should be happy and profit by all this. That's not my way of thinking. I want to succeed where I want, when I want, and how I want. My God! People crowding around our pictures, why? Do they crowd into a chemist's laboratory? You have read how Manet used a black mirror to gauge values. All that is very complicated. What can they understand about it? Nothing! A chemist works in peace. We, we belong to everybody! What anguish!' After a rather long silence he added, 'All this deprives me of the prestige that was so lovely.' Then he went on with great violence:

'Théodore Duret, that Duret who is mentioned in the memoirs you have just been reading, what a man! He had pictures by all of us. He sold them two years ago, and he himself solemnly wrote the preface to his own catalogue. "I was their friend. I frequented their studios. Therefore I can be relied upon when I say that what I am selling today is the best of their work." I went to his exhibition. He was there. He tried to shake hands with me. I refused. He said: "What are you thinking of? Us, two old friends? I can send you my seconds." "You can send me what you like," I said, "but I won't shake hands with you. If you are bankrupt, if you have to sell your pictures, you should at least sell them sadly. But you glorify yourself as having been one of our friends. You have pasted up signs all over Paris: *Duret Sale*. I won't shake hands with you. Besides, your auction will fail. Some of us are well represented in your collection, others not. You are losing our respect and you won't make any money." It was a terrible execution. He turned pale and so did I.' Again silence.

'I am not a misanthrope, far from it. But it is sad to go on living surrounded by swine. Tissot, that old friend I lived with so long, had such fun with, knew so well, and who bought several of my pictures. He sold them; that was his affair. But the other day when I went into Durand-Ruel's I said, "How do you happen to have that?" "It's Tissot's," he said. "I gave it to him." "He sold it to me," Durand-Ruel replied.

'I was about to write Tissot a terrible letter. But what's the use? I shall do up some drawings he once gave me and send them back to him without a word. He'll understand. For him to have sold it! Now he's got religion. He says he experiences inconceivable joy in his faith. At the same time he not only sells his own products high but sells his friends' pictures as well. — Practically everyone I have given pictures to has sold them. . . . To think that we lived together as friends and then —. Well, I can take my vengeance. I shall do a caricature of Tissot with Christ behind him, whipping him, and call it: *Christ Driving his Merchant from the Temple*, My God!'

We went out. In order to distract him a little I said, 'Is it true that you wanted to marry my cousin Henriette?'

'You know about that?' He burst into laughter. 'She is nice, isn't she? Sweet — very nice. I approached her father. He said, "Ask her yourself." So when I was helping her into a cab I said, "Mademoiselle Henriette, your father has given me permission to ask for your hand." So, instinctively, she gave me her hand. "But no," I cried, "I want to marry you." I told her that if she wanted me to dye my hair I would. It was all because of that fool of a Zoé whom I had fired that morning. I said to her, "You make me regret that I am not married. How can a man live with an idiot, a fool like you?" I had not yet told her that I was going to be married. When I have a wife, Zoé will have to toe the mark . . .' He was still laughing aloud when he boarded the streetcar.

It was in 1897, in Clermont-Ferrand, towards the end of July or the beginning of August. One o'clock has just rung out. On my way back from Royat on foot, as I was crossing the Place Jaude diagonally, I bumped into a grey-bearded man shrouded in a bulky Inverness cape and absorbed in a reverie so deep that when I apologized, he looked startled. 'What are you doing here, Monsieur Degas?' I cried. — 'Ah, it's you! What am I doing? I am bored to tears. For the past week I have been in Mont-Dore hospital for my throat. I had the bright idea of coming here for a little diversion this morning and I am no less bored than I was back there.' — 'Allow me to try and divert you.' — 'You will never succeed in diverting me. I am a dead man, or all but dead, for the thought that he is going blind is death to a painter.' . . . I interrupted him: 'You have not yet dined, I vouch? What do you say to the idea of having lunch with me?' . . .

He allowed himself to be convinced and off we went to lunch, arm in arm. Informed of the occasion, the hotel proprietor lived up to his reputation and the fare was exquisite. The profit was all mine for, with a mischievous glint in his eye, Degas submitted certain of his colleagues to a right dressing-down and submitted them to such wittily harsh yet accurate criticism that I wept for laughter. Little by little, my mirth spread to my interlocutor and his sullen countenance began to brighten up. He was a different man by the time we got up from table. Life no longer appeared so grim. 'You are the best of doctors, despite the fact that there is no such thing as a good doctor,' he muttered, smiling happily, 'so I do not feel like parting company with you. It is time I returned to Mont-Dore. Make up your suitcase. You are coming with me.'

The invitation was too tempting to be turned down. For two whole days I never left his side. . . . Once he felt at ease, the man was a wonderful conversationalist and there was always substance to his conversation. He had read very widely, with immense thoughtfulness, and he had always retained the essence of what he read. . . .

Even if Degas was not, as was his venerated master, Ingres, a fanatic of draughtsmanship, this natural inclination alone might explain the distance at which he always held Delacroix. 'In art,' he said, 'one is never entitled to disregard what is true. But this truth,' he would add, 'may be rendered only if one does not seek out ugliness as a matter of principle and so much so that one remains blind to all else. I feel the utmost disgust for those platitudinous realists who today may be seen basing their interpretations of life solely upon the coarse side of human nature. The true realist dissimulates nothing but he places things where they belong; he classifies the features that go to make up his composition according to their degree of interest; in this way, he makes a series of choices and if his choices are judicious, this is style. This was how Chardin worked, who while treating the most vulgar motifs with admirable conscientiousness, nonetheless succeeded in lending them elegance, grace and distinction.'

It was in the course of these conversations that, in passing, Degas spoke of his attempts at modelling which his failing eyesight had led him to substitute for painting as a means of expression. When I enquired whether this new craft had cost him an effort, he cried:

'But I have long been familiar with the craft! I have been practising it for upwards of thirty years, not, to tell the truth, continuously but from time to time, when I feel like it or need to.'

'Why on earth should you need to?'

'Have you read Dickens, Monsieur?'

'Indeed I have.'

'And have you read his biographers?'

'None whatever.'

'Impossible! So it is I who must inform you that whenever he came to a difficult passage in one of those scenes with several protagonists at which he excelled, whenever he lost his way in the complicated weave of his characters and did not know what lot should befall them, he got himself out of the knot, for better or for worse, by building figures to whom he assigned the names of the characters. When he had them on the table in front of him, he endowed them with the personalities which were possibly or necessarily suitable to each, he had them talk to each other, after the manner of Lemercier playing with his *pupazzi*, and the situation instantly cleared up, the newly alert novelist resumed his task and brought it resolutely to successful conclusion. I instinctively adopted the same system. You are doubtless aware that, about the year 1866, I perpetrated a *Scène de steeplechase*, the first, and for long after the only scene of mine to have been inspired by a racecourse. Now, while at the time I was reasonably well acquainted with "the noblest conquest ever made by man", while I happened fairly frequently to mount one and had no great difficulty in telling the difference between a pure-bred and a half-bred, whereas I was quite familiar with the anatomy and myology of the animal, which I had studied on one of those anatomical models to be found in any plaster-caster's premises, I was totally ignorant of the mechanism that regulated a horse's movements. I knew infinitely less on the subject than a non-commissioned officer whose lengthy and attentive practice enables him to visualize the animal's reactions and reflexes, even when he is speaking of an absent horse.

'Marey had not yet invented the device which made it possible to decompose the movements – imperceptible to the human eye – of a bird in flight, of a galloping or trotting horse. For his studies of horses, which are so sincere and which he used in his military canvases, Meissonier was reduced to parking his carriage for hours on end on the Champs-Elysées. There, alongside the footpath, he would study the horsemen and their handsome, frisky horses. Thus, this bad painter was one of the best-informed on horses that I have ever met.

'I wanted to do at least as well as Meissonier but I did not restrict myself to sketches. Very soon, it became evident that the information they provided would lead nowhere if I did not use them in modelling experiments. The older I became, the more clearly I realized that to achieve exactitude so perfect in the representation of animals that a feeling of life is conveyed, one had to go into three dimensions, not merely because the activity itself requires prolonged observation from the artist and more sustained attention, but also because this is an area in which approximations are unacceptable. The most beautiful and the best-wrought drawing is always less than the precise, the absolute truth and thus leaves the way open to all that is fraudulent. You know the much-vaunted and, in fact, very worthy drawing in which Fromentin captures the stride of a galloping Arabian steed; compare it with reality and you will be struck far less by what it expresses than by all that it lacks. The natural disposition and true character of the animal are absent from this enthusiastic improvisation by a very clever hand.

'The same is true of renditions of the human form, especially of the human form in motion. Draw a dancing figure; with a little skill, you should be able to create an illusion for a short time. But however painstakingly you study your adaptation, you will achieve nothing more than an insubstantial silhouette, lacking all notion of mass and of volume and devoid of precision. You will achieve truth only through modelling because sculpture is an art which puts the artist under an obligation to neglect none of the essentials. It is for this reason that, now that my bad eyes prevent me from undertaking a canvas, now that I am allowed only pencil and pastel, now more than ever I feel the need to convey my impressions of form through sculpture. I examine my model's nose and, in a series of sketches, fix its varied aspects which

I then collate in a tiny piece, the structure of which is solid and which does not lie.'

'In fact, you are as much a sculptor as a painter, more so perhaps.'

'Not at all! The only reason that I made wax figures of animals and humans was for my own satisfaction, not to take time off from painting or drawing, but in order to give my paintings and drawings greater expression, greater ardour and more life. They are exercises to get me going; documentary, preparatory motions, nothing more. None of this is intended for sale. Can you see me designing my studies of horses after the fashion of a Frémiet, with such wealth of picturesque detail, which never fails to startle the middle classes? Or can you see me bending my studies of nudes into attitudes of false elegance, like Carrier-Belleuse? You will never catch me scratching the back of a torso nor revelling in the palpitating flesh that you critics are always caressing when you speak of the academic sculptors of the Institut. What matters to me is to express nature in all of its aspects, movement in its exact truth, to accentuate bone and muscle and the compact firmness of flesh. My work is no more than irreproachable in its construction. As for the *frisson* of flesh — what a trifle! My sculptures will never convey that feeling of completeness that is the *nec plus ultra* for the makers of statues, because after all, nobody will see these experiments, nobody will take it into their heads to talk about them, not even yourself. Before I die, all of this will disintegrate of its own accord and it will be just as well, as far as my reputation is concerned.' . . .

1896–1912

25 May 1896

To Henri Rouart So here is your posterity on the march. You will be blessed, oh righteous man, in your children and your children's children. During my cold I am meditating on the state of celibacy, and a good three-quarters of what I tell myself is sad.

I embrace you.

*

Thursday

To Louis Ganderax Yes it is true, my dear Ganderax, I was surprised by this act of journalism. You saw my impatience very clearly at Mme Straus at table, when you quoted me to your neighbour. You must not disturb me any more. The danger and the vexation of being honourably mentioned, I thought I was safe in that respect from you . . . you will cause a little embarrassment between us.

Greetings to the household, Degas

15 Nov. 1897

To Madame Ludovic Halévy It is not the Academy, it is a regimen to which I am now condemned and which prevents me from being seen. Adhesions of the pleura to the lungs, that is **my** weakness, and I cannot go out into the street or loiter there; and in the evenings, very nearly every evening, I listen to Zoé who falls asleep whilst reading to me; and the iodized cotton-wool scratches.

Thursday I am hoping to go and have dinner with you, if the doctor whom I shall see tomorrow or the day after, does not tighten up my incarceration. There you are!

I have a deal of bother as a manager.

How relationships change, how worthless one becomes, how one is no longer as one used to be.

Greetings, Degas

*

Dec. 1897

To Henri Rouart I was inconsolable, my dear friend, to know that you had been and gone. Your letter told me that you would come and see me, but never did I dream that it would be in the afternoon. For you there is no commission, no work, no anything that I would not leave for the pleasure of seeing you, do you hear, my old friend.

*

Saturday, 18 December 1897

To Henri Lerolle But Thursday I am booked at Halévy's, my dear Lerolle, and you must excuse me.

It is in vain that I repeat to myself every morning, tell myself again, that one must draw from the bottom upwards, begin with the feet, that the form is far better drawn upwards than downwards, mechanically I begin with the head.

Greetings, Degas

*

Undated

To the Fèvre family . . . Since my eyesight has diminished further, my twilight has become more and more lonely and more and more sombre. Only the taste for art and the desire to succeed keep me going.

Devoting one's joy to contemplating the world and thinking it over, it is worth living for, and this is why, despite all the miseries and the sadness of my life, I still consent to live.

But why are there so many blind and deaf people passing through life without the slightest idea of what life is really about?

TO THE MARQUIS GUERRERO My dear Edouard, It is not possible to receive a more cruel blow than you have just had. I have seen similar blows around me and judging by the sight of the poor parents I consider them to be terrible. An old bachelor like myself can have known nothing of the joys and sorrows of a family — so they say.

I am still intending to go to Naples to visit such of my family as are still there. You should urge me a little for I am 65 years old.

Writing is a fatigue that I avoid with my unfortunate eyes, which will soon leave me. I work with the greatest difficulty, and that is the one joy I have.

<p style="text-align:center">*</p>

TO THE FÈVRE FAMILY . . . I am still on a diet, and if I could get away from my damned studio, I wouldn't mind going to the countryside to eat vegetables a little fresher than those here.

I embrace you all.

Your old uncle, DEGAS

From the diary of Daniel Halévy

I went to see Degas when someone told me that he had been ill with intestinal grippe for the last two months. . . . It gave me rather a shock to see him dressed like a tramp, grown so thin, another man entirely. He seemed touched and pleased to see me. He asked for news of all the family and then started right away talking compulsively.

'Education! What a crime! Look at the Bretons. As long as they make the sign of the cross they are good people. But take away their faith and they become cowards. What a crime! Art for the people! How dreary! Beauty is a mystery —' and he repeated, 'Beauty is a mystery.' At one point he said, 'Since our misfortunes.'

He meant since the victory of the Dreyfusards. But I felt no embarrassment, no irritation. I listened to him with infinite respect as though he had been telling stories of another world; and he listened to me affectionately.

'Beauty is a mystery, but no one knows it any more. The recipes, the secrets are forgotten. A young man is set in the middle of a field and told, "Paint". And he paints a sincere farm. It's idiotic.'

Paris Monday, *September, 1906*

To Jeanne Fèvre I had not received any news from you. I am very grateful to
you, dear Jeanne, for thinking of sending me some at last. Writing means more and more
tiredness to me, and even sorrow. What a blessing eyesight is, my God!

I did not leave Paris this summer. I once had the inclination to get out of this damned studio.
I no longer have it.

But I will have to go back to Naples and I will be happy to call to see you on the way there
or on the way back. I love you a lot all the same even though I don't show it. I embrace you all.

Your rather old uncle, Degas

*

Paris 12 Oct. 1906

Dear Monsieur Durand-Ruel, I am still counting on you for Monday, the damned rent
(2000). It will be necessary all the same to get down to painting. Many thanks.

Degas

*

17 Jan. 1907

To Jean Rouart Your father reminded me yesterday evening, my dear Jean,
that I did not reply to your good letter. You cannot imagine to what a degree my sight, which
still exists a little, keeps me from writing – it is pain, it is disgust, anger. – Will you be able to
read me? I myself am incapable . . .

I came back from Naples a few weeks ago, family affairs. – One of these days I shall certainly
do a tour in you part of the world.

I embrace you and wish you a happy New Year.

Degas

*

Saturday, *c. 1907*

To Alexis Rouart My dear friend, it appears that you are dragging on, that you
are not yet getting around. Give me then some news about yourself in your beautiful round
hand. This awful cold weather is affecting everyone. Your brother insists that it has always
been like this. I don't think it used to be in the old days. It is true that in the old days I was
young.

Recover a little. I leave you. It troubles me to write, I can't see what I am writing.

Best wishes to everybody,

Your old friend, Degas

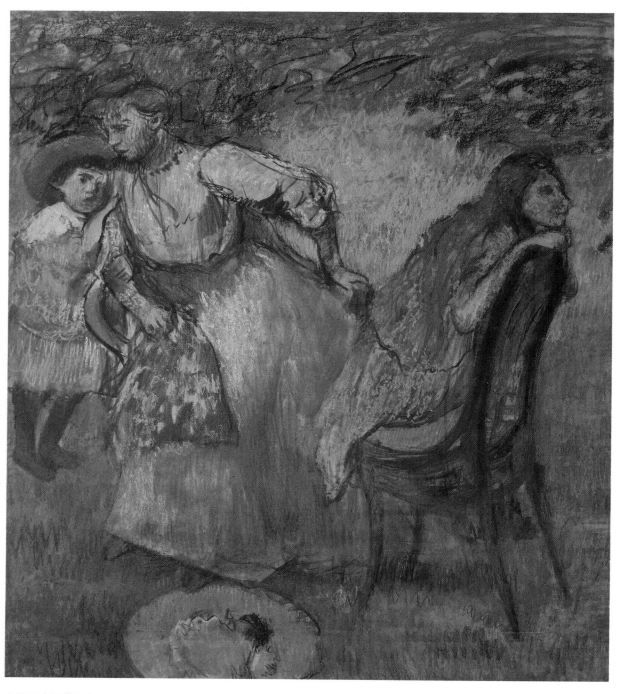

MME ALEXIS ROUART AND HER CHILDREN

6 Aug. *1907*

To Alexis Rouart I am not worth very much as regards correspondence, my
good friend. – My excuse might be that you were expecting it.

I am still here working. Here I am back again at drawing and pastel. I should like to succeed
in finishing my articles. At all costs it must be done. Journeys do not tempt me any more.
– At about 5 o'clock one dashes out into the surroundings. There is no lack of trams that take
you to Charenton or elsewhere.

Sunday I am going with Saint-Maurice to see your brother who is gradually recovering.
In the evening one returns to the great city.

I have pains in my kidney, which will not stop. And you, where are you with your pains?
Write to me. You have a fine handwriting.

My good wishes to Mme Rouart.

Your old friend, Degas

1908

DEAR MONSIEUR DURAND-RUEL, As usual I am counting on you for the 15th. Be good enough to reserve me 2000 francs and to send them to me tomorrow, Tuesday.

I did not dare to speak of money yesterday in front of the model.

DEGAS

*

Undated

DEAR MONSIEUR DURAND-RUEL, Here is a thing. You will guess the rest, the rest in the shortest possible delay. Take care, I am going to raise my prices. Life is getting very short, and it takes too long to earn money.

Sincerely yours, DEGAS

*

I shall gladly receive the samples this afternoon. Perhaps we shall both achieve wealth at the moment when we no longer need it! – So let it be.

17 June 1909

TO DANIEL HALÉVY My dear Daniel, I cannot make a rendezvous. All these days I am a little in the air.

Best wishes to your mother.

DEGAS

*

Monsieur A. Rouart
Grand Hotel Bellevue
San Remo

Friday, *11 March 1910*

No, my dear friend, I am no longer of these artists who race to the Italian frontier. One remains in the damp, facing the Bal Tabarin. You will soon return to our waters.

I do not finish with my damned sculpture.

Greetings, DEGAS

*

1912

TO THE FÈVRE FAMILY . . . My sister Thérèse has just died in Naples.

I embrace you, my dear nieces.

I don't write any more.

The day after tomorrow I begin my seventy-eighth year.

DEGAS

NUDE IN A TUB

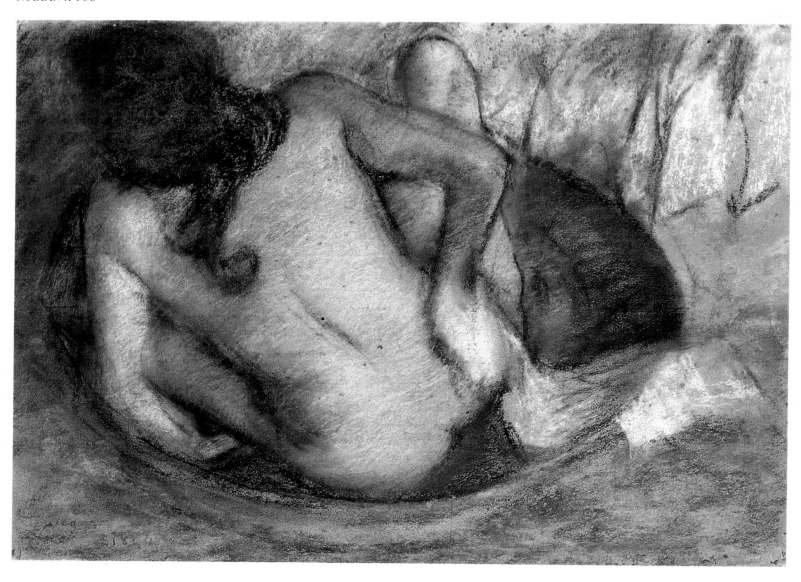

AFTER THE BATH

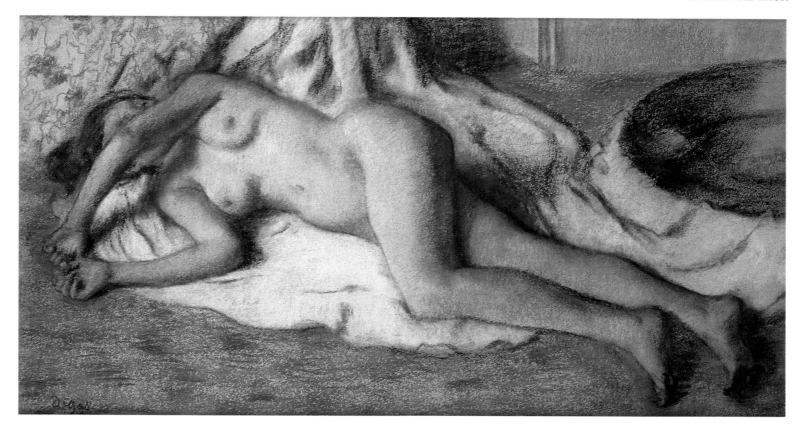

THE BAKER'S WIFE

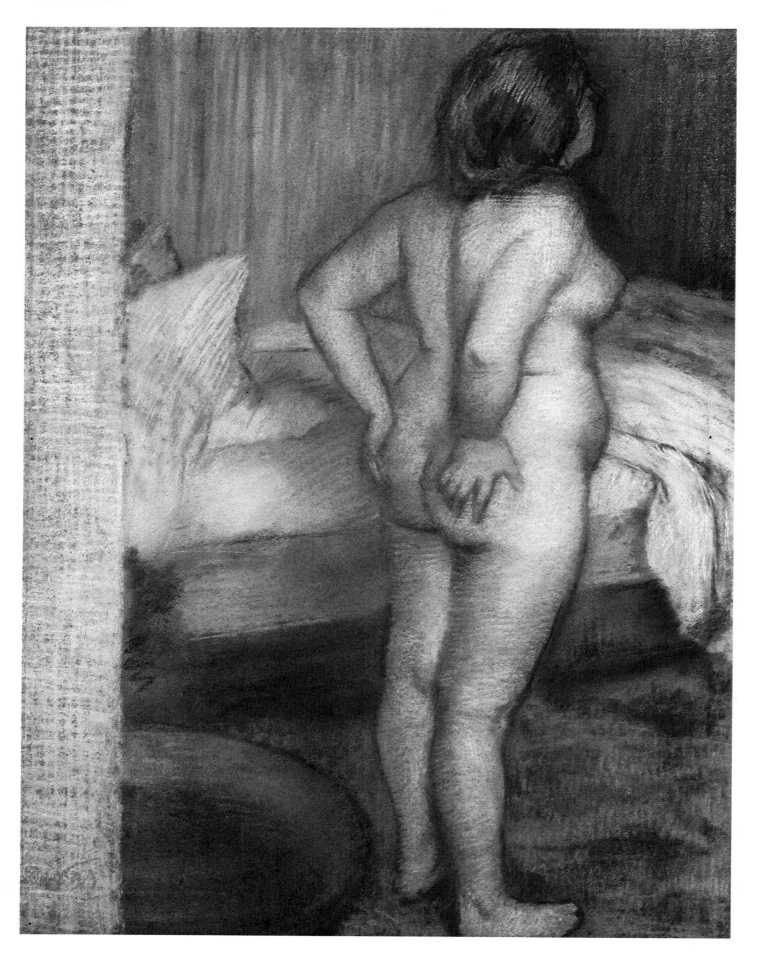

GIRL DRYING HERSELF

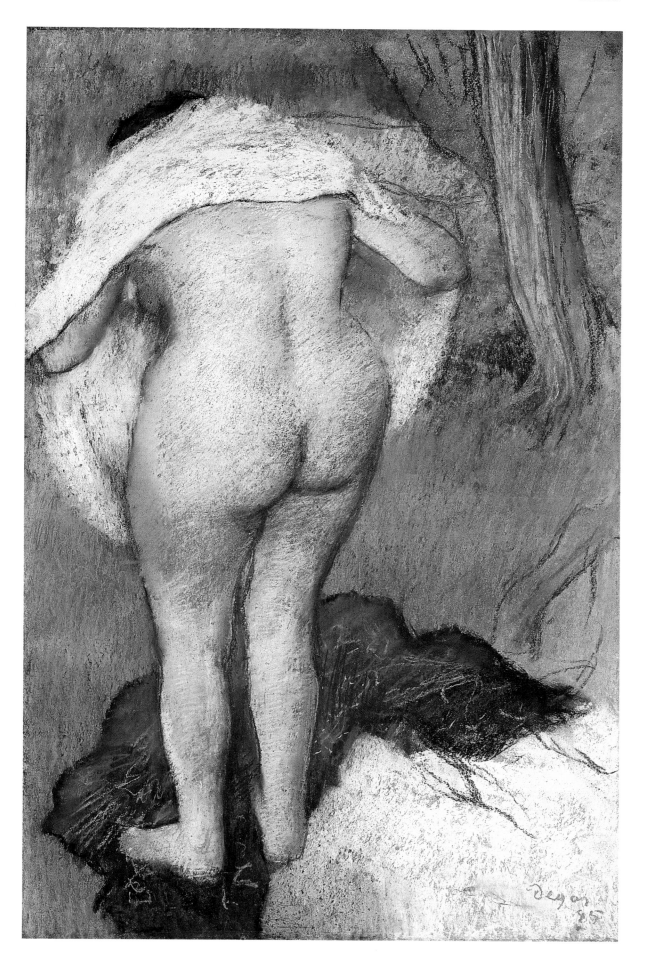

WOMAN AT HER TOILETTE

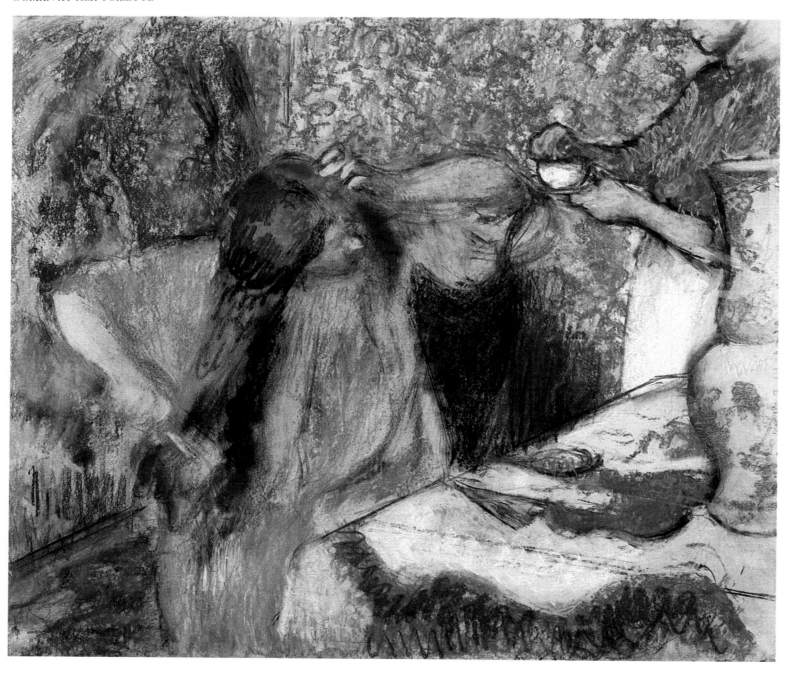

A WOMAN HAVING HER HAIR COMBED

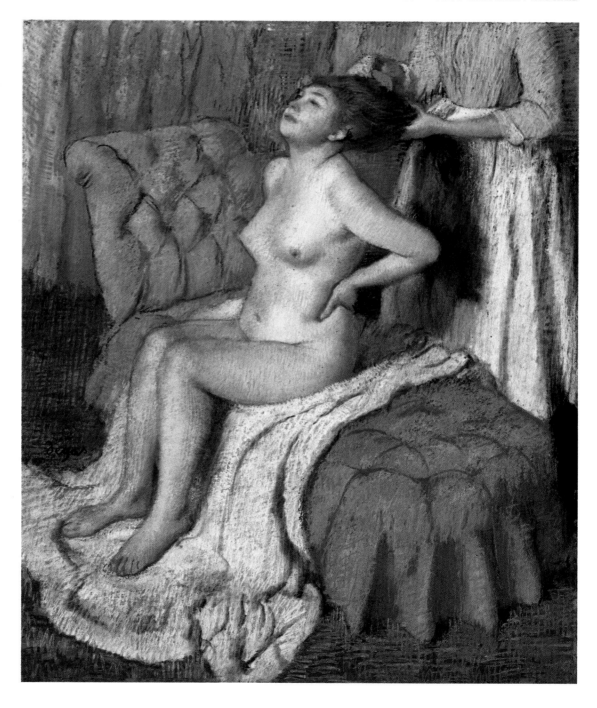

WOMAN IN A TUB

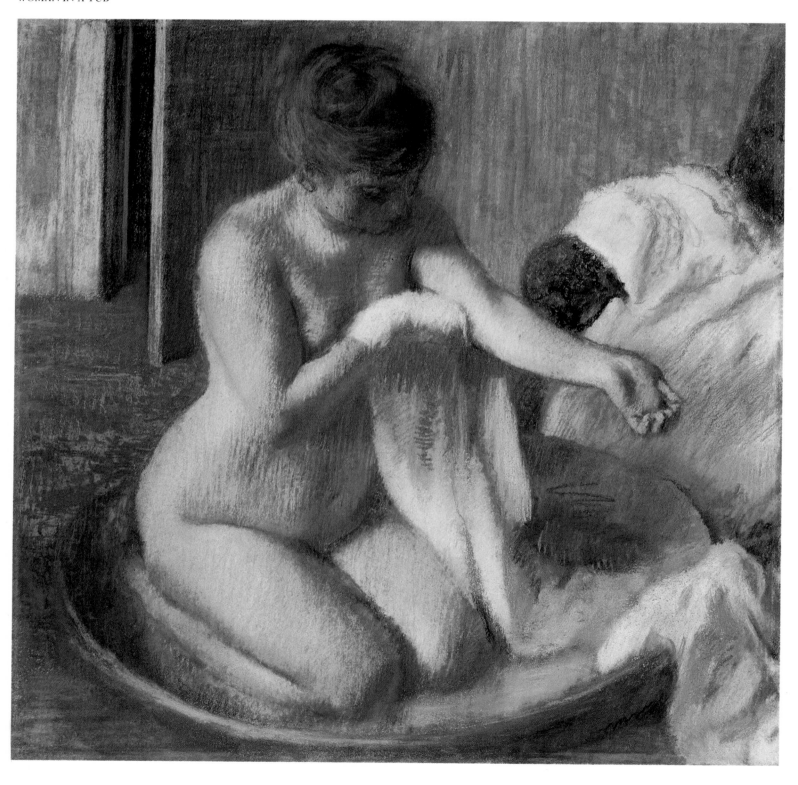

WOMAN DRYING HER LEFT ARM

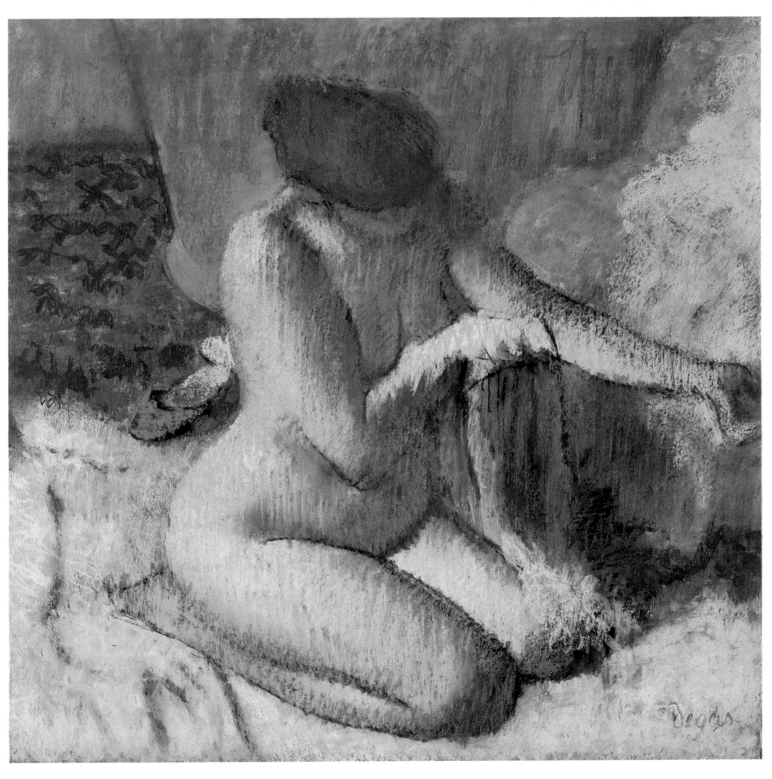

WOMAN IN A TUB

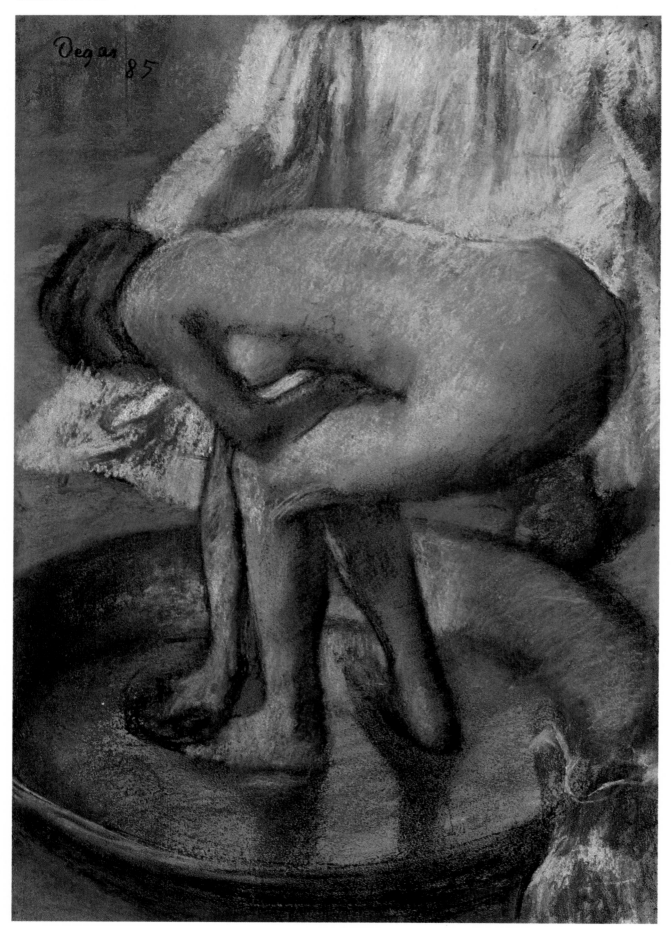

WOMAN DRYING HER FOOT

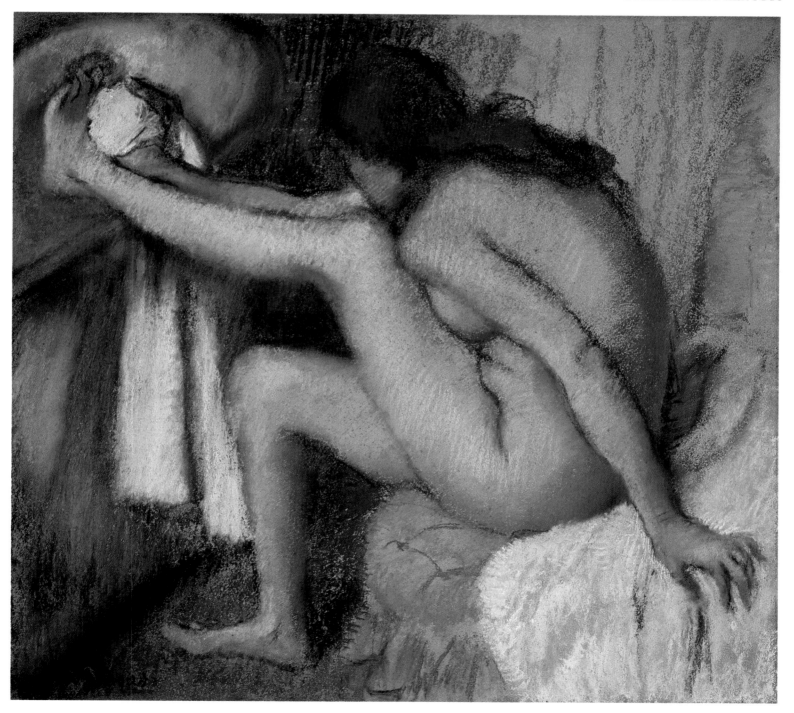

LANDSCAPE: STEEP COAST

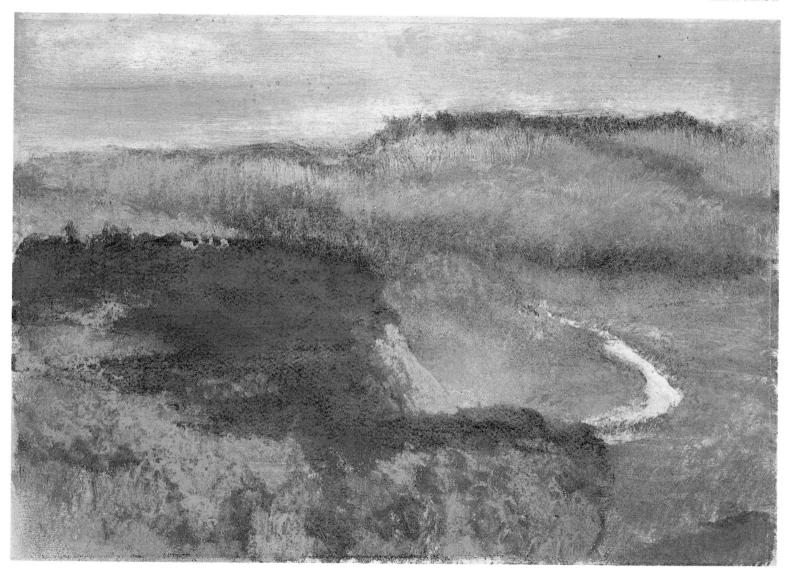

L'ESTEREL

FRIEZE OF DANCERS

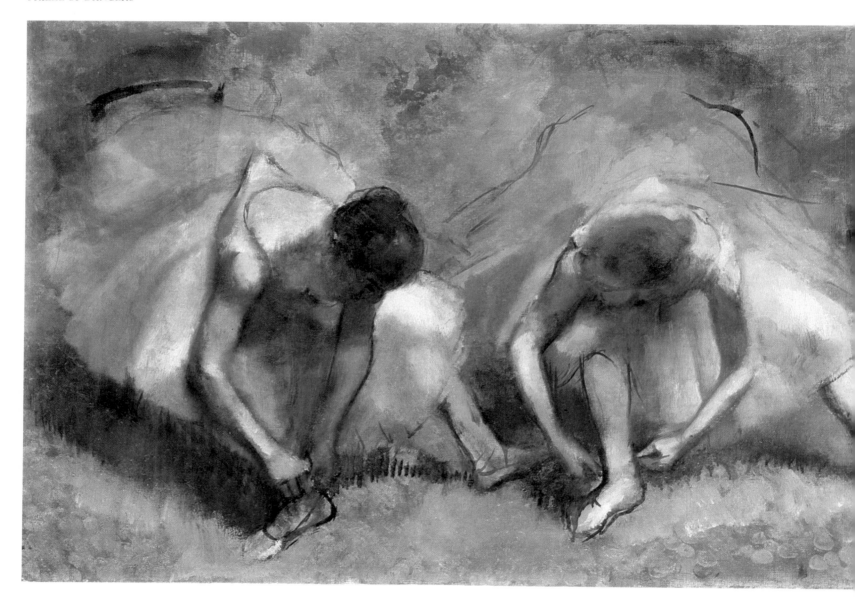

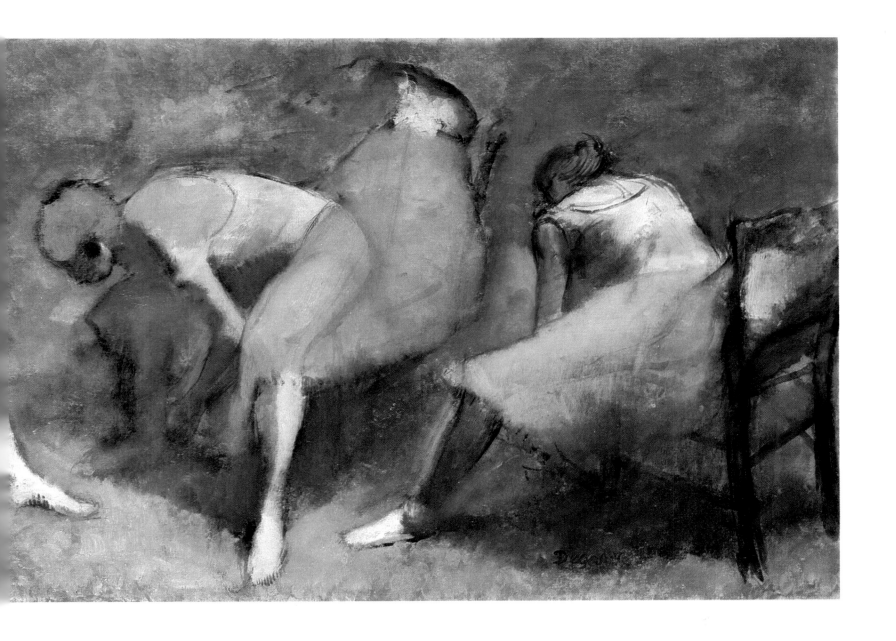

GROUP OF DANCERS

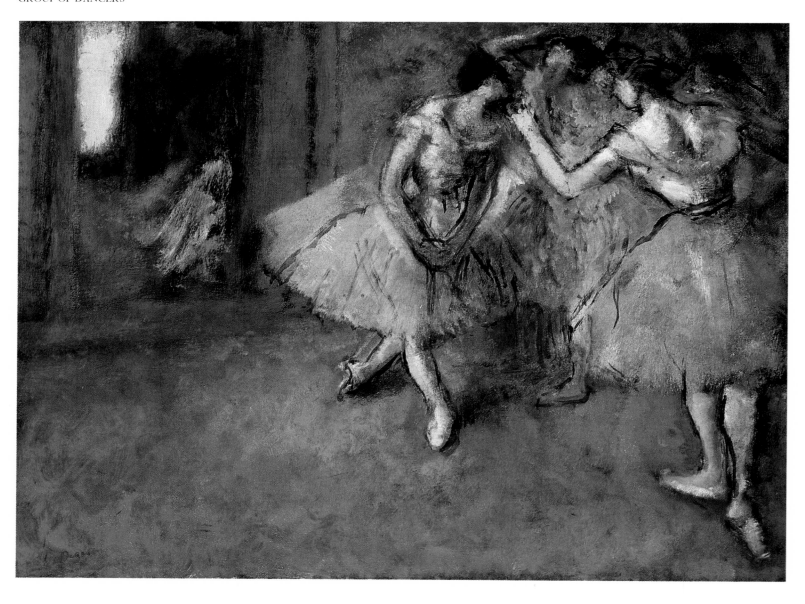

DANCE REHEARSAL IN THE FOYER OF THE OPERA

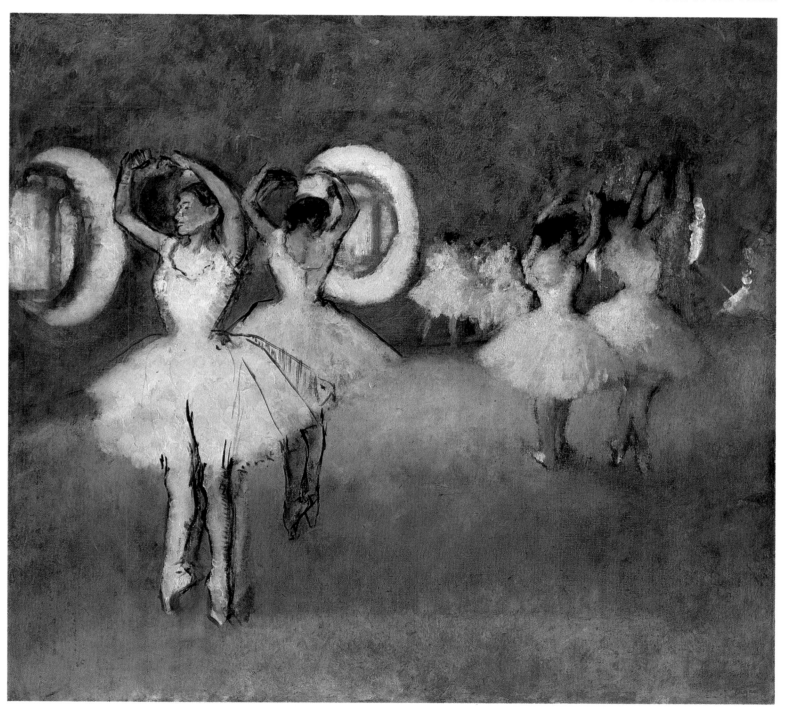

STUDY OF DANCERS

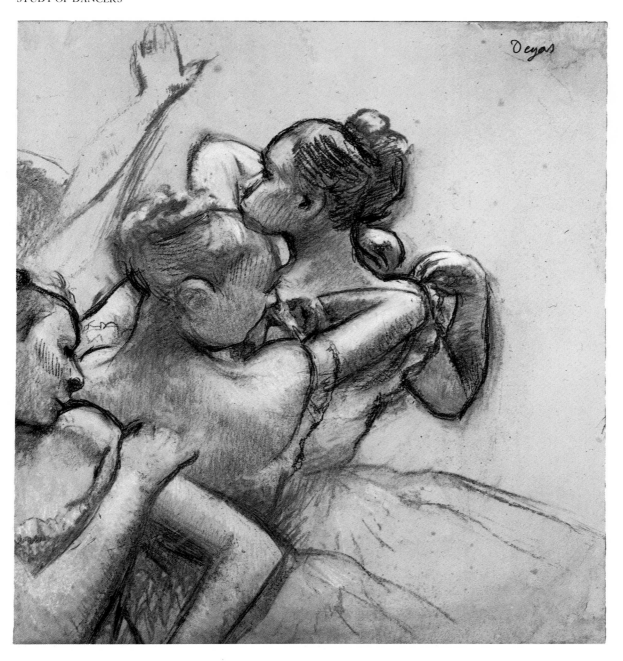

FOUR DANCERS

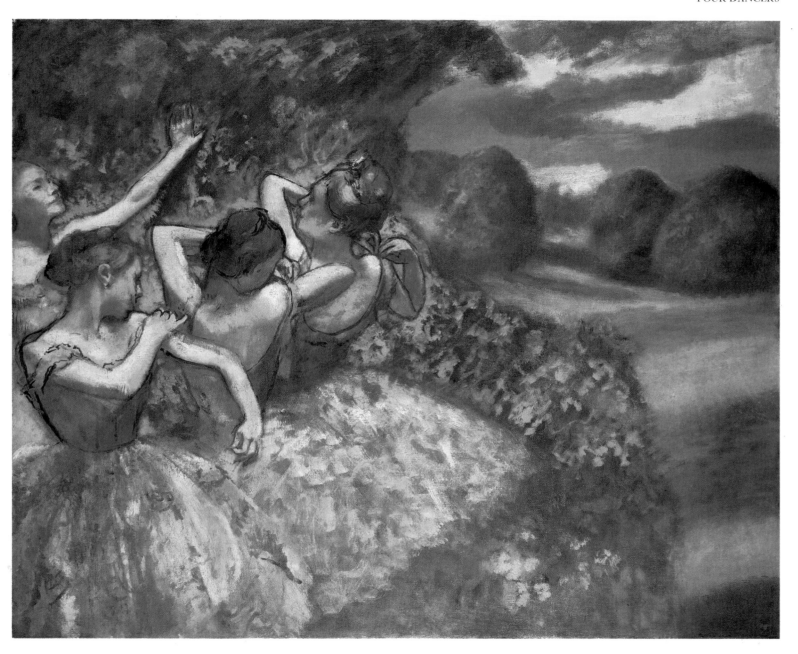

THE REHEARSAL ROOM

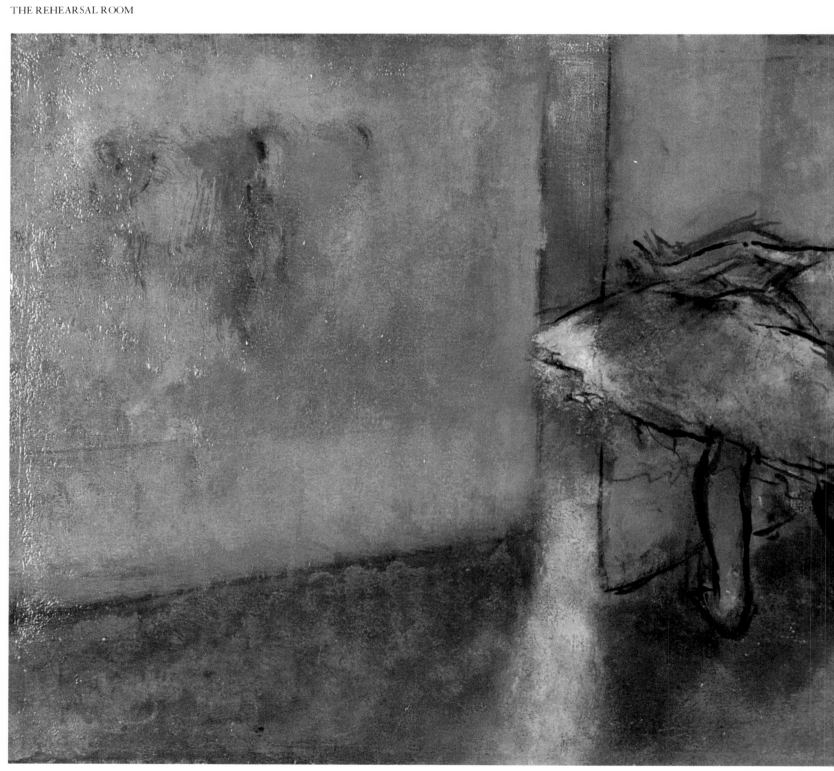

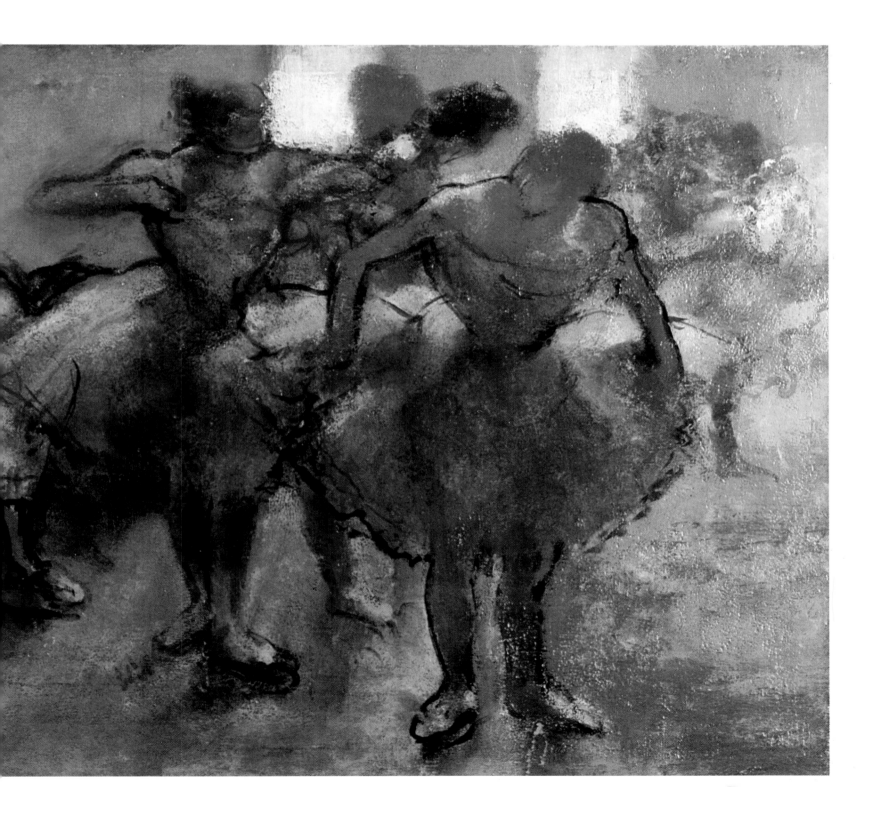

TWO DANCERS AT THE BAR

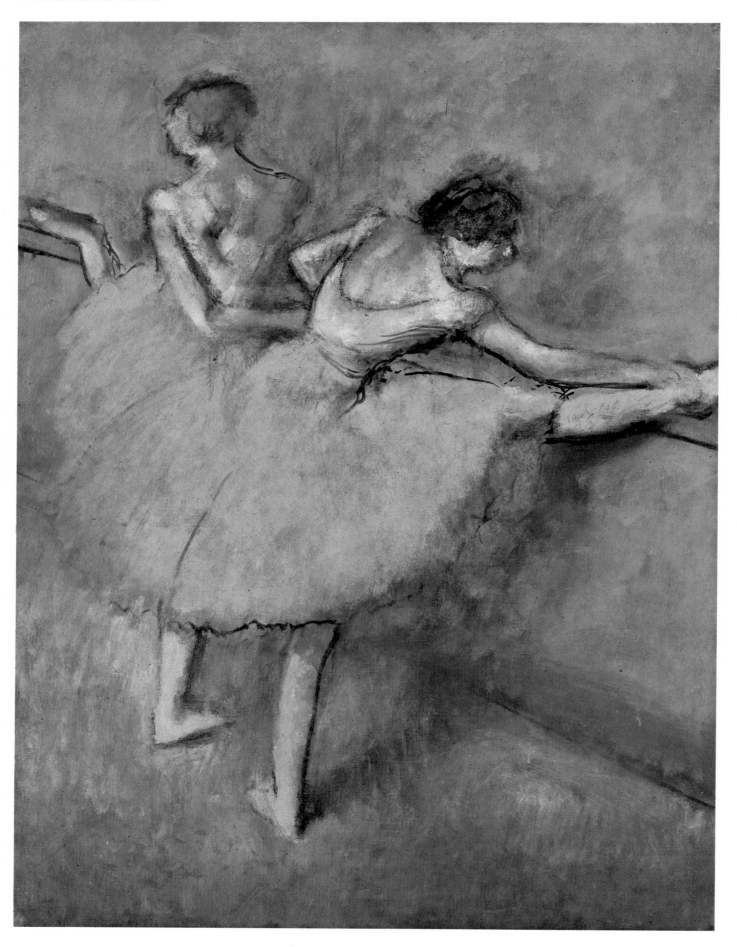

TWO DANCERS AT THE BAR

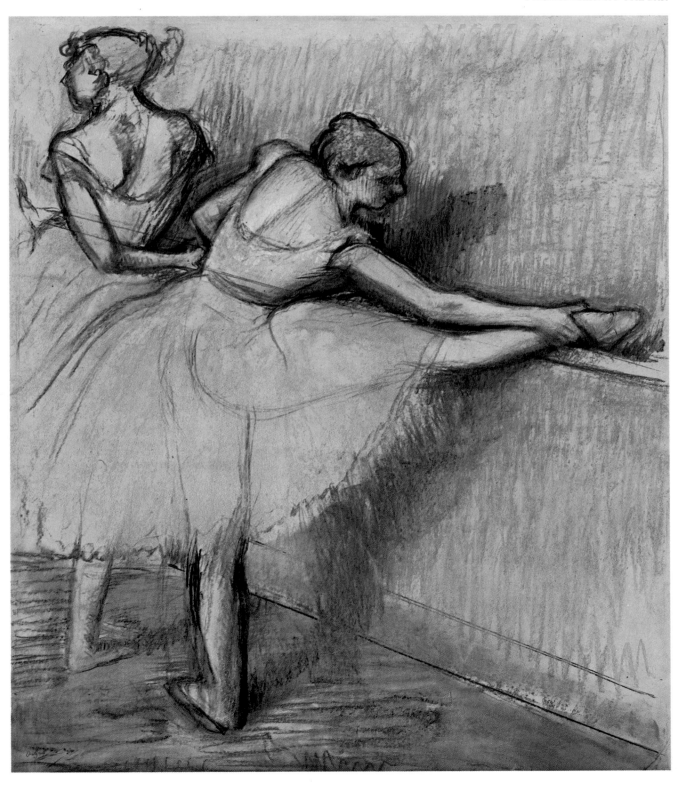

THE BATH

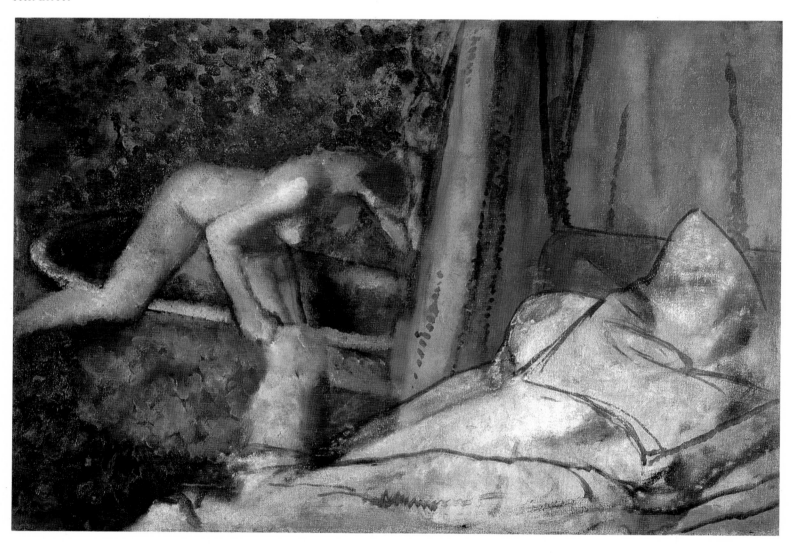

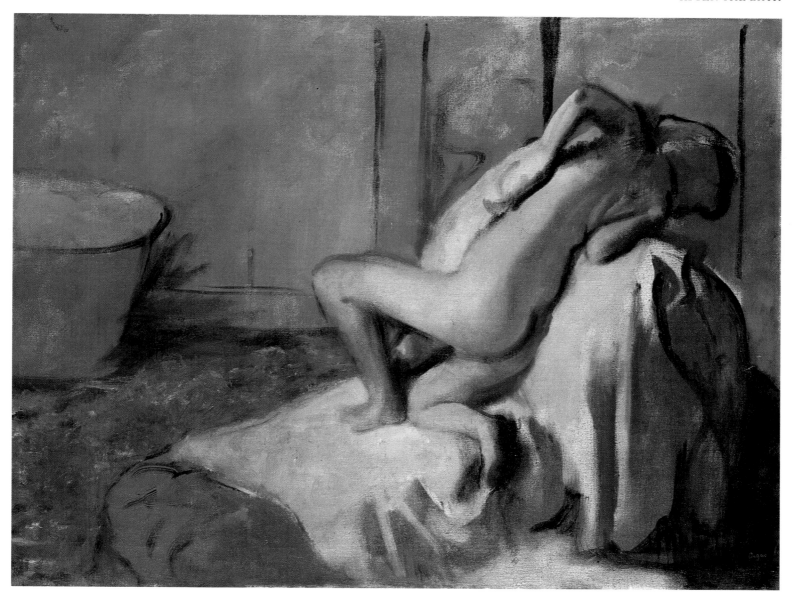

BREAKFAST AFTER THE BATH

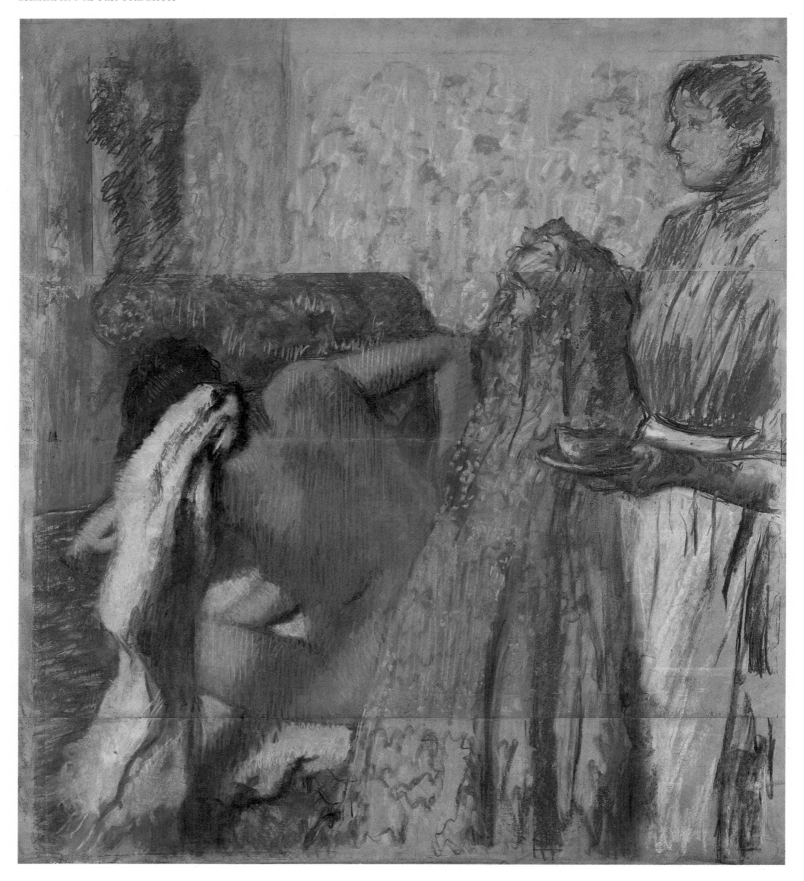

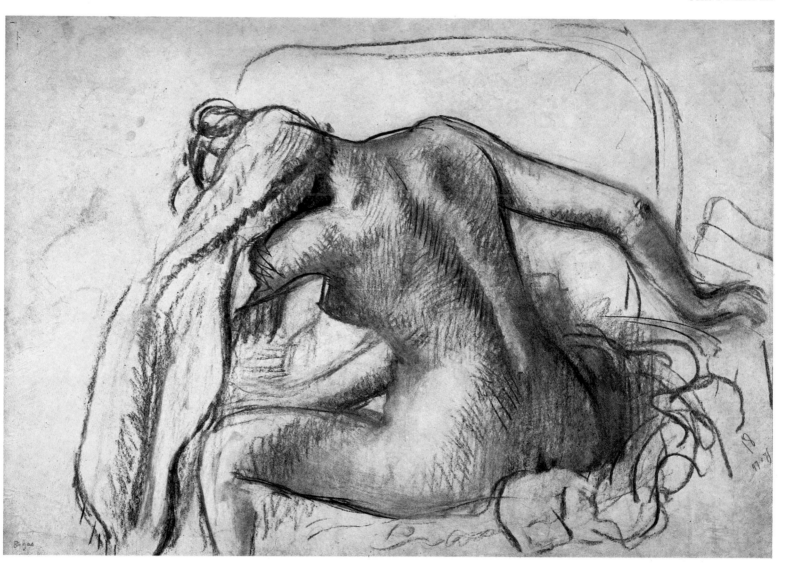

WOMAN DRYING HER HAIR

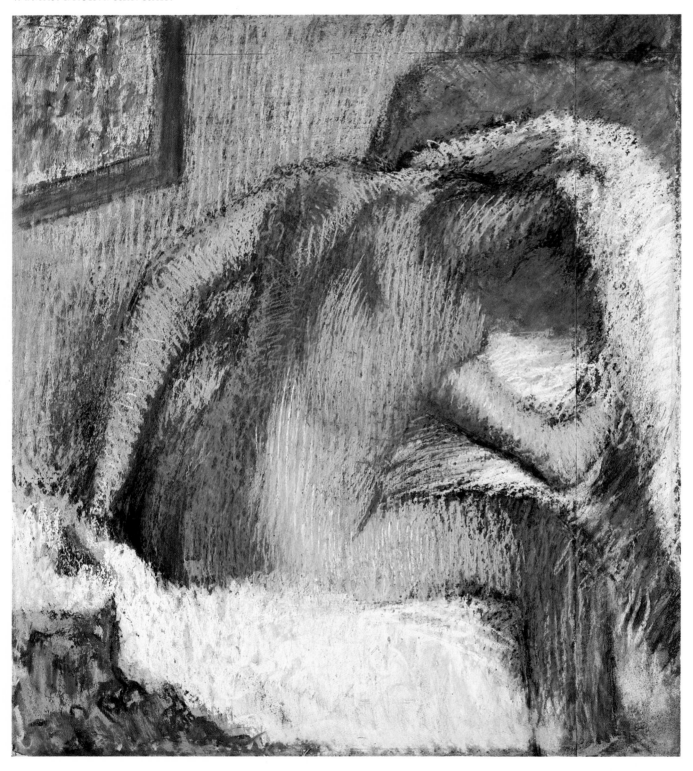

WOMAN DRYING HER NECK

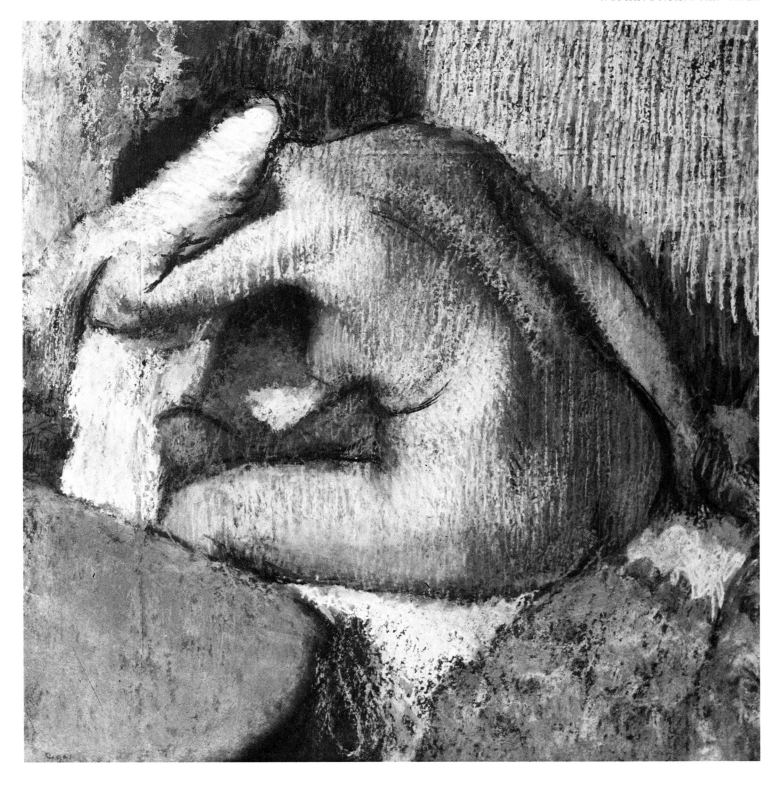

THE BATHERS

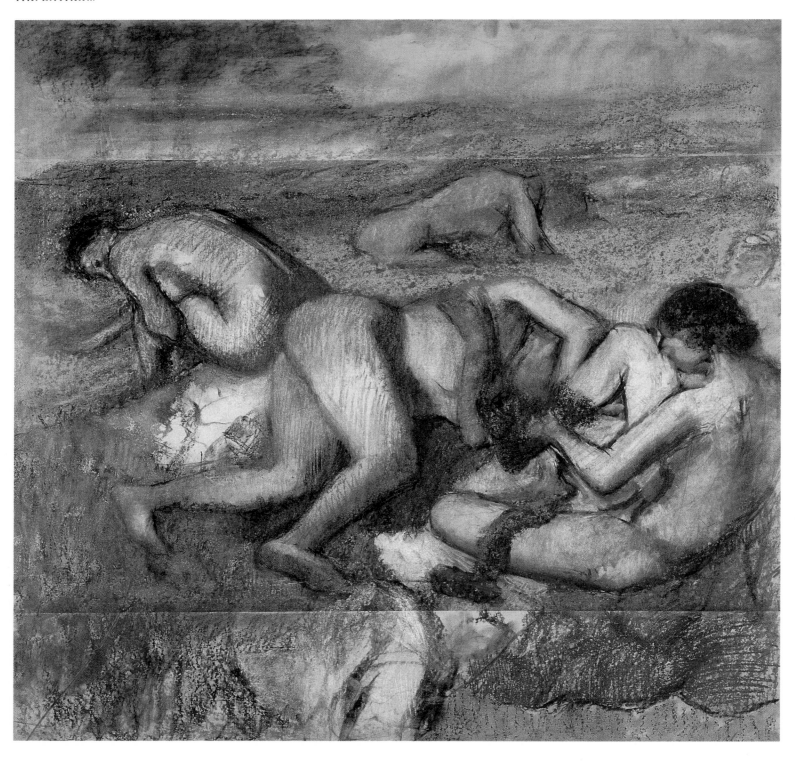

AFTER THE BATH

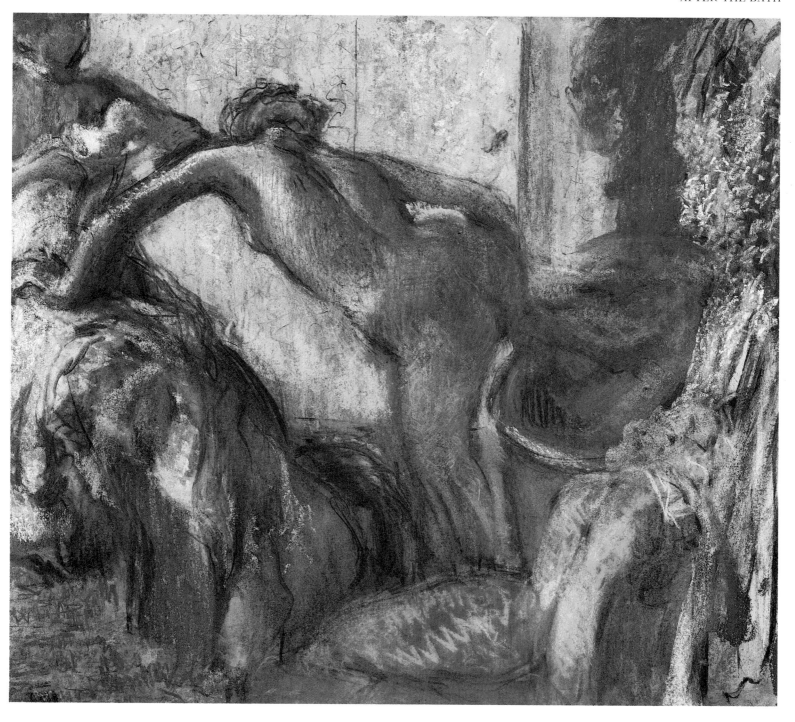

SEATED NUDE FROM BEHIND, COMBING HER HAIR

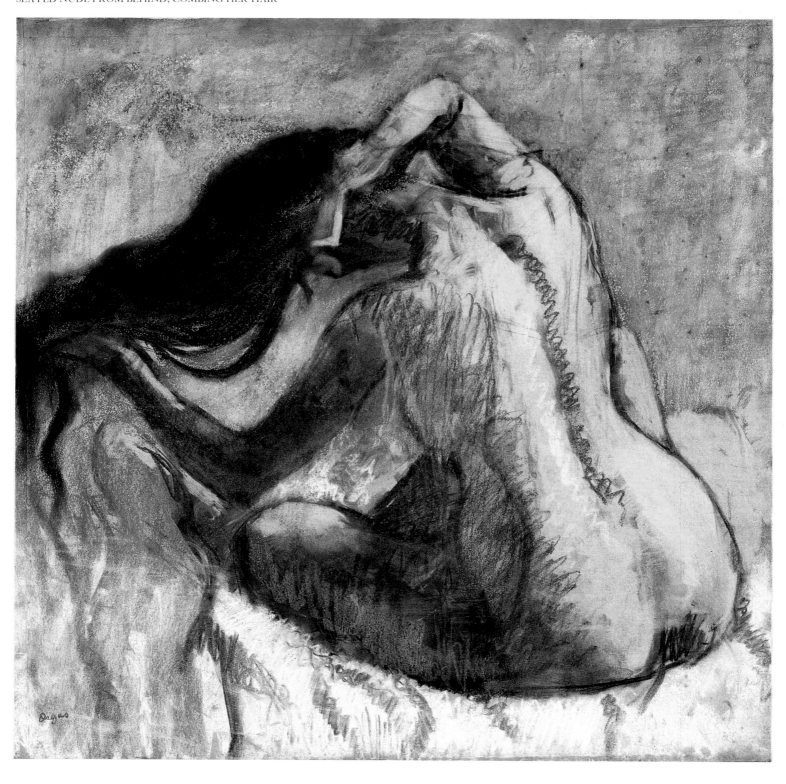

c.1895–c.1912

NUDE ON THE EDGE OF THE BATH DRYING HER LEGS

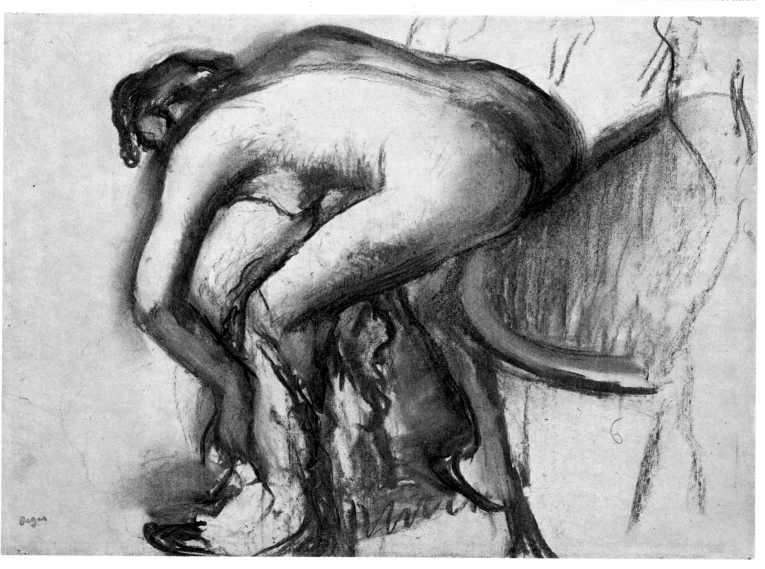

STUDY OF A NUDE

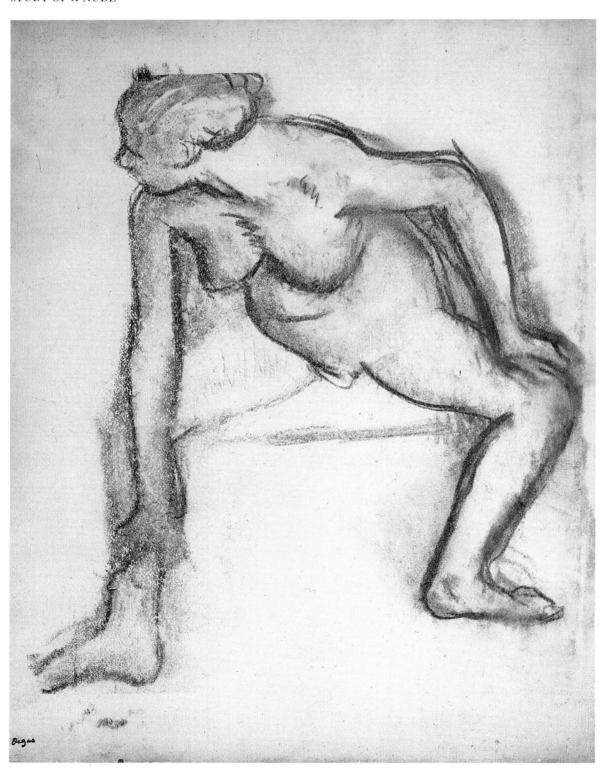

THE GREEN DRESS

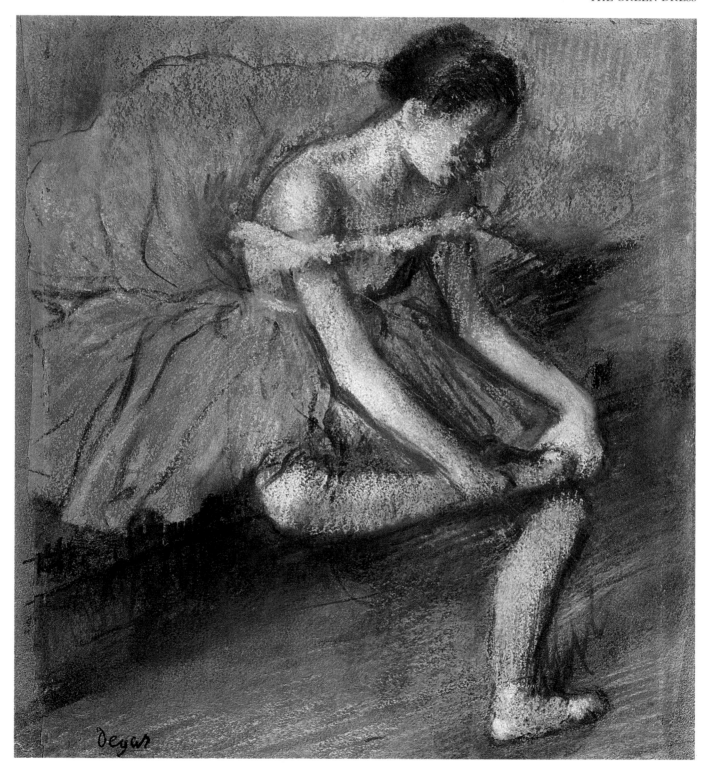

DANCER

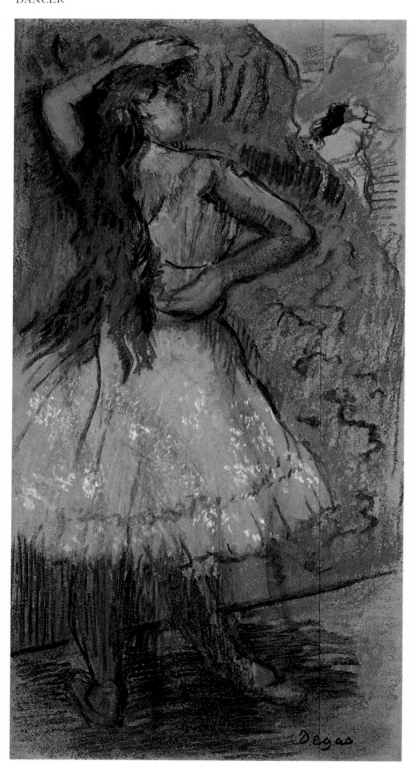

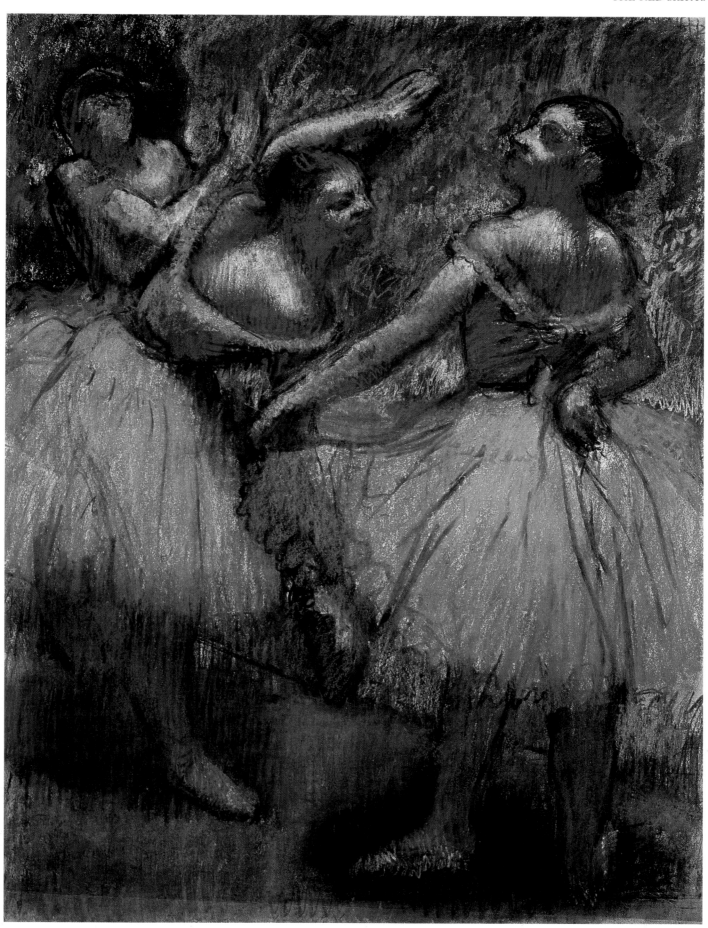

THE DANCERS

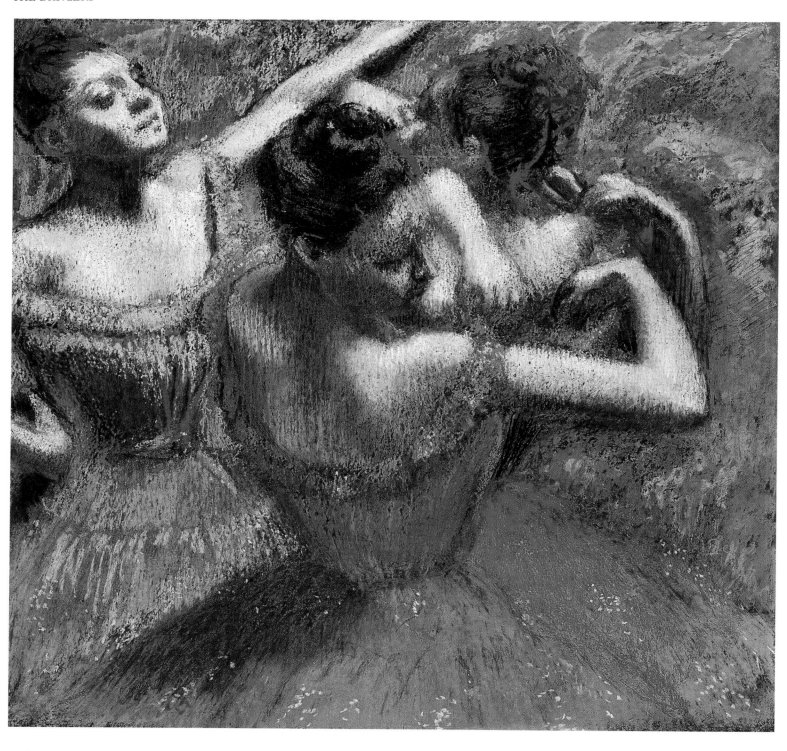

DANCERS

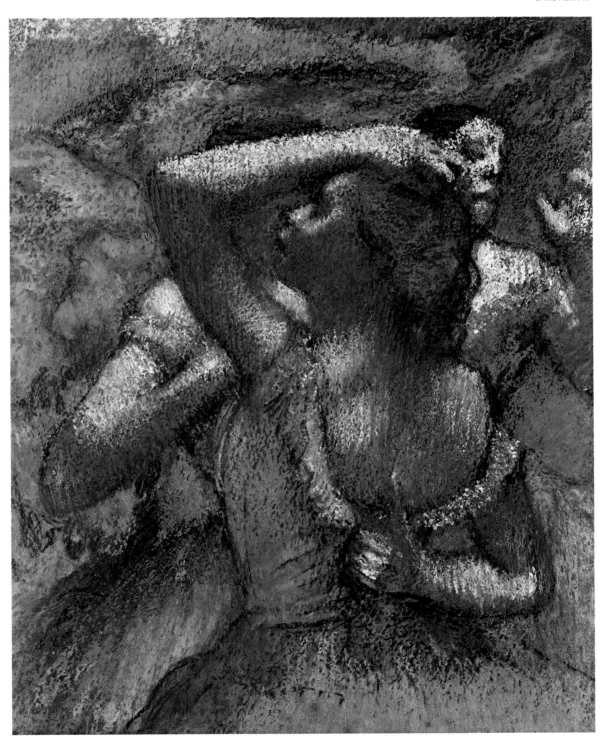

DANCERS IN GREEN AND YELLOW

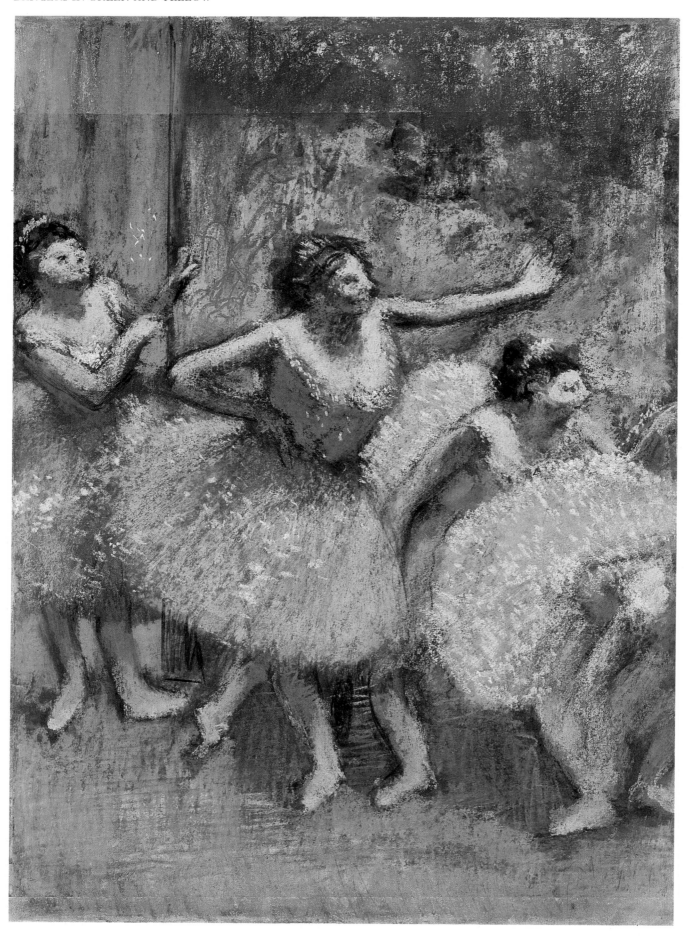

*c.*1895–*c.*1912

DANCERS IN GREEN AND YELLOW

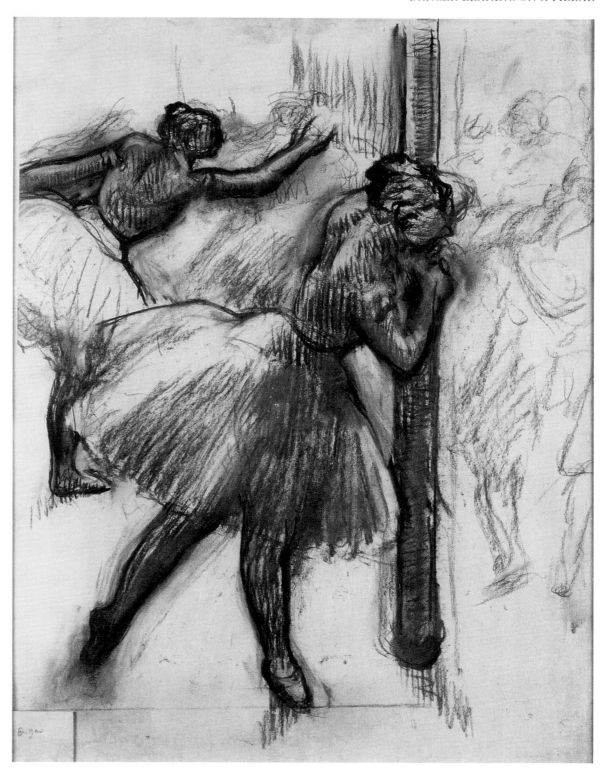

THREE NUDE DANCERS

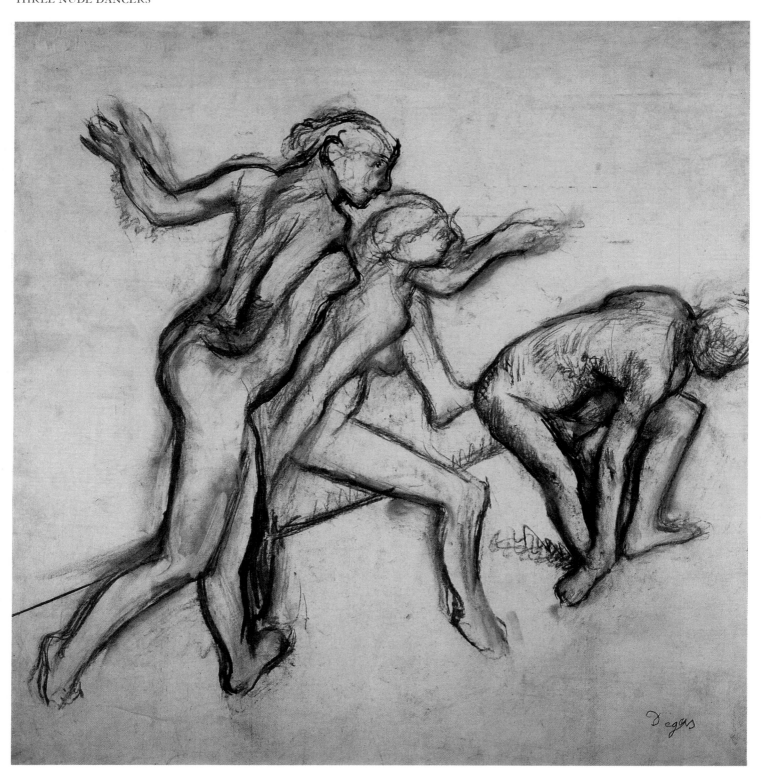

GROUP OF DANCERS

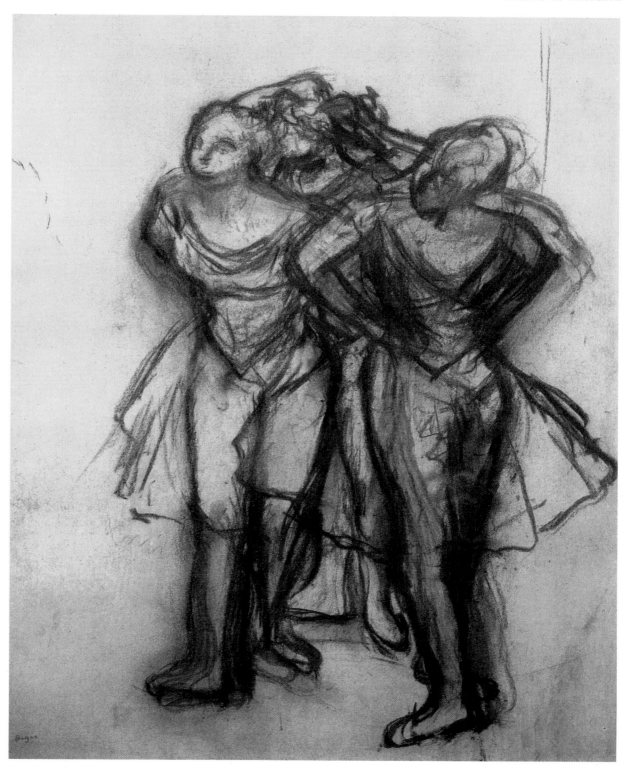

TWO DANCERS, HARLEQUIN AND COLOMBINE

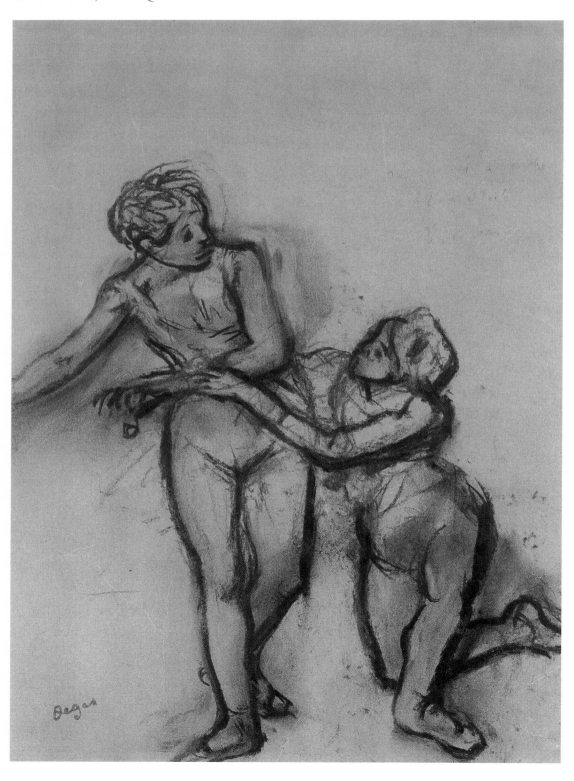

TWO DANCERS RESTING

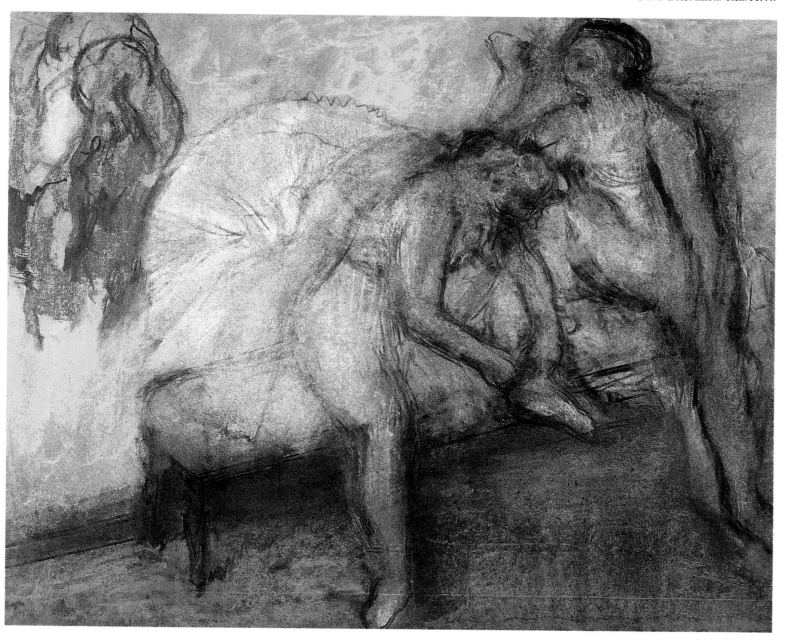

Degas' conversation recorded by his contemporaries

Rich and varied though Degas' own writings are, they include only limited and largely oblique references to his views on art. In his conversation, however, Degas was celebrated for his witty and incisive judgments on all aspects of his profession, from the achievements of his contemporaries to the reputations of past masters, from the decline of technical standards to the outrages of the critical press, from his views on women, politics and trade to the latest gossip from the Paris studios. In spite of his hatred of journalism and his suspicions of writers, many of his acquaintances saw fit to record his words, though it is significant that most withheld from publication until after his death.

Georges Jeanniot had known Degas for several decades and had been influenced by him in his own early development. He achieved some celebrity as an illustrator, but it is perhaps in his Boswell-like recording of times spent with Degas that he will best be remembered. Jeanniot's recollections, published in 1933, show how persistent some of Degas' preoccupations were: his emphasis on tradition in art, his fascination with techniques and materials, and his voracious appetite for collecting the work of other artists all recur in this and other memoirs.

One of Degas' most distinguished admirers was the young Paul Valéry, soon to become one of France's greatest poets and men of letters. His book Degas Dance Drawing is a remarkable collection of analyses, perceptions and recollections, including a number of remembered conversations with the elderly artist. Valéry was fascinated by Degas' ideas and habits of thought, and characteristically discussed his attempts at poetry and his encounters with the contemporary poet, Stefan Mallarmé. He also included the first-hand account of Ernest Rouart's period of study with Degas, again reminding us of Degas' preoccupations with the art of the past, in this case the work of Mantegna.

Other writers had a more professional interest in Degas and their accounts of the artist reflect this. Ambroise Vollard had already established himself as an influential and courageous art-dealer, promoting the work of Renoir and Cézanne as he was later to promote Picasso and Matisse. His association with Degas was a long-standing one and Vollard delighted in assembling fragments of gossip, legendary anecdotes and occasionally confused reminiscences. His taste for the colourful recollection was shared by a quite different character, George Moore, the Irish writer who contributed criticism to art periodicals and published a number of vivid novels in the Realist manner. Moore got to know Degas in his time in Paris and his account contains some celebrated passages, not least the famous and much misquoted claim that Degas represented his nudes 'as if you looked through a keyhole'.

One of the four accounts of Degas at the very end of his working life comes, not from a writer or fellow-artist, but from a model. 'Pauline', as she calls herself, posed several times a week for Degas as late as 1910 and later recalled a delightful series of glimpses into the artist's studio life and conversation. Though these reminiscences, too, appear to have been subtly embroidered in places, there is an unmistakable authenticity in Pauline's accounts of gruelling modelling sessions, Degas' reluctance to part with money and his occasional bursts of frankness and good-humour. Despite his entrenched right-wing views and bizarre obsessions, Degas' relentless study from the living model in his late seventies reminds us that some of the central preoccupations of his career still remained, more than half a century after his tentative beginnings in Italy.

'It is very good to copy what one sees; it is much better to draw what you can't see any more but in your memory. It is a transformation in which imagination and memory work together. You only reproduce what struck you, that is to say the necessary. That way, your memories and your fantasy are freed from the tyranny of nature. This is why pictures made in such a way, by a man who has a cultured memory and knows the old masters and his craft, are almost always remarkable works – look at Delacroix.'

During this conversation, we were going up the stairs at the Louvre.

'Did you see, a while ago,' he said to me, stopping when we were in front of the Medici Venus, 'that she is out of the vertical? She is in a position which she could not hold if she were alive. By this detail, a fault according to people who know nothing about art, the Greek sculptor gave his figure a splendid movement, while still retaining the calm which characterizes masterpieces.'

*

'It has to be said, we are living in strange times: this oil painting we are doing, this very difficult craft we are practising without knowing it! Such incoherence has probably never been seen before.

*

'Oh! Women can never forgive me; they hate me, they can feel that I am disarming them. I show them without their coquetry, in the state of animals cleaning themselves!'

'You think they don't like you?'

'I am sure of it; they see in me the enemy. Fortunately, for if they did like me, that would be the end of me!'

*

Once in the street: 'Well, Degas, since we are talking about women, what do you think of Gavarni?'

The previous night a party had been given in his honour at the Moulin Rouge.

'But, he was a great philosopher. He too knew women. I did not go to the party last night – I did not want to see all these gentlemen lay hands on what does not belong to them.'

'But what about his art?'

'H'm! It is a particular kind of drawing, of course. It is a manner of expressing oneself in drawing, but it is only a manner; it is not an expression of art. Now, Daumier, he had a feeling for the antique. He understands it so well that when he does *Nestor striking Telemachus*, it is expressed as it was in Tanagra. I was talking about it to Gérôme, at the café La Rochefoucauld, I spoke highly of Daumier.

'"So, you esteem that pompous ass?" said Gérôme.

'"But I believe that there were three great draughtsmen in the nineteenth century – Ingres, Delacroix and Daumier!" I said.

'"Well, the other day, as I was searching through my portfolios, I rediscovered a *Rue Transnonain*, I'll send it to you," Gérôme said.

'The following day, at my concierge's, there was a roll containing *La Rue Transnonain* and *La Liberté de la Presse*.

'I thanked him, that excellent Gérôme, I wrote to him: "My collection was lacking these

From *Memories of Degas* by Georges Jeanniot

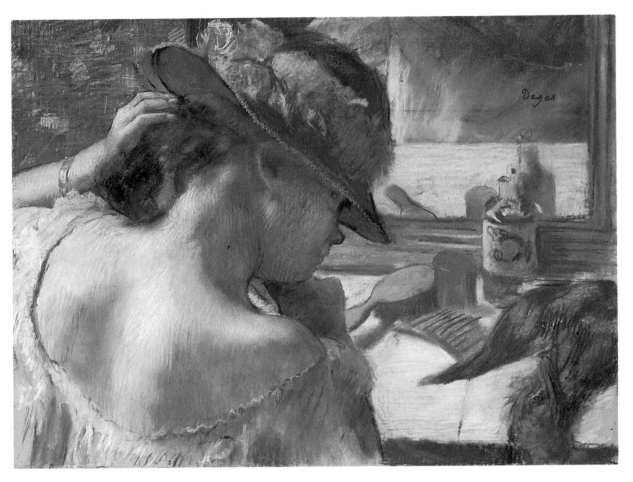

AT THE MIRROR

precious proofs, I am very grateful to you . . ." When talking sculpture with Gérôme, he will tell you in the end only painters understand how to make a sculpture.'

*

'At the moment, it is fashionable to paint pictures where you can see what time it is, like on a sundial, I don't like that at all. A painting requires a little mystery, some vagueness, some fantasy. When you always make your meaning perfectly plain you end up boring people. Even working from life, you must compose. Some people think it is forbidden!

'On this subject, Monet told me: "When Jongkind needed a house or a tree, he would turn round and take them from behind him."

'Well, yes! Why not? Corot, too, had to compose from nature. That is mainly where his charm lay. A picture is an original combination of lines and tones which enhance each other.'

Degas greatly enjoyed walking in the countryside. The air in the woods, the pure air falling from the trees or rising from the wet earth would put him in the best of form. One evening, in the Côte d'Or, he told me as we were walking along the edge of Charmois Wood: 'There are people who are always talking about the Masters; when they frequent them it is always to try and rob them. They don't understand them, they use them and they dishonour them. The secret is to follow the advice given by the masters in their work by doing something other than what they have done.'

The first time I took my wife to Degas' home, rue Blanche, he approached her as she was inquisitively looking at his apartment and at a few beautiful old pieces of furniture, and murmured in her ear: 'So! You thought that in an artist's place, it would be amusing, different, didn't you?... Don't you believe it, dear Madame, you are in the home of a bourgeois!'

*

'Basically, we don't know anything, neither where we come from nor where we are going; so why should we try to elucidate a mystery that nobody has yet managed to penetrate, because it is quite evidently impenetrable? It is much better, if one is an artist, to give free rein to one's inspiration towards beauty, in the way one understands!'

*

Apart from his outburst of temper, he had a dignity which put him in the superior realms of the élite, as the following anecdote shows.

It was at his friend Henri Rouart's sale. This sale was held in the largest of the auction rooms where Manzi and Joyant had established their trade in pictures and *objets d'art*. Degas stayed in a distant room. Suddenly a reporter rushes in:

'Monsieur Degas! Do you know how much your painting of *Two Dancers at the Bar with a Watering Can* has just been sold for?'

'No.'

'Four hundred and seventy-five thousand francs!'

'Oh! That is a good price,' Degas said.

'What! You are not disgusted that this painting won't ever bring you more than the 500 francs you were paid for it?'

'No, sir. I am like the racehorse who wins the Grand Prix, I am satisfied with my ration of oats.'

*

In the course of one of our walks, when Degas walked slowly, our attention was suddenly drawn to two individuals on bicycles, carrying a folding iron bedstead at least two metres long. The appliance was resting at both ends on one of our acrobats' shoulders. How had they achieved this balance? The fact was that they were spinning along with that equipment, among cars, buses and trams on the main boulevard. Many were the pedestrians who stopped to enjoy that dangerous spectacle.

Degas took my arm:

'Do you see that?'

'I do, so?'

'It presages the end of art and humanity.'

'Oh! Oh!' I said.

'Quite; the passion for speed in spite of anything is immoral and immorality generates death. I feel sorry for our successors; they are heading for a monstrous hecatomb. Come with me a little further and then I shall abandon you to the perils of the street.'

'You're damned gloomy today.'

'No, I am right. We are witnessing the origins of a great catastrophe.'

Degas would admit no argument when there was any question of 'Monsieur' Ingres. To someone objecting that the great man's figures were like zinc, he would retort, 'Maybe so! . . . But what a zinc-worker . . . a genius!'

One day Henri Rouart took upon himself to reproach the *Apothéose d'Homère*, with coldness, observing that the gods in it, frozen as they were into lofty attitudes, breathed an icy atmosphere.

'What!' Degas burst out. 'But what could be more admirable? The whole canvas is filled with the air of the empyrean.'

He was forgetting that the empyrean is a region of fire. . . .

<p style="text-align:center">*</p>

On this day Degas talked to me about Ingres and his relations with him . . .

Telling himself that he really must engage Ingres in talk, he began timidly and finally broke out with: 'I am studying painting, just beginning, and my father, who's a man of taste and an amateur, seems to think I may not be an absolutely hopeless case.'

'Study line,' Ingres told him . . . 'draw lots of lines, either from memory or from nature.'

Another time, Degas described this interview with one rather important variation.

According to this, he must have gone back to Ingres' house, as above, but accompanied by Valpincon, and carrying a portfolio under his arm. Ingres looked through the drawings in it, closed it, and said: 'Excellent! Young man, never work from nature. Always from memory, or from the engravings of the masters.'

<p style="text-align:center">*</p>

Degas had known Moreau very well, and painted his portrait. One day Moreau twitted him: 'Are you really proposing to revive painting by means of the dance?'

'And you,' Degas retorted, 'are you proposing to renovate it with jewellery?'

He would say too of Moreau: 'He wants to make us believe the Gods wore watch-chains . . .'

A visit he paid to the Musée Moreau in the rue de la Rochefoucauld made him abandon the idea he had formed of creating his own museum, which would have included his private collection (and perhaps a part of his studio). 'How truly sinister,' he remarked on coming out, '. . . it might be a family vault. . . . All those pictures crammed together look to me like a *Thesaurus*, a *Gradus ad Parnassum*.'

<p style="text-align:center">*</p>

One day at the races, happening to be next to Detaille, the latter borrowed his field glasses. When he turned round to give them back, Degas remarked, 'Just like a Meissonier, isn't it?' The other gave a start, but – naturally – said nothing.

Another thing he said of Meissonier – as small in size as his paintings, and immensely fashionable at the time – was: 'He's the giant of the dwarfs!'

Degas had connections in all camps, and one day at a café he was with a group of hack painters he knew slightly, when one of them said, 'Look, do you really think Corot can draw trees?'

'I'm going to astonish you,' said Degas. 'He can draw figures even better!'

One day at the Louvre, I was walking with Degas through the main gallery. We stopped in front of an imposing picture by Rousseau, a magnificent rendering of an avenue of huge oaks.

After admiring it for some time I remarked how conscientiously, how patiently the painter, without spoiling anything of the total effect of the masses of foliage, had worked at the minute details, or at adequately producing their effect – to a degree that suggested endless labour.

'How superb,' I said, 'but what a bore, to make all those leaves . . . It must have been fearfully tedious . . .'

'Rubbish,' said Degas. 'If there were no tedium, there'd be no enjoyment in it.'

*

He would say too: 'Painting isn't so difficult when you don't know . . . But when you do . . . it's quite a different matter!'

*

Severely self-critical, he would take a certain pleasure in repeating what a critic had said about him in a review of an exhibition: 'Continually uncertain about proportions.' Nothing, he claimed, could better describe his state of mind while he was toiling and struggling over a work.

About drawing again, his constant preoccupation, he would say: 'Drawing and delineating are two quite different things, you must never confuse them.'

*

After a performance of *Faust*: The dressing-room of the old trouper (Faure) was thronged with admirers in ecstasies about his talent: 'Wonderful, sublime, incomparable! . . .' – and so on.

'And so simple!!!' cut in a voice from the back of the room. It was Degas.

Faure swung round, furious. 'You'll pay for that one, my lad!'

And in fact he did make him pay, with a thousand petty annoyances, sending the bailiff to collect pictures not delivered on time, etc.

*

He told me that, dining one day at Berthe Morisot's along with Mallarmé, he gave vent to his feelings about the agonies of poetic composition. 'What a business!' he lamented. 'My whole day gone on a blasted sonnet, without getting an inch further . . . And all the same, it isn't ideas I'm short of . . . I'm full of them . . . I've got too many . . .'

'But, Degas,' rejoined Mallarmé, with his gentle profundity, 'you can't make a poem with ideas . . . *You make it with words.*'

*

At dinner, with Mallarmé: 'Art is falsehood!' And he goes on to explain how a man is an artist only at certain moments, by an effort of will. 'Objects have the same appearance for everybody. . . .'

*

At *seventy*, he told Ernest Rouart: 'You have to have a high conception, not of what you are doing, *but of what you may do one day*: without that, there's no point in working.'

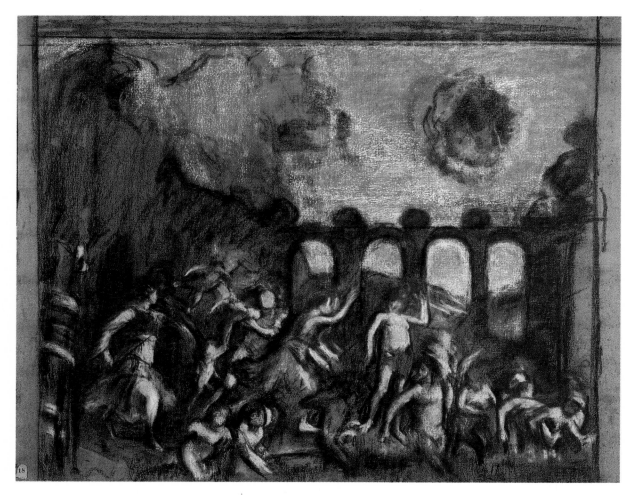

COPY AFTER MANTEGNA: WISDOM EXPELLING THE VICES

When Degas made me copy the Mantegna in the Louvre, *Wisdom Expelling the Vices*, he had
some novel ideas about how the old masters worked, and wanted me to make the copy
according to a technique he had thought up, which was much closer to that of the Venetians
than to that of Mantegna. . . .

First he told me: 'You are to make a groundwork in green, and let it dry for a few months in
the open air. Why, Titian himself would wait maybe a year before a picture was ready for more
work! Then when the preparation is thoroughly dry, it can be glazed with red, and we'll have
the right tone.'

While I was preparing my copy in terre-verte, Degas came to see me in the Louvre:
'But that isn't green! It's grey! Let me see you do it in apple green! . . .'

So I turned to the brightest shades to find a green that would suit him. Visitors at the
Louvre thought I was crazy. 'What! Do you really see the picture in that colour?' 'Certainly.
Can't you see it's green all over?'

Finally the sketch was finished with great difficulty. It is a highly complex composition, and
placing all the figures in it was hard work. . . .

All this time Degas would be saying: 'When are you going to finish? I've started a copy at
my place, and I've almost finished the drawing. Come and see it.'

I went to his studio, and there he showed me a pastel sketch on canvas, in camaïeu, from a photograph. Working intensely while I watched, he added a few accents to his drawing. And finally he left it in that state. . . .

When my ground was finished it was taken off to the rue de Lisbonne to dry in the yard. Three months later it was taken back to the Louvre where we made an appointment for putting on the glazes. . . .

Finally, behold, he comes along with a very hurried step, sliding on the Louvre parquet, swinging the wide sleeves of his Inverness cape like a bird's wings.

'What! Haven't you done anything!'

'But I was waiting for you . . .'

Some growling on his part, a rather flustered silence on mine. The fact was he would have liked me to have started muddling over my canvas, so that he could come along later and give a few masterful hints. But since I had done nothing, a start had to made. Taking a good red, we glazed it over the groundwork to get the right flesh tints.

The result was not very good. Adding some burnt sienna, we fiddled about for a while. Finally he left me, with: 'See you add all those tones – blue, red, yellow – very lightly, like watercolours, to let the ground show through, and the effect will be very good.'

I wrestled with that wretched canvas as best I could, and I must own that the final result was anything but brilliant. The amount of oil it took to apply the paint yellowed it dreadfully.

*

'If Rembrandt had known about lithography,' he was fond of saying, 'heaven alone knows what he might have made of it.'

From *Degas: An Intimate Portrait* by Ambroise Vollard

'Vollard, please do not say anything against fashions. Have you ever asked yourself what would happen if there were no fashions? How would women spend their time? What would they have to talk about? Life would become unbearable for us men. Why, if women were to break away from the rules of fashion – fortunately there is no danger – the government would have to step in and take a hand.'

*

I had come to invite Degas to dinner that evening.

'Certainly, Vollard,' he said. 'But listen: will you have a special dish without butter prepared for me? Mind you, no flowers on the table, and you must have dinner at half past seven sharp. I know you won't have your cat around and please don't allow anybody to bring a dog. And if there are to be any women I hope they won't come reeking of perfume. How horrible all those odours are when there are so many things that really smell good, like toast – or even manure! Ah –' he hesitated, 'and very few lights. My eyes, you know, my poor eyes!'

From *Degas: An Intimate Portrait* by Vollard

'But what about yourself, Monsieur Degas? Why haven't you ever married?'

'I, marry? Oh, I could never bring myself to do it. I would have been in mortal misery all my life for fear my wife might say, "That's a pretty little thing," after I had finished a picture.'

*

'People call me the painter of dancing girls. It has never occurred to them that my chief interest in dancers lies in rendering movement and painting pretty clothes.'

*

VOLLARD: But how is a painter to learn his *métier*, Monsieur Degas?

DEGAS: He should copy the masters and re-copy them, and after he has given every evidence of being a good copyist, he might then reasonably be allowed to do a radish, perhaps, from Nature. Why, Ingres —

V.: Ingres never worked out of doors; but I understand that Manet tried his hand at *plein air*, didn't he?

D. (irritated): Never say *plein air* to me again! (A pause.) Poor Manet! To think of his having painted the *Maximilian* and the *Christ with the Angels*, and all the others he did up till 1875, and then giving up his magnificent 'brown sauce' to turn out a thing like the *Linge!*

V.: I understand that Courbet could not stand even the *Christ with the Angels*.

D.: Well, for one thing, Courbet contended that, never having seen an angel, he could hardly know whether they had behinds or not; and, what was more, in view of their size, they could not possibly fly with the wings Manet had given them. But all that talk makes me sick. There is certainly some fine drawing in the *Christ*. And what transparent impasto! What a painter!

*

Degas never lost an opportunity to proclaim Carrière one of the great painters. Yet that day, as he inspected the different pictures and stopped in front of the Carrières he was irritated because the art critic kept pointing them out to him, and his only comment was, 'I can't see very well today.'

Degas stopped to look at each canvas, and presently gave a little exclamation of disgust. 'To think,' he remarked, 'that not one of these fellows had ever gone so far as to ask himself what art is all about!'

'Well, what *is* it all about?' countered the critic.

'I have spent my whole life trying to find out. If I knew I should have done something about it long ago.'

Suddenly we heard someone call 'Monsieur Degas!' It was Vibert, the well-known painter of *The Cardinals*.

'You must come to see our exhibition of watercolours,' he said. Then he gave a sidelong glance at the old mackintosh Degas was wearing, and added:

'You may find our frames and rugs a little too fancy for you, but art is always a luxury, isn't it?'

'Yours, perhaps,' retorted Degas; 'but mine is an absolute necessity.'

AT THE MILLINER'S

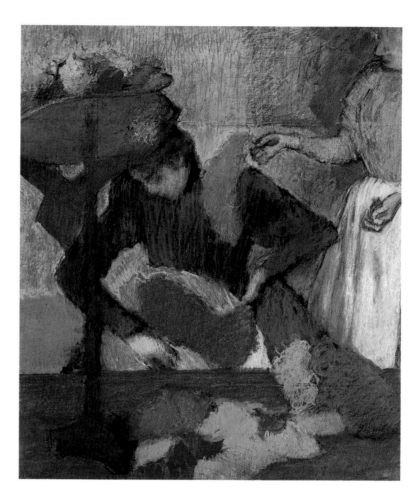

Knowing the difficulty Degas had in making up his mind to leave his studio, I was not a little surprised when he informed me that he was going to spend a fortnight with his friend Monsieur Henri Rouart at La Queue-en-Brie.

'I ought to be able to get a few landscapes out of it,' he said. 'Will you come to see me there?'

I was only too glad to accept his invitation. When I had arrived at La Queue, Monsieur Rouart's gardener directed me to a pavilion, where, on the doorstep, I saw an old man with thick glasses, dressed in denim trousers and a straw hat. No one would ever have suspected that this mild figure was the terrible Degas.

'I've been outside long enough,' he said, as I approached. 'There's still a few minutes before lunch; I'm going to work a little more.'

I made as if to go, but he stopped me. 'Oh, you can come with me. I'm only doing landscape at present.'

I followed him into a little studio he had fixed up for himself in the grounds. He turned his back to the window and began to work on one of his extraordinary out-of-door studies.

I could not get over my surprise at this method of doing a landscape indoors, and when I mentioned the fact, Degas replied:

'Just an occasional glance out of the window is enough when I am travelling. I can get along very well without even going out of my own house. With a bowl of soup and three old brushes, you can make the finest landscape ever painted. Now take old Zakarian, for example. With a nut or two, a grape and a knife, he had material enough to work with for twenty years, just so long as he changed them around from time to time. There's Rouart, who painted a watercolour

on the edge of a cliff the other day! Painting is not a sport . . .'

'As I was walking along boulevard Clichy the other day,' I said, 'I saw a horse being hoisted into a studio.'

Degas picked up a little wooden horse from his work table, and examined it thoughtfully.

'When I come back from the races, I use these as models. I could not get along without them. You can't turn live horses around to get the proper effects of light.'

'What would the Impressionists say to that, Monsieur Degas?'

Degas replied with a quick gesture:

'You know what I think of people who work out in the open. If I were the government I would have a special brigade of gendarmes to keep an eye on artists who paint landscapes from nature. Oh, I don't mean to kill anyone; just a little dose of bird-shot now and then as a warning.'

'But Renoir paints out in the open air, doesn't he?' I queried.

'Renoir is a law unto himself. He can do anything he likes. I have a Renoir in my studio in Paris I'll show you some time. Lord, what acid tones it has!' Degas was suddenly silent, then:

'Renoir and I do not see each other any more,' he said.

*

ONE OF THE VISITORS: Monsieur Degas, were there any of Monet's pictures at the Durand-Ruel exhibition?

DEGAS: Why, I met Monet himself there, and I said to him, 'Let me get out of here. Those reflections in the water hurt my eyes!' His pictures always were too draughty for me! If it had been any worse I should have had to turn up my coat collar.

VOLLARD: I understand that you are not on very good terms with Monet.

D.: No —, not since the 'Affair'. I made up with him for the sake of convenience.

ANOTHER VISITOR: How did you manage, Monsieur Degas, when you painted that *plein air* called *Le Plage*, the one Monsieur Rouart has?

D.: It was quite simple. I spread my flannel vest on the floor of the studio, and had the model sit on it. You see, the air you breathe in a picture is not necessarily the same as the air out of doors.

*

Degas was the most helpful and valuable friend imaginable when it came to advice and criticism in painting. When Gervex was at work on his *Lesson in Anatomy* Degas said to him: 'Did you ever see a student taking notes while the professor is lecturing? . . . He ought to be rolling a cigarette.'

And it was this bit of advice which made the picture.

However, when Gervex was doing his *Rolla*, Degas happened to see the picture, and again made recommendations. 'You must make it plain that the woman is not a model. Where is the dress she has taken off? Put a pair of corsets on the floor near by.'

The canvas was refused by the Salon on grounds of indecency.

'You see,' said Degas afterwards, 'nude models are all right at the Salon, but a *woman undressing* – never!'

On arriving at my shop, he stopped at once to look at the Cassatt.

'She has infinite talent,' he remarked musingly. 'I remember the time we started a little magazine called *Le Jour et La Nuit* together. I was very much interested in processes then, and had made countless experiments . . . You can get extraordinary results with copper; but the trouble is that there are never enough buyers to encourage you to go on with it.'

'The smallest plate you ever made would sell now, Monsieur Degas. . .'

'Nobody would buy etchings when I was interested in doing them,' he answered. His eye fell on one of Gauguin's pictures, and he went on:

'Poor Gauguin, way off there on his island! I'll wager he spends most of his time thinking of rue Lafitte. I advised him to go to New Orleans, but he decided it was too civilized. He had to have people around him with flowers on their heads and rings in their noses before he could feel at home.'

*

We were discussing fresco. Degas said: 'It has been the ambition of my life to paint on walls; – but you have got to remember that a house changes hands, and consequently one's work is apt to be destroyed.'

But even if a collector had owned his own house, Degas would always have suspected that the minute he finished a fresco for him his patron would lose no time having it transferred to canvas and taken to a dealer.

'If I could only be certain that my work would not rise in value,' he grumbled.

Degas used to say that if he had let himself follow his own taste in the matter, he would never have done anything but black and white.

'But what can you do,' he would ask with a gesture of resignation, 'when everybody is clamouring for colour?'

*

One day I arrived at Degas' studio as he was getting a canvas ready. He was all at sixes and sevens.

'What a cursed medium oil is anyway! How is one to know the best canvas to use – rough, medium or fine? And as for the preparation, is white lead better, or glue? Should there be one layer, two, or three?'

He was equally perplexed about the minimum preparation the old masters used. He would struggle with canvas for a while and then go back to pastel.

'I will never touch a brush again,' he would declare. Then, as if irresistibly lured by its very difficulties, he would return to oil once more.

I told him about the painter Y., who had come to me in great excitement, exclaiming: 'Well, I've found my true style at last!'

Said Degas, 'Well, I'm glad I haven't found my style yet. I'd be bored to death. . .'

*

'Upon my word, Vollard, the day will come when they'll be trotting Raphael and Rembrandt about on the boulevards, just because the public is supposed to have a right to beauty.'

From *Degas: An Intimate Portrait* by Vollard

One day when I was with Degas we ran across Monsieur Michel L., a painter whom he had known for a long time. Degas passed him by without so much as a glance. 'We once exchanged pictures,' he explained to me afterward, 'and would you believe it, I found the one I had given him for sale in a shop. I took his own back to him the next day.'

'What did he say to that? I shouldn't think that a man who can afford Watteaux would ever find himself in need of ready money.'

'Oh, I didn't even ask to see him. I just left his canvas on the doorstep along with the morning's milk.'

Degas had once made a present of a pastel to another of his friends, the painter Z., who later sold it. Dagas was offended, and afterwards when they happened to meet, he walked by without a word. But Z. ran after him and burst out with: 'Really, Degas, I've had such terrible expenses – my daughter was married you know . . .'

'Monsieur,' interrupted Degas, 'I do not understand why you should tell me about your family. I really have not the pleasure of knowing you.'

<div align="center">*</div>

Degas has often been reproached for his unrelenting attitude towards people.

'If I did not treat people as I do,' he would say in his own defence, 'I would never have a minute to myself for work. But I am really timid by nature; I have to force myself continually . . .'

<div align="center">*</div>

With such strict respect for the work of others, it is easy to imagine how Degas felt when anyone took the slightest liberty with his own. One day I noticed a damaged canvas of his on the wall, representing a man on a sofa and beside him a woman who had been cut in two, vertically.

VOLLARD: Who was responsible for cutting that picture?

DEGAS: It seems incredible, but Manet did it. He thought that the figure of Madame Manet detracted from the general effect. But I don't, and I'm going to try to paint her in again. I had a fearful shock when I saw it like that at his house. I picked it up and walked off without even saying goodbye. When I reached home I took down the little still life he had given me and sent it back to him with a note saying: 'Sir, I am sending back your *Plums*.'

V.: But you made up with Manet afterwards, didn't you?

D.: Oh, no one can remain at outs long with Manet. But the trouble is that he soon sold the *Plums*. It was a beautiful little canvas . . . (He paused.) Well, as I was saying, I wanted to restore Madame Manet to life and give the portrait back to him, but I have kept putting it off, and that is why you see it the way it is. I don't suppose I ever will get around to it now.

V.: Do you think that Manet would have been equally capable of cutting up a Delacroix or an Ingres?

D.: A Delacroix or an Ingres? – Oh, yes, I believe so, the b——! But if I had, I think I would have finished with him for good and all.

Some time later I happened to meet Degas accompanied by a porter wheeling one of Manet's pictures on a cart. It was one of the figures from the subject picture entitled, *The Execution of Maximilian*, and showed a sergeant loading his gun for the *coup de grâce*.

D. (pointing to the canvas): It's an outrage! Think of anyone's daring to cut up a picture like that. Some member of Manet's family did it. All I can say is, never marry, Vollard . . .

'The artist must live apart, and his private life remain unknown.'

I said to him at once, 'How are your works to become known?'

He answered, 'I've never heard of anyone buying a picture because it was spoken about in a newspaper; a man buys a picture because he likes it or because somebody told him to buy it.'

*

As they entered the apartment the eye of the visitor was caught by a faint drawing in red chalk placed upon a sideboard; he went straight to it. Degas said, 'Ah! look at it, I bought it only a few days ago; it is a drawing of a female hand by Ingres; look at those finger-nails, see how they are indicated. That's my idea of genius, a man who finds a hand so lovely, so wonderful, so difficult to render, that he will shut himself up all his life, content to do nothing else but indicate finger-nails.'

*

'Leave me alone; you didn't come here to count how many shirts I have in my wardrobe?'

'No, but your art, I want to write about it.'

'My art, what do you want to say about it? Do you think you can explain the merits of a picture to those who do not see them? *Dites*? . . . I can find the best and clearest words to explain my meaning, and I have spoken to the most intelligent people about art, and they have not understood – to B. for instance; but among people who understand, words are not necessary, you say humph, he, ha, and everything has been said. My opinion has always been the same. I think that literature has only done harm to art. You puff out the artist with vanity, you inculcate the taste for notoriety, and that is all; you do not advance public taste by one jot . . . despite all your scribbling it never was in a worse state than it is at present . . . *Dites*?'

*

Speaking to a landscape painter at the Cirque Fernando, he said, 'You deal with natural life, I with artificial life.'

*

Speaking of Roll's picture of *Work*: 'There are fifty figures, but I see no crowd; you can make a crowd with five figures, not with fifty.'

*

'. . . I assure you no art was ever less spontaneous than mine. What I do is the result of reflection and study of the great masters; of inspiration, spontaneity, temperament – temperament is the word – I know nothing.'

*

'The dancer is nothing but a pretext for drawing.'

*

'Hitherto the nude has always been represented in poses which presuppose an audience, but these women of mine are honest, simple folk, unconcerned by any other interests than those involved in their physical condition. Here is another; she is washing her feet. It is as if you looked through the keyhole.'

From *Degas and his Model* by Alice Michel

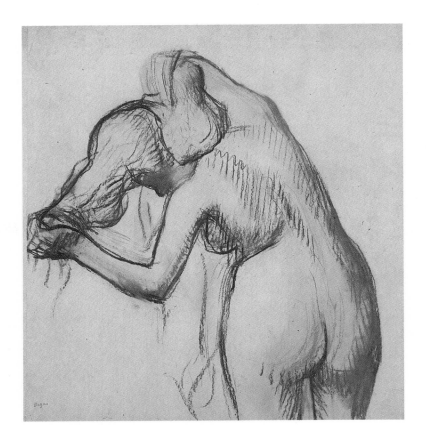

FEMALE NUDE DRYING HER NECK

'Good God! You really are posing badly today!' shouted Degas to his model, accompanying his words with a furious blow on the turntable. 'If you're tired, say so.'

'Yes, I am,' admitted Pauline, who had been making a last effort over the past few moments to balance on her left leg, while struggling to hold her raised right foot behind her with her right hand.

'Well, have a rest then. You can try to get the right position later.' Sulkily the young girl slipped her bare feet into the old shoes beside her, got down from the modelling table in silence and went over to the stove. She rubbed her leg which had gone numb because of the difficult pose and glanced irritatedly across at the old artist from time to time as he continued to model his statuette.

Why had he been grumbling at her all afternoon? 'Stand better than that!' 'Lift your foot!' 'Shoulders back!' 'Don't go all limp!' Wasn't she doing her best to pose properly? . . . And why wasn't he saying anything? He was usually so talkative. Whenever she tried to start a conversation he only replied in monosyllables . . . and his poor old maid whom he had snapped at so roughly this morning that she had cried, and all on the pretext that the fire hadn't been properly lit . . .

Sunk in his armchair, one hand over his eyes, he sighed deeply.

'Oh, my dear girl, how awful it is not to be able to see clearly any more! I have had to give up drawing and painting and for years now content myself with sculpture . . . But if my eyesight continues to dim I won't even be able to model any more. What will I do with my days then? I will die of boredom and disgust . . . Oh Lord, what have I done to you that you punish me like this? I have devoted my whole life to my work and have never sought after honour or gain . . . Oh God, don't inflict on me the torment of going blind!'

There was so much anguish in his words that the young girl was greatly moved by them even though it was not the first time she had heard this complaint. She tried to console him:

'Come now, Monsieur Degas, you aren't going to go blind, don't think that. Your eyes are tired because of the cold; as soon as it is warm again you will surely feel better.'

'Do you think so, Pauline?'

'Of course I do, Monsieur Degas. And your doctor will say the same thing as me, you'll see. He'll also tell you that you're in fine form for your seventy-six years. Just think, you work every morning without even taking a rest on Sundays or holidays. Many an artist younger than you doesn't do as much . . . And you have a good appetite, a good digestion; you sleep well, you don't suffer from rheumatism like your old friend, Monsieur Rouart.'

'But Pauline, you're forgetting my weak bladder.'

'That's what you get for not behaving yourself when you were younger,' said the model jokingly.

'Ah, you minx, remembering all my little secrets . . .'

*

Having recited all the phrases which the young girl knew already, he suddenly uttered a series of words which were so crude and excessively vulgar that Pauline, whose job as a model hadn't exactly turned her into a prude, uttered a scandalized cry.

He stopped in surprise.

'What's wrong?'

Not wanting to repeat the coarse language she commented:

'You have said things, Monsieur Degas, that would make a trooper blush.'

'Poor girl!' he replied mockingly. 'Have I offended your innocent ears? You didn't have to listen to me. I'm so absorbed in my work that I talk without knowing what I'm saying. Come on, pose for me.'

The sitting continued in silence until Pauline, tired of performing gymnastics on one leg, asked for a rest.

As she moved around the stove, she tried to remember the tune of a minuet. Not succeeding, she said:

'Monsieur Degas, would you mind teaching me that very pretty tune you were singing just now?'

'Of course not, my dear girl. I'll sing it for you.'

He stood in front of Pauline and as he sang the tune of the minuet he bowed to her; laughing, she did the same, amused at the comical spectacle they presented: she, quite naked, wearing only a pair of sandals on her feet, and he, an old white-haired man wearing his long sculptor's smock. Degas seemed blissfully happy. When the minuet was over, he seized the model by both hands and twirled her round as he began to sing an old French song.

From *Degas and his Model* by Alice Michel

'I don't really believe you,' said Pauline jokingly. 'Who is to know if you're not still chasing around these days? While Zoé thinks you are lying peacefully in bed perhaps you are across the street in the Bal Tabarin dancing a jig.'

'Aha, so you think I'm as sprightly as that, do you? Well, I'll have to disillusion you. You should know that I, who live opposite that dance hall, have not once set foot in it because of those floods of light I see when the door opens . . . I do like that kind of very bright lighting a lot. But these days my poor eyes can't cope with it any longer and I avoid it as much as I can . . . That's why I always keep the workshop curtains closed; harsh light hurts my eyes too much.

'But it's true, isn't it, Pauline, that people imagine that artists and their models spend their time getting up to all sorts of obscenities? As far as work goes, well, they paint or sculpt when they're tired of enjoying themselves . . . And when people talk of ballet dancers they imagine them as being covered with jewellery and lavishly maintained with a mansion, carriage and servants, just as it says in story books. In reality most of them are poor girls doing a very demanding job and who find it very difficult to make ends meet . . . I've got to know these little ballet pupils since they've been coming to pose for me.'

'How hard it must be to stay on tiptoe!' said Pauline, who for the past few moments had been looking at the figurine of a dancer which was on a turntable. 'How does Yvonne manage to hold a pose like that for you? I couldn't do it for a second!'

'Am I asking you to?' replied Degas gruffly. 'That's not what you're here for . . . Let's start work; but don't get up on the table. Stand beside me. I'll do the head.'

The model was now so close to the old artist that he only had to stretch out his hand to touch her. Each time he felt her face or neck his fingers, which were covered with a greenish plasticine, left some traces and this annoyed Pauline intensely. She would have found it easier to put up with if Degas had copied her features, which she knew to be delicate and pretty; but he gave to the face of his statuette the same vulgar and almost coarse expression which had shocked her in the past in his drawings . . .

*

'I am always thinking of death. Whether it be day or night-time, it is always before my eyes . . . Oh! how sad it is to be old! You, my girl, have no idea what it is, you with your mere twenty-five years.'

He collapsed into the armchair and covered his eyes.

Torn between annoyance and pity the young girl looked down at him. Her robust youth was both offended and amazed by these lamentations which were repeated nearly every day in terms which hardly ever varied. Knowing that he liked to be consoled, however, she said:

'Come now, Monsieur Degas, why are you always talking about death? You are only seventy-six; you have plenty of time to think about it . . . I bet you'll live longer than Harpignies who's in his nineties now.'

'Ha ha! Old Harpignies! It's true, he's still around and isn't ready to snuff it yet.'

*

As soon as lunch was over, the old artist went up to the studio, followed by the model. While she was getting undressed in her corner, Pauline heard Degas utter an exclamation and then say in annoyance: 'How stupid I must be to have put corks into this figure! Fool that I am, with my obsession of wanting to save a few pennies! There's the back completely ruined! Oh, why did I get myself involved in sculpture at my age? What a venture for a painter! I'll never figure it out!'

The young girl listened to his complaints with a derisive smile. She knew that at the first opportunity he would put in some more pieces of cork so as not to have to use too much plasticine, which he considered to be too expensive. And when, by dint of pushing the arm or the leg forwards or backwards, one of these discs came back to the surface, at a place where he was least expecting it, he would begin his lamentations again, calling himself a fool, a miser . . .

When she walked out from behind the screen, Pauline saw Degas busily plugging the hole which the extraction of the cork had left and said to herself that he would certainly never make any progress with this statuette. In view of the old artist's impassive face she didn't dare start a conversation and walked around the fire, hoping that Degas would eventually say something to her.

Sitting in his armchair, he remained lost in thought for some little while. He broke the silence to ask the model about her previous day's sitting and wanted to know if M. Blondin had won a prize at the salon, if he had any medals, if he was ambitious.

'Oh yes!' said Pauline, 'he's ambitious all right! He's acting all high and mighty with me now that he's won his second medal and he's already beginning to prepare the ground for himself among influential people.'

'Hm! How ridiculous they are with their medals!' said Degas, shrugging his shoulders. 'Those people don't talk like us, saying that such and such a thing happened in such and such a year. No, they say: The year I won my medal, or my first prize, or my purple ribbon, just as women say: The year I got my beautiful velvet dress . . . And to think that even my friends, my best friends, are chasing after honours and distinctions and talk of nothing but salons and exhibitions! I maintain that the true artist has nothing to do with all this s———. If he is genuinely talented he can exhibit his work anywhere, even in a shoemaker's shop. He will certainly find people who will notice and appreciate it.'

'But you used to exhibit works yourself,' said Pauline. 'The other day I read a pamphlet by Huysmans where he was saying a lot about you.'

'Huysmans?' said Degas contemptuously. 'He's a stupid s———. What was he doing talking about painting? He knew nothing about it! All these writers think they can sit down and become an art critic as if painting weren't the least accessible form of all.'

He got up and stood gesticulating in front of the young girl.

'What age is this that we are living in, Lord God! Everybody, even you models, come and talk to you about art, painting, literature, as if all they needed to know was how to read and write . . . In days gone by weren't the common people more content without all this useless instruction they're given in schools? . . . One of Zoé's brothers is a butcher and the other a carter; neither of them can read or write, but they're none the worse off for that.'

His voice grew more and more strident:

'Nowadays they want to popularize everything: teaching, and even art . . . All people talk about now is popular art . . . What criminal folly it is! As if artists themselves didn't have enough trouble learning what art is! . . . But all this comes from these ideas of equality . . .

From *Degas and his Model* by Alice Michel

How infamous it is to talk equality, since there will always be rich and poor! In the old days everyone stayed in his place and dressed according to his station; now the most insignificant grocer's boy reads his paper and dresses up like a gentleman . . . What an infamous century this is! . . .'

*

'Monsieur Bartholomé! . . . Do you know him, Pauline?' he once asked the young girl.

'Very slightly, Monsieur Degas. Juliette often poses for him.'

'Ah! what an able man he is! He can do what he likes with his hands: he can set up a framework, build up a figure, work with marble. And what's more he often has casters calling round . . . Oh, how I wish I could get a caster to come here as well! But I never manage to finish my sculpture; things just keep going wrong.'

'But you have already had some figures cast,' remarked Pauline. 'In the vitrine downstairs there's a statuette which has exactly the same pose that I'm holding at the moment.'

'Oh yes!' said Degas, 'I modelled it ten years ago, and that's the last time the caster was here. The model who posed for it has started working in sculpture. It was Bartholomé who gave her that idea . . . Why did he have to put all that stuff into her head? She left me, of course, just when she was doing exactly what I needed . . .'

Silence fell for a moment. Then the old artist said:

'Tell me, Pauline, do things go wrong for other sculptors when they are making their figures?'

'Of course they do,' said the model, trying to console him. 'That still happens to them quite often, even to the best.' . . .

'Monsieur Degas, do you remember the first time I visited you? Louise had brought me here so that you could tell me if I looked good enough to pose as a model.'

'Yes indeed, I remember that I was the first to see you naked. But it didn't all happen easily. You didn't want to take off your shift; Louise had to tear it off you. You looked so chaste; it was charming.'

'Just think! Taking all your clothes off in front of a man!'

'Is an artist a man?' replied Degas, shrugging his shoulders. 'You were pretty all right, but you really did pose badly! It was impossible to get you to draw yourself up.'

'You taught me to do it by pinching me in the back.'

The old artist laughed:

'Little minx! I shouldn't have paid you for the sittings you did, seeing as it was me who taught you to pose . . . Come on, we're going to have to sort out all these drawings that are lying around . . .'

*

A few days later, the old housekeeper was standing at the second-floor door watching for the model's arrival. She explained to Pauline that Monsieur had caught a chill and had to stay in bed as the doctor had advised. Unable to work, he had asked her to tell Pauline to go and see him in his bedchamber. With Zoé going ahead of her, the young girl walked along a corridor, then crossed through two enormous lounges and walked into a bedroom where a great log fire was burning. At first she was dazzled by the light dancing on the floor and the wall, but eventually Pauline made out the copper crossbars of the little bed and, amidst the white sheets and pillows, the pale face of Degas. Reaching out his hand to her he said gloomily:

'Oh, my dear girl, I am very ill. I am going to die; I feel it.'

Pauline made an effort to sound casual:

'But of course you're not, Monsieur Degas. You told me that six years ago and you bounced back more sprightly than ever. It will be just the same this time.'

'But this time I am six years older!' said Degas. 'Ah, no, I will never see my studio again.'

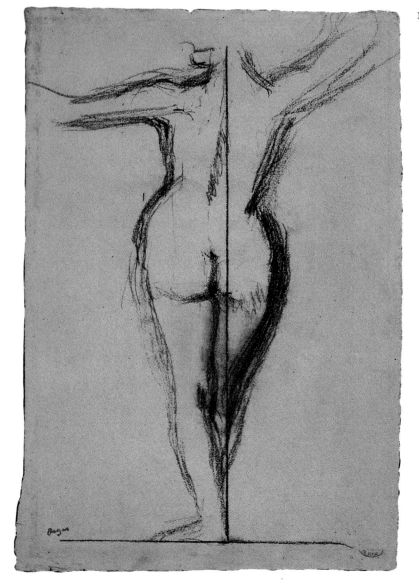

NUDE

'Speed, is there anything more stupid? . . . People will tell you in the most natural way: in two days you must be able to draw . . . But there is nothing that can be done without the patient collaboration of time.'

'Art critic! Is that a profession? When I think we are stupid enough, we painters, to solicit those people's compliments and to put ourselves into their hands! What shame! Should we even accept that they talk about our work? As if the muses did not set an example by working in solitude! "Alone and in a state of collectedness" – that is how the antique represents them. If by any chance they get together, it is not to talk; talking degenerates into argument. It is to dance that they gather. They don't mix otherwise . . .'

'Painting, is it made to be seen? You must understand, one works for two or three living friends, and for others one hasn't met or who have died. Has it got anything to do with journalists if I am making paintings, boots or slippers?'

Degas one day confided to a friend: 'See how different the times are for us; two centuries ago, I would have been painting "Susannah Bathing", now I just paint "Women in a Tub".'

'I have perhaps too often considered woman as an animal.'

'In our beginnings, Fantin, Whistler and I were all on the same road, the road from Holland. Go and see at the exhibition in the Quai Malaquais a small picture, toilet scene by Fantin; we could have signed it, Whistler and I.'

'If Raphael were to see a Cabanel, he would say, "Good Lord, it is all my fault!" But, seeing a Daumier he would say: "Well, well! . . ."'

'If Veronese landed on the banks of the Seine it would not be to Bouguereau, but to me, that he gave his hand as he stepped out of his gondola.'

On Puvis de Chavannes: 'Nobody has equalled him in finding the right place for the figures in a composition. Try to displace one of his figures by a point or a line, you won't be able to, it's impossible.'

On Whistler: 'He draws by distances, not by depths.'

Of Berthe Morisot: 'She made paintings as she would hats.'

'Art is vice, you don't marry it legitimately, you ravish it!'

'A picture is something that requires as much trickery, malice and vice as the perpetration of crime, so create falsity and add a touch from nature . . .'

'Art is the same world as artifice, that is to say, something deceitful. It must succeed in giving the impression of nature by false means, but it has to look true. Draw a straight line askew, as long as it gives the impression of being straight!'

'One gives the idea of the truth by means of the false.'

'A painting is above all a product of the artist's imagination, it must never be a copy. If, at a later stage, he wants to add two or three touches from nature, of course it doesn't spoil anything. But the air one sees in the paintings of the masters is not the air one breathes.'

'If I were to open an Academy, I would have a house with five floors. The model would be on the ground floor with the first-year students. The best pupils would go to the fifth.'

'What is essential is to establish and to express the dominant tone around which the harmony of a picture is organized. In order for that tone to be more truthful and forceful one must, if necessary, combine some false tones in order to show it off.'

'Drawing is not what one sees but what one can make others see.'

'Drawing is not form, it is the sensation one has of it.'

'Make a drawing, do it again, make a tracing of it, start again, and do another tracing.'

'I am a colourist with line.'

'To colour is to pursue drawing into greater depth.'

'The art of painting is to surround a touch of Venetian red so that it looks like vermilion.'

'The day when people began to write Intelligence with a capital "I", all was damn well lost. There is no such thing as Intelligence; one has intelligence of this or that. One must have intelligence only for what one is doing.'

'I must impress upon myself that I know nothing at all, for it is the only way to progress.'

'The Gods are dead, poetry alone is left to us, the last star in the night of chaos.'

Degas said: 'I don't want a funeral oration.' Then 'Yes, Forain, you will give one, you will say "He greatly loved drawing!"'

'I would like to be illustrious and unknown!'

List of plates

Guide to the principal personalities mentioned in the text.

BARTHOLOMÉ, Paul-Albert
Bartholomé was a sculptor and one of the two or three closest friends of Degas in his maturity. As a sculptor he was able to give practical advice to Degas when he was modelling his wax figures and Degas, in his turn, encouraged Bartholomé in the production of his own masterpiece, the *Monument aux Morts*, made in memory of his wife.

BLANCHE, Jacques-Emile
A personal friend of Degas in the later part of his career, Blanche was a painter who had considerable success as a society portraitist in France and England. He painted one of the few portraits of Degas in his later years and wrote, in 1919, a study of French painting sub-titled *From Delacroix to Degas*.

BOUGUEREAU, William
One of the most celebrated and popular Salon painters of the day, who specialized in large compositions of a pseudo-classical or allegorical kind, often featuring a number of nudes. His slick technique and fashionable appeal was often seen by the Impressionists as the antithesis of their own.

BRAQUEMOND, Félix and Marie
Degas was closely involved with both of the Braquemonds during the years of the Impressionist exhibitions, encouraging them to exhibit and participating with them in some of the activity of organization. Félix was principally known as a print-maker and pastellist, his work based on meticulously observed detail and a highly polished technique; his wife, Marie, was closer in spirit to the Impressionists, exhibiting a number of vivid oil-paintings of figures in the open air.

CARRIÈRE, Eugene
At one time Carrière was very highly regarded for his largely monochrome portraits and figure-studies, although his critical reputation later declined. Degas is known to have expressed his admiration for Carrière, and it seems that Degas' own interest in black and white, and his tendency to build pictures up in monochrome before applying colour, found an echo in Carrière's work.

CASSATT, Mary
Born in Pittsburgh, Mary Cassatt studied art in America and Europe before coming to Paris. Degas was one of the first to encourage her talent and a close friendship grew up between them. Degas based a considerable number of pastels and prints on portraits of Cassatt and there is some suggestion that they established an amorous relationship. The two artists worked together on the projected journal *Le Jour et la Nuit*, one of Degas' contributions being his etched portrait of Mary Cassatt at the Louvre. Cassatt's later pastel style was heavily influenced by Degas.

DEGAS, Achille
Edgar's younger brother by some four years and the model for several of the artist's earlier portrait studies.

DEGAS, René
The artist's youngest brother, who accompanied him on his journey to New Orleans in 1872. René had established himself in business in New Orleans and married his own cousin, Estelle Musson (whom Degas painted several times). Degas broke off relations with his brother when he abandoned Estelle, though the two brothers were reconciled in Paris later in life.

DEGAS, Marguerite
The eldest of Degas' two sisters and the one with whom he maintained a close relationship throughout his life. Marguerite married the architect, Henri Fèvre, who emigrated with his family to Buenos Aires. Degas continued to correspond with his sister and, after her death, with the family.

DESCHAMPS, Charles
An art dealer who worked for Durand-Ruel in London. In the 1870s Degas met Deschamps in London and tried to encourage the dealer to promote his work in England.

DIHAU, Désiré
Dihau is the bassoonist shown prominently in the foreground of Degas' orchestra pictures. He was a friend of the artist's in the late 1860s and early 1870s and corresponded with him on his New Orleans visit. Degas was also friendly with Dihau's sister, Marie, and painted several pictures of her.

DURAND-RUEL, Paul
An important figure in Impressionist circles, Durand-Ruel was a leading picture-dealer and promoter of their work. He appears to have established a special relationship with Degas in which the artist supplied him (sometimes after much procrastination) with pictures to sell, while the dealer released money when Degas was in need of it. Durand-Ruel presented the exhibition of Degas' landscape monotypes in 1892.

FAURE, Jean-Baptiste
Faure was a distinguished operatic baritone and an imaginative collector of contemporary paintings. Apart from pictures by Manet, Faure bought several important early paintings from Degas, including *The Ballet Scene from Robert le Diable*. Degas' relationship with Faure was soured by the long period taken by the artist to rework certain pictures already paid for, and eventually Faure sued for the delivery of his paintings.

FÈVRE, Jeanne
The daughter of Degas' sister Marguerite, who helped to care for the artist in his old age. Her reminiscences, *Mon Oncle Degas*, written in 1949, provide a useful collection of documents and memories.

FORAIN, Jean-Louis
Degas had several friends who were famous as illustrators or print-makers rather than as painters, and Forain was the most well-known of these. A household name for his satirical and humorous drawings in the popular press, Forain developed an economical graphic style which has occasional echoes of Degas' own. Forain also exhibited a number of paintings in the Impressionist exhibitions.

FRÖLICH, Lorenz
Frölich was a Danish painter who worked in Paris for many years, returning to Denmark in 1872. Little is known about his friendship with Degas.

GÉRÔME, Jean-Léon
Gérôme was one of a number of successful academic painters personally known to Degas. He was renowned for his highly finished and grandiose depictions of classical and oriental subject-matter.

HALÉVY, Daniel
The son of Degas' close friend Ludovic Halévy, Daniel continued in the family tradition and became one of the most distinguished historians and writers of his generation. As a teenager he was captivated by Degas' opinions and conversation and compiled a series of notebooks based on Degas' visits to the family household. Published in 1960 as *Degas Parle*, Daniel's memories form one of the most intense portraits of the artist in his later life.

HALÉVY, Ludovic
Childhood friend of Degas, and later a novelist and librettist, Ludovic Halévy remained one of Degas' closest acquaintances until their estrangement at the time of the Dreyfus affair. Ludovic and his wife Louise provided Degas with a second home and Degas appears to have contributed to some of Halévy's projects in a modest way. Halévy is represented by Degas in a number of his pictures, including a group of monotypes illustrating Halévy's story of back-stage life, *La Famille Cardinale*.

HECHT, Albert
Parisian banker, collector and ballet-enthusiast, Degas depicted him looking through binoculars in the foreground of his picture *Ballet Scene from Robert le Diable*.

JEANNIOT, Georges
A successful illustrator of popular magazines and books, Jeanniot was part of Degas' circle of friends in his later years. It was in Jeanniot's studio at Diénay that Degas made a number of colour monotypes during the famous carriage-journey of 1890. Jeanniot subsequently wrote down his recollections and published them as *Souvenirs de Degas* in 1933.

LAFOND, Paul
An early supporter of Degas and later one of his first biographers. Lafond became the curator of the municipal museum in Pau, in southern France, where he was visited by Degas on more than one occasion. He was also responsible for buying *The Cotton Office, New Orleans* for the Pau collection, the first public purchase of a picture by Degas.

LEPIC, Ludovic
Count Ludovic-Napoléon Lepic, amateur artist and breeder of dogs, played a crucial role on Degas' career when he introduced him to the principle of the monotype print-making technique in about 1874. He exhibited in the first two Impressionist exhibitions and was represented by Degas in a picture called *Place de la Concorde (Vicomte Lepic and his two daughters)*.

LEROLLE, Henri
Degas' letters to Lerolle suggest a long-standing and intimate friendship, and it is recorded that Lerolle was one of the group of artists present at Degas' funeral in 1917. Lerolle was a painter, a musician and a collector of pictures; Degas attended his musical soirées and Lerolle eventually acquired a number of his pictures.

MANET, Edouard
Although two years older than Degas, Manet established himself in the public eye much earlier with controversial paintings like *Le Déjeuner sur l'herbe* and *Olympia*. Manet's emphasis on modern subject-matter was undoubtedly a factor in Degas' change of direction in the 1860s, though later Degas claimed that Manet had been influenced by him. The two artists had much in common and enjoyed periods of intimacy, but their friendship was an intermittent one.

MEISSONIER, Ernest
A painter who specialized in military and historical pictures distinguished by their fine detail and painstaking verisimilitude. As a young man, Degas copied some horses from Meissonier's *The Emperor at Solferino* and later introduced them into his own horse-racing scenes. On another occasion Degas is said to have remarked that everything in Meissonier's pictures looked as if it were made of metal, except for the armour.

MOORE, George
Moore was an Irish writer who spent a number of years in the artistic circles of Paris, getting to know the Impressionist painters and writing criticism for a variety of periodicals. He met Degas in the mid-1870s and left behind a number of vivid vignettes of the artist and his views. Degas disapproved of Moore's journalistic activities and refused to speak to him again after one notable indiscretion.

MOREAU, Gustave
Born some eight years earlier than Degas, Moreau exercised a considerable influence over him during their brief friendship in the late 1850s. Moreau shared Degas' love of past art but was to continue to paint exotic and fantastical pictures long after Degas had turned to modern life subjects. Degas later satirized his former friend, whose densely coloured and richly worked paintings were to be much admired by the Symbolists and Surrealists.

PISSARRO, Camille
A leading member of the Impressionist group who was instrumental in the organization of their exhibitions and in the encouragement of younger artists. Pissarro's left-wing political views must always have been at odds with those of Degas, but they exchanged cordial letters and worked closely together, notably while involved in their etching experiments during the preparations for the journal *Le Jour et la Nuit*. Pissarro's letters to his son Lucien express the highest regard for Degas' judgment in matters of art.

ROUART, Henri
Henri Rouart attended the same school as Degas, they belonged to the same army unit during the siege of Paris and they remained close friends until Rouart's death in 1911. Rouart was a prosperous industrialist who bought a number of major pictures from Degas, and an amateur artist who contributed to seven of the Impressionist exhibitions. Degas painted him and several members of his extensive family (including his children Hélène, Alexis, Ernest and Louis) during the course of his career, and even gave painting lessons to Ernest in the 1890s.

SOUTZO, Nicolas
A Greek expatriate prince who was a friend of Degas' father and an amateur painter and print-maker. Soutzo's landscape studies impressed the young Degas and it was Soutzo who appears to have introduced him to etching.

THIEBAULT-SISSON, François
An art critic who knew Degas in the 1890s and published his memories of an encounter with the artist under the title of *Degas sculpteur* in 1921.

TISSOT, James
Tissot and Degas studied together for a while in the studio of Lamothe, a minor follower of Ingres. In the 1860s, Tissot developed a meticulous and highly finished realist manner which proved successful with the public and ensured his own prosperity. His friendship with Degas reached a peak in the years around 1870, when Degas painted Tissot's portrait and sent him several long letters from New Orleans. After the Franco-Prussian War Tissot moved to England, resisting Degas' invitations to exhibit in the Impressionist exhibitions.

TOURNY, Joseph-Gabriel
A French painter and engraver who befriended Degas on his visits to Rome in the 1850s. Degas made an etched portrait of him (perhaps under Tourny's guidance), depicted at a window working on one of his own engravings.

VALADON, Suzanne
Celebrated as an artist and as the mother of Maurice Utrillo, Valadon's drawings were much admired by Degas. She had started life as a model for a number of Degas' artist friends, before establishing herself as an artist in her own right.

DE VALERNES, Evariste
De Valernes had studied with Delacroix and was able to pass on some of his views and techniques to a younger generation. Despite the difference in their ages, he established a warm and long-lasting relationship with Degas, who painted his portrait twice. In the poverty and obscurity of De Valernes' old age, Degas was able to offer him discreet financial assistance.

VALÉRY, Paul
Paul Valéry, the celebrated writer, theorist and poet, was still unknown and unpublished when he first met Degas. One of his first major works, *La Soirée avec Monsieur Teste*, was partly based on his view of Degas and he was to publish, in 1937, a collection of reflections on the artist under the title *Degas Danse Dessin*.

VOLLARD, Ambroise
As a picture-dealer, Vollard got to know the artists of the Impressionist generation and helped in promoting the careers of many of its prominent figures. In his rôle as a writer, he collected memories and incidents from the lives of Cézanne, Renoir and Degas and left behind a rich source of anecdote, gossip and local colour which is untroubled by historical method.

WHISTLER, James McNeill
American by birth but European by inclination, Whistler lived and worked in Paris and London from 1855 onwards. Both his paintings and his public utterances attracted public outrage, but his talent was admired by Degas and many others. The young Sickert was sent to Degas with an introduction from Whistler, and Whistler was known to be in awe of Degas' art as well as his wit.

Suggested Further Reading

C.W. Millard, *The Sculpture of Edgar Degas*, Princeton, 1976.
T. Reff, *Degas: The Artist's Mind*, Harper & Row, 1976.
T. Reff, *The Notebooks of Edgar Degas*, Oxford, 1976.
I. Dunlop, *Degas*, Thames and Hudson, 1979.
S.W. Reed and B.S. Shapiro, *Edgar Degas: The Painter as Printmaker*, Boston, 1984.
G.T. Shackleford, *Degas: The Dancers*, Washington, 1984.
G. Adriani, *Degas: Pastels, Oil Sketches, Drawings*, Thames and Hudson, 1985.
R. Kendall, *Degas 1834–1984*, Manchester, 1985.
E. Lipton, *Looking into Degas*, 1987.
R. McMullen, *Degas: His Life, Times, and Works*, Secker and Warburg, 1985.
R. Thompson, *The Private Degas*, London, 1987.

Text sources

All the extracts from Degas' Notebooks were translated from *The Notebooks of Edgar Degas* by T. Reff, Clarendon Press, Oxford, 1976. Unless indicated below, all letters are taken from *Degas Letters*, edited by Marcel Guerin and translated by Marguerite Kay; Bruno Cassirer, Oxford, 1947.

The following letters were translated from *Some Unpublished Letters of Edgar Degas*, Art Bulletin, Vol. L, No. 1, March 1968 by T. Reff:
To René de Gas, 1860, To the Salon Jury, 1870, To Charles W. Deschamps, 1875, To Mme Dietz-Monnin, *c.*1878, To Alexis Rouart, *c.*1907

The following letters were translated from *More Unpublished Letters of Edgar Degas*, Art Bulletin, Vol. LI, No. 3, September 1969 by T. Reff:
To Gustave Moreau, September 1858, To Gustave Moreau, November 1858, To Gustave Moreau, April 1859, To Ludovic Halévy, 1886, To Jeanne Fèvre, 1906

The following letters were translated from *Mon Oncle Degas* by Jeanne Fèvre, Editions Pierre Cailler, Geneva, 1949:
To Auguste de Gas, October 1872, To Evariste de Valernes, Saturday (?), To Marguerite Fèvre, November 1892, To Marguerite Fèvre, 15 August 1895, To Marguerite Fèvre, 18 August, To Henri Fèvre, 18 November 1895, To Henri Fèvre, 19 January 1896, To Henri Fèvre, 18 May, To the Fèvre family, July 1901, To the Fèvre family, 1912.

Extracts from the works of the following authors come from the publications indicated:
Daniel Halévy: *My Friend Degas* translated by Mina Curtiss, Rupert Hart Davis, London, 1966 and *Degas Letters*, edited by Marcel Guerin, Bruno Cassirer, Oxford, 1946.
Georges Jeanniot: *Souvenirs de Degas*, La Revue Universelle, 15 October and 1 November 1933.
Alice Michel: *Degas et Son Modèle*, Mercure de France, February, 1919.
George Moore, *Memories of Degas* from the Burlington Magazine, January and Feburary 1918.
François Thiebault-Sisson: *Degas, Form and Space*, edited by J. and M. Guillaud, Rizzoli, New York, 1984.
Paul Valéry: *Degas Dance Drawing*, translated by D. Paul, Pantheon Books, New York, 1960.
Ambroise Vollard: *Degas, An Intimate Portrait*, translated by Randolph Weaver, George Allen and Unwin Ltd., London, 1928.

The following extracts come from *Degas et son oeuvre*, by P.-A. Lemoisne, Paris 1946–1949:
Degas' account of his meeting with Ingres, as recorded by Moreau-Nélaton.
Degas' account of *A Dance Examination*.

The collection of sayings and aphorisms of Degas come from the authors cited, in the following order:
No. 1. P.-A. Lemoisne 2. ibid. 3. ibid. 4. J. Fèvre 5. Walter Sickert, *Degas*, The Burlington Magazine, Vol. CLXXVI, No. XXXI, November 1917.
6. M. Guerin 7. Henri Hertz, *Degas*, Librarie Felix Alcan, Paris, 1920.
8. D. Halévy 9. P.-A. Lemoisne 10. ibid. 11. ibid. 12. ibid. 13. ibid.
14. H. Hertz 15. W. Sickert 16. P.-A. Lemoisne 17. H. Hertz 18. ibid.
19. P.-A. Lemoisne 20. H. Hertz 21. P.-A. Lemoisne 22. H. Hertz
23. ibid. 24. P.-A. Lemoisne 25. Andre Gide, *Journals 1889–1949*, Penguin, 1967. 26. P.-A. Lemoisne 27. J. Fèvre 28. ibid. 29. P.-A. Lemoisne.

Picture acknowledgements

The author and publisher are grateful to the museums and collections credited with each illustration for permission to reproduce the paintings in this book. Photographs were supplied by these collections except in the following cases:
Artothek, Munich 124, 163, 239
Art Resource, New York 66
Bulloz, Paris 250
Bridgeman Art Library, London 77
Fitzwilliam Museum, Cambridge 74, 197, 312
Réunion des Musées Nationaux, Paris 13, 16, 19, 25(L), 28, 29, 36, 40, 41, 48, 49, 54, 55, 56, 57, 58, 59, 60, 61, 73, 81, 84, 86, 87, 107(L), 119, 133, 154, 156, 165, 166, 179, 182, 184, 185, 187, 188, 195, 203, 207, 222, 226, 253, 259, 279, 294, 297, 304, 307
Studio Lourmel, Paris 295